To Paulette with lots.

Love from Stephen for no

other reason than because

you're you! xxxx Feb '84.

The Shell Guide to Photographing Britain

By the same author

Byron's Greece (with Elizabeth Longford)
Colour in Focus (with Bob Clark)
A Dictionary of Photographers, Terms and Techniques
The Camera at War
A Writer's Britain (with Margaret Drabble)
James Joyce's Odyssey (with Frank Delaney)
The Book of Portrait Photography (with Mayotte Magnus)

THE SHELL GUIDE TO
PHOTOGRAPHING
BRITAIN

Jorge Lewinski

Hutchinson
London Melbourne Sydney Auckland Johannesburg

Hutchinson & Co. (Publishers) Ltd
An imprint of the Hutchinson Publishing Group
17–21 Conway Street, London W1P 6JD

Hutchinson Group (Australia) Pty Ltd
30–32 Cremorne Street, Richmond South, Victoria 3121
PO Box 151, Broadway, New South Wales 2007

Hutchinson Group (NZ) Ltd
32–34 View Road, PO Box 40–086, Glenfield, Auckland 10

Hutchinson Group (SA) Pty Ltd
PO Box 337, Bergvlei 2012, South Africa

First published 1982

Designed and produced for Hutchinson & Co. by
BELLEW & HIGTON
Bellew & Higton Publishers Ltd
17–21 Conway Street, London W1P 6JD

Although sponsoring this book, Shell UK Ltd would point
out that the author is expressing his own views

Set by Western Printing Services Ltd
Colour separations by Fotographics Limited
Printed and bound in Great Britain

British Library Cataloguing in Publication Data

Lewinski, Jorge
The Shell guide to photographing Britain
1. Travel photography—Great Britain
I. Title
778.9′4 TR790
ISBN 0 09 147060 9

CONTENTS

1 TECHNIQUES

Among the visual arts photography alone captures and preserves the very moment of experience. While artists in other media are also able to give expression to their vision, they cannot fix the experience in an instant, and the remembered image is never the same as the actual one. Photographic image-making, and the photographer's way of seeing, is unlike that of any other medium known to us. Why should this be so?

The unique quality of photographic vision

In the first place, the photographer records the reality in front of him instantaneously. A photograph, however, is never a mere copy of that reality. Because the camera is aided and abetted by the human brain and eye, which choose a certain segment of the scene, and select a precise moment in which to bring it to light, it is no longer a mere copy which formulates itself on the film, but a personal interpretation of reality. The uniqueness of photography lies precisely in the fact that a mechanical contrivance – minutely accurate and precise – is put into the service of a critical and original eye.

And yet remarkably few photographs are truly memorable. The great majority taken every day are predictable, uninspired and very ordinary. Why then this paradox? The reason lies, I feel, in the fact that photographers, for much of the time, are not fully aware of their medium's true capabilities. Too many seek to imitate images they have seen – creating 'Hobbemas' in the countryside or 'Rembrandts' in portraiture. The camera is not at its best when churning out pastiches, but it can enable you to create fresh and original images.

Photography is a dynamic medium. It transforms living, real fragments of life into images redolent with the vigour and spontaneity of the moment. But only if you approach the subject in the proper spirit. If you treat nature and human beings as potential still lifes, they will indeed appear so in your pictures. If you are completely aware of your environment, however, and if you are able to react spontaneously to what you see, then your images will acquire an original and individual quality. The strength of photography lies in its peculiar characteristics – the property of instantaneous and direct response to reality, the capacity to originate images which mirror your own feelings about, and reactions to, what you see at a given moment, and the marvellous ability to present you with the gifts of chance and the unexpected.

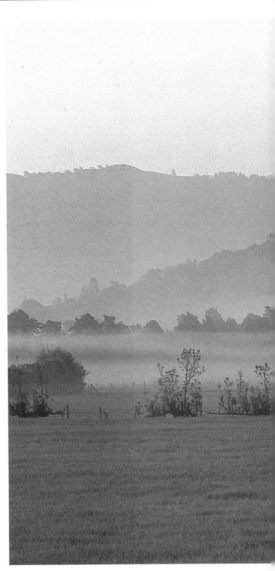

Cezanne, confronted with Mont St Victoire, ruminated, pondered, added to and transformed. Cartier-Bresson, by contrast, is a concentrated eye – seeing all, responding to all, and ready instantly to commit a vivid image to the frame of his Leica.

The need for involvement

The secret of the great photographers was that they were always totally involved with their subject. If you do not care for the countryside this book will not help you a great deal. Even if you are in love with nature, though, but are not

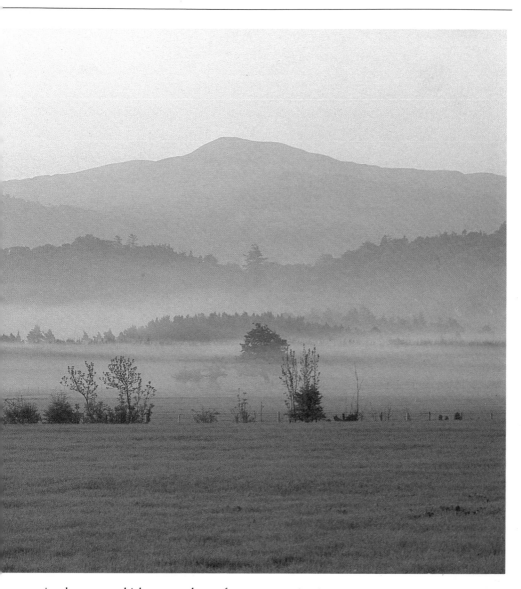

quite clear as to which stop to choose for your shot, your efforts may still be thwarted. For this reason *The Shell Guide to Photographing Britain* offers basic technical advice as well as suggestions about where to photograph.

Let us then sum up briefly. Good photography depends, firstly on an understanding of and involvement with your subject, and secondly on using photography, a dynamic medium, in a dynamic way – seeing and reacting spontaneously and, above all, avoiding static, predictable and preconceived images. Lastly it must rely on a thorough knowledge of and familiarity with your apparatus. You can act

Daybreak near Keswick in the Lake District. The early morning mist is just beginning to clear; the sun about to rise over the horizon. Such moments last for a very short while.
Pentax 6×7cm, wide-angle lens, Agfachrome 50S, ¹/₃₀ at f8.

quickly and without hesitation only if you can forget the technicalities – simply because they have become totally ingrained through constant practice. There is, of course, one more element, so far unmentioned, but of crucial importance – visual and aesthetic sensibility. This will be discussed later, but for the moment let us consider our main subject – the countryside.

WHAT IS A LANDSCAPE?

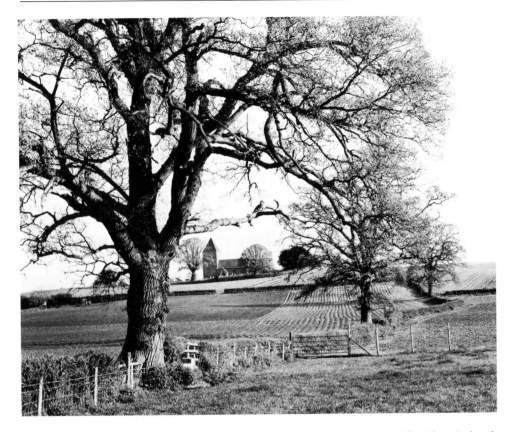

Most dictionaries define a landscape as 'that portion of the land which the eye can comprehend in a single view' or 'a pictorial representation of an actual or imagined inland scene'. Both definitions refer to an image of a piece of land, but in photography landscape is much more than that. On the simplest level it can be the sweep of a panorama or a small segment of a scene – a tree, a rock, or part of a ploughed field. Naturally seascapes and mountains fall within this definition. A successful pictorial landscape, however, is not simply a description; it is more like a portrait of a locality. A portrait which, when seen, say, by a native of the land, could be identified as an image of that particular locality and no other. And just like a human portrait, it must take into account not only the exterior appearance but also the personality of the sitter. A serious landscape photographer, when confronted with his subject, must ask himself several searching questions before he reaches for his tripod. What is peculiar to this particular landscape? Its hills, its winding river, or its open plains? Are trees and fields important in forming its general

Landscape near Allensmore. The rich agricultural Herefordshire countryside is serene and gentle. Nikon FE, medium wide-angle lens, FP4, 1/125 at f16.

appearance? Has it been largely remodelled by man's tenure? If so, are its houses, fences or walls characteristic? Only when you have clearly established the main features – the distinguishing marks – of the terrain will you be able to find the best way to photograph it.

The 'correct' photographic solution

What is required in each case is an intellectual interpretation as well as a simple description. Fundamental differences in interpretation are called for when photographing distinct types of landscape. Let us take two extreme examples – mountain and pastoral scenes. The first calls for a stronger and more masculine approach, accentuating ruggedness and height, using strong contrasts of black and white, while in the second category we would think in terms of undulation, flow and horizontality, using the

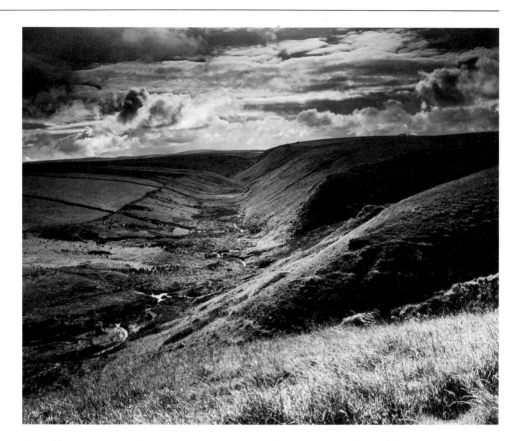

The wild expanse of Brendon Common on
Exmoor. The dominant mood is desolate.
Pentax 6×7cm, wide-angle lens, Tri X, ⅟₆₀ at f22,
yellow filter.

gentler tones of greys or pastel colours. The
same criteria apply when we contrast a peaceful
village and, say, a cathedral or a prehistoric
monument. Naturally other factors have to be
taken into account, like colour, light and mood,
all of which will be dealt with later.

This kind of approach – being guided by the
qualities of the subject, searching for a distinc-
tive portrait – is possibly the purest and most
profound in landscape photography, but it is
not the only one. You can also treat landscape
as a sculptor treats his clay – shaping it to a
preconceived idea, creating not so much a study
of a locality, but an abstract, universal image. In
this case the photograph becomes mainly a
study of design and texture. It is an entirely
valid approach, but in the long run is far less
satisfying. The same argument can be applied to
the simple record study – perfect technically,
clearly describing an area, but lacking in depth

of perception, and certainly short on personal
involvement. We may admire it as a piece of
perfect workmanship but nevertheless fail to be
moved by it.

It is possibly because of the need for empathy
with our subject, that often the best landscape
photography comes about when we tackle our
own country, or at least a region which we
know well. Edward Weston's best work clearly
comes from California and his beloved Point
Lobos; Ansel Adams excelled in the American
Rockies; Henry Emerson in the Norfolk
Broads; and Bill Brandt in his adoptive north of
England. Familiarity does not breed contempt
but, on the contrary, love and understanding. It
therefore seems that for the best results you
should either 'plough your own furrow' or,
alternatively, instead of covering a large area of
country in a short time, choose one region only
and stay there as long as possible, getting well
acquainted with it. It is partly for this reason
that I have selected – within each type of land-
scape – one or two areas only, treating them
thoroughly, rather than giving a bird's-eye view
of many.

INDIVIDUAL TREATMENT

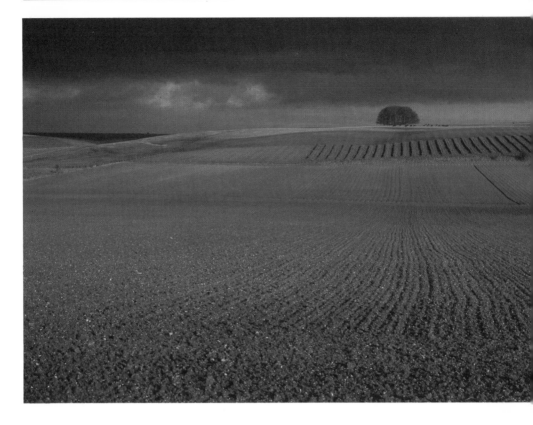

In landscape photography the images should flow naturally from your encounter with nature – only very broadly based on your preconception of the area. Nothing is more likely to stifle creativity than the deliberate search for an ideal composition. There is, in any case, no formula, no fool-proof recipe for a meaningful image. Composition is important, but it must become your servant, not your master. It is you who takes a picture, not the ghost of a Claude or a Poussin. Photography is strictly a love affair between you and your subject – and the more passionate it is, the better the results.

Stereotyped, formula pictures are an example of mental laziness leading to pictorial shortcuts. Another quite common example is the habit of opting for the easiest and most obvious visual solution – a straight, middle-of-the-frame photograph. But the greatest satisfaction lies in creating something not seen before. Then it is really yours. Otherwise the next photographer, following in your footsteps with an equally good camera, would come out with exactly the same picture. Think how many millions of photographs of Nelson's Column there are in

the world, and how very few really unusual ones.

Acquiring a discipline

A good photographer having found an interesting subject asks himself immediately: 'How can I photograph it so that it looks even more exciting and beautiful?' He is bound to avoid the simplest solution. Instead he will stop and think. He will look at all the possibilities. How does the light fall on the subject? From which direction? What other elements could be included to strengthen the meaning or improve the composition? Perhaps another time of the day would be better? Which angle is the best for the subject? And only then will he proceed to photograph it. Obviously if it is a street fight he is about to shoot, a split-second decision must be made. But landscape will not escape – it will wait for him. Consequently the use of a tripod for landscape photography is strongly recommended, even if it is not strictly necessary. It slows you down, gives you time for thought and allows you to select the best frame (you can see

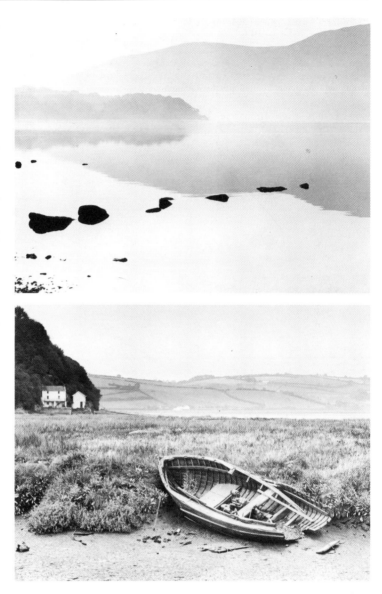

To achieve simplicity of composition it is important to concentrate on the main feature of a landscape. Above left: Marlborough Downs near West Kennet. Above right: Ullswater in the Lake District. Right: Laugharne in South Wales. On the left is Dylan Thomas's house.

it so clearly when the camera is stationary). The smaller aperture used with the tripod will improve the clarity and focus of the image.

Simplicity is the key

The discipline of taking extra care and time in your picture-making may yield an additional bonus. It can direct you towards stronger and simpler images. When you have ample time to examine your frame, you will often notice that by excluding a part of the scene, or some small element of it, you improve it greatly. With a

hand-held shot, and the speed it involves, you tend to include too much. Looking at the pictures of great landscape photographers the first thing you notice is their simplicity of structure. Only a few lines – a few shapes – and a minimum of colours. Photography thrives on simplicity. The realistic nature of the medium makes you notice and 'read' all the subject matter included far more intensely than in painting; consequently the superfluous details are far more noticeable than they were in reality, and the picture seems more cluttered.

15

SELECTING THE SUBJECT

There is no such thing as an inherently unphotogenic type of landscape: beautiful pictures can be made virtually anywhere. Nevertheless selection of the scene is important. As we have already noted simple, direct, strongly structured pictures are by far the most successful. The human eye loves simplicity. This is the first law of the *Gestalt* Theory of Perception. The eye, according to the psychologists of perception, also enjoys regular, clearly defined shapes or arrangements of shapes. Because of this preference for simplicity and conciseness the panorama admired from mountain-tops (invariably marked with a star in all the guide books) is so disappointing in photographs. The eye when viewing it on location scans the scene, enjoying separate parts of it, jumping from one to the other, revelling in its grandeur and its scope. The camera records all indiscriminately – and all the little joys the eye picked up are reduced to insignificant specks. The grandiose view is reduced to a grey mass of details, with no distinguishing marks, nothing for the eye to rest upon. And, above all, no design, no organization imposed by the seeing eye.

Establishing order

The landscape in most cases is just such a conglomeration of shapes, lines and colours, and if simply recorded would most likely remain

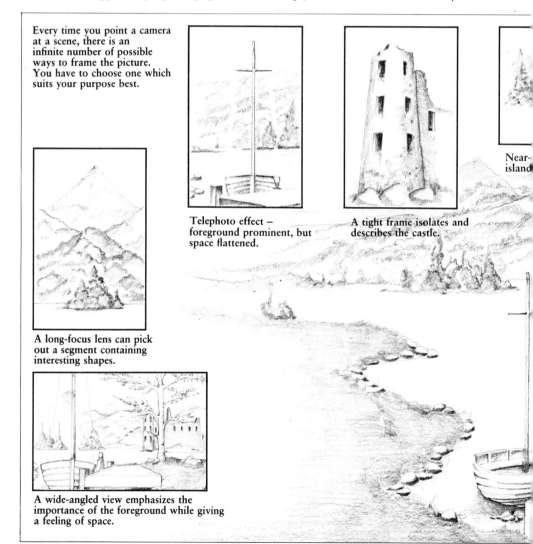

Every time you point a camera at a scene, there is an infinite number of possible ways to frame the picture. You have to choose one which suits your purpose best.

Telephoto effect – foreground prominent, but space flattened.

A tight frame isolates and describes the castle.

Near-island

A long-focus lens can pick out a segment containing interesting shapes.

A wide-angled view emphasizes the importance of the foreground while giving a feeling of space.

chaotic and random, as is most of nature in the raw. It is the creative eye of the photographer which must impose order and some constancy. There is no question, needless to say, of arranging anything in a deliberate way. Photography is too serious a medium to allow subterfuge. Nor is there any need for deception. You can 'organize' reality simply by skilfully selecting the angle of the shot, by coming nearer to exclude unwanted detail, or by making the foreground stand out more prominently and perhaps shielding the unwanted parts. With a little care, the scene will suddenly begin to acquire a definite shape and coherence.

The process of organizing or designing an image is, of course, not arbitrary. There is, or at least there should be, a distinct purpose in all you do. You have already identified the main features of the landscape; now all you do is bring these to the fore by arranging them in the frame in such a way that the eye of the prospective viewer will be able to follow your own thoughts and feelings. Matisse put it lucidly: 'Composition is the art of arranging in a decorative manner the various elements at the painter's disposal for the expression of his feelings.' Matisse, of course, had complete control over his canvas; we do not. We have to use what is in front of us. Nevertheless we can still achieve a great deal.

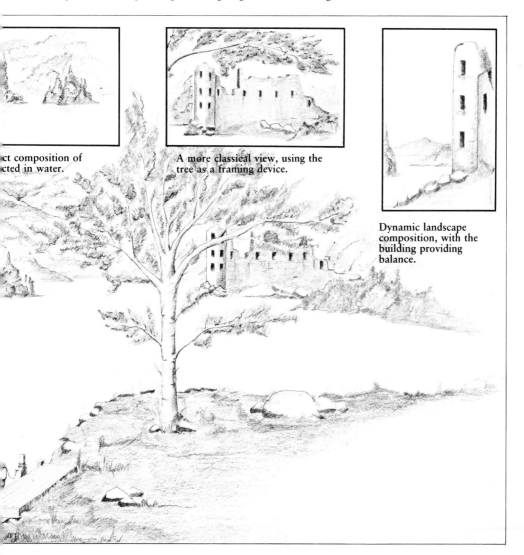

ct composition of
cted in water.

A more classical view, using the tree as a framing device.

Dynamic landscape composition, with the building providing balance.

COMPOSITION

Basically there are no hard and fast rules for photographic composition. Photography being a dynamic medium relies on the reality and vigour of life for its chief appeal. As the photographer cannot be bound by rules he must develop an eye for form and design, which can be called upon almost without conscious thought. The only way to do this is by looking at many pictures, analysing them, and by constant practice.

Let us consider a brief outline of those principles of composition which, if used flexibly, could be useful to a photographer.

At the outset, there is the question of order itself. In speaking of order within an image we mean that a photograph can be clearly read by the viewer, that its main theme and its principal features are not buried among other elements, but are seen clearly and prominently. And also that the subject is placed within the frame in such a way that it does not disturb the eye – that it is contained within a balanced composition. If a central position were selected for it (the easiest way out) it would, of course, be in perfect equilibrium, but at the same time this would also mean that the least exciting arrangement had been chosen. The eye of the viewer would come to it as a matter of course, and since there would be little else of interest within the rest of the frame it would soon tire. A static composition of this kind is, on the whole, anathema to photography. Life means movement, activity, excitement and tension. An image taken from life must also possess these qualities.

Dynamic balance

Ideally the visual structure of a photograph should be orderly and organized, but its balance should be dynamic and not static. How can these two demands be reconciled? Simply by placing the main feature slightly off-centre and balancing it with a secondary point of interest on either side. An examination of well-known photographs will soon reveal that most of them are based on this simple principle. In a composition of this kind the eye is no longer the prisoner of one object, but can wander freely from the main to the secondary subject, explore on the way the rest of the image, and come back, as it should, to the principal part. By making the eye scan the image, the photographer has endowed it with vigour and a sense of implied movement.

There do exist a number of more-or-less orthodox rules of composition, such as the arbitrary division of the picture into three parts and the placing of the main subject on the third – both on the horizontal and the vertical plane – a rule as old as the Italian Renaissance. Equally arbitrary is the famous Golden Rule, which almost calls for a ruler and a pocket calculator. It is, of course, quite illogical to ask a photographer to apply this kind of methodology. It may be more helpful to mention a few visual, compositional devices, designed merely to attract and hold the eye of the viewer. Three such devices come readily to mind: the use of continuity or rhythm within the image, such as the long line of a road or the crest of a hill; the use of similarities of shapes and lines, where a cloud echoes the shape of a tree, or a furrow the line of the fence; and the use of 'closure', in which the subject is framed by a feature in the foreground such as a tree or a wrought-iron gate.

Design as meaning

So far we have discussed the structure of the image from a purely visual point of view. However, composition can be employed not merely to please the eye, but also to play an intellectual role. The human brain, we know, is an incredibly complex instrument – a highly sophisticated computer. It stores in its memory millions of past experiences which, in a flash,

Newstead Abbey, Nottinghamshire. An example of 'closure'. The image is framed within a frame. The eye is led instantly to the main feature.

Fields in Northamptonshire near Olney. In this composition, dynamic balance is achieved by placing the focal point – the tree – far to the left. The composition would be unstable if there were no visual elements balancing it on the opposite side. These are provided by the expanse of the sky, the dark patch of the field and the tree's branches stretching to the right.
Pentax 6×7cm, wide-angle lens, Tri X, ¹⁄₆₀ at f16, yellow filter.

Hebden Bridge, Yorkshire, in winter. It is important to provide the spectator with continuous, clearly defined lines of 'viewing'. The eye dislikes being jostled from one point to the next, without connecting lines between them. Conversely, it enjoys a smooth passage along the image. Continuous lines also lend a picture rhythm.
Nikon FE, wide-angle lens, Tri X, ¹⁄₆₀ at f16.

The Llangollen Valley near Llantysilio Mountain. This composition is based on visual repetition. The eye is particularly attracted by similarities occurring between two entirely different elements – here the shape of the smoke partly resembles the group of trees. Note also the dynamic balance between the two.
Pentax 6×7cm, medium wide-angle lens, Tri X, ¹⁄₆₀ at f11.

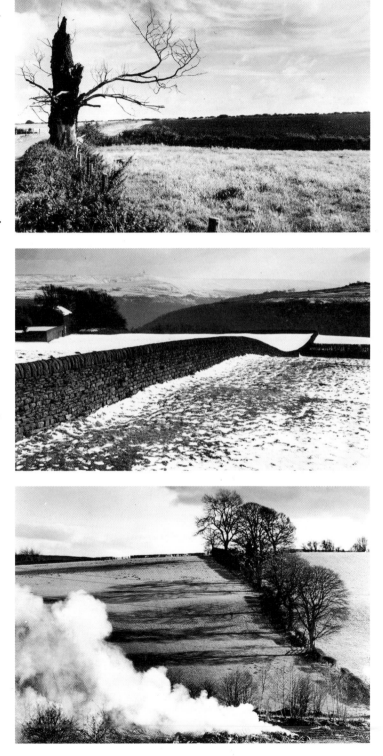

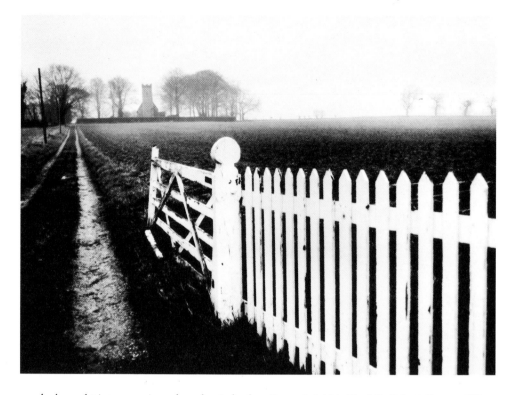

can be brought into conscious thought. Indeed it acts on the slightest of prods or associations. It is aware, for example, that sharp instruments and angles, as well as rough surfaces, can be unpleasant, while smooth, soft ones can bring rest and comfort. Thus the image with sharp and protruding angles, like broken branches, will immediately create an unpleasant association: it will set the required mood. There is a wealth of possible nuance which shapes and lines can suggest.

The diagonal

The diagonal is one of the most important graphic features in photography. Its vigour and thrust, as opposed to the placidity of a horizontal line or the steadying influence of a vertical, gives a photograph liveliness and an implied movement which, as we have already seen, is of prime importance.

The diagonal line, running in the picture from the bottom left-hand corner to the top right, often gives an impression of elation; the line traversing from top left to bottom right can be read as a depressing, pessimistic descent. This is because of our habit, in the West, of reading from left to right. The eye habitually

Above: A field in Norfolk. Below: Burway Hill, The Long Mynd. Both pictures make use of the diagonal line, which gives the compositions visual energy. Note the difference between a descending and an ascending diagonal.

goes first to the left of the picture and reads it from this direction unless it is drawn away by a very distinct shape on the right.

Viewpoint

Compositional effects can often be achieved simply by selecting a suitable angle of shooting. Almost invariably we look at the world from an

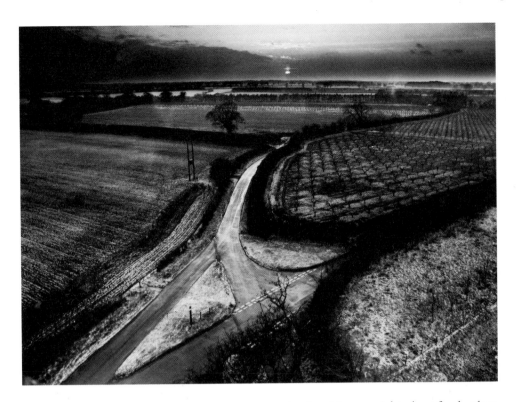

Above: Norfolk fields seen from the church at Ranworth at sunset. Below: The church at Potterne in Wiltshire. These pictures demonstrate the possibility of alternative viewpoints. A change in the angle of shooting invariably attracts the eye.

eye-level position – upright, about five feet from the ground. Pictures taken at eye level therefore seem slightly ordinary; on the other hand it is always desirable to offer the spectator something he does not often see for himself. A change of the viewpoint is one possibility. The creative photographer should always be on the lookout for new visual possibilities.

Format and filling the frame

The format of the image, too, has thematic possibilities. Apart from merely finding the best format for the subject (long and narrow for a pastoral meadow, vertical for a soaring mountain or a group of tall trees), a skilful photographer may use the frame in a more sophisticated way, selecting a variety of proportions, each to a slightly different effect.

The frame itself is a very important tool in imaginative hands. It is vital to learn to fill the frame as tightly as possible. Leaving too much space or superfluous detail around the subject is a distinct disadvantage, even with black and white, where you can effect some improvement in the printing stage. Printing only a small part of the negative is bound to affect the quality and grain adversely.

Three-dimensional space

The choice of frame and viewpoint can also influence the portrayal of three-dimensional space within the image. Every photograph, in effect, is a translation of the three-dimensional world into the confines of a two-dimensional piece of paper or film. With skill, it is possible to create a startling illusion of depth. The most popular method is contained in the perennial advice given to beginners: 'Try to see your picture in three independent planes – foreground, middle distance and far distance.' This kind of composition is bound to create the illusion of space, since it will probably make use of most of the visual expedients contributing to the enhancement of plasticity. It will contain, most likely, objects of diminishing size (objects nearer the camera appear to be larger than more distant ones); there may be some overlapping of shapes and objects, again automatically suggesting distance between them. And since a fairly large area of the scene will be included, the aerial perspective will come into operation (distant planes appearing lighter and hazier); there may even be lines converging into the distance, equally contributing to the 3-D effect. Indeed, the third dimension can be accentuated by the use of a wide-angle lens which has the property of 'stretching' the space in the image (see Chapter 2).

Pattern of fields seen from the air (Isle of Wight). Seen from above – with no sky-line to interfere – the geometry of fields can be fascinating. It is not all that difficult to shoot from the air. Short air-trips are fairly cheap and most pilots will cooperate. A long-focus lens is necessary of course.

Right: Angler in the Woodlands Valley of the Peak District. The human figure immediately becomes the focus of attention, especially if, as here, it is the only vertical among mainly horizontal lines. Nikon FE, medium wide-angle lens, FP4, 1/125 at f8.

The foreground

The foreground is particularly important. It helps create the impression of space – while often strengthening the theme of the picture by allowing the photographer to place an important visual 'clue' prominently. It also frequently plays an important role in the visual impact of the image. The tone of the foreground – whether it is an object like a gate, a tree trunk, an animal, or a hedge, or even merely a patch of grass or undergrowth – is predominantly darker than the rest of the picture, and in consequence provides a solid base for the image, as well as a striking contrast of dark against light. In order to attract and hold the attention a picture, by and large, should consist of contrasting areas of tone or colour, or otherwise of contrasting shapes; both add considerably to the visual tension and interest.

The human figure

One of the most difficult, and interesting, aspects of landscape photography is the use of the human figure as an integral part of the composition. A human figure in a vast expanse of space and nature also acts as a contrasting element – a kind of punctuation mark.

For us there is no greater attention-stealing

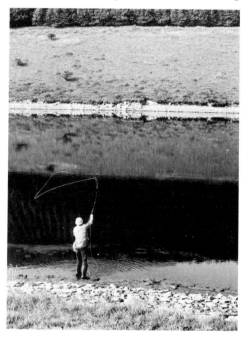

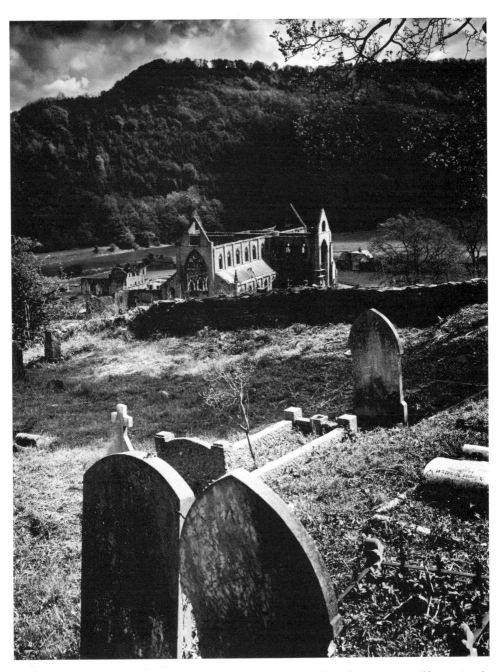

Tintern Abbey in Gwent. Elements in the foreground lead the eye into the picture and, even more important, they strengthen the impression of three-dimensional space.
Pentax 6×7cm, wide-angle lens, Tri X, 1/30 at f22.

feature than another human being. We are endlessly interested in our fellow humans – in their appearance and their activities. On the whole you will find that people in the country are very kind and helpful and quite willing to be photographed. Few will be trained models, though, and most will tend to pose too self-consciously and in consequence appear awkward and even out of place. It will require time and patience on your part to put them at ease.

At this stage, however, it is the human figure as an element of composition that we are interested in. Because of its visual strength it should be treated with great care. In landscape photographs it is often best to use people further away from the foreground, where they do not monopolize attention.

PHOTOGRAPHING IN COLOUR

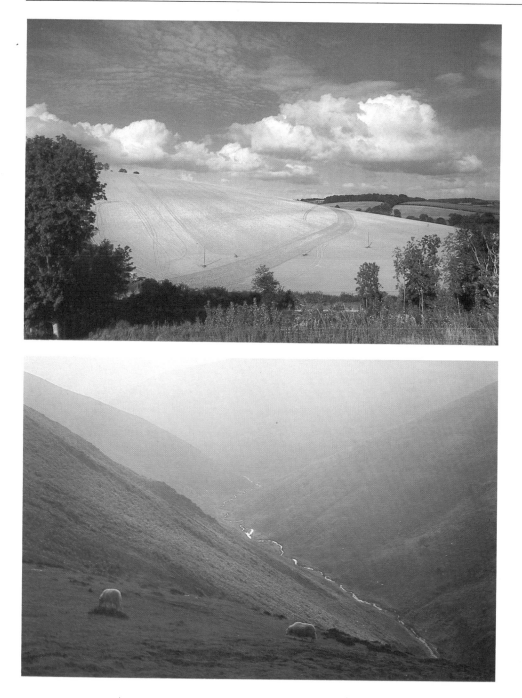

These pictures show the effect of different lighting conditions on colour. Top: The view from Hod Hill, Dorset. This was taken on a clear summer's day, with the sun almost behind the camera. The strong light provides a vivid contrast of yellow fields, blue sky and green foliage. Above: Cardingmill Valley in the Long Mynd. This was taken into the sun in the early morning, with the low light bringing out the delicate, muted tones of the receding ranges of hills.

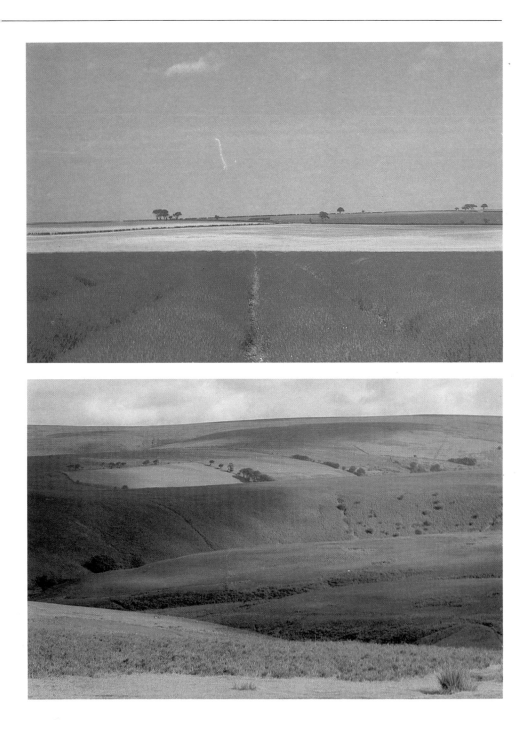

Two examples of ways in which colour is present in the landscape. Top: Lavender fields with poppies behind at Choseley near Thornham in Norfolk. The composition is created by splashes of vibrant colour, used in an almost abstract way.

Above: Lanacombe in Exmoor. Here the range of colour is restricted, the subtle tones of green providing the visual interest. Both pictures rely on the use of colour for their impact, rather than on strong compositional features.

Tonal values

Many books warn against mixing black and white and colour while shooting on location. Up to a point they are right, but not entirely. Most professionals working on an assignment invariably shoot both at the same time. It is possible to adjust your vision from colour to black and white, and vice versa, but a conscious effort must be made.

Some colours are visually stronger and brighter than others, and this must be taken into account in the composition of an image. A patch of red on one side of the picture – or yellow, which is the brightest colour – will require a strong balancing element on the opposite side. The emotional impact of certain colours in a given composition would be lost in a black and white version of the same picture. A photographer must learn to see and compose in the two media in a different way.

Furthermore the eye reacts differently to out-of-focus colour than it does to unsharp monochrome. Blurred, floating patches of colour in the foreground may be quite acceptable, even pleasing, while a similar effect in black and white is positively disturbing.

Colour harmonies

The theory of colour harmonies is as old as painting itself, but it was only the poet Goethe in the eighteenth century and, more conclusively, the nineteenth-century French scientist Michel Eugène Chevreul, who were able to assemble various assumptions about the behaviour of colour into a convincing thesis. We are discussing here not the science of colour photography, as it applies to the manufacture of films, but the aesthetics of colour perception.

The theory revolves largely on the so-called colour circle, which Goethe drew first. At the basis of the circle are the three primary colours – red, yellow and blue. They are called 'primaries' because, in fact, any colour of the rainbow can be created from varying mixtures of them. By mixing the primaries in pairs we acquire a so-called secondary colour – thus red and yellow result in orange, yellow and blue become green, and red and blue give violet. Each secondary colour can be now placed in the colour circle opposite that primary which is not one of its constituents; it is then deemed to be its complementary (green being complementary to red, orange to blue, and violet to yellow). Still further intermixture of the secondaries with the

In different circumstances light will show a bias towards either warm or cool colours. 'Colour temperature' is measurable in degrees of Kelvin (K), and bias can be corrected with a filter.

K up to:	Blue bias		Source, correction filter & exposure
18000			Snow, blue water UV + pale yellow + 1 to 2 stops
6000			Deep shadow, blue sky 81A + $\frac{1}{2}$ stop
5400			Noon sunlight Daylight film optimum
5000			Average daylight (overcast) UV + $\frac{1}{2}$ stop
4200			Early morning and evening sunlight 82A + 1 stop

primaries adjacent to them on the circle (say orange and yellow) will give us six more colours – called tertiary. Thus a full colour circle will have all the reddish/yellowish colours on one side and the blue/violet range on the other.

On the basis of such a colour circle Chevreul suggested two kinds of harmonies. The first harmony occurs when a family of similar colours is involved – as in the autumnal colours of red, brown and yellow – all from one side of the circle. The second harmony is achieved by an interaction of a primary with its complementary. This is often called the harmony of contrast.

Simultaneous contrast

Both Goethe and Chevreul noticed a curious optical phenomenon. When we look intently for a short while at a patch of red and then swiftly shift our gaze to a white surface, we can clearly see there the illusion not of red, but of its complementary – green. The same manifestation will take place with all other primary/complementary pairs. This visual effect is called simultaneous contrast, and its existence is at the root of the harmony of contrasts. In practice it means that because of the effect of the simul-

taneous contrast, each adjacent colour of a primary/complementary pair enhances the other visually – red therefore boosts the vividness of its neighbour, green, and vice versa. The well known warm/cold relationship of colours, used by painters and photographers alike, is also based on simultaneous contrast. Warm colours from the red/yellow band interact, vibrate with and enhance cold colours from the blue/violet range.

In fact these colours possess yet another visual property. Warm colours – especially red – seem to advance towards the viewer; their counterparts, the cold hues – blue especially – appear to recede into the distance. This optical interaction can add greatly to the three-dimensional quality of an image. It is precisely this phenomenon which causes blue-tinged mountains to seem to float away into infinity.

Muted colours

Having explored some of the possibilities of using various colours and their respective effects on our vision, it must be emphasized that by far the most effective and pleasing landscape photographs in colour are precisely those which display a restrained and muted palette. On the whole, flowers excepted, nature in our temperate zone is not given to excesses of colour. A sensitive photographer of the British countryside should bear this in mind. It is predominantly the first kind of harmony – that of similar colours – which is the most gratifying.

Colour or monochrome?

Colour photography is more naturalistic than black and white and leaves, somehow, less to the imagination. Monochrome, on the other hand, has qualities akin to abstraction. It has been in use now for a very long time, and because we have come to take it for granted, we rarely stop to consider the totally distorted image of reality that it offers us. All the colours of our environment are translated into various shades of black and grey, and more often than not this translation is grossly inaccurate. Imagine a red rose photographed against the background of a green tree. In a monochrome print both tones print in a similar tone of grey. It is because of these radical falsifications of tonal values that a photographer working in monochrome must learn an entirely different and new visual language. He must, of necessity, become far more graphic in his approach.

Yet in colour the same rose will shine like a beacon within the image, becoming an unassailable focal point. There may be no need, when working in colour, for strong effects of tones and shapes: a small touch of colour will do the trick. Thus while the photographer in monochrome must aim for bold compositions, rich in contrast, his colour counterpart will gain his effects from the nuances of hues. At the same time, colour used as an aesthetic, artistic medium can present all sorts of dangers and pitfalls. Strong colours entirely true to nature may, in a photograph, jar and disturb the eye. At other times colour photographs can appear sentimental and garish. The fault may lie, at times, with the photographer who, having loaded his camera with colour film, seems hell-bent on finding colourful subject matter. There is also another danger: since colour is more realistic, it is subject to greater attentive scrutiny by the viewer. Small departures from colours to which the spectator is used may disturb him more intensely than any element of unreality would in black and white. And then there is the problem of colour being seen differently by different people. There is no mathematical formula for the colour red. There are many nuances of red. So how red is a pillar box?

Slides or prints?

Which should you choose then for photographing the countryside? Colour or black and white? There can be no clear cut answer. Each has its own advantages. Colour, on the whole, seems to be more popular among amateurs. In the past reversal films or slides seem to have been preferred. Professionals shooting for subsequent use in books or magazines also use colour transparencies. And as far as fidelity of colour is concerned, there is little doubt that reversal film is far more accurate, as well as more vivid in saturation, than a colour print. Nevertheless it is often inconvenient to set up a projector and subject your friends to a formal viewing session. How much more casual and pleasant just to show a few prints. The quality of colour negatives and colour printing by reputable laboratories today has greatly improved, so that there is no reason why you should not build up a very respectable collection of colour prints. The serious amateur, however, will still prefer to print his own photographs, and here monochrome with its greater control, ease of use, and competitive price, scores heavily.

2 LIGHT

It is said that photographers 'paint with light'. This may be true, to some extent, in studio photography, but in landscape photography it is the light which is the painter – and the photographer its humble interpreter. Light possesses its own special attributes. A change in the quality of light can transform the scene, adding strength and gaiety, creating mystery or drama.

Brightness or intensity

What we see is merely the amount of light a

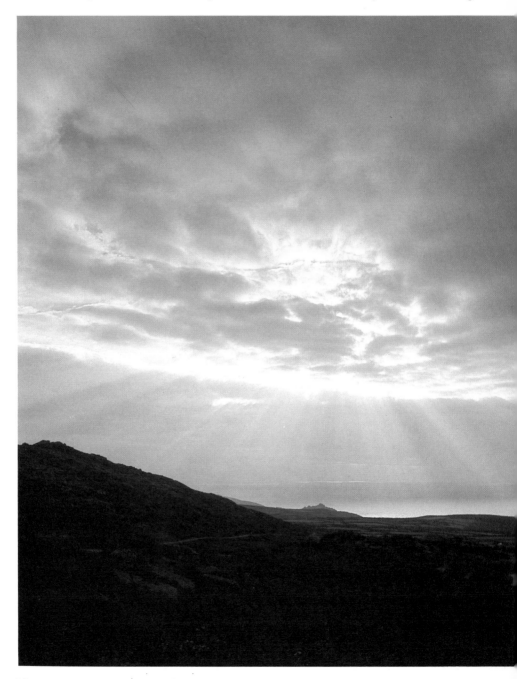

specific object or surface reflects. Thus white rock will reflect more light, and seem brighter, than a black, freshly ploughed field, in spite of the fact that both receive precisely the same amount of sunlight. Consequently the quality of a photograph depends not only on the brightness of the light alone, but also on the contrasting luminosity of its component parts. We distinguish tones and colours only by comparison with other, neighbouring areas. White will seem brighter in an overall dark composition than it would in a high-key light picture.

Quality

The second important aspect of light is its overall quality. Is it harsh, direct midday sunshine, or soft light transmitted through a morning haze or a mist, or merely filtering through a veil of light clouds? Here it is largely a question of contrast. The light may be too harsh at midday, too soft in the mist. This is where judgement and experience come in. We shall see in the location exercises how the choice of film or exposure can bring some adjustment, both in colour and black and white. It is possible, technically speaking, to reduce harshness and boost a soft contrast. The experienced photographer in colour, however, will prefer to work without extremes of light. Certainly too harsh lighting is rarely flattering either to a human face or to a landscape.

Colour of light

The third main attribute of light is its colour. As we know the eye has a marvellous ability to adjust very quickly to various sources of illumination, so that it barely notes the colour of light at a given moment. Yet if, as an experiment, you made an exposure of one particular position of a seascape or landscape every two or three hours throughout a day, from dawn to dusk, you would see how dramatically the colour of light changes. The overall pinkish hue of early morning grows cooler, becoming a neutral blue tone late in the morning, and then from midday onwards gradually acquiring warmer tones again, sometimes achieving brilliant orange hues at sunset.

Direction of light

Each of the three basic lighting directions – frontal, side and back – gives a different effect, and can be useful in a specific situation. Work on a small manageable detail – like a flower or a tree trunk – and observe how it changes, with the relative position of the light source.

The Cornish coast near the village of Zennor at sunset. The exposure was taken from the sky. Pentax 6×7cm, wide-angle lens, Ektachrome 200, 1/60 at f11, Cokin tobacco T1 graduated filter.

Above: St Juliot, near Boscastle. Left: Horton Tower, Wiltshire. The picture of Horton Tower was shot straight into the sun, with a very wide-angle lens and an exposure taken from the sky. As a result, the tower assumes an almost abstract appearance. When photographing St Juliot, I took care to hide the sun behind trees in order to reduce flare.

Front lighting is usually recommended to beginners because it is perhaps the easiest to control. A light source over your shoulder illumines the subject well, and exposure estimation is quite straightforward. Nevertheless, this is the least exciting kind of lighting. Lit frontally, the subject seems flattened and lacking in plasticity. If, however, the subject is light in tone – like a birch tree – and the background dark, it stands out, and can produce a striking image.

Sidelighting is the most rewarding for the landscape photographer. In the early morning and late afternoon the shadows stretch long and graceful, creating exciting lines and areas of darkness and light. The texture of the subject stands out in strong relief and this, as well as the criss-crossing of the shadows, endows the image with a three-dimensional quality.

The feeling of space is even greater with the light source facing you. All the objects – trees, houses, figures – stand out dramatically against the brillance of the background, casting shadows directly towards the camera. This is a thrilling and powerful kind of lighting, but one fairly difficult to handle. The exposure problems with *contre-jour* lighting will be discussed in the following chapter. All you have to do is decide whether to expose for the light – creating detailless shadow areas – or for some detail in the shadows, which will bleach-out the high-

light areas. Both solutions are valid depending on the effect required. Lens flare could be a problem with the camera facing the sun. You can sometimes eliminate this by tilting your camera slightly up or down. A lens hood would help. If you are using a tripod, you can get rid of the flare by carefully casting a shadow over the lens. On the other hand, the lens flare could be incorporated into the image, and the floating discs of light used to dramatic effect.

Diffused light

The use of strong directional light creates dramatic and striking effects, but there are occasions when soft, indirect light can be as effective. When working with indirect lighting in monochrome photography you need a fairly strong composition, both in light and dark areas, or distinct directional lines, otherwise the overall image may appear flat. But the image will gain in subtlety of tone, which strong directional light often eliminates. In colour, however, you can sometimes dispense with strong compositional arrangements: the delicate gradations of greens, browns or even monochromatic greys revealed by soft lighting can produce enchanting effects. In fact, most colours appear richer in saturation, and their delicacy of tone is far more evident, on days when the sun is slightly overcast. Landscape, if not too dramatic and flamboyant in type, lends itself very well to diffuse lighting conditions.

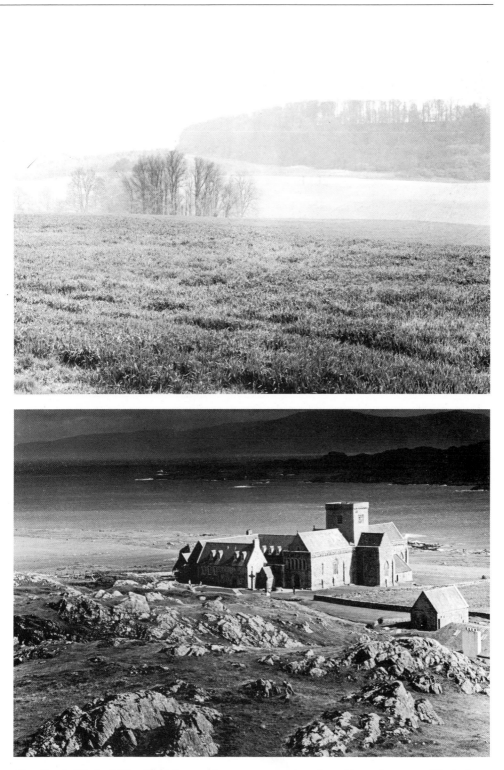

Top: On the Pilgrims' Way, Kent. Bottom: Iona Cathedral. Two completely different kinds of light are used to establish mood. The first has distinctly romantic and sensitive undertones, while the latter highlights the rugged and dramatic aspects of the landscape.

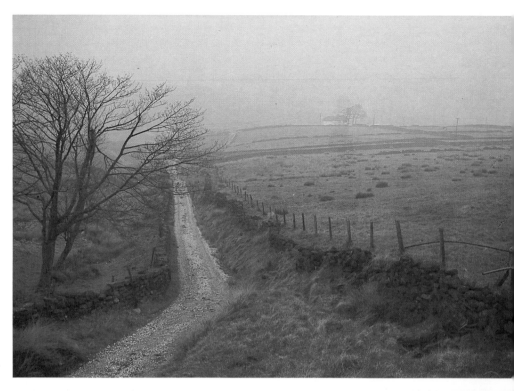

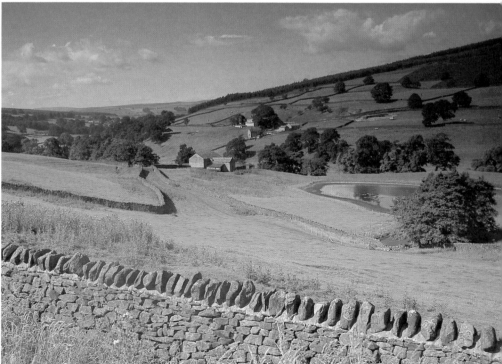

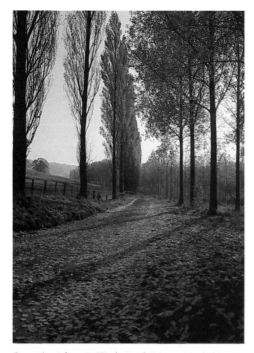

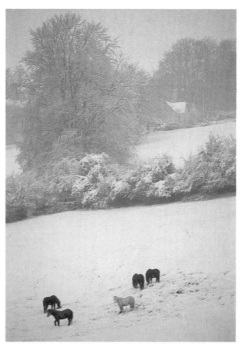

Opposite (above): Wadsworth Moor, Yorkshire, in the winter, and (below) Wharfedale near Bolton Abbey in late summer. The contrast between the quality of light in winter and in summer is quite marked. Here it transforms the colour and mood of basically similar scenes.

Left: The Cotswolds near Kite's Nest in autumn. The light in spring and autumn, especially in the early morning, often has the delicacy of a watercolour. Above: The whiteness of the snow provides a contrasting background for the dark shapes of the horses.

The quality of the light changes markedly from one season to the next. Spring light has, on a good day, a clarity you hardly ever encounter in the autumn. Autumn light, curiously enough, is often warmer in colour, with delicate tinges of burnt orange as if to match the foliage of the trees. Winter light loses this warmth and tends to be greyer and bluer, even when there is midday sunshine. Summer, although a favourite season for many photographers – because of the length of day and the chance of brighter light – tends to produce a hazy light which is not very good for effective landscape photography. In the summer, therefore, there is no alternative but to get up early, rest in the middle of the day, and resume photographing in the late afternoon. On the other hand, in the early spring, late autumn and, of course, in winter you can work quite effectively through most of the day – weather permitting – since the sun stays low in the sky.

There are no hard and fast rules about where it is best to photograph at different times of the year. Only a very rough guideline can be sug-

gested, and then only tentatively. Lack of vivid vegetation and denuded trees create a stark and dramatic effect. This wintry bleakness can best be exploited in mountainous or rocky terrain. Pastoral, cultivated landscape, on the other hand, seems to be most effective when photographed during the high activity of harvest time, or immediately after. Empty fields, punctuated by haystacks and sheaves of corn, are visually very interesting. Burning or burnt-out stubble is another feature worth looking for. River valleys, dales, and undulating downlands – not to mention parks and gardens – come to life in spring. But then spring is a good photographic time anywhere. In autumn, forests, woods and tree-covered hills come in to their own. Seasonal colour schemes are perhaps too well known to spend much time on, but it is worth keeping in mind that we do associate spring with greenness, summer with golden fields, autumn with the red-browns of trees, and winter with blues and greys. So if you are working on a series of pictures of one season, it may be useful to keep within one tonal range.

THE TIME OF DAY

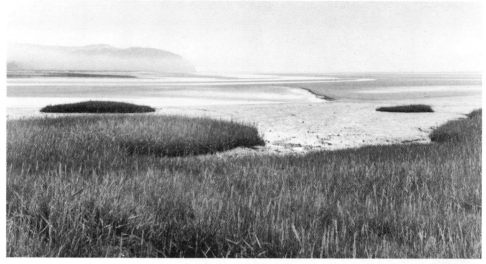

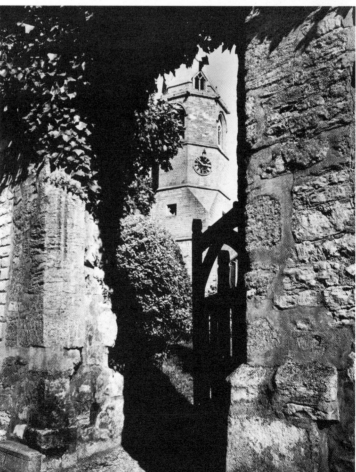

Above: First light at Laugharne Bay with the tide out. The light at dawn has a clarity and delicacy which no other time of day can match. It seems to fill the scene evenly. You need a tripod and fairly long exposures as the brightness of the light can be very deceptive. Nikkormat FT2, medium wide-angle lens, Tri X, $1/15$ at f8.

Right: The church at Helpston, Lincolnshire, in the early afternoon. In summer the sun stays high for a large part of the day, and landscapes are generally best shot early or late. Overhead sunlight, however, can be exploited successfully in architectural photography (and also in forests), particularly when a high angle of light is needed to penetrate normally dark or shaded areas. With strong light overexposure and subsequent underdevelopment may help to improve image quality. Pentax 6×7cm, wide-angle lens, Plus X, $1/30$ at f16.

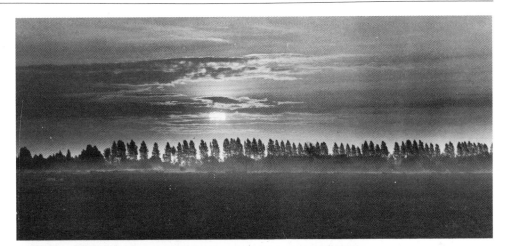

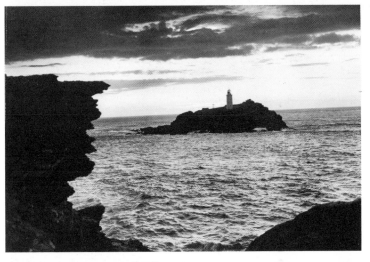

Above: Sunset over the Cotswolds near Sezincote. If the meter is pointed towards the sky, the foreground will be considerably underexposed. One solution is the use of a graduated filter (white to yellow, or pale yellow to orange) which enables you to retain the detail in the foreground.
Nikon FE, 80–200mm zoom lens, FP4, 1/30 at f8, white to yellow graduated filter.

Centre: Godrevy Lighthouse, St Ives. Twilight can be very beautiful. This shot was taken an hour after sunset. It required a tripod. Even then, with the exposure based on the sky, the rocks are lacking in detail.
Pentax 6×7cm, wide-angle lens, Tri X, 5 at f16.

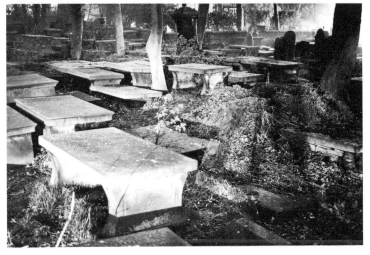

Left: Haworth cemetery at night. You can exploit the mood of the night with the odd light source – the moon, or light from windows. The Brontë churchyard was shot in the light of a street lamp behind the camera and another to the right.
Mamyiaflex C3, wide-angle lens, Tri X, 3 at f16.

THE SKY

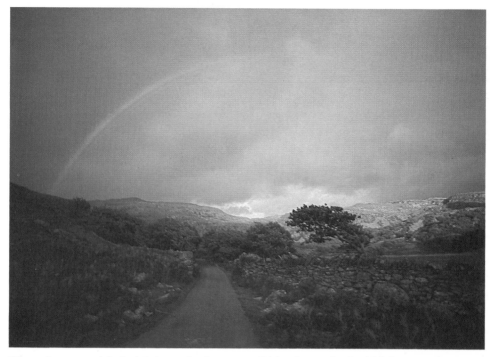

'I have done a good deal of skying today,' wrote John Constable to a friend. 'The landscape painter who does not make his skies a very material part of his composition neglects to avail himself of one of his great aids.' It is not an exaggeration to say that the sky is even more important to the photographer than it is to the painter. Naturally the styles of landscape photographers vary a great deal. Some, like Mario Giacomelli (who shoots a lot from the air), or Raymond Moore (who uses a lot of close-ups, and more recently shoots rather deliberately drab and melancholy landscapes with empty skies), hardly ever feature it. Most of the romantic landscapists, however – photographers like Ansel Adams, Minor White or Alfred Stieglitz – use the sky as an integral part of the image. Indeed in Stieglitz's famous 'Equivalents' the sky is the sole object.

For the photographer the most exciting characteristics of the sky and clouds are their variety and changeability. Often you can not merely include the sky, but also deliberately use it as a compositional aid – waiting for the clouds to place themselves in a specific position in the image, or even to assume shapes which echo those in the landscape. Cumulus clouds especially, with a brisk wind about, are a delight to watch. It is possible – although some purists would never permit it – to collect a series of 'cloud negatives' which later, in the secrecy of your darkroom, you can print in into otherwise cloudless skies. Frankly no one would know, and the trick is not as difficult (or dastardly) as some would make it.

In black and white photography, when sky and clouds are part of the picture, a yellow/green filter is always an advantage. It makes the blue sky appear darker and the white clouds whiter and more prominent, while at the same time lightening the tone of the green foliage, slightly enhancing the brilliance and contrast of the image. Remember that on average the sky is four times as bright as the landscape below it. So a compromise exposure must be made, or either one or the other will suffer. This is where the graduated filter is so useful (see Filters). One of the most striking effects is achieved when the sun hides behind a small cloud. Try not to overexpose since this will reduce the impact of the glowing light.

As you would expect, the most interesting cloud effects often occur in spring and in autumn, and also in the early morning or late evening. The most dramatic time of all is during a change of weather – either just after the rain, with the sun breaking through, or before a storm. These are wonderful moments – often lasting no more than a few seconds – so be on your guard.

Opposite: Rainbow over Snowdon. Because of their impermanence, there is a temptation to shoot rainbows quickly and carelessly. In fact, you would be well advised to 'bracket' your shots, as it is very difficult to judge the exposure correctly. On the whole, it is better to underexpose, lest the rainbow be too faint. Nikon FE, standard lens, Kodachrome 64, 1/125 at f16.

Top: Cumulus clouds over a field, Wiltshire. Nikkormat FT, wide-angle lens, 1/60 at f16, deep yellow filter.

Centre: Oban harbour, Western Highlands. Pentax 6×7cm, wide-angle lens, Tri X, 1/60 at f11, white to orange graduated filter.

Black and white films are more sensitive to blue than to yellow. Thus with normal exposures the sky tends to be overexposed and clouds poorly rendered. To correct this, either use a yellow or orange filter to reduce the oversensitivity to blue, or underexpose the sky while keeping the foreground correctly exposed. In good lighting, as in the picture above right, you can afford to use a yellow filter, but in less strong light, as in the view of Oban, use a graduated filter. At times, especially when the sky is grey, even a graduated filter may not be enough and it becomes necessary to 'burn in' the sky during enlarging.

Right: Glen Coe seen from the east. Pentax 6×7cm, wide-angle lens, Tri X, 1/15 at f16, white to orange graduated filter.

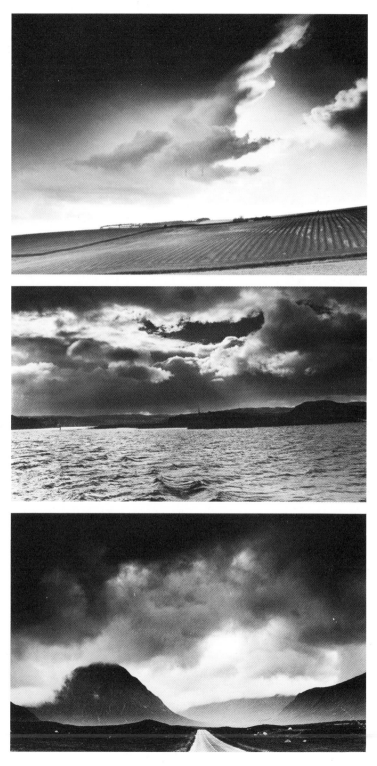

'BAD' WEATHER

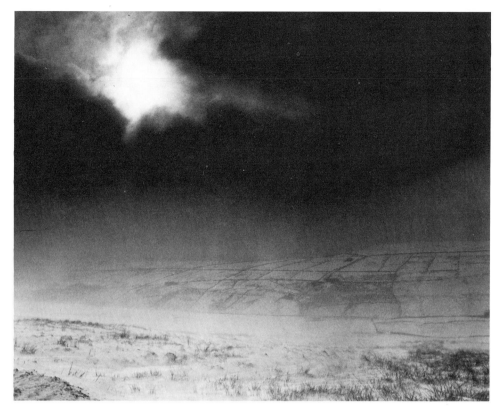

There is no such thing as 'bad' weather in landscape photography. The unpredictable British weather, with its shifting light and changing cloud formations, provides a wealth of exciting and unusual pictorial possibilities. And since 'bad weather' pictures are taken less frequently, this in itself makes them striking, and worth pursuing.

On the whole, overcast, rainy weather and misty atmospheric conditions give soft, diffused light. This casts no shadows, but in return provides a fine rendering of detail, since even the shadow areas are well lit. Colour in delicate light seems to glow more intensely – the greens seem greener, the reds and yellows of flowers acquire an extra brilliance. Needless to say, poor lighting conditions call for a fast film – the graininess of which seems to fit the atmosphere – and recourse to a tripod. But all in all, it is worth your while to brave the elements, for the results may exceed your expectations.

Mist and fog

Remember that certain colours tend to be accentuated in the soft light of a moisture-laden atmosphere. Generally speaking, misty conditions show a tendency to blue, and in poor light a UV filter should be used. But when the sun penetrates the mist – a magical moment – the light appears much warmer and redder. Expose for highlights – allowing for a slight overexposure in order to penetrate the mist and register some details – but no more than a stop, lest it ruin the overall effect.

Rain

Contrary to expectations, rain need not stop you working. Admittedly, it can damage your equipment, so an umbrella and a dry cloth to wipe the camera are both essential. Since it is difficult to juggle an umbrella and a camera, use a tripod or at the very least a monopod.

Again, rain will give you beautiful, subdued but vivid colours. Aim to shoot into the light, which will capture the sparkle on the raindrops. A fast shutter speed will not stop the rain, so try using a slow shutter speed instead ($\frac{1}{15}$ second): if you shoot into the light, against a dark background, this will produce a tracery of lines. Alternatively, it may be worth your

while to experiment with a small portable flash.

Even if you do not feel brave enough to venture out, remember that rain on the window-pane, if the view is at all interesting, can produce striking effects.

Snow

Snow creates powerful graphic effects, mainly because the whole image is converted into strongly delineated areas of black and white.

With snow never expose for highlights. It is useless pointing your camera or the light meter towards the snow-covered landscape. The exposure indicated by the powerful reflection will invariably be too short, and result in underexposed pictures (the snow will print dirty grey and the shadow areas will lack detail). Either take a reading from some middle tone (say your hand in the shadow), or alternatively increase the indicated exposure – from an overall reading – by one or two stops. In falling snow, snow-flakes can be registered on the film only with a fairly fast shutter speed – a minimum of $\frac{1}{125}$ second.

Remember also that snow landscapes tend towards bluish colours, especially in the shadow areas. A UV filter is indispensable, but on an overcast day you may find that a light yellow (5–10) filter is an advantage.

Stormy weather

A good photographer tries to make his point by emphasis or even a slight exaggeration. Thus stormy weather shots should be made even more dramatic and threatening than they appear in reality. In black and white photographs the sky can be darkened by using a graduated filter (see Filters), and when shooting in colour a light amber, graduated filter can be very effective in boosting the prevailing mood. Slight underexposure, too, will accentuate murky and forbidding weather.

Lightning

In order to be able to photograph lightning, first establish in which part of the sky it seems to be appearing – flashes of lightning usually follow in sequence. Having done this, using a tripod, aim the camera at this part of the sky, stop down to about f5.6 or f4, and open the shutter (use a B setting for the shutter and keep your finger on the release). The lightning will take its own picture. As this usually takes at least a few seconds, it is better if the overall light is very low, otherwise you will overexpose the scene and the lightning will not make a strong enough contrast. Late dusk or night give the best results.

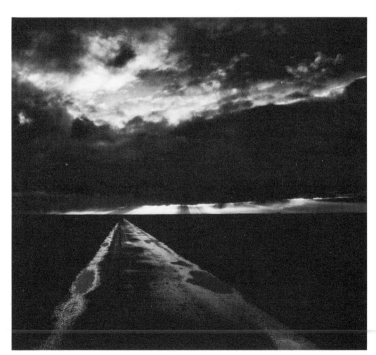

Opposite: Fields near Hebden Bridge. Evocative pictures can be taken even in extremely bad weather. It is advisable to boost the contrast by underexposure and overdeveloping. Nikon FE, wide-angle lens, Plus X, $\frac{1}{30}$ at f11.

Right: The Wash, Norfolk. A minimal composition in which weather is the main feature. Shot in the early morning, after heavy rainfall. Pentax 6×7cm, wide-angle lens, Tri X, $\frac{1}{16}$ at f16, graduated orange filter.

3 EQUIPMENT CAMERAS

There is no single ideal camera for landscape photography. With the proliferation and sophistication of photographic equipment today there are on the market at least fifty excellent cameras which provide more than adequate results, while allowing a landscape photographer flexibility and convenience. As you would expect, the better and more versatile the camera, the more expensive it is. But this does not necessarily mean that only highly priced cameras are suitable. Some less expensive cameras will certainly provide good results.

General remarks Most suited and recommended are the 35mm single lens reflex or, better still, the 6×7cm SLR. While 35mm image quality is naturally inferior to that of the larger format, and thus needs careful handling, modern films are able to cope with most problems. Through-the-lens viewing is necessary for close-up work with architectural details or flowers, but even for general work the SLRs are the most direct and intimate cameras.

Below is a pared down list of the major camera types.

SIMPLE DIRECT VISION CAMERAS
Because these have a separate viewing system (not through the lens) the image seen is not exactly the same as taken – especially in close-ups. (This discrepancy is called parallax.) Most of them use 35mm film, but some can only be fitted for 126 cartridge film – which means a limited choice of film. The less expensive models have only a fixed lens, usually giving acceptable sharpness from 6 feet to infinity, but some are fitted with a range finder, which is far more accurate and preferable. The majority are without a built-in exposure meter; instead you are provided with a set of symbols for some exposure control. For accuracy a separate exposure meter (see page 46) is desirable. In spite of their relatively modest price these cameras give quite adequate quality.

35mm SINGLE LENS REFLEX (SLR)
The choice is staggering – prices range from around £40 upwards. Middle price range SLRs would do the job perfectly, since they allow for interchangeable lenses and provide variable shutter speeds – mostly from 1s to $^1/_{1000}$s. There is a choice of different focusing systems to suit individual tastes. The majority have built-in exposure meters. Most of the leading brands on the market provide excellent results.

2¼ × 2¼ in (or 6×6cm) SLR
There are many models on the market providing an excellent image and operation. Most of them have all the creative controls of the 35mm SLRs. A number of 2¼ × 2¼ in SLRs tend to be dear as well as a little bulky for fast operation. The square format of the image is not ideally suited for landscape photography. It calls for constant mental adjustments in spite of which you still tend to take too many square images.

2¼ × 2¼ in (or 6×6cm) TWIN LENS REFLEX

These are often cheaper than SLRs and largely more reliable, since they are very simple in construction. Some older and cheaper models (like certain of the direct vision cameras) present a problem with parallax. But in better and more recent models this problem no longer exists. If you do not mind the square format, these cameras can be highly recommended.

6×7cm 'IDEAL' FORMAT SLR CAMERAS
There are few models on the market, and these are rather expensive, but if you can afford it this is an ideal instrument for landscape photography. Its large image area provides superb quality, both in monochrome and colour. It possesses all the necessary controls and technical features and allows maximum flexibility as well as the advantage of 'through-the-lens' viewing.

LENSES

As with cameras the choice of lenses can be bewildering. One major camera manufacturer lists upwards of sixty lenses, from the Super Fish Eye (extremely wide angle) to a monster telephoto – indispensable for the paparazzi when photographing their unsuspecting victims from a nearby mountain. The wise landscape photographer will have no use for most of them.

General remarks You very rarely need to open up to more than f3.5, and the so-called very fast lenses with wide apertures of f1.2 or f2 are often prohibitively expensive and rather bulky. Choose a good lens of about f2.8 or f3.5, and you will never regret it.

Though close-up attachments for lenses – replacing more expensive macro-lenses – are quite good and useful, their counterparts for long lenses – telephoto converters, which convert short-focus lenses into long-focus lenses – are not recommended.

Here follows a list of the most useful lenses, in order of preference and according to their versatility.

MEDIUM WIDE-ANGLE LENS
35mm focal length for a 35mm camera
65mm focal length for a 2¼ × 2¼ in camera
75mm focal length for a 6×7cm camera
This is very useful as a general purpose landscape lens. It is a little wider than a standard lens and also good for interiors. Its shorter focal length gives greater depth of field, thus permitting inclusion of foreground interest while retaining overall sharpness.

MEDIUM TELEPHOTO LENS
Approx. 90mm focal length for a 35mm camera
Approx. 150mm focal length for a 2¼ × 2¼ in camera
Approx. 200mm focal length for a 6×7cm camera
When buying a second lens this could be a good choice. It is excellent for getting to grips with the selection of subject matter and tighter framing. In colour photography it will enable you to experiment with an out-of-focus foreground, while its shallower depth of field allows for emphasis by differential focusing (focusing on the main subject and allowing the rest of the image to be out-of-focus).

NORMAL, STANDARD LENS
 50mm focal length for a 35mm camera
 80mm focal length for a 2¼ × 2¼ in camera
105mm focal length for a 6×7cm camera
As its field of vision is the nearest to that of the human eye, this lens is excellent for factual recording of the countryside. In fact it is a good, all-round lens, but its orthodox vision tends to produce rather ordinary images, less imaginative than those of the first two choices.

ZOOM LENS
These are mainly intended for 35mm cameras, since zoom lenses for larger formats would be expensive as well as unwieldy in field operation. A focal length of 80–200mm is especially useful if you already own a short lens.

A zoom lens will open up an entirely new visual world for you. Suddenly you will be able to create tight, precisely-fitting framings; you will be able to bring the beauty of a distant row of trees into a controlled composition. A zoom is worth investing in, but only if a quality lens is within your means.

MACRO-LENS
Again, this lens is designed for a 35mm camera, and is useful only if you are interested in close-ups of flowers, rocks, etc. If you are, you will enjoy discovering the almost abstract qualities of details and textures. Standard lenses cannot be focused at distances very close to the subject.

FILTERS

Monochrome

Since the development of panchromatic emulsion modern black and white films are, on the whole, sensitive to all colours. Nevertheless, they still show a certain weakness for blue, which in consequence becomes slightly overexposed; at the same time they are less sensitive to yellow and green, which tend to be comparatively underexposed. As a result when exposing correctly for the foreground (the field or a forest) the sky often comes out in the print as a blank white, the clouds not printing very well. Hence the first 'rule' in monochrome landscape photography could be, 'Keep your yellow filter on,' especially with a blue sky.

The guiding principle of any filter is that it tends to lighten parts of the scene of its own colour, while it darkens the parts in complementary colours (see colour circle). Of course the stronger the filter – from yellow, to orange, to red – the greater the effect on the tonal range. A red filter turns a blue sky almost black. (See page 31, bottom.) With a largely overcast grey sky, a yellow or even red filter will not help much; but you can darken it in the print. All you have to do is to underexpose the sky in shooting. The trouble is that if you reduce the exposure for the sky the rest will suffer too. The answer is a so-called graduated filter. This is white, not affecting the exposure, in the bottom part and a dark tone, or yellow or orange in the top part, with a graduated transition, not a hard line. Be careful lest features overlapping the sky – like a tower or a tree – are so severely underexposed that they also print very dark.

Yet another alternative is to use a polarizing filter. A polarizing filter placed in front of the lens and rotated to a certain position will block out ultra-violet light. Since a blue sky contains a large proportion of ultra-violet light it will be darkened in the print. Again it works effectively only with a blue sky; a grey sky will be largely unaffected.

Colour

Discussion of filters for colour photography leads us into more speculative territory. On the whole, for straight photography you should not find it necessary to use any filters, except on rare occasions filters of a corrective type. Thus if you photograph during the day with an artificial light film (specially rated for studio lighting), you can convert the film to daylight with a correction filter.

Nevertheless, in practice you can use certain filters to create special effects, but be very careful not to go over the top. Modern manufacturers tempt unwary photographers with a veritable rainbow of filters, guaranteed to turn their pictures into creative masterpieces. More often than not these are garish and in bad taste. Few serious photographers would ever use a one-colour filter to change the whole colour mood of a photograph, unless it be to tone down the pinkness of early morning or the warmth of a sunset, which is rarely done. Nevertheless, the delicate hues of some graduated filters can be useful. An empty grey sky can be given a slight yellowish tinge, which adds drama. A blank sky can be improved by a bluish cast. These should be used with great restraint, though.

On the other hand, graduated neutral grey filters could be an asset. Neutral grey does not affect the overall colour and merely deepens the tone of the sky. Similarly a polarizing filter can be recommended for the same purpose. It also does not alter the colour, but merely deepens the blue of the sky.

The only filter which can be recommended without reservation is a standard ultra-violet (UV) one. Many photographers keep it permanently on the lens. It is almost indispensable in the mountains and near the sea, where it absorbs the excessive blueness ever present in high altitudes and near the water. Elsewhere it is entirely harmless, protecting the lens without affecting the exposure in the least.

Filter factors

All filters – with the exception of UV or sky filters – tend to reduce the amount of light penetrating through the lens on to the frame of the film. Consequently, in order to achieve the correct exposure, the relative opacity of the filter must be taken into consideration. Manufacturers of filters generally indicate the amount of extra exposure required with a given filter. This is marked on the filter itself and is called a 'filter factor'. It may vary from +1 (double exposure needed) to +3 (eight times) or even more. With built-in meters and 'through-the-lens' metering it is not necessary to increase the exposure as the meter reads the light passing through the lens and so takes the filter into account. On the whole, yellow filters require less extra exposure than other strong filters. UV or sky filters, however, do not require any additional exposure at all, and so do not have a filter factor.

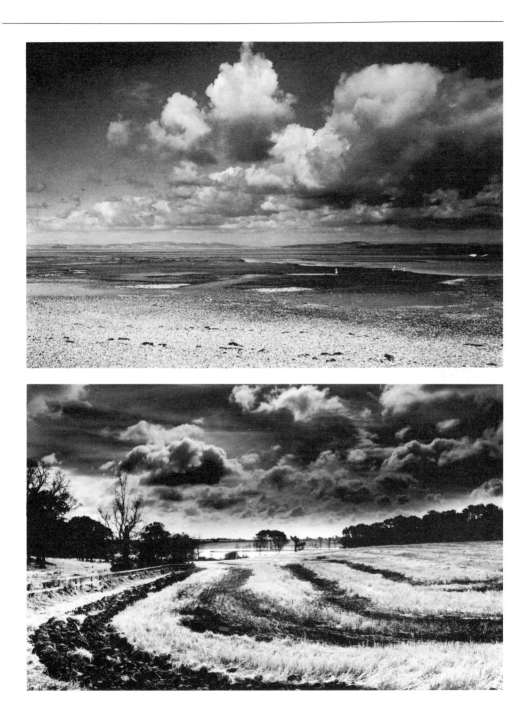

Top: Morecambe sands, Lancashire. An example of
the easiest situation in which to use a graduated filter
– when the line of the horizon is straight, and not
interrupted.
Nikkormat FT2, wide-angle lens, FP4, 1/60 at f16,
white to deep-yellow filter.

Above: Weston Underwood in Northamptonshire.
When shooting into the sun the clouds tend to be even
more overexposed than usual and a strong filter is
necessary.
Pentax 6×7cm, wide-angle lens, Tri X, 1/60 at f16,
pale yellow to red graduated filter.

FILM AND ACCESSORIES

Black and white films

For a landscape photographer in monochrome the choice of film is quite straightforward. You can either use a faster film, which allows shorter exposures and a relatively small aperture (giving greater depth of focus), but which also has a coarser grain and brings a certain loss of quality; or a slower film, with its attendant inconvenience in exposure times, but the distinct bonus of finer quality and cleaner rendering of detail. The choice naturally will also depend on the camera you are using. If it is a 2¼ × 2¼ in or better still a 6 × 7cm format, you will be able to use faster film and still retain sufficient quality. But if, like the overwhelming majority, you have a 35mm camera, and you like fairly large, sharp and grainless prints, you would be well advised to use a slower film. It is, of course, possible to obtain acceptable, even good, quality from a fast modern 35mm film, but this demands meticulous care both in shooting and in processing.

The new black and white films (from Ilford and Agfa) which work on the principle of a dye-forming image (like colour negative films), are a distinct improvement and worth trying.

25 or 32 ASA	Very slow films. Extremely
Ilford–Pan F	fine grain and resolution.
Kodak–Panatonic X	Excellent for close-ups or
Agfa–Agfapan 25	architecture, or when
	exceptional quality is
	needed.

100 or 125 ASA	Medium speed films. Very
Ilford–FP4	good all-round performers.
Kodak–Plus X	Recommended for general
Verichrome Pan	35mm work.
Agfa–Agfapan 100	

400 ASA	Fast all-purpose films.
Ilford–HP5	Not recommended for
Kodak–Tri X	35mm when very fine
Agfa–Agfapan 400	quality required.

New dye films
Ilford XP 1
Agfa Vario XL

General remarks

Since a majority of landscape photographs can be taken from a tripod and since, in any case, they are mostly shot in good daylight, a slower film is definitely recommended. Slow film also provides negatives with a slightly higher contrast (the faster the film the softer in contrast it is), which is particularly good for strong, dramatic results.

Infra-red monochrome films

Some very unusual effects can be obtained with infra-red film, which is sensitive to infra-red waves and the longer wave lengths of the colour spectrum. This normally requires a red filter for the most interesting results. The film is quite slow (about 50 ASA without a red filter) and generally should be shot from a tripod. The best effects are achieved with blue skies and green foliage, the green showing up light against the darker skies. The film is available mainly in 35mm.

Colour films

Negative films

There are, on the whole, very small variations between leading manufactures. Films of varying speeds are available – roughly from 100 to 500 ASA. Needless to say, the fast films show more apparent graininess, which can be quite noticeable in larger blow-ups. Also, their colour saturation suffers, very fast films giving flatter and duller hues. Most of the colour negative films are made to suit daylight colour temperature, although some 'L' type films (with long exposures for tungsten/artificial illumination) are also available.

Colour reversal films

As with colour negative films, a whole range of materials with various speed ratings is available, from films rated at about 25 ASA right up to very fast films of around 400 to 500 ASA. As with negative films, the quality of resolution and colour saturation decreases and the grain size increases with the faster variety. This does not necessarily mean that the overall quality of fast films is distinctly inferior. They certainly produce different results – they are a little less sharp, and also render colours less brilliantly – but these faults may, at times, be considered suitable for certain subjects, a blizzard for example. While colour negative films can be corrected, if necessary, in printing by using special correction filters (not their grain or resolution, but the rendering of colour), your control over colour with reversal films – colour transparencies – is limited. Because of this it is seriously worth considering the different makes of reversal films.

Colour reversal films from different manufacturers tend to show distinct colour biases, and they often differ in general brilliance and colour saturation as well. Kodachrome, for example – on the whole, unbeatable for sheer quality of grain and sharpness – is far more

brilliant in colour saturation than, say, Agfachrome. There are other differences. Ektachrome films show a slight tendency towards blue – especially when shooting on a dull day – and it may be advisable to use an 81C (or very pale yellow) filter, which corrects excessive blueness. Agfachrome, on the other hand, shows a certain bias towards warm greens and yellows, while Fuji leans distinctly towards yellow.

So take your pick:

25 ASA (and also 64 ASA)	Kodachrome (only in 35mm)	Brilliant reds and yellows. Extremely fine grain.
50 ASA	Agfachrome 50 (also the equivalent 'amateur' CT18)	Warm tones. Excellent for out of doors.
64 ASA	Ektachrome	Colder colours.
100 ASA	Agfachrome 100/CT 21	Rather more grainy.
200 ASA	Ektachrome	
400 ASA	Ektachrome	

Accessories

Tripod
This is a very important piece of equipment. Obviously, for a wandering landscape photographer it should be as light as possible, but not so light that it lacks steadiness and firmness of support. Monopods, too, are worth considering, and with a steady hand can give support of up to ⅛ second. In landscape photography complete control of camera position is important, so that either a 'pan-and-tilt' head, or better still a solid ball and socket, which on the whole is more flexible and quicker in use,

should be fitted to your tripod. Some tripods are fitted with a special socket which permits fixing of the camera very near to the ground, which on occasions is very useful.

Cable release
If you do use a tripod, this is an obvious addition to your bag. Otherwise you may clumsily move your camera during a long exposure.

Lens hood
This will do no harm and on occasion – especially with the sun against you or on your side – it will bring a distinct improvement in your image quality. Modern 'bloomed' lenses have made lens hoods less of a necessity, but undoubtedly they are an advantage.

Motor drive, or auto-wind
This is very rarely of any use to a landscape photographer. Rather save the money and buy more film.

Flash gun
These are rarely used, if at all. But occasionally you can use a flash as an additional light source, simply to add sparkle to foreground objects, especially on a very dull day. Also some interesting effects can be obtained at night or late in the evening. The make is not important. Choose a light and convenient model – even if it is not very powerful.

Small tape recorder
Travelling and shooting landscapes, churches, and villages, you can easily lose track of localities, names, and details. Here a pocket tape recorder is a boon. Each time you make an exposure describe briefly the location, time, or light measurement; it may be of future use. If a tape recorder is too expensive you can settle for a notebook, but make it a habit to take notes. You will be pleased and relieved to have them.

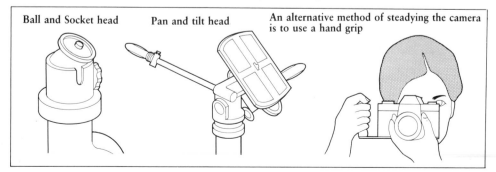

Ball and Socket head Pan and tilt head An alternative method of steadying the camera is to use a hand grip

EXPOSURE MEASUREMENT

In the late nineteenth century Oscar Gustave Rejlander used his pet cat's eyes as an exposure meter. The more the pupils were closed, the less exposure was required – say, instead of 30 seconds only 10. Fortunately we can now be a little more accurate. A correct exposure for a given landscape has to be intelligently assessed and decided upon. Naturally this is done with the help of an exposure meter either on or outside the camera – but it must always be the photographer's conscious decision. There is only one criterion. Which part of the scene is the most important? Which part will the viewer look at first? Once this is established, the exposure reading is taken accordingly. A hasty, lazy pointing of the camera or the meter in the general direction of the landscape will not do. Only the reading from the key feature is the right one, and if this is too far to walk towards and measure directly, some part of the scene nearby, similar in tone, should be used. In the photograph on page 31 (top) the reading was taken from the group of trees – the key feature – while the reading in the photograph on page 28 was taken from the sky, and the rest of the scene had of necessity to be slightly underexposed,

since it was less important. At times, however, you may wish to expose reasonably correctly for two parts of a scene with dissimilar tonal values. Here a compromise exposure should be found, either roughly midway between the two extremes, or favouring one part over the other. In each case the decision is taken by a thinking photographer and not by a machine.

The precision of exposure calculation is more important in colour photography, where a difference of half a stop may be crucial to the success of the picture. In a way, the exposure calculation differs slightly from colour to black and white. While it is best, of course, to aim for correct exposure, if you allow for the possibility of error and try to compensate for it with one or two extra frames – professionally called 'bracketing' – in black and white, on the whole, it is better to err on the plus side (rather too much than too little exposure). In colour the opposite applies. It is far better to underexpose a fraction, rather than overexpose – bleached, empty highlights are very unpleasant in colour. In any case, if you aim to have your colour slides reproduced, printers always prefer a darker slide to a light one.

In this scene the foreground is important, and the reading should be taken from a mid-tone near the camera position.

Here the sky dominates, while the foreground is merely a frame. Take a reading from the sky, away from the sun.

When photographing into the sun, with your subjects largely in their own shadow, read for the shadow area too.

When both sky and foreground are interesting, compromise. Take a reading from both, and calculate an average exposure (or use a graduated filter).

Some basic types of exposure meters

Built-in meter

Most of these are now directly connected to the aperture ring or to the shutter control. As we have noted, it is best to point the camera with the meter at the main feature, rather than take the reading from the general scene. Thus completely automated cameras, where the camera does all the 'thinking' and the photographer cannot override its 'decisions', are not suitable for serious landscape photography.

Hand-held meters

a. Selenium meter (eg. Weston-Master)
These are accurate in normal lighting conditions and quite reliable. They do not require a battery. A disadvantage is that, because they rely on a selenium cell alone, they are insensitive and unreliable in dim light.
b. CdS (Cadmium Sulphide) meter (eg. Lunasix)
This meter uses an ordinary battery which magnifies the impulse from the photo-electric cell. It operates on the 'photo resistance' principle (the electrical resistance changes directly in proportion to the amount of light it receives). Therefore it is more sensitive than a selenium meter – it will read in moonlight and give an exposure measurement for up to several hours. However, it requires a battery change once a year or so, and is naturally more expensive.

Spot meter

This special, narrow-angle meter measures the light falling on a small, distant spot, important for the picture. It works like a small telescope. It is a very useful and accurate method of exposure calculation – if somewhat costly.

All these meters will measure the light required for an exposure quite efficiently, but it cannot be stressed too strongly that they only give an estimate of an exposure for the interpretation of the photographer. It is especially important to bear this in mind when taking photographs either facing the light or with the light at an acute angle to the camera. In a situation of this kind a large part of the scene is back-lit; in other words, some of the objects or persons facing the camera are in the shadow. The meter will only tell you the total amount of light coming towards the camera – which is quite considerable. But in fact you need your exposure to allow for the details in the shadow, and this the meter will not report. You should therefore cheat the

Two ways of reading for exposure. Left: Reflected-light method, giving more accurate exposure for a specific area. Right: Incident-light method, which averages the overall light.

meter; turn away from the scene to be photographed and take the reading – or allow the camera to take the reading – from an equivalent shadowy area, say in your own shadow.

With a hand-held meter there are two possible ways of taking a reading. Either by means of reflected light – in which case the meter is pointed towards the *subject* – or alternatively by the incident light method. In this case the meter is provided with a white, plastic, dome-shaped attachment, which you clip on to the cell window; you then point the dome towards the *light source*. In each case the reading should be identical, but if a more precise reading from the main feature is preferable, the reflected light system may be more suitable.

Reciprocity failure

Photographic films, both black and white and colour, are manufactured to produce predictable and stable (reciprocal) results over a specified range of exposures. If you were to double the exposure time at normal speeds of approximately between $\frac{1}{1000}$ second, and 1 second, this would invariably double the optical density of the emulsion. But at long (and also very short) exposure times, the reciprocity law does not operate. It requires more than double the exposure time to produce the reciprocal increase in optical density. For example, an exposure of 5 seconds at f11 will produce a given density, but in order to double this density, it will require more than the double exposure of 10 seconds at f11. It would probably need 15 to 20 seconds at f11. The precise amount of extra exposure required will vary from film to film.

STORAGE, CLASSIFICATION AND DISPLAY

Professional photographers, whose living depends on it, invariably store and catalogue their usable material in such a way that they can find any picture they need within minutes. There is no reason why amateurs should not do the same – especially as their hobby could well develop into a profitable side-line. Many picture agencies and libraries gladly take good work from amateurs on a consignment basis; they usually keep fifty per cent of the proceeds when a picture is sold. However, they only accept first-class work – sharp, well exposed and well documented landscape and topographical subjects. The great bulk of their stock is in colour (if necessary they can make a black and white from a colour transparency, but not the other way around), and there is little restriction on size (from 35mm to 5×4in). Nevertheless, monochrome is still used extensively, and although few agencies stock monochrome prints, they may ask for specific places or subjects. If they do you must be able to lay your hands on the picture immediately. However, even if you have no intention of selling your pictures, it is very annoying to have shot some lovely sunsets at Hartland Point, and then two months later not to be able to find them. So what is the best method of storing pictures?

Black and white photographs present no problems. Every film you shoot should be numbered and entered into a book with a date and subject description, and the negatives stored in consecutive order. At the same time (and not two or three weeks later) you should make a contact print of the film. This can be done as follows: cut your negative into strips (35mm into sixes, 2¼×2¼in into threes), and in the darkroom place these on a 10×8in pieces of photographic paper, cover it with sheet of glass, and expose it in the light of the enlarger – then develop, fix and dry in the usual way. Keep the contacts under different headings, so that if you need a picture of, say, Exmoor you can locate it in a box labelled 'Somerset', or 'West Country' or 'Moors'. The contact sheet should be marked with the number of the negative on the back.

Colour is a little more difficult. In the first place, while you keep all your black and white negatives, with colour transparencies you should only keep the most usable material. So the moment your colour is processed, make a selection and throw away all the unusable frames. You then have two or three alternatives. In the first place the slides can be mounted individually, either in cheap plastic mounts (Kodachrome and one or two other makes

come back from processing ready mounted) or, especially if you intend to project them, in more expensive glass mounts. If you intend offering them to a picture library they should be mounted in glass for safety. Mounted slides can be stored in special storage units or in transparent sheets with pockets; a pocket for each slide. This is the most economical and convenient way. Sheets of slides – each on a specific subject – can be kept in ordinary office files, with the subject marked in bold print on the side of the file. If you wish to offer your slides to

One way to display large landscape portraits is by mounting and framing in glass or perspex.

book publishers or magazines, however, you can store and display them in large black double cardboard mounts with windows or cut-outs (usually from six to twelve on a board). Each sheet can be inserted into a transparent protective envelope; presented in this way the transparencies can be readily looked at on a viewing box. Since the black mounting boards are quite stiff they can be stored on shelves like books.

It is very important to identify each shot precisely. A week's shooting expedition in, say, Wiltshire, Devon and Somerset, could result in as many as 500 pictures. It is quite impossible to remember every shot. The easiest way to keep track of them is to record each shot as you take it on a small tape recorder. You simply say: 'Passed Cleeve Abbey. Turned onto the B3190. Shot a group of trees with some cows on the right of the road; two shots in black and white and three in colour.' On your return you simply transcribe the tape, and afterwards there will be no problems in labelling the pictures. If you plan to sell your pictures you will need to be able to give an exact location for every one.

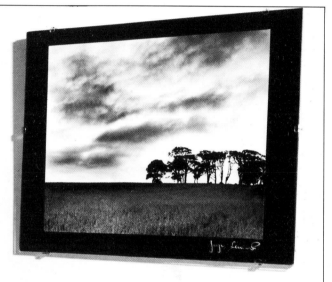

MOUNTAINS

Landscape photography is often a matter of chance. Having loaded your cameras, checked your selection of filters and your stock of film, and then set out in high hopes, you are just as likely, an hour or so later, to be disappointed as elated with what you have seen and photographed. Grey flat lighting may seem to have dulled the beauty of the countryside, yet a moment later a single shaft of sunlight can transform the scene. Mountain photography is sub-

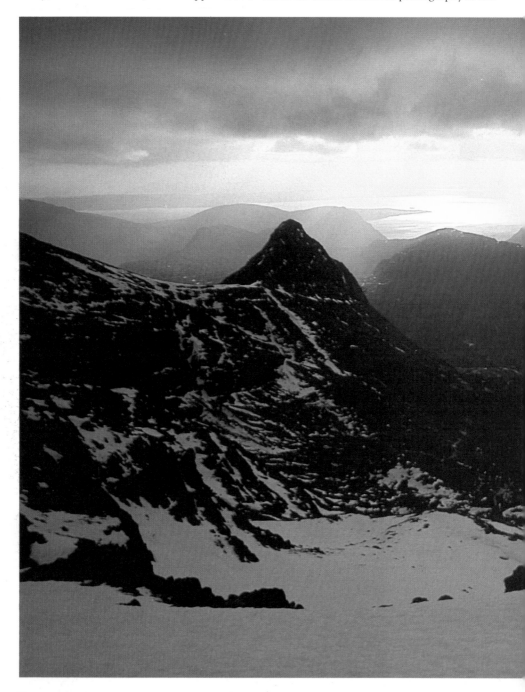

ject to sudden and dramatic change more often than any other kind. Because of the ever-present likelihood of changes in the lighting conditions you should never be in too much of a hurry. When photographing a mountainous area, try

Isle of Skye. Picture taken from near the summit of Sgurr nan Gillean, looking south along the Cuillin Hills. The distant water is the sea-loch of Coruisk. Nikon, 18mm wide-angle lens, Kodachrome 25, 1/16 at f8.

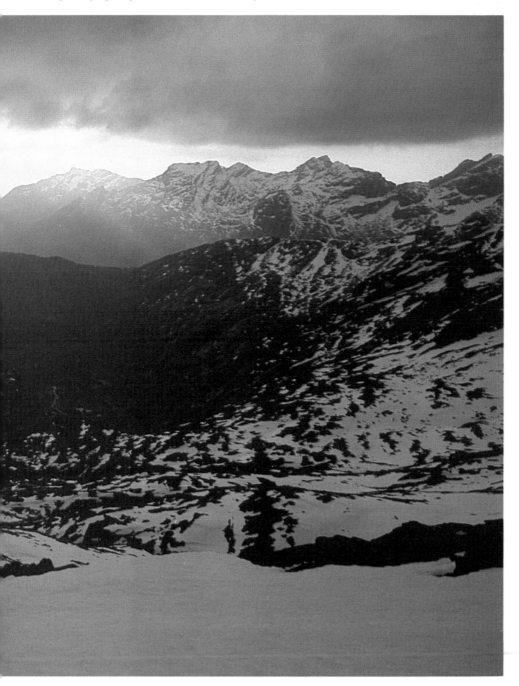

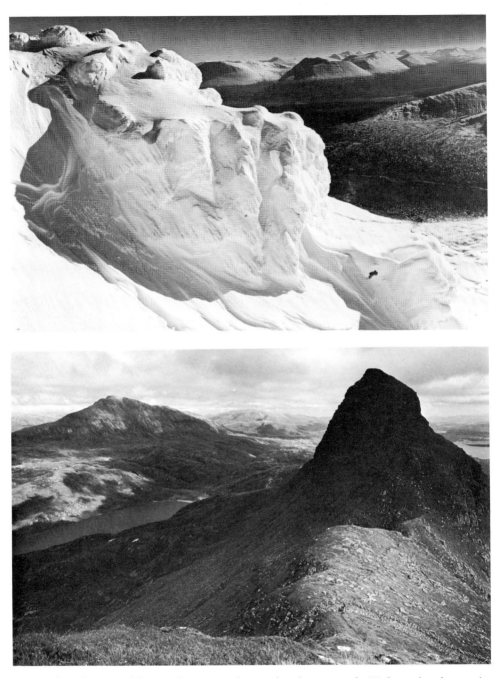

to stay there for several days and savour to the full the changes in the scenery effected by the weather as well as by the time of day.

At the very outset, you are faced with a basic question: to climb or not to climb, to photograph from above or below. It is true, of course, that many splendid photographs have been taken from mountain-tops, but on the whole the grandeur of mountain scenery is partially reduced and dissipated if you shoot downwards rather than upwards. We have already seen that broad vistas often turn out to be disappointing, and naturally with the camera looking downwards you tend to lose one of the greatest assets of landscape photography – the sky. It is especially important to include the sky because the soft fluffy shapes of the clouds provide a contrast which highlights the ruggedness of the mountains. After all, the most characteristic qualities of mountains are their vastness, in-

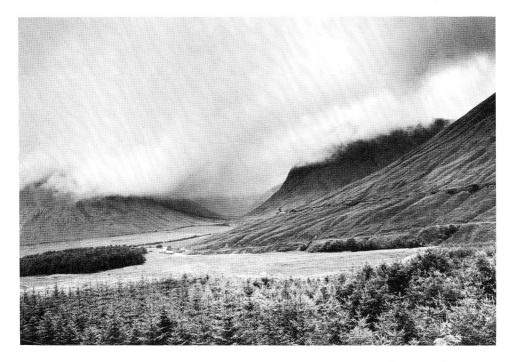

Glen Douchary, looking north. The clouds
obscuring the mountain-tops give an impression of
height.
Nikkormat FT2, wide-angle lens, Plus X, 1/60 at f16.

Opposite above: Looking from Black Mount
towards Rannoch Moor. The picture was exposed
for the middle tones of the sky, and not the snowy
foreground.
Nikon FE, 28mm wide-angle lens, Ilford Pan F,
1/125 at f8.

Opposite below: Canisp and Suilven Mountains,
Sutherland.
Nikon FE, 24mm wide-angle lens, Ilford Pan F,
1/60 at f5.6.

accessibility and height, and these are best illus-
trated and emphasized from below. It is also
much easier when looking at mountains from
below to simplify the composition and avoid
the unnecessary minutiae which can spoil the
overall effect. Simple as well as not too clearly
discernible shapes are always more impressive
and dramatic. It is also for these reasons that a
range of mountains, reduced through haze or
mist to a mere gradation of tones with most of
the details obscured, is often so impressive and
mysterious. Because of the need for simplicity,
monochrome photography – with its uni-
formity of colour and subtle range of tones –
lends itself well to mountain photography.

Colour, as we have noted, can be too realis-
tic, almost prosaic, and leaves little to the im-
agination. It is also quite difficult to handle at
high altitudes. The bluish tones of distant
ranges, merely variations of grey in black-and-
white photographs, become pronounced and
very cold in colour photographs and need care-
ful filtering. A UV filter, indispensable in moun-
tain photography, is not enough and you have
to resort to using pale pink or pale yellow filters
to counterbalance the blue and to give greater
warmth.

As with the majority of landscape subjects, it
is advisable to keep to morning and evening
sessions. In spite of the vagaries of the British
weather, autumn and even winter are exciting
seasons for mountain photography: you can
start later in the morning and carry on shooting
throughout the day. During these seasons the
sun stays fairly low in the sky and the fact that
you aim the camera upwards most of the time,
at an angle to the direction of the light, helps to
avoid flat lighting lacking in contrast. There is
nothing worse for mountain photography than
constant blue skies with a persistent heat haze,
which you often encounter in summer.

Snowdonia 1

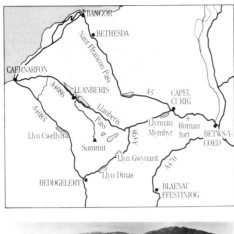

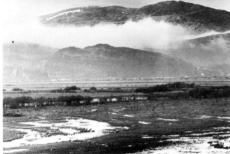

The Snowdon range seen from near Porthmadoc. Pentax 6 × 7 cm, wide-angled lens, Tri X, 1/60 at f16.

Right: The view from the railway station at Snowdon's summit, taken in the late afternoon in September.
Wide-angle lens, Ektachrome 200, 1/125 at f11.

The mountains of the Scottish Highlands are undoubtedly the most spectacular in Britain. For the totally committed mountain photographer the Grampians and the Cairngorms must be the first choice, but Scotland is very far from the south and the Highland district is served by only a limited number of roads. Any serious mountain photographer, therefore, would almost certainly require some walking and climbing experience. It is mainly for these reasons that we chose Snowdonia for our mountain location. It is only 250 miles from London and provides a fairly compact area which is easy to explore. The focal point of the area is Snowdon itself, the highest mountain of the range at 3560 feet, and you can virtually drive around the range in a couple of hours. What is more, there is a charming mountian railway running from Llanberis to the summit. The train goes conveniently slowly for photographic purposes.

The best way to approach Snowdonia is from the east on the A5, crossing the beautiful Vale of Llangollen, through Betws-y-Coed, past a Roman fort to Capel Curig, turning immediately after on to the A4086 leading to Llanberis Pass. Within a half a mile of the turn-off there is a spectacular view of Snowdon in the distance, reflected in the little lake Llynnau Mymbyr. The view is especially beautiful in the late afternoon, with the sun almost back-lighting the mountains and the perpetual snow on the skyline. A few miles further on you reach crossroads, one leading to Llanberis Pass and the other – the A498 – turning south to Beddgelert.

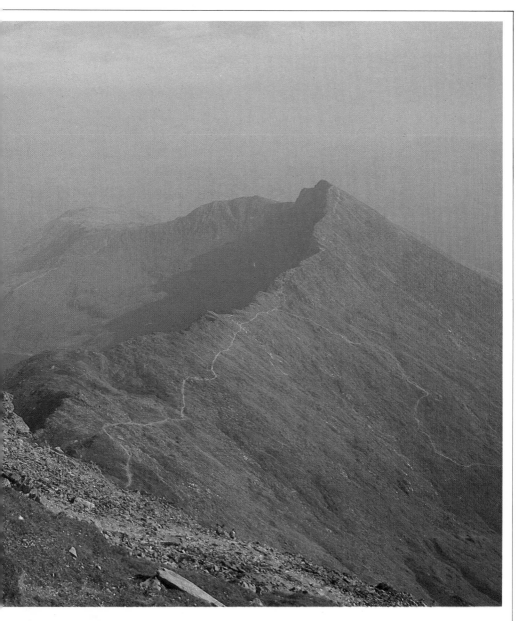

If you turn south, within a mile you are confronted with a superb view, first across the valley and then across the lake Llyn Gwynant. It is best to be there early in the morning, when it is bathed in sunlight, with successive lines of mountains stretching far into the distance. In the late afternoon the sun is hidden behind Snowdon and the valley is steeped in shadows.

In Snowdonia there are many possible photographic sights to choose from apart from Mount Snowdon itself. Just north of Snowdon the pass of Nant Ffrancon starting at the village of Bethesda is truly stupendous. In the northern part of Gwynedd near Conwy is the splendid Bodnant Garden, famous for its rhododendrons in the spring and also for its distant views of Snowdon. Southwest of Snowdon lies Blaenau Ffestiniog, a Welsh slate-roofed village with extensive but largely abandoned slate quarries. Still further south, but towards the coast, lies the austere Lleyn Peninsula with windblown beaches and secluded villages in the hills. Most of Snowdonia comprises a National Park, with numerous camping sites and information centres. The best time to photograph it is in the autumn, but the months of late April and May are especially good, with clear light, beautiful skies, and fewer cars upon the road.

Snowdonia 2

Right: Snowdon seen across Llynnau Mymbyr in the late afternoon. The unruffled surface of the lake reflects the clouds and mountain.
These photographs show different ways of framing. On the right I use a wide-angle lens, and above a long-focus lens, framing only part of the scene in a vertical format.
Both Tri X, 1/60 at f16.

Llanberis station at the foot of Mount Snowdon. Opened in 1896, this spectacular rack-and-pinion railway runs from Llanberis to the summit of Snowdon. The very slow progress of the train allows you to select your shots at leisure and to frame them carefully. It is worth spending time photographing at the summit. You may be tempted to use only a wide-angle lens in order to encompass the sweep of the mountains, but remember to use a long-focus lens as well; it pays to pick out specific details of the panorama – framing only a small mountain lake, or a green patch of woods.

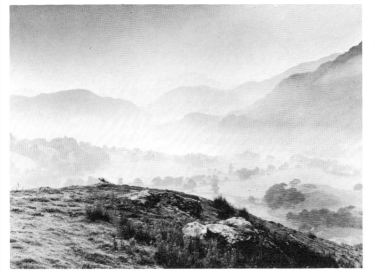

Left: Scene from Capel Curig taken in the late afternoon in November. Wide-angle lens, Agfachrome 50S, 1/60 at f11.

Opposite: The Snowdon range seen from just past Pen-y-Gwryd towards Nantgwynant Pass. An early morning September mist shrouds the mountains. Wide-angle lens, Tri X, 1/60 at f11.

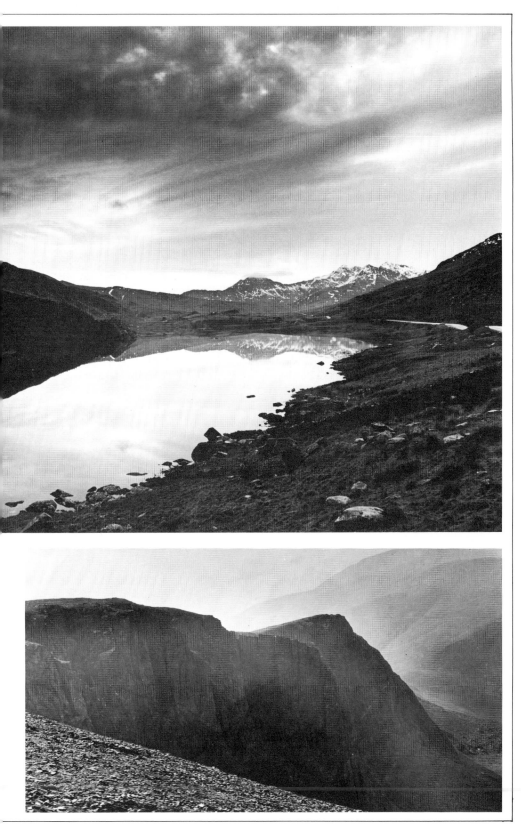

HILLS AND DALES

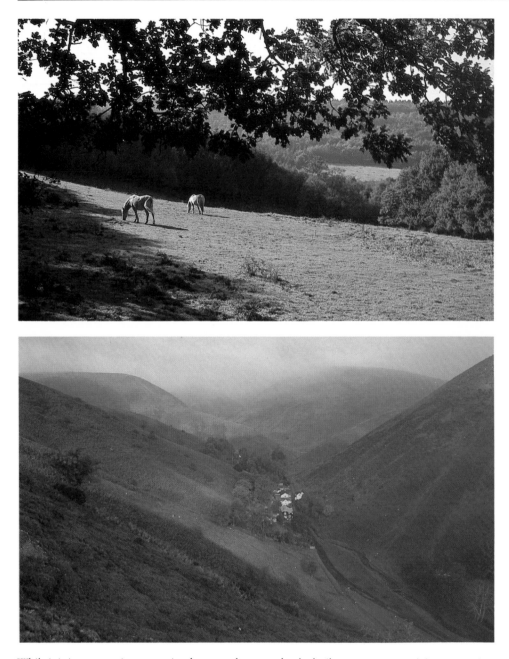

While it is important in mountain photography to convey elevation, loftiness and even a certain aloofness, with valleys and dales the exact opposite applies. They are associated with refuge and shelter, and project a feeling of safety and comfort. Consequently, they are best viewed from a high vantage point. If you look at a valley from its lowest point, where most roads tend to be built, you cannot see it in perspective. You are too enclosed, and your viewpoint is restricted. Even a wide-angle lens will fail to convey its true nature. In any case, you are rarely able to encompass both sides of the valley within the frame, and, even if you could, the large triangle of the sky would tend to dominate the image. So the order of the day is to find a

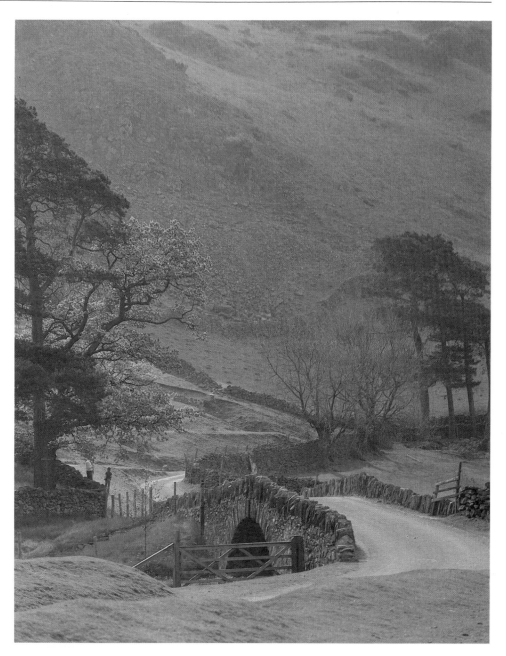

Towards Loweswater, Lake District.
Pentax 6×7cm, medium wide-angle lens,
Ektachrome 64, 1/60 at f16.

Opposite above: Leith Hill, Surrey.
Pentax 6×7cm, wide-angle lens, Agfachrome 50S,
1/60 at f11.

Opposite below: Cardingmill Valley, Salop.
Pentax 6×7cm, wide-angle lens, Ektachrome 200,
1/30 at f11.

good vantage point and to look down at the valley. Fortunately, not all the roads run alongside the river or the stream: many wind their way along the side of the valley, as in some of the Yorkshire Dales or in the Peak District. Failing this, it is not too difficult to make a short climb in order to command a sweeping view. A high viewpoint emphasizes the main features.

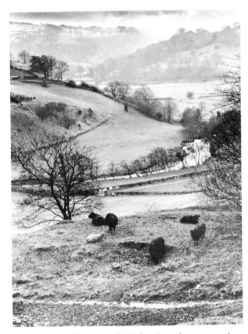

Elwy River valley, North Wales. Seen from a good vantage point, the stream defines the valley contours. Pentax 6×7cm, wide-angle lens, Plus X, 1/30 at f16.

Right: Llantysilio Mountains, looking towards Llangollen Valley.
Pentax 6×7cm, wide-angle lens, Tri X, 1/30 at f22.

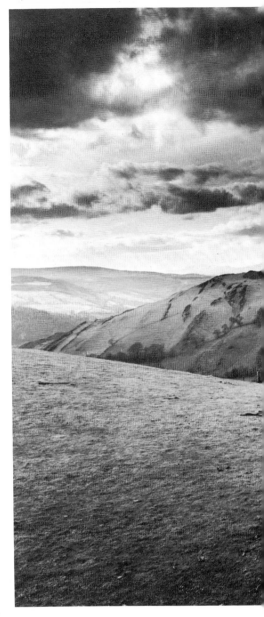

In the first place there is the flowing line of the valley, at its best an 'S' curve, and this can only be appreciated from above. Secondly, there is the stream or river at the base of the valley. This tends to present a problem. On the whole it is difficult to find a stretch of clearly visible river. More often than not it is screened by trees or high banks. If you are fortunate enough to find a suitable viewpoint, however, the presence of a silvery ribbon of water glimmering in *contre-jour* lighting can make an interesting composition.

A very photogenic aspect of many British valleys is the simplicity and smoothness of their surface. The Yorkshire Dales, for example, with countless sheep pastures broken up at random by drystone walls, provide the photographer time and again with marvellous graphic effects. The walls emphasize the sweeping lines and sinuous contours of the slopes.

Valleys and dales come to life in the spring.

The freshness of the greenery wears off towards the summer and the slopes begin to lose their velvety texture. Dawn and early morning in the dales can be an unforgettable experience. With little traffic on the roads, you can stop almost anywhere – often it is difficult to resist stopping every twenty yards or so. With every twist of the road the scene changes enchantingly. Colours, too, acquire a freshness in the clear morning air, and it is easy to fall under their spell, only to find later that your colour slides somehow fail to reflect your experience on location. They often appear somewhat green and monotonous. Always look for some colour ac-

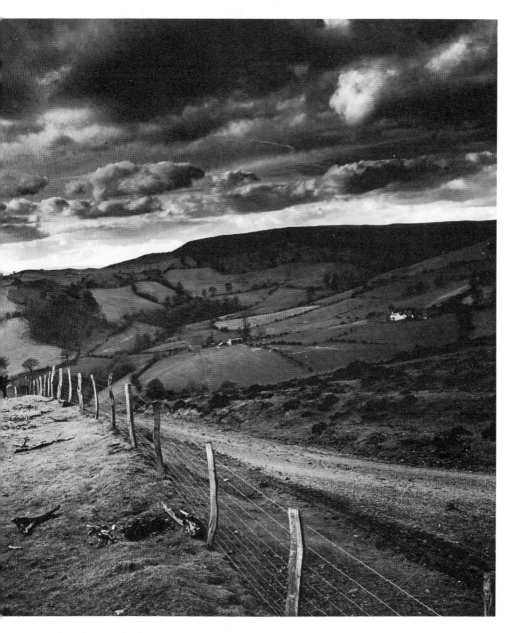

cents: a few flowers, the brown roof of a hut, a close-up of a wall. An interesting detail in the foreground may save the picture. Also bear in mind that when shooting downwards, including little sky, or slightly against the light, you should be careful not to underexpose. At times it is worth overriding the dictates of the meter and opening up a stop. Large areas of darker tones tend to absorb the light and subsequently appear too dark in the photograph.

Hills are included in this· chapter mainly because the photography of hilly country is very similar to that of valleys. English hills, in particular, like the Malvern Hills, the Quantocks, the Chilterns and especially the Cotswolds, are very gentle in character, with soft curves and rounded outlines – almost a concave version of a dale. You can see the hilliness from a distance, as, for example, when you approach Malvern from the east. But when you are very near or among them you hardly experience their height at all. However, hills lack the smoothness of a dale, often being wooded in places. Also they are rarely bisected by hedges and walls. In consequence they are most difficult to photograph. They do not possess a unity of character; their essential nature is more elusive and more difficult to pinpoint.

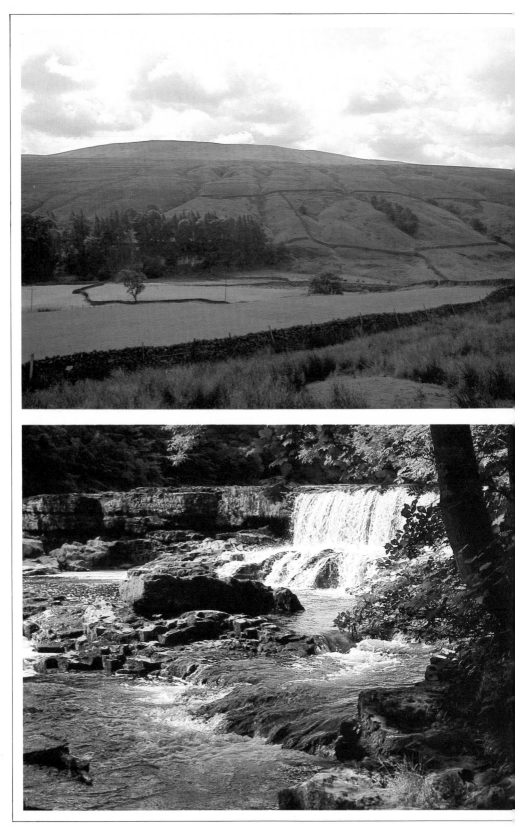

The Yorkshire Dales 1

The serenity of the Yorkshire Dales is best expressed with simplicity of composition and economy of line. The rivers of the dales carve out a roughly rectangular area nestling in the northern part of the Pennines. Since each of the rivers is conveniently chaperoned by a road, you can drive along most of them in a day. Not all the dales are of equal beauty, though. Ribblesdale, on the west, is perhaps the least photogenic, being rather wide and flat. Coverdale, although a spectacular sight in places, is a little austere and rather barren. For me the most beautiful are Wharfedale and Wensleydale – not only because both are exceptionally photogenic, but also because there are other interesting features in their vicinity. In Wensleydale you will find the most attractive of the Yorkshire waterfalls – the Aysgarth Falls. Off Wharfedale lies the very impressive Gordale Scar, and in nearby Malham are many underground caves as well as the famous Malham Cove. In Wharfedale itself is Bolton Abbey.

Opposite above: Wensleydale near Burtersett early in the morning, with the sun partially obscured by a light cloud and only a small pool of light on the ground.
Medium wide-angle lens, Agfachrome 50S, 1/60 at f11.

Opposite below: Part of the Aysgarth Falls on the River Ure seen from the left bank in late summer.
Wide-angle lens, Agfachrome 50S, 1/125 at f8.

The most exhilarating way to make your first acquaintance with the dales is to spend the night somewhere in the Lake District – Windermere is quite close, Kendal even nearer – and then rise before dawn and drive along the A 684 towards the M6 and Sedbergh. Just before Sedbergh you dip under the motorway and enter the antechamber to Wensleydale – Garsdale. The sun, if you have chosen the right day, should be just in front of you, low on the horizon, throwing into sharp relief the undulations of the valley, the white shapes of the grazing sheep and the houses of villages with early morning smoke rising from their chimneys. The transition from Garsdale to Wensleydale is hardly noticeable, except that the dale widens slightly. The slopes are smoother so that the stone walls, and occasional groups of horses and cows, stand out more sharply.

Some thirty miles from the motorway, still on the A684 and deep into Wensleydale, you will find a delightful alternative to the smoothness of the dales – the Aysgarth Falls. It is worth spending an hour or two there. The falls, a series of three separate falls actually, occupy about half a mile on the River Ure. You catch a first glimpse of them from a sixteenth-century bridge, but in summer the upper reaches of the falls are partly obscured by overhanging trees and bushes. However, a path on the right of the bridge reached by a gate in the wall will lead you right up to the rushing waters, tumbling over limestone ledges.

A mile or so past Aysgarth turn left into the B6160, drive along pretty Bishopdale, and just past the village of Cray you will meet the river Wharfe and the beginning of Wharfedale, with the village of Hubberholme nestling in the conjunction of the two dales. A little further on and it is time to make another detour, along narrow roads leading to the sheer, dramatic cliffs of Gordale Scar, immortalized by Thomas Gray who ended his essay 'On Gordale Scar' with the words: 'I stayed there (not without shuddering) a full quarter of an hour, and thought my trouble richly paid for the impression will last for life.' Early in the morning, or better still in the afternoon, it is a majestic sight – the rocks closing in on the silver thread of the thundering waterfalls.

You return from the gorge to the serenity and calm of Wharfedale. Parts of the dale, especially those near Appletreewick and beyond, are possibly even more photogenic than Wensleydale. Finally you reach Bolton Abbey and the little valley in front of it.

65

The Yorkshire Dales 2

Left: Gordale Scar looking away from the waterfall. The low angle of the late afternoon sun creates a dramatic pattern of light and shade. This was taken almost directly into the light with a deep lens hood protecting the lens from flare.
Pentax 6×7cm, wide-angle lens, Tri X, 1/30 at f22, tripod.

Below left: Wharfedale, north of Bolton Abbey. A typical dale farm surrounded by trees and hedged in by stone walls, taken early on a summer morning.
Pentax 6×7cm, medium wide-angle lens, Tri X, 1/60 at f11

Opposite above: Wensleydale near Hawes. This composition uses only the lines of a ploughed field, a hut and its guardian tree. Often simple compositions are the most effective.
Wide-angle lens, Tri X, 1/60 at f22

Opposite below: A scene characteristic of Wensleydale, with lines of stone walls crossing the slope and trees framing the composition. This was shot against the light, so that a deep lens hood was necessary.
Medium-wide angle lens, Tri X, 1/30 at f16.

The Malvern Hills

Great Malvern – cosily tucked away on the western slopes of the Malvern Hills – has the air of a placid continental spa. Its popularity has declined somewhat since Victorian times, but it still offers wonderful walks, delightful views on both sides and excellent, if slightly old-fashioned, hotels. Photographically the most rewarding site is the British Camp, easily reached by road some three or four miles from Great Malvern and then by a short steep climb. Seen from the summit at sunset, the bare, angular slopes acquire dramatic plasticity with their hollows, hillocks and ribbons of paths. They form excellent foregrounds for the distant views below, and a slight haze or mist accentuates the feeling of space and height.

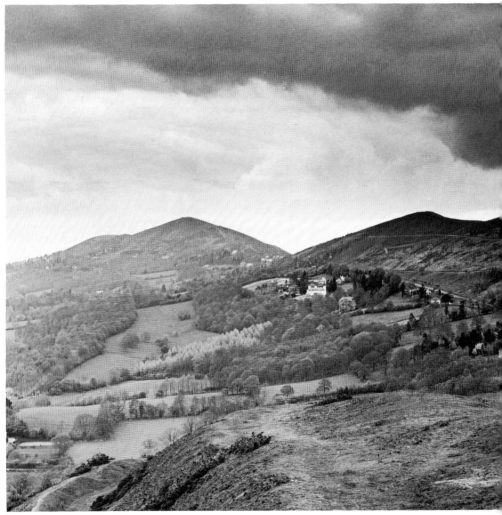

Left: Wide-angle view of the Malvern Hills, seen from the west near Malvern Wells. Most of the hills are dotted with groups of white houses which give the photographs scale and perspective and also act as visual punctuation marks. If you photograph the Malverns from the west, late afternoon provides the best light.
Wide-angle lens, Tri X, ¹/₆₀ at f16.

Above: The Malvern Hills seen from the British Camp, looking down towards Colwall Green. The haze, persisting well into late afternoon, would spoil colour photographs, but in monochrome it adds mood and a three-dimensional quality to the foreground slopes and trees.
Standard lens, Tri X, ¹/₆₀ at f16

Top: The Malvern Hills from the British Camp looking south. Late in the evening, the low sun throws the bare hills into deep relief. The British Camp is frequented by a number of walkers, so it is interesting to pick out single figures against the hills.
Wide-angle lens, Tri X, ¹/₆₀ at f16.

DOWNS AND MOORS

At a first glance downs and moors seem to have little in common. Confined strictly to the southern part of England, downs are largely cultivated and domesticated by man; moors are windswept, barren and given over entirely to sheep farming. At one time, however, downs were also predominantly sheep country, but in the last century they came increasingly under the plough. Their colouring is also different. Downs in summer form a yellow-gold patchwork of more or less regular shapes, while moors display a sombre but infinitely subtle variation of greens, browns and mauves. Yet in basic shape they are alike, being mostly low, gentle undulations with long attenuated lines, crossing and re-crossing each other. It is this variation of shape which attracts the photographer in the main. Never dull, never quite repeating themselves, downs are almost always prefixed with the adjective 'rolling'.

In each case, too, there is also a splendid visual bonus. On Exmoor, Dartmoor or the North Yorkshire moors, the soft lines are occasionally broken up by a row of trees perching on the top of a ridge, while the downs, especially in Wiltshire or Berkshire, are often crowned by graceful and quite regular clumps of trees. Gilbert White used to call a patch of woods of this kind 'a hanger', but in downland they are smaller and more compact than the Surrey variety. These natural visual accents are perfect for distinctive landscape compositions; they also lend themselves well to combination with the sky and clouds. Since you rarely have to climb in order to photograph downland or moorland – which are much more attractive seen from below – the sky becomes a very strong feature.

While the sweeping lines of moors and downs invite wide-angle views, it is also worth looking at them, the downs especially, through a long lens. Often compact framing with a well-placed clump of trees slightly off-centre can be extremely attractive. Despite their similar structures, moors on the whole are sombre melancholy places, and occasionally forbidding and dramatic. Downs, on the other hand, are generally gay and flamboyant. Each should be photographed in a way which reflects its prevailing mood: moors, with a strong contrast of light and shade, and clouds and skies in general rendered darker (with red and orange filters); downs, in a softer contrast with fluffy clouds (yellow or dark yellow filters at the most). Both downs and moors are at their best in mid- and late summer, but spring with its flocks of lambs is also attractive.

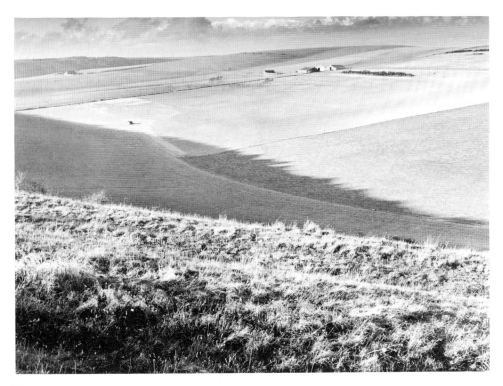

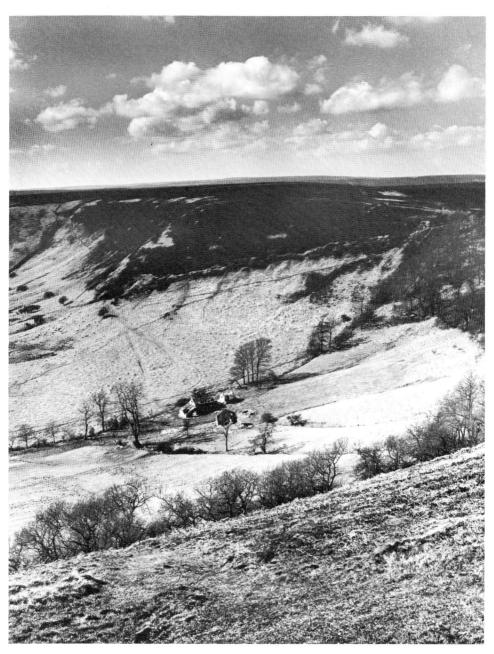

Above and right: Fylingdales Moor. Large areas of
even tone – alternately light and dark – are broken by
lonely groups of trees or abandoned dwellings. The
arrangement of these elements is all-important. The
scale of the large picture captures the moorland's
rugged character, whereas the details become the
focal point in the small picture.
Nikkormat FT2, standard lens (above), 200mm
long-focus lens (right), Plus X, 1/30 at f16, tripod.

Opposite: The South Downs near Wilmington in
the Cuckmere valley.
Pentax 6×7cm, wide-angle lens, Tri X, 1/60 at f22.

Marlborough Downs 1

The Marlborough Downs are a compact area of undulating countryside south of Swindon and north of Marlborough and Avebury. The whole area can be crossed and recrossed in less than two hours, but a more leisurely exploration soon pays rich dividends. It is ideal country for a photographer who loves uncluttered expanses of cultivated fields. These have clear dividing lines, and are topped here and there by small but very neat and beautifully shaped clumps of trees which almost invariably are unified and

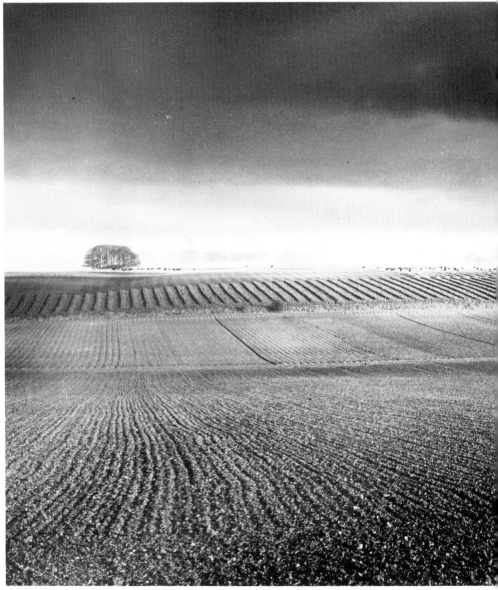

symmetrical in form – a little like the crown of a bowler hat. It is difficult to find a design feature as captivating as these 'hats'.

The most attractive way to come upon the Marlborough Downs is from Marlborough itself, a charming, busy Wiltshire town. Travel north on the Swindon road – the A345 – and turn left almost immediately into the side road leading to Rockley and Broad Hinton. Within a couple of miles of Rockley, the landscape begins to assume a rolling downland character.

It is most beautiful when you reach the Ridgeway – the famous pathway which crosses the whole of the Marlborough Downs – at Hackpen Hill, with its three delightful clumps of trees. Time permitting, you can take a two-mile walk to the old site of Barbury Castle. Morning or evening light offers the most striking effects on the Ridgeway.

The Ridgeway, Marlborough Downs. A simple but effective composition.
Pentax 6×7cm, wide-angle lens, Tri X, 1/30 at f22.

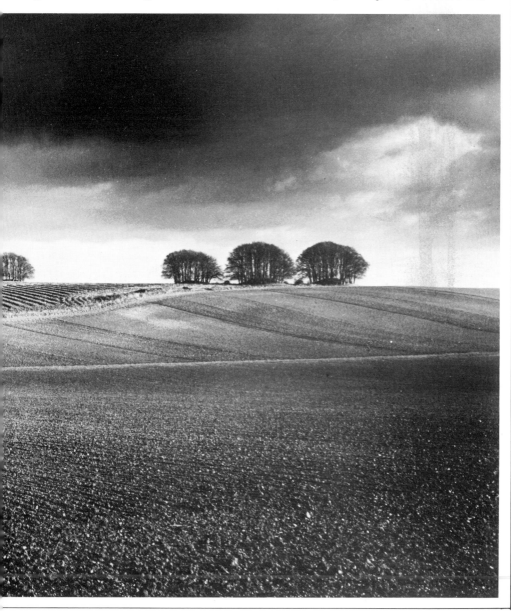

Marlborough Downs 2

The Ridgeway near Hackpen Hill. The beaten track among the fields, with a procession of sheep disappearing behind the slope of the hill. A strong wind creates waves in the cornfields. One of the most popular walking tracks, the Ridgeway runs from near the Valley of Pewsey in the south to Liddington Castle in the north, a distance of ten miles. Long-focus lens, Tri X, 1/125 at f8.

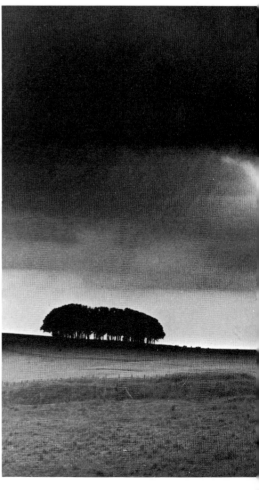

Above: A group of trees a little past Rockley in the Marlborough Downs. When shooting from among the trees, it is important to retain a sharp focus on the foreground while the far distance is still in reasonable focus. The tripod is indispensable since you have to stop down as much as possible.
Wide-angle lens, Tri X, 1/30 at f22.

Marlborough Downs near Badbury. This is a typical downland scene: a field of corn alongside a pasture with a group of trees at the top of the hill and the cows at their afternoon siesta. Wide-angle lens, Tri X, 1/125 at f16.

Below: **Barbury Castle, Wiltshire.** Dusk can be very dramatic. All you need is a good sky, with the setting sun breaking through the clouds, and an interesting skyline. Pentax 6×7cm, 55mm wide-angle lens, Plus X, 1/30 at f11.

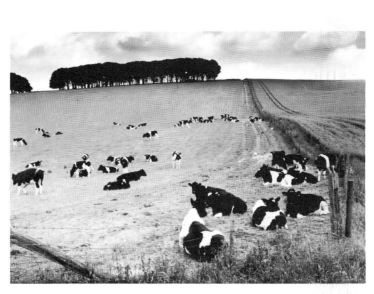

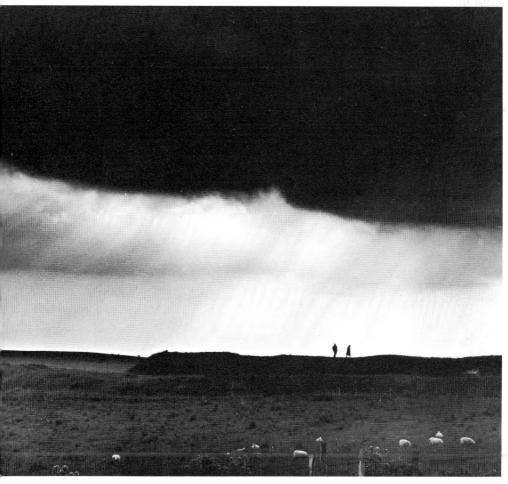

Exmoor

Exmoor is permanently associated with R. D. Blackmore's *Lorna Doone*, though in all fairness 'Doone Country', two miles southwest of Brendon, is not its most picturesque spot. The area of Dunkery Hill, south of Luccombe, is far more interesting and the main road from Porlock to Lynton running between Exmoor and the sea is truly enchanting. While Dartmoor is wilder, no moorland in England equals Exmoor for sheer beauty. In summer, the delicacy of its colours is breathtaking and its graceful, ever-changing contours with the occasional line of trees are very graphic. There is only one drawback for the photographer – Exmoor's notorious weather, arguably the wettest in England. (A lengthy stay is thus strongly recommended in order to capture the photogenic moments.) A shaft of light breaking through the stormclouds will reveal a dramatic landscape for your camera. Exmoor's strength also lies in the contrast between the bare, heathery moors and the rich patchwork of fields by the sea.

Right: The view from the A39 looking down towards the moors, starting just beyond the cultivated fields, and the charming tiny village of Oare. From Oare you can walk to 'Doone Country' for two miles along Badgworthy Water. The narrow road running west from Oare which joins the main road provides a number of spectacular moments, especially near Robber's Bridge and Weirwood Common. I used a wide-angle lens to retain sharp focus from the foreground to infinity.
Tri X, 1/30 at f22, tripod.

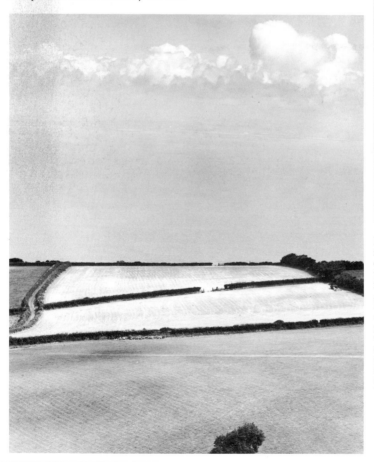

Left: Looking down from Porlock Common over cultivated fields towards the sea, taken in the late afternoon. Almost the whole length of the A39 alongside Exmoor is punctuated by beautiful vistas. A new toll road avoiding the very steep descent to Porlock Bay is also very attractive. Standard lens, Tri X, 1/60 at f16.

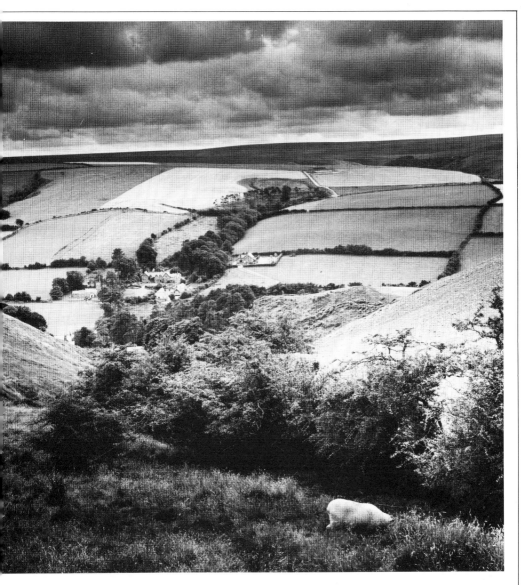

Left: A very grey day in late summer. The graceful contours of Exmoor reveal layers of dark and light tone. A low sun can bring them into sharp relief, but even in less bright light, as here, they are still photogenic.
Wide-angle lens, Tri X, $\frac{1}{60}$ at f8.

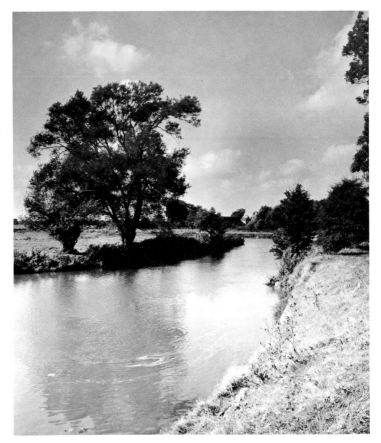

Willows overlooking the Thames at Kelmscot. A yellow filter is sufficient to bring out the white clouds.
Nikkormat FT, medium wide-angle lens, Plus X, ¹⁄₁₂₅ at f11.

Opposite above: Filby Broad. Winter snow contrasts with the darker tones of water and trees.
Pentax 6×7cm, wide-angle lens, Tri X, ¹⁄₁₅ at f22.

Opposite below: Rollesby Broad. Light plays an important part in the photographing of water, adding brilliance and lustre.
Pentax 6×7cm, medium wide-angle lens, Tri X, ¹⁄₆₀ at f11.

Britain is not exceptionally rich in mountains, and even high hills can be counted on the fingers of both hands, but with rivers and lakes it is an entirely different matter. Fed by generous rainfalls, an extensive network of rivers and streams flows to the sea, or into lakes and marshes. The range is enormous. There are swiftly flowing mountain streams in Scotland; the majestic rivers which rise in Wales, the Wye and the Severn chief among them; the crystalline streams that emerge from the downlands; and the sluggish but charming rivers of Suffolk and Norfolk. As with the rivers, so with the lakes. The Lake District alone has ten major lakes and innumerable small ones. To the north are the Trossachs in the Highlands and a whole group of splendid lakes in western Scotland including Loch Lomond and Loch Ness. In the east are the Norfolk Broads, while in Wales there are several lakes of great beauty, especially in Snowdonia. Each of these could provide a landscape photographer with subject matter for weeks, let alone days.

Rivers and lakes call for quite different treatment photographically. Broadly speaking, rivers represent movement and life, whereas lakes convey tranquillity and repose. Nevertheless, both possess three attributes in common, if to a different degree. These are luminosity, reflection and translucence. Because rivers are never still, they possess great brilliance. At the same time, they are rarely as reflective as the generally placid lakes; their waters are less transparent too – except for chalk rivers. Thus the way you photograph a lake or a river must take into account these special qualities, or the lack of them.

Rivers are seen to their best advantage from a slightly elevated point of view and partly against the light, so that the water acquires a scintillating quality. It also helps to show a stretch of the river with a bend or curve, which adds to the impression of liveliness. Lakes, however, are best photographed in a moment of tranquillity. The early morning is the best time for this, before the slightest breeze has ruffled

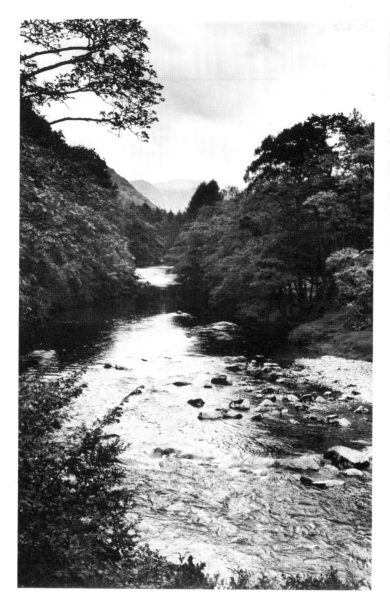

Left: The River Wye, photographed from above – and against the light – so that the dark banks set off the brightness of the water. Pentax 6×7cm, wide-angle lens, Tri X, 1/60 at f16.

Opposite above: Fog on Rollesby Broad. When photographing scenes like this in colour, it is advisable to bracket the shot and generally to underexpose in order to obtain stronger images. Pentax 6×7cm, wide-angle lens, Ektachrome 200, 1/60 at f8.

Opposite below: Grasmere Lake. Early morning light is highly photogenic, especially with a mist masking unnecessary detail and delicately outlining the main elements of the composition. Pentax 6×7cm, wide-angle lens, Ektachrome 200, 1/15 at f16.

the mirror-like surface. The moment the wind rises, the magic is almost over. There is an unavoidably romantic quality about a lake photographed at dawn, which even the flintiest-hearted photographer can sense.

But these are only very general suggestions. In view of the enormous variety of both rivers and lakes, it is not possible to adopt a common approach for all of them. Mountain streams evoke a different response from that of the very tame and highly regulated River Thames. It is also interesting to note that the movement of water can be beautifully portrayed by deliberately blurring it through a long exposure, while keeping the rest of the image very sharp. The photographer John Blakemore tends to select only a single stream, or rather small details in it, such as the sharpness of the stones and rocks. He uses a large-view (plate) camera on a tripod, and long exposures (from a quarter of a second to one second), which give the water a strange foam-like appearance.

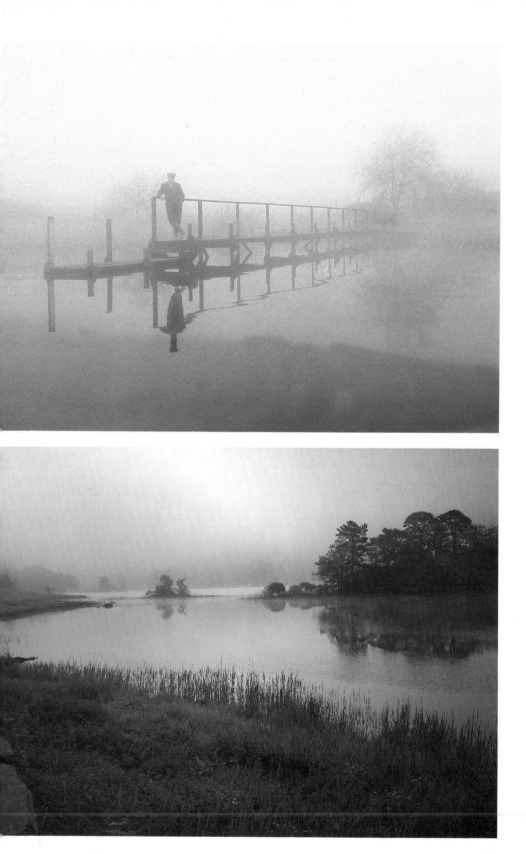

River Avon

If you are looking for a suitable subject for a pictorial essay which is both varied and yet compact and which can be presented in a narrative form (say, in an audio-visual sequence), there is no better choice than one of Britain's rivers. They all have a beginning and an end, and can be subject to various interpretations.

The task is not entirely easy, because there is no river which has a road following its course throughout, but part of the pleasure lies in finding roads that come near to it in various places. One of the fascinating aspects of a river is that it is often a focal point for many people and for different reasons. This is what I have

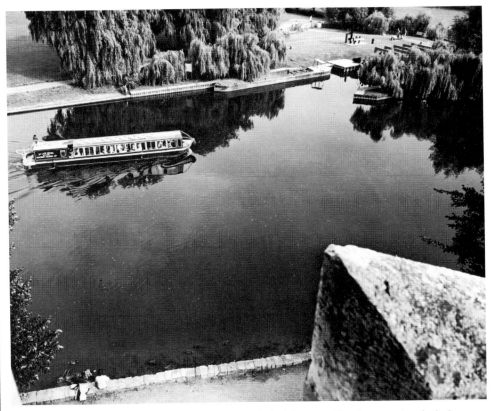

Here are just three variations on the theme of locks. Above is the lock at Stratford-on-Avon seen from the top of the church. Below left, the barge passing through the lock at Fladbury. Below right,

the lock-keeper at Evesham opening the lock gates. All were taken on Tri X. A wide-angle lens was used for the bottom two pictures and a long-focus lens for the one at the top.

tried to show here. I followed the course of the Avon from the point at which it joins the Severn at Tewkesbury as far as Stratford-on-Avon – roughly a distance of thirty miles – and was amazed at the variety of pictures I could take, both of the landscape itself and of the many interesting people I met on or near the river. In these two pages I have only concentrated on human life connected with the river. I could easily have chosen a dozen other subjects. The large number of fishermen alone could fill the spread, and riverside pubs and restaurants, boatyards, locks, bridges and the people who live on the river all provide material.

Above: Amateur artists painting the old bridge at Pershore. This is a much loved subject, and on many a Sunday afternoon in summer, the bridge seems to be surrounded by easles and paint boxes. Taken in the morning. Standard lens, Tri X, 1/125 at f11.

Left: A pair of young fishermen near Bredon on the Avon. Early morning mist softens the opposite bank, which is dotted with cows. Fishermen are a good, reliable subject; they are always still and in repose, and never object unless you make too much noise. Medium wide-angle lens, Tri X, 1/125 at f11.

The Trossachs 1

Fisherman on the west side of Loch Katrine. Most of the road around the lake belongs to the Water Authority and is out of bounds to tourists, but the western part can be reached by a side road from Loch Arklet. It is best to visit it in the morning with the lake seen against the light. Medium wide-angle lens, Agfachrome 50S, 1/60 at f8.

The Trossachs in Central are smaller than the Lake District, more compact, far less crowded and offer the photographer a great variety of scenery. Nowadays, they are possibly a little neglected – they enjoyed their greatest popularity in the wake of Sir Walter Scott's poem 'The Lady of the Lake' – and because of that, are less commercialized and less spoilt than their counterparts in Cumberland.

The best way to explore the area is to start at Callander, 'the gateway to the Trossachs'. Drive along Loch Venachar to the charming, small Loch Achray, easily approachable from almost all sides, and then to the most famous of the Trossachs' lochs, Loch Katrine. Unfortunately, the beautiful road along its northern banks is closed to tourists, but a pleasant alternative is to take a trip in the boat which sails from the pier several times a day. From Loch Katrine, you can cross Achray Forest, with beautiful views at the top, to the next line of lakes – Loch Ard, Loch Chon and Loch Arklet – right to the banks of Loch Lomond and then back, with a short visit to the other side of Loch Katrine.

Very early mornings on any of the Trossachs' lakes are enchanting, especially if there is little breeze and the surrounding mountains are reflected on the surface. Try the late afternoon trip on Lake Katrine. On the return journey to the pier, you can watch and photograph the setting sun across the lake. An evening on the Lake of Menteith, with a ferry to the Priory on the island of Inchmahome, is also highly recommended. Driving north from Callander there are several more lakes to explore – the elongated Loch Lubnaig and then, left of the main road, the beautiful Loch Voil and its small neighbour Loch Doine, set in the midst of spectacular mountain scenery.

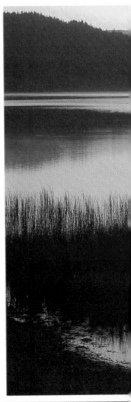

Early morning on Loch Achray. The most accessible by road of all the Trossachs' lakes, it is also the smallest, so that the opposite bank is much nearer to the foreground, which is important in tight compositions. Very early in the morning when the light is still quite weak, the shapes acquire almost abstract qualities.
Wide-angle lens, Kodachrome 64, 1/30 at f8

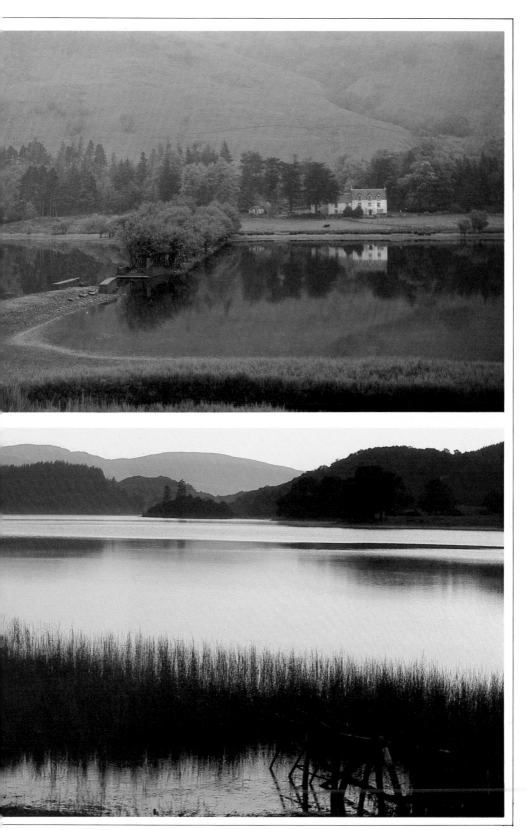

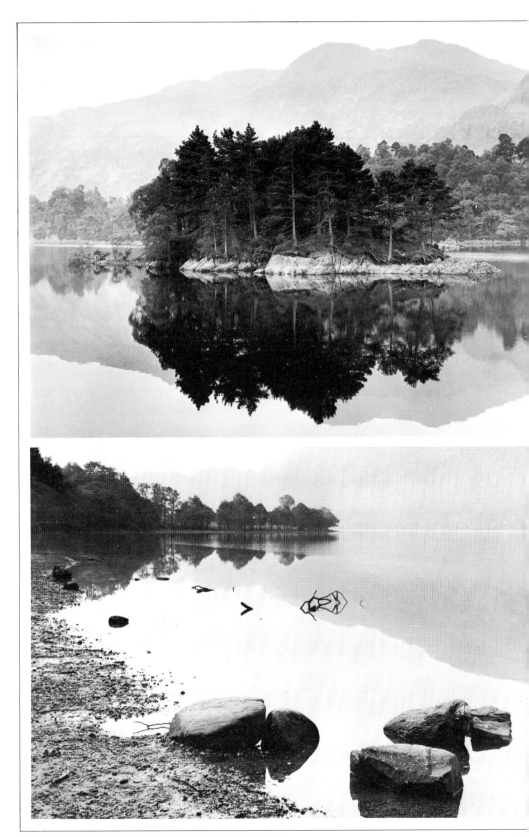

The Trossachs 2

Opposite above: Ellen's Isle on Loch Katrine, made famous by Sir Walter Scott in the nineteenth century. Tourists flocked to the Trossachs for many years afterwards. The early morning calm gives the water a polished, reflective surface.
Standard lens, Tri X, 1/60 at f11.

Opposite below: Loch Chon seen from the west against the dawn light. In photographing lakes, it is often important to include strong subjects in the foreground to create a contrast with the delicate tones of the far distance.
Wide-angle lens, FP4, 1/30 at f16, tripod.

Above: The small mountain lake of Loch Drunkie, seen from a vantage point high in the Achray Forest on Duke's Pass towards Aberfoyle. Taken in afternoon light, with a haze obscuring most of the details.
Long-focus lens, FP4, 1/125 at f11.

Centre: Small church on a peninsula jutting into Loch Achray. The fence, distorted by the wide-angle lens, provides a line for the eye to follow to the secondary centre of interest – the horses.
Wide-angle lens, FP4, 1/60 at f16.

Below: The entry into Loch Ard from the west. The fisherman's hut at the edge is balanced by the distant mountain, while the foreground grasses provide a firm compositional base.
Medium wide-angle lens, FP4, 1/60 at f16.

The Lake District

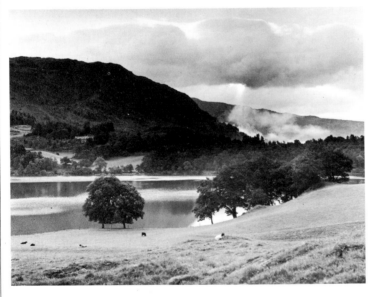

Top: Ullswater very
early in the morning.
Pentax 6×7 cm,
wide-angle lens,
Agfachrome 50S,
$1/30$ at f11.

Rydal Water at 6 a.m.
Mamyiaflex C3,
standard lens, Plus X,
$1/30$ at f8

The High Tarn, taken
in the late afternoon,
shooting into the light.
You can reach The
Tarns by road from
Hawkshead and then by
a short walk from the
car park.
Mamyiaflex C3,
standard lens, CT18,
$1/60$ at f8.

The Lake District is arguably the most attractive area in England, and you could spend a lifetime photographing it, every year discovering new delights. But precisely because it is so beautiful, it is also the most frequented. From May right up to late September, it is filled with tourists – walking, camping, photographing, and mostly driving. If you are looking for the inspiration of solitude and calm, you will not find it in the spring and summer months among the lakes. Not unless you are prepared to rise at

five each morning, work for three or four hours, and spend the remaining day resting. However, late autumn and early spring can also be delightful, if unpredictable, as far as the weather is concerned. But then, the lakes can be beautiful even on a dull day. In these off-season periods, the roads are fairly empty and it is easy to stop, jump out and take a few shots.

As all photography addicts know, the best moments seem to happen on a narrow mountain road, in the high season, with a string of

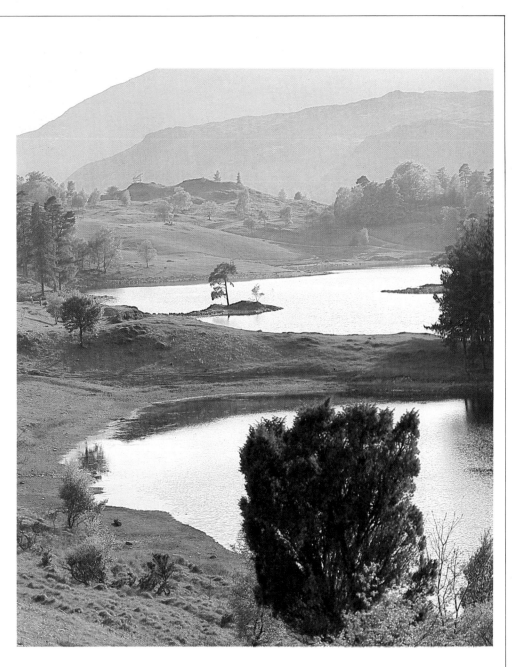

cars behind you. The best way to photograph the Lake District, however, is not from the main roads or the most famous beauty spots. Rather select one of the smaller lakes, park comfortably in a car park, and then take a short walk around its shores. With most of the small lakes, you should be able to do this in under an hour. My most memorable moments were spent walking very early in the morning around Rydal Water and Grasmere. Some of The Tarns (small lakes high in the mountains) can also be reached by road and then by a short, if slightly more strenuous, walk. While these gentle trips can be most enjoyable, if you want dramatic impact in your landscapes, go for a very early morning drive through the mountains. Even in the high season, you will meet only an occasional car. Start, for example, from Borrowdale, drive along the west side of Derwentwater and then turn sharp left to Stair, and on through the mountain passes past the tumbling waters of Keskadale Beck to Buttermere.

THE COAST

Travelling around Britain, you can encounter almost every type of coastal scenery. There are over 6000 miles of varied and attractive coastline: salt marshes, glittering mud flats separated by estuaries and inlets, beaches of shingle, and rocky shores. At low tide, the flat sands recede into the horizon at Morecambe in Lancashire. At nearby Formby, the dunes form mile upon mile of beautiful and bizarre undulations. The coast crumbles into sinister shapes and lines in Suffolk, and rises in the north to the formidable jagged cliffs of Scotland. Few parts of the country are more than 100 miles from the sea, and most people live within 50 miles of the nearest tidal water. Britain's excellent road network makes much of this splendour easily accessible.

While the inland landscape can be transformed by weather or the time of day, its transformation is never as abrupt and as complete as that of a seascape. Often it is the tides which effect the change, but the sea itself can change its mood and its appearance very rapidly.

Confronted with this natural abundance, you should be very discriminating in your choice of location. What are the factors which make one stretch of coastal scenery more photogenic than

Whitby seafront. A wide-angle lens exaggerates the size of nearer objects and diminishes distant ones, creating a three-dimensional effect.
Nikon FE, wide-angle lens, FP4, ⅟₆₀ at f16.

Right: Teignmouth Bay. The children in the foreground are a vital part of this composition, and it was necessary to wait until the figures assumed a photogenic pose.
Pentax 6×7cm, wide-angle lens, Tri X, ⅟₆₀ at f16, orange graduated filter.

another? As with landscape in general, it is the variety of shapes and lines and, of course, the quality of light. The proximity to land of large expanses of water usually provides a clear, translucent light, and near the shore, the skies are likely to have stronger and more varied cloud formations than inland. But photographing the sea and sky alone, although often made rewarding by the nuances of light, can in the long run be a little tedious. What you need is an interesting conjunction of sea and shore. The best results, when shooting seascapes, are

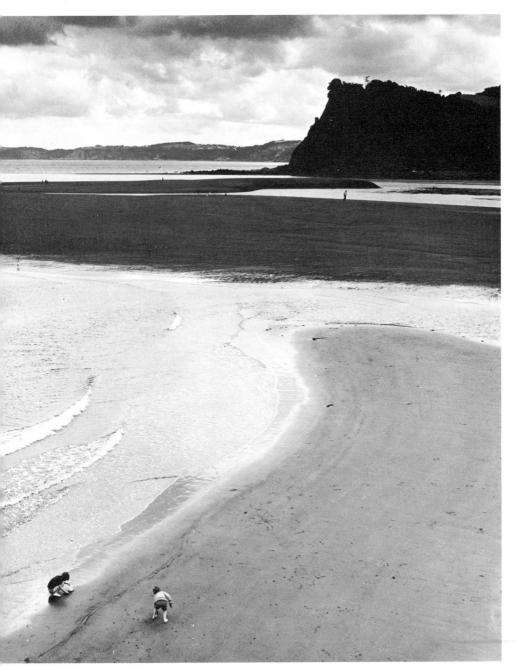

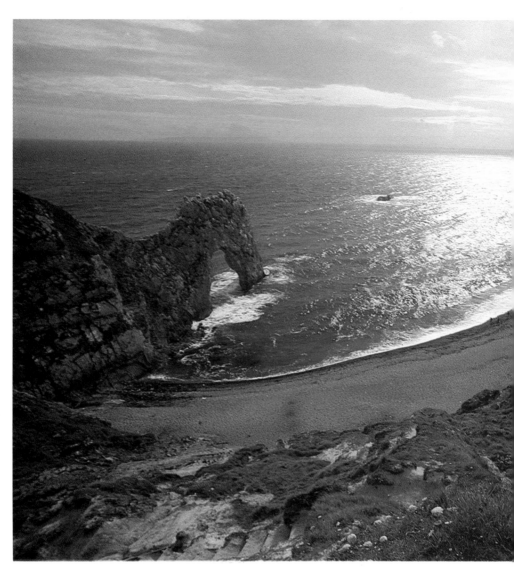

obtained when you aim the camera along the coast, rather than straight at the sea.

Holiday resorts, on the whole, should be avoided. More often than not, they are laid out in a straight line along the seashore, offering very little visual excitement. There are exceptions, of course, where they are situated in a bay and where the hotels and the main road do not crowd right into the sea. In Teignmouth, for example, at low tide, the sea creates an attractive curve and the waves form a foamy, undulating line. Low tide seems to offer more photographic possibilities than high tide. The sand left by the retreating waters acquires a velvet texture. At times, when accompanied by the wind, it has a regular, ridged pattern.

The choice of the time of day is important. On the western coasts, late afternoon and evening are naturally the best. The sea then acquires a brilliant sheen and the figures on the shore cast long shadows towards the land and the camera. The opposite is true of the eastern coast, and there, in Suffolk, Norfolk and further north, the early morning light can be very beautiful. The most attractive light effects can often be obtained either an hour or two after sunrise or before sunset. At these times the sun, when masked by cloud, can light up the sea further away from the coast, forming a luminous line on the horizon and casting pools of light on the water. The clouds – backlit – are at their most spectacular. You will need a strong filter or they will be too bright to print through.

The most characteristic qualities of the sea are its vastness and its boundlessness. I would therefore advise against using a long-focus lens,

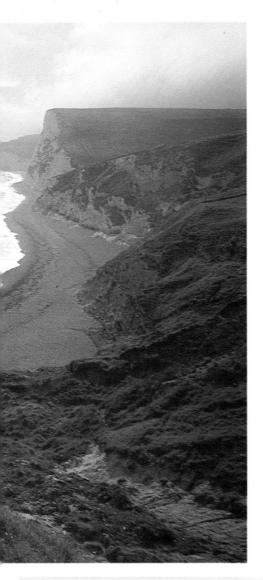

which tends to compress and confine the space. A wide-angle lens is the most suitable, and it brings the expanse of the sky into the frame.

As the horizon is straight, it is very easy to use graduated filters in seascape photography. For monochrome, you can almost leave a white to light orange (or dark yellow) graduated filter permanently on the camera, only adjusting and checking its horizontal level. For colour, you could use a light amber (or light tabasco) graduated filter for special effects, but be careful to cover the sea as well as the sky lest you end up with a differently coloured sky reflected in the water.

Left: Durdle Door, near Lulworth Cove. The reflection in the sea of the late afternoon summer sun is reduced by the use of a polarizing filter. A very wide-angle (20mm) lens was used, so that Durdle Door, jutting out to sea, is balanced by the distant line of cliffs.

Norfolk coast. Breakwaters, and other items of marine architecture, are best seen against the deserted sands. Nikon FE, wide-angle lens, Ilford XP1, 1/30 at f22.

Left: Boscastle Bay. To heighten the contrast in monochrome seascapes, photograph rocks when a low sun highlights them and the sea is in shadow. Pentax 6×7cm, wide-angle lens, Tri X, 1/60 at f16.

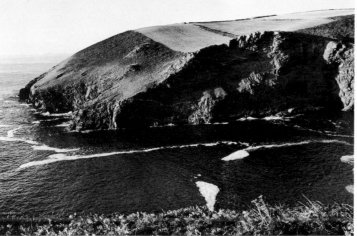

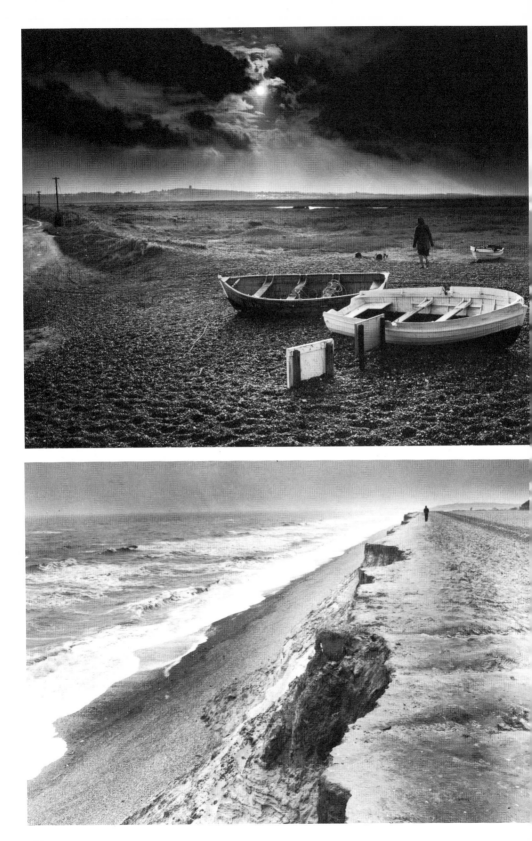

Opposite above:
Cley-next-the-sea. A
pale yellow to deep
orange filter was used
when shooting into the
sun, in order to retain
foreground detail
without overexposing
the sky.
Pentax 6×7cm,
wide-angle lens, Tri X,
¹⁄₆₀ at f11, graduated
filter.

Opposite below:
Covehithe. To
emphasize the nature of
coastal erosion, a
wide-angle lens was
used from a fairly low
position.
Pentax 6×7cm,
wide-angle lens, Tri X,
¹⁄₆₀ at f16.

Above right: St
Michael's Mount.
Another example of the
use of a wide-angle lens
from a very low
viewpoint.
Pentax 6×7cm,
wide-angle lens, Tri X,
¹⁄₃₀ at f22.

Right: Freshwater Bay
cliffs. When texture is
important in a picture,
it is essential to use a
very small aperture.
Nikkormat FT,
wide-angle lens, Plus X,
¹⁄₃₀ at f22, graduated
orange filter.

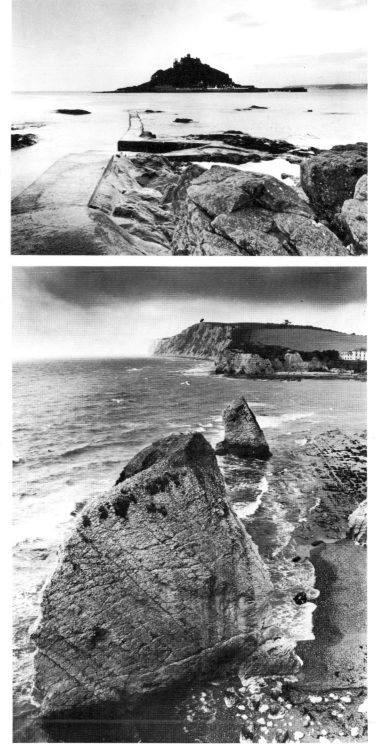

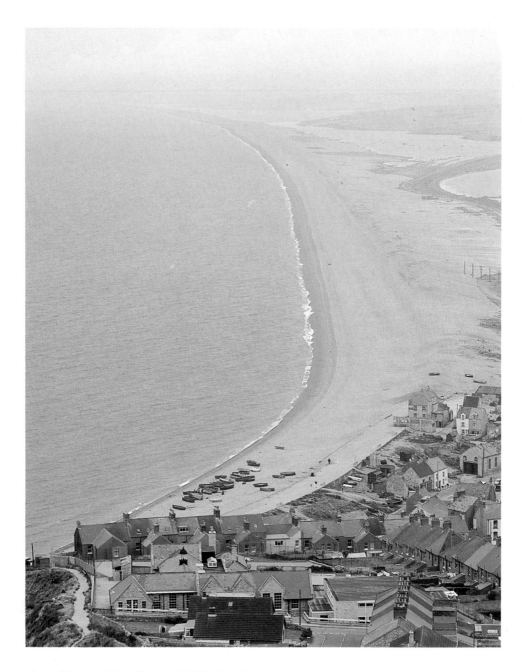

Above: West Bay, Isle of Portland. Diffused early morning light is very soft, and casts no shadows. It usually contains some bluish tones, producing the pale mauve tint seen in this picture.
Pentax 6×7cm, medium wide-angle lens, Ektachrome 64, 1/30 at f16.

Opposite above: Hunstanton Beach. Note the dynamic composition; the expanse of dunes

balances the blue huts near the picture's edge.
Pentax 6×7cm, wide-angle lens, Ektachrome 200, 1/15 at f22.

Opposite below: Alum Bay and the Needles. This picture was taken from the chairlift which runs from the beach to the top of the cliff.
Mamyiaflex C3, wide-angle lens, high-speed Ektachrome, 1/125 at f8.

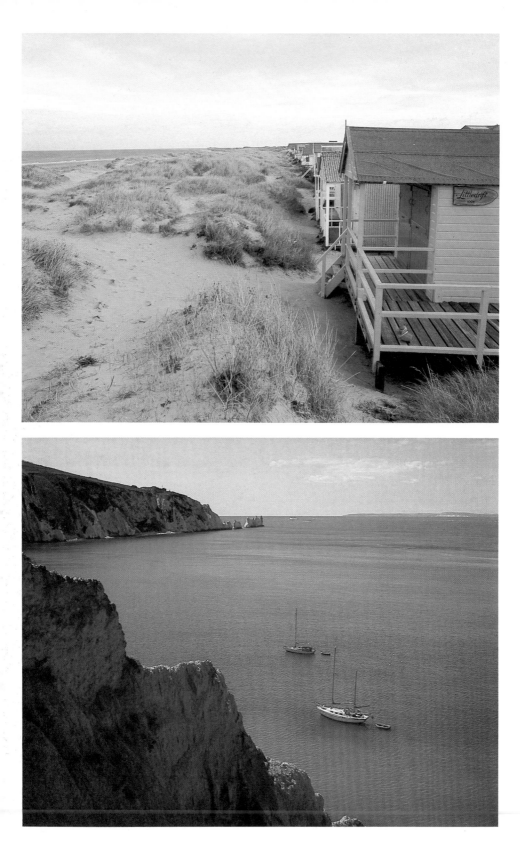

97

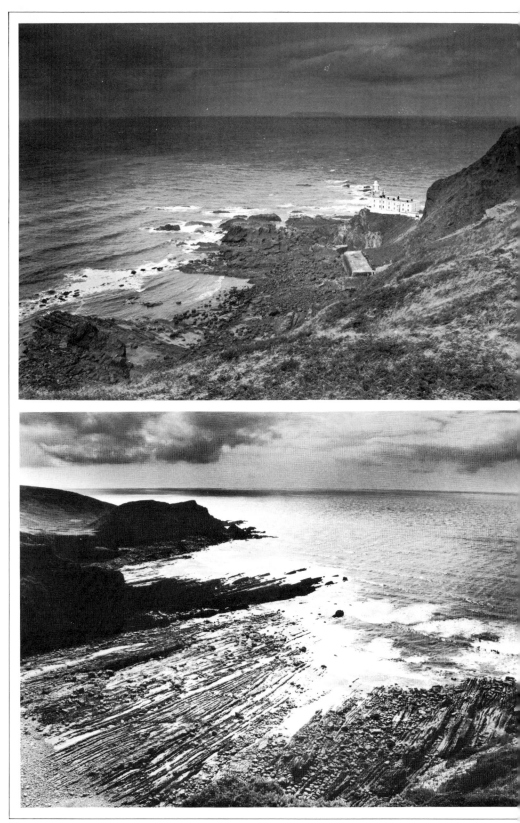

Hartland Point

I have selected Hartland Point in Devon for a number of reasons. In the first place, it is a particularly rugged piece of coastline. Secondly, the sheer, black rocks which jut into the sea are topped by rather gentle, cultivated fields. Thus in the late summer, in a light breeze, the white waves of the sea below find an echo in the rippling corn along the cliff-top. Furthermore, Hartland Point is not a seaside resort, and it is thus never overcrowded. At the same time, it is accessible by a very good road from Clovelly – an attractive and unusual seaside village some four miles away. There is a car park from which you can venture on a breathtaking walk for half a mile or so along a cliff-top path.

Choose the late afternoon and take a tripod with you. It will come in handy when the light begins to lose its intensity, but when it is still important to retain sufficient depth of focus on both the rocks and the sea. As you walk along the cliffs, the scenery below changes rapidly. Leave the path from time to time and approach the cliff face. Each approach will offer a different picture.

Although a wide-angle lens is always useful in seascape photography, at Hartland Point take a longer lens as well. The more distant cliffs extending into the sea look splendid when isolated by a long lens, especially with a very low, setting sun. With a low sun, it is better to underexpose a little (take a reading from the rocks and stop down by one or two stops), especially if you are using colour. It is important to retain some detail and tone in the brightly-lit water, otherwise it becomes a glaring pool of light. At sunset, try to position yourself above a distinctive rock formation which projects into the sea – there are several there. Use a wide-angle lens. The promontory will provide an interesting foreground for the sun's disc.

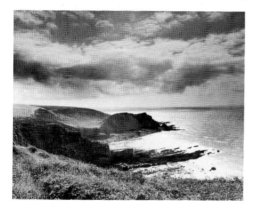

The late afternoon sun makes the black rocks stand out in sharp relief, and even the grass acquires a strong texture. It is essential to use a lens hood, otherwise a flare may appear in the cloud portion of the picture. A white to light orange graduated filter was used to darken the sky.

Left: The same view, but this time with a slightly longer lens in order to isolate the fan-like formation of ridged rocks. Here, too, the accent is on the sea and the rocks, rather than on the sky. Both Nikon FE, 55mm Micro Nikkor f3.5 lens, FP4, 1/125 at f11. Above, graduated filter; left, yellow filter.

Left, above: The lighthouse just before sunset. A strong graduated filter keeps the sky and sea quite dark, so that only the lighthouse itself and the foamy line of waves is strongly delineated. The foreground was further darkened in printing. The lighthouse can be visited every weekday in the afternoon. A tour of inspection is provided. Nikon FE, 28mm Nikkor H f3.5 lens, 1/60 at f11, deep orange graduated filter.

Hartland Quay in the late afternoon. Seen from a high viewpoint, people, rocks and even the pebbles on the beach stand out in strong relief. With a high-contrast scene of this kind, strong on overall pattern, it is important to include a dominant design feature – in this case an S-curved formation of rocks. With this as a focal point, the rest of the image can be composed by selecting a few distinct groups of people. Nikon FE, 80–200mm Nikkor zoom f4.5 lens, FP4, 1/250 at f11.

PASTORAL LANDSCAPE

The word 'pastoral' evokes perhaps the most 'English' kind of landscape. It brings to mind idyllic images of fields and meadows, green in the spring, golden in the summer, and black, brown or red in the autumn. Only in late autumn and winter do the harsh realities of nature give the lie to this essentially urban and romantic view of rural life. 'Pastoral' has been defined as having the simplicity or natural charm associated with the countryside. The photographic approach to pastoral landscapes should reflect this definition. The images should be simple – overloading with detail and fussiness never works – but they should also have the serenity and charm of country life. Mountains have drama; water, glitter and brilliance; and downs and hills, flamboyance. But pastoral landscapes express a particular idyll – contemplative solitude, a steadfastness born of the regularity of the seasons, the gentleness of a benevolent nature.

A photographer of pastoral landscape today, however, works under a considerable handicap in comparison to, say, Doctor Henry Emerson. This great nineteenth-century precursor of pastoral photography portrayed Norfolk in the 1870s. The mechanization of agriculture has destroyed much of the charm of the countryside. In the first place, tractors are not especially photogenic compared with a plough and team of horses; neither are harvesters, nor other modern implements. Modern farm build-

Lenham village. An archetypal pastoral scene.
Pentax 6×7cm, wide-angle lens, Agfachrome 50S, 1/60 at f11.

Left: The Quantock Hills from the roof of Aisholt church.
Pentax 6×7cm, medium wide-angle lens, Tri X, 1/60 at f16.

ings cannot compete with the old thatched out-houses. And yet, the charm of the countryside remains. The fields are the same, even if the method of stacking hay is different. It is, however, more difficult to achieve romantic authenticity. In fact, this effect is seldom really genuine, for in order to achieve it, you have to cheat a little – mainly by avoiding some of the more ungainly intrusions of modern civilization, or perhaps by modifying them.

Photography relies on selection. In pastoral photography, however, the selection and fram-

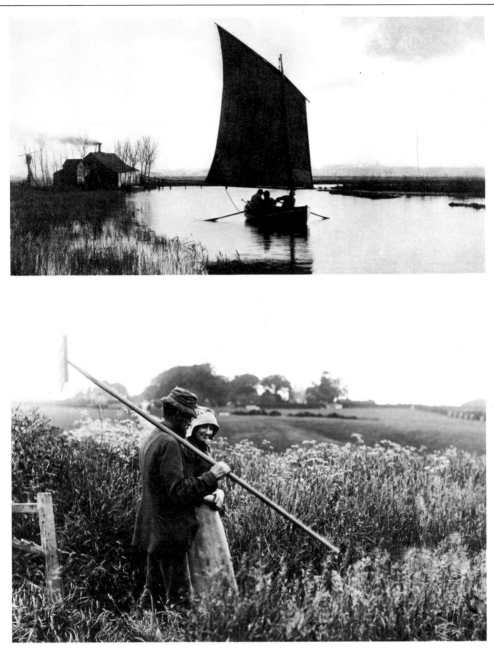

The timeless quality of rural life formed the theme of Frank Meadow Sutcliffe (1853–1941) and Peter Henry Emerson (1856–1936). Both photographers chose homely, familiar subjects and created simple effective compositions. Sutcliffe strove to capture the impromptu in his depiction of life in Whitby, Yorkshire. Emerson was more painterly in his treatment of the life and landscape of the Norfolk Broads.

Although neither man wished to recreate Arcadia, both were Victorian intellectuals who regarded the country as a repository of virtue. This view coloured their attempts to show the realities of daily life around them. Thus even the pictures of toil and deprivation speak of the dignity of labour of the rural poor.

It was easier for Sutcliffe and Emerson to achieve romantic authenticity than it is for us. The mechanization of agriculture was only beginning, and much of the 'antique' charm their pictures hold for us would not have existed for them.

Top: 'The Old Order and the New', Peter Henry Emerson, 1886.
Above: At Lealholm, near Whitby, Frank Meadow Sutcliffe, c.1880.

Right: Near Sawrey, Cumbria. A pastoral scene in Beatrix Potter countryside; a peaceful setting for animals both real and imaginary. Nikkormat FT, standard lens, Plus X, 1/60 at f8.

Below right: Dove Cottage, Grasmere. The brilliant backlighting of the cottage and its garden creates a halo effect, giving the picture a suitably romantic aura. Nikkormat FT2, medium wide-angle lens, Plus X, 1/60 at f8.

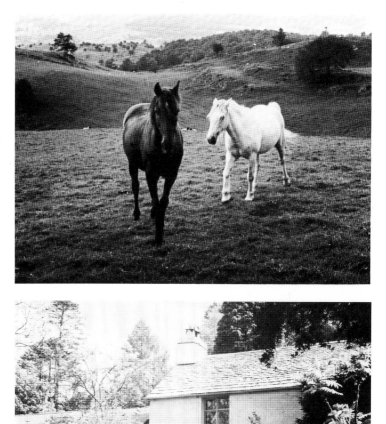

ing of the image from the greater reality in front of the lens has to be even more careful. The enemies of the idealized pastoral image are the television aerial and the electricity pylon, and many a beautiful shot is spoilt by one or the other. Sometimes you can be enchanted with the overall view and overlook these signposts of the twentieth century, only to discover them with dismay later in the print.

Although the colours of the earth or the nature of the crops may vary, pastoral landscapes in the different regions of Britain are not radically dissimilar. Admittedly, the kinds of field boundaries differ, but the ploughed field or the field heavy with corn is the same in Scotland as on the Berkshire Downs. The symbols of pastoral life are also similar: horses, cows, sheep, haystacks, smoke from cottage chimneys, nests of rooks, burning stubble in the fields, or the fields themselves punctuated by trees beneath billowing clouds. These are the abiding features of the pastoral landscape which can be found in Wales as readily as in the Lincolnshire Wolds.

On the Farm 1

A farm in Dorset set in an almost abstract pattern of dark green hedges. Taken from the vantage point of the adjacent hill with a long (300mm) lens.

Rural Hampshire. Taken against the light and the brilliance of the water, this photograph shows a very high contrast. A polarizing filter helped to intensify the greens and a slight underexposure accentuated the saturation of the dark tones. 28mm lens.

Opposite: Little Langdale, Cumbria. Taken in a late afternoon in July, this picture owes all to the light. The low rays of the sun bring out a three-dimensional quality in what is basically a one-colour picture, even to the extent of enhancing the various shades of green. $\frac{1}{60}$ at f5.6, tripod.

Landscape photographers tend to look for the majestic or dramatic – for spectacular views of distant mountains or classical vistas of avenues of trees – but humble subjects, too, can be very photogenic. While it is true that modern farms with their corrugated iron barns, efficient machinery and shiny cars are hardly romantic, nevertheless farms and farming activities are part of the rural environment. The photographic problems associated with farms are the same everywhere. Photographed with care – with due regard for composition and lighting – they can be very picturesque. The choice of viewpoint is particularly important. The picture should be given an interesting pattern of shapes and tones which, in a way, overrides the ordinariness of the subject matter.

Haymaking in the Isle of Wight. Monochrome pictures are far more dependent than colour on overall graphic design. A carefully selected viewpoint made the most of the arrangement of the haystacks, while the shutter was released at the moment the man on the cart, stacking the bales, was in the best position, outlined against the sky. Nikkormat FT2, wide-angle lens, FP4, 1/60 at f16.

On the Farm 2

The farmyard at Woodseats Hall, Barlow, Derbyshire. To achieve depth of field, the lens was stopped down.
Nikon, 35mm wide-angle lens, Panatomic X, 1/8 at f11, tripod.

Top right: Waiting for food on a Cornish farm. Cows are most accommodating models. Their colouring often helps to add a touch of contrast, as well as to balance the composition. In this case the picture is 'made' by one cow seemingly more extrovert than the rest.
Nikkormat FT2, wide-angle lens, Tri X, 1/60 at f16

Above: Ploughed field in Suffolk. The heavy loam of a freshly ploughed field in Suffolk shows the strong contrast created by *contre-jour* lighting. A slight mist and a very low viewpoint also helped to increase the feeling of three-dimensional space.
Pentax 6×7cm, wide-angle lens, FP4, 1/30 at f22, tripod.

VILLAGES

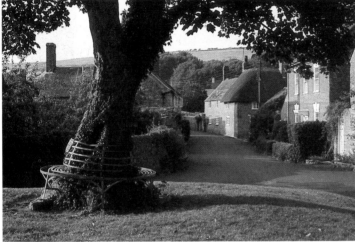

**Burton Bradstock, on the coast of Dorset.
Taken in the warm afternoon sun in August.
Pentax, wide-angle lens.**

**Top: Montacute in Somerset. A typical village
scene, taken from the grounds of Montacute House.
Pentax, standard lens, Ektachrome 64.**

Lacock, often called a
show village, is owned
by the National Trust
and is completely
unspoiled.
Pentax 6×7cm, standard lens, Ektachrome 200,
1/60 at f11.

A real village can be compared to an individual.
Like a portrait photographer, you should aim
to interpret and externalize the distinctive fea-
tures of its personality.

Many villages have been partly turned into a
weekend refuge for the urban rich, becoming
prettyfied and tamed in the process. So in search
of the real thing, you would be well-advised to
stay away from 'picturesque' villages near big
towns. It is in the hills, the mountains and the
moors that you will find unspoilt, beautifully

situated villages and high vantage points from
which to photograph them.

The grandeur of mountains or lakes can be
shown in a single image. A village, however, is
made up of a multiplicity of images, and is best
represented by a collage of pictures, starting
with a long view and moving in, until a single
window or an individual face comes into focus.

Generally speaking, buildings are far better
photographed in strong, angled light; frontal,
flat lighting is invariably disappointing. A vil-

lage is, in the first place, a group of buildings extending in depth. Thus a suggestion of three-dimensional space in your picture is essential. Low – evening or morning – light emphasizes space, as do strong foreground elements. All three photographs on these pages use foreground quite effectively. Not only do they increase the illusion of space, but they also create a frame. Framing or 'closure' emphasizes the smallness and compactness of a subject and also suggests intimacy.

The characteristic regional 'colour' of a village is determined by the kind of building materials used, such as ham stone in Somerset, timber in Wiltshire, or the blue/grey Purbeck and Portland stone of Dorset.

In an interesting village, you need time to record such details as public house signs and interiors, chimneys, the gardens, windows and architectural features of cottages, or the carvings or stained-glass windows of the church. Parish churches offer a wealth of interpretive possibilities. Many village communities are a microcosm of the county as a whole. Ideally, in order to create a composite picture of village life, you should spend a week or two there.

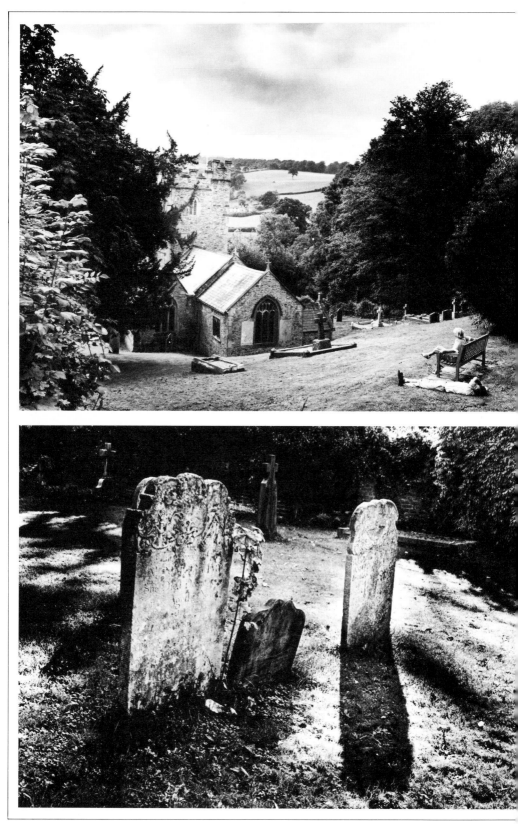

The Village 1/Landmarks

Two institutions dominate village life – the church and the public house. A village without either, worse still without both, is a village without a focal point. But while village churches are, on the whole, exceptionally well-preserved and mostly retain their original architectural features, a genuine, traditional village pub is more difficult to find. Many have been redecorated in a pseudo-antique style which often is far from the real thing. An honest village pub is a treat, with its beautifully worn and functional interior, a log fire burning in the grate and, often, locally brewed beer. You could also do worse than to collect photographs of pub signs – many of these are original and distinctive.

With village churches, it is difficult to go wrong. For me, there is no image more satisfying than a village churchyard with its church nestling among the tombs and trees. The tombstones alone are worth a detailed study; the patina formed by weathering, the texture of mosses and the old lettering are fascinating material for a photographer.

Spend an hour or two in the cool interior of the village church. Use a tripod. Choose a time after the service when you have the church to yourself, so that, undisturbed, you can discover the pew carvings, the play of light on the stone floors, the marble heads of entombed local dignitaries, and the candlesticks. Remember that with a tripod you are able to stop down for brilliant sharpness and expose for as long as you have to. But bear in mind that with exposures of more than one second, the colour may be affected by reciprocity failure.

Opposite above: Aisholt Church in the Quantocks, much loved by Wordsworth. The church is beautifully situated, and the view from the tower is also worth the effort. Pentax 6×7cm, wide-angle lens, Plus X, 1/60 at f16.

Opposite below: Stoke Poges, Buckinghamshire. An atmospheric churchyard, with the low sun dappling the gravestones. Mamyiaflex C3, standard lens, Tri X, 1/60 at f16.

Above right: The Black Bull, Etal, Northumberland. A typically old-fashioned thatched pub with an attractive sign. The foreground flowers help to set off the house.

Right: The White Hart. There are a number of books about village pub signs. You can even specialize in specific subjects, like flowers or, more popularly, animals. Nikkormat FT2, 80–200m Nikkor zoom lens, Kodachrome 64, 1/125 at f8.

The Village 2/Cottages

Having observed the village from a distance and looked at it from different angles and viewpoints, you should try to gain a more intimate acquaintance. And what could be more intimate than the village's dwellings? On the whole, the tempo of village life is slower than that of a town. A more serene approach to life is clearly reflected in the care lavished on their cottages and the great attention paid to detail. Many cottages are quite beautiful, and in the summer cottage gardens are filled with flowers. But even more fascinating are the building details: the texture of stone, the colour of timber, and the innumerable small architectural features – gables, cornices, fences, decorations and embellishments. Cottage windows, with their curtains, flowers and little figurines, frequently draw the eye. There is an astonishing variety of these. A study of them can make a fascinating collection.

Top: Lavenham, Suffolk. Groups of cottages combine in interesting and varied shapes. The figure animates the composition.
Nikon, standard lens, Plus X, ½₅₀ at f5.6.

Above: Thaxted, Essex. Pargeting (left) is a traditional form of plasterwork in East Anglia. The intricately carved doorway, the cobbled street and the half-timbered frame (right) make their own, textured pattern.

Pentax, standard lens (left), 28mm wide-angle lens (right), Plus X, ½₅₀ at f5.6.

Opposite: Cottage garden in Easton, Hants. Changing light affects colour values. This photograph, taken at dusk, shows a saturation in the blues and purples of the flowers which seem to glow in the evening light. At midday, greens and reds are accentuated.
Wide-angle lens, Kodachrome 25, 1 at f16, tripod.

The Village 3/Country Life

It is a sad fact that village craft activities – such as haymaking, shoeing, thatching, harnessmaking, and beekeeping – are slowly disappearing. Thus, apart from their pictorial interest, these are subjects well worth recording. We owe much to Emerson for his record of Norfolk reed-harvesting, and to Sutcliffe for his pictures of Whitby fishermen. A well-shot pictorial essay on any of the village craft activities may be of value in the future.

Blacksmith, Sydling St Nicholas, Dorset. Nikon FE, 24mm wide-angle lens, FP4, ¹/₁₂₅ at f11, direct flash.

Thatcher, Wylye Valley, Hampshire.
Nikon, 200mm telephoto lens, ¹/₁₂₅ at f5.6.

Haymaking, Little Langdale, Cumbria.
Nikon, 200mm telephoto lens, ¹/₁₂₅ at f5.6.

Hunting scene, Mappowder, Dorset. The eye follows the road towards the group of huntsmen. Nikon, 300mm telephoto lens, hand-held, 1/250 at f4.5.

Maypole scene, Sydling St Nicholas, Dorset. A very wide-angle lens was used to frame all the dancers. The sky was printed in. Nikon, 20mm wide-angle lens, 1/125 at f11.

CATHEDRALS, ABBEYS AND CASTLES

Canterbury Cathedral. The choristers add a human touch to an architectural study.
Nikkormat FT2, wide-angle lens, Plus X, ¹/₁₂₅ at f8.

Opposite: Dryburgh Abbey. A very slow exposure registered the shimmer of the leaves.
De Vere 10×8in, standard lens, Agfachrome 50S, 1 at f45.

The traveller crossing Britain is time and again struck by the way that the countryside is dominated by its churches, cathedrals, castles and, to a lesser extent, abbeys. Even if they no longer fulfil their original functions, these historic buildings retain their strong symbolic associations. Some castles such as Warwick, until recently, or Sizergh in the Lakes have been continuously inhabited. Most today are either ruins or monuments. The cathedral is often the focal point of an entire region. Iona's cathedral is visible from every part of the island and even from out at sea. Constable painted the pointed spire of Salisbury Cathedral (the highest in England) from almost every point of the compass; and Ely Cathedral could be seen for miles from every direction before the fens were drained.

Cathedral interiors are full of photographic interest. They are particularly rich in light effects. The medieval craftsmen-builders, especially after the advent of the Gothic style, designed their churches so that the faithful, on entering, would be overawed by the quality of light. The play of light on carvings, decorative details, and columns, offers the photographer great scope for interpretation.

Strangely enough, cathedrals are among the most neglected subjects of location photogra-phy. Because the light, although beautiful, is never strong enough for a hand-held snapshot, and possibly because he finds the proportions of the interior daunting, the average amateur usually confines himself to a few shots outside, sometimes with the family posing in front. And yet, it is relatively easy to photograph a cathedral with good results – you could almost say easier than producing an interesting landscape. All you need is a tripod, a wide-angle lens and an exposure meter – either hand-held or built-in in the camera. Most serious amateurs possess all three. You do not need special equipment for serious architectural photography. All the pictures on this and the following pages were taken with ordinary good-quality cameras – many with a 35mm single lens reflex – and in none of them was any additional lighting used.

The way in which vertical lines in a picture

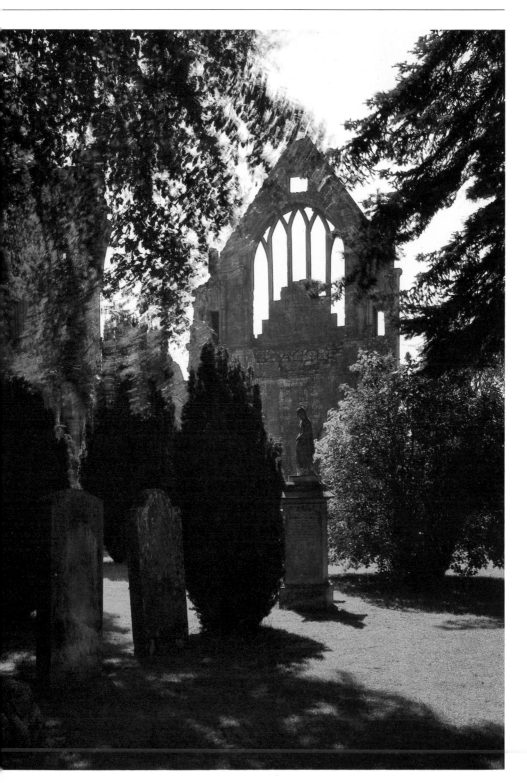

converge, caused by the need to tilt the camera upwards, is sometimes considered a drawback. Not so. In the first place, when you look upwards verticals do seem to converge, so why object when they do the same in a photograph? If anything, this adds to the feeling of height and space, which is precisely what cathedral architecture is about. But if you wish, converging verticals can be straightened out in monochrome photographs during printing, as the diagram on the right shows.

Similarly, the strength of light is not a serious obstacle. There is no reason why, if you use a tripod, you should not expose your film for as long as is necessary – for a minute or even ten minutes. This will allow you to stop your camera down and achieve a great depth of focus. Any modern meter will tell you how long to expose for, but you must remember to allow for reciprocity failure and increase your exposure accordingly.

Castle Howard. The greyest day can still produce a dramatic shot. Pentax 6×7cm, wide-angle lens, Plus X, 1/30 at f16.

Below: Shooting upwards with a wide-angle lens can cause distortion. To correct this, tilt the base board when printing. Stop the lens down to the maximum to keep the image sharp.

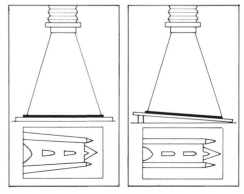

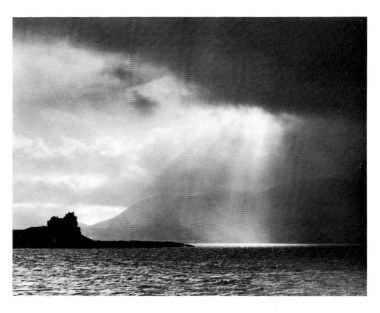

Above right: Duart Castle, impregnable and aloof, on a rocky promontory. Nikkormat FT2, 80–200mm zoom lens, Plus X, ¹/₁₂₅ at f8, orange graduated filter.

Right: Holy Island Castle. A low viewpoint can emphasize the height and isolation of a castle. Pentax 6×7cm, medium wide-angle lens, Plus X, ¹/₆₀ at f16.

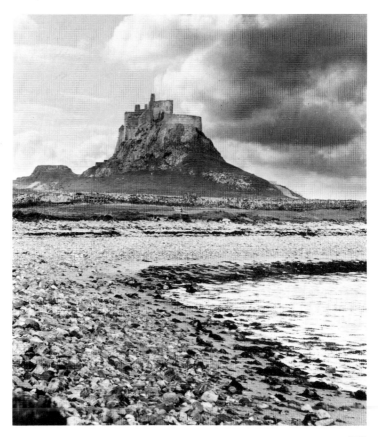

119

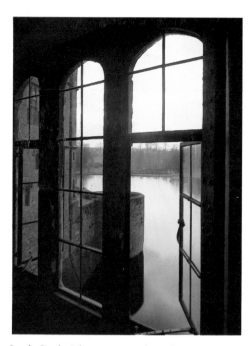

Leeds Castle. The moat seen through a window. This was taken in early March at about 6 p.m. The sun on the horizon emphasizes the fact that the castle is surrounded by water. A long exposure, of 5 seconds at f16, was used to bring everything into focus.

Right: Leeds Castle, taken in bright, early afternoon light. The tree and flowers give shape to the composition. A long lens was used, with the stop far down. The camera was tilted in order to bring the daffodils into focus. The danger with tilting the camera is that you can make buildings appear to lean inwards.

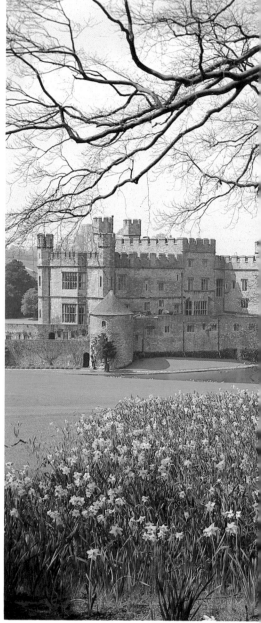

As for access, by and large, no special permits are needed. You usually have to pay a very small fee for permission to use a tripod (it is about £1 in Wells Cathedral, and only 50p in Ely), and in some cathedrals you may be asked to contribute something to the upkeep or the restoration fund.

Wide-angle lenses will enable you to include a sizeable portion of the architecture. Shorter lenses can be used, though, for details of carvings or interior decoration. Similarly, parts of the vaulting or paintings on the ceilings can be photographed to advantage with long lenses and relatively long exposures. So do not despair if you have no wide-angle lens in your bag.

When photographing interiors you are no longer at the mercy of the weather. However,

shafts of strong sunlight filtering through the windows and doors of a cathedral are notoriously difficult to photograph because of the excessive contrast of light and shade which no film is able to accommodate. Diffused light, even when it rains outside, is very suitable.

While cathedral interiors can be very exciting, the true landscape photographer feels more at home in the open air. Ruined castles and abbeys offer the best of both worlds – the formalism of architecture against the backdrop of nature. There are few sights more romantic

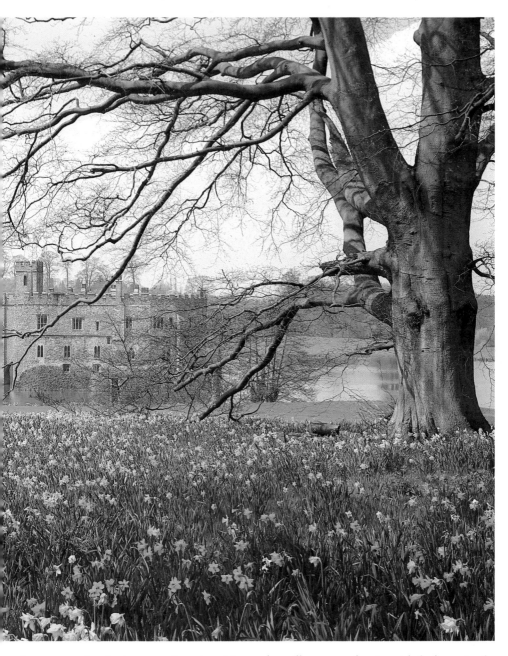

than a proud ruin in a rural setting. Most abbeys are usually tucked away in a valley, next to a river. Britain's medieval and Renaissance strongholds, however, dominate their environment. Indeed, the network of castles built by the Normans was primarily designed to overawe the populace. These assertions in stone can make dramatic images, strategically set as they are on an eminence or a rocky promontory. Landscape photography is at its best when it confronts the viewer with a contrast. This can be found in the reflection of a majestic outline in the still waters of a Scottish loch, or in the emergence of a mighty keep from a gentle English meadow.

Britain has many beautifully situated ancient ruined abbeys – Rievaulx, Tintern, Fountains, Byland and Bolton, among others. Almost all are interesting photographically and can be explored without hindrance. This exploration with a camera brings you into close contact with the buildings. It can become an intimate encounter, an almost tactile discovery of the past.

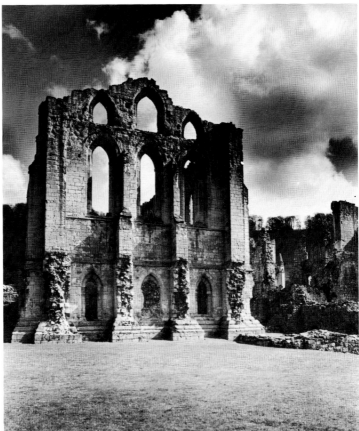

Prior's Door, Ely Cathedral.
Opposite above: Interior of Wells Cathedral.
Opposite below: Vaulting of the Lady Chapel, Wells Cathedral.
Unlike the exteriors of buildings, interiors can be photographed at any time – with the camera on a tripod the length of exposure is immaterial. Careful selection of architectural details can produce effective results.

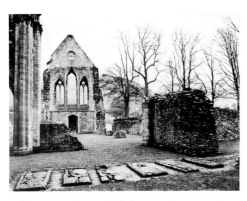

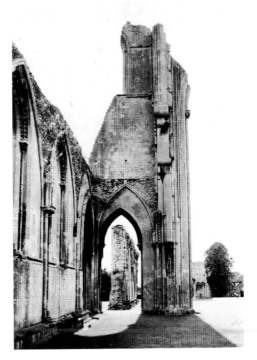

Valle Crucis Abbey. A little-known Cistercian abbey, near Llangollen.
Pentax 6×7cm, wide-angle lens, Tri X, 1/30 at f22.

Above right: Choir ruins, Rievaulx Abbey.
Pentax 6×7cm, medium wide-angle lens, Tri X 1/250 at f22, yellow filter.

Right: Glastonbury Abbey. Details of ruins can often give a sculptural effect.
Pentax 6×7cm, wide-angle lens, Tri X, 1/60 at f22.

Bolton Abbey

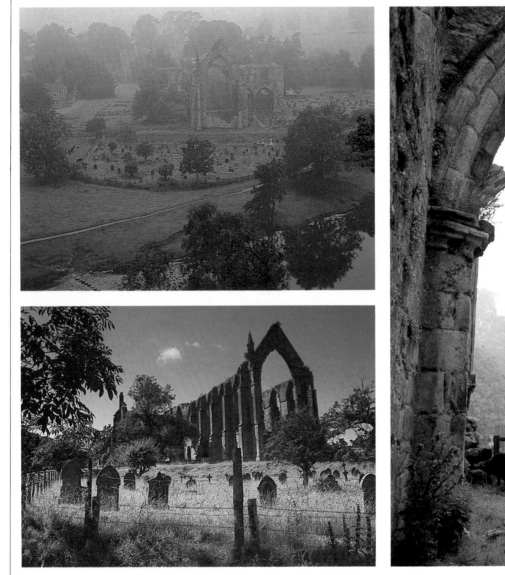

Contrasting lighting conditions. The picture on the top was taken in an early morning mist, giving a soft overall light with the shadows well lit; the slight bluish tone of the distant trees creates a feeling of depth. The picture above was shot in the late afternoon, with a stronger contrast of light and shade and thus a more three-dimensional appearance. The view above right was taken from inside the Abbey in the early morning. The viewpoint and lighting help establish an air of mystery.

Top: Pentax 6×7cm, 75mm Takumar medium wide-angle f3.5 lens, Ektachrome 200 ASA, $\frac{1}{60}$ at f11.
Above: Pentax 6×7cm, 55mm Takumar wide-angle f3.5 lens, Agfachrome 50S, $\frac{1}{125}$ at f11.
Above right: Pentax 6×7cm, 55mm Takumar wide-angle lens, Ektachrome 200, $\frac{1}{30}$ at f11.

Bolton Abbey lies in the heart of the Yorkshire Dales. The River Wharfe sweeps past it in a graceful curve. The Abbey can be seen from many elevated points, especially from the main road to its north and from a high hill overlook-ing the river (with its famous stepping stones). Cross the road from the car park, open a little gate in the wall which skirts the main road and there you see it — presiding over the valley.

When I arrived, in the late afternoon, the

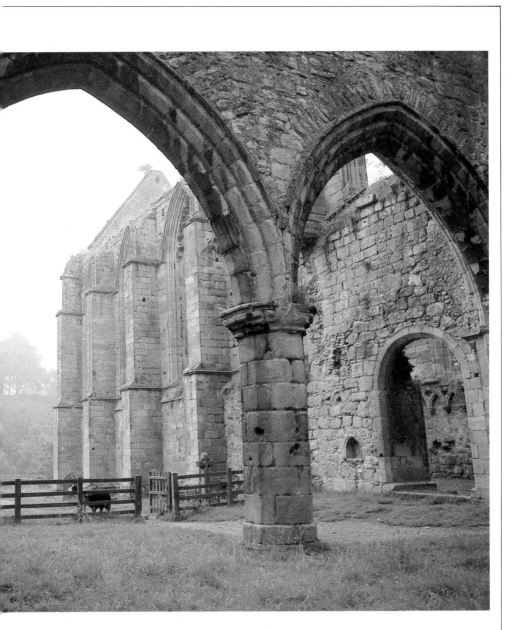

clear light had caused deep shadows to form inside the ruined part of the Abbey. (The restored nave serves as a parish church.) The strong texture of the walls was thrown into relief. It was a Sunday afternoon and in the valley below picnicking families had laid out their baskets on the grass and children were paddling in the shallows. It was a charming sight, but if you want to photograph the Abbey in its natural setting alone, the weekend is a time to avoid. So I returned in the morning.

A light mist was hugging the ground and, from a distance, the Abbey had acquired an air of mystery which contrasted completely with the mood of the day before. The delicate tones of a very early morning mist are especially beautiful in colour – Kodak Ektachrome 200 ASA is particularly good in soft lighting conditions. The diffused light cast hardly any shadows and yet enhanced the three-dimensional quality of the structure. This was strengthened by the bluish tinge of the distant hills, seen through the opening in the arches. Make sure that you climb the steep hill opposite – the view of the Abbey and the river is certainly worth the effort.

Ely Cathedral 1

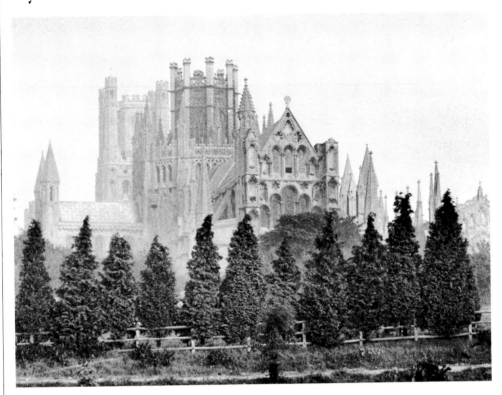

As with Bolton Abbey, two separate photographic sessions are strongly recommended. In order to be able to appreciate a great building, you should always try to see it lit by both an evening and a morning light. Each time, new facets and new points of interest are revealed.

Ely Cathedral boasts two outstanding features – the tower and the octagonal lantern, one of the finest engineering feats of the Middle Ages. The first is best seen lit by an evening and the second by a morning sun. I chose to shoot the outside of the Cathedral, as well as its surroundings, from several viewpoints in the late afternoon. I returned the following day for the second session just before it opened, a little before 7 a.m. In this way, I had enough time to photograph the Cathedral from the front, looming out of the early morning haze, with the diffused sunlight directly behind it and the cannon in front seen in sharp relief. After that, I spent the rest of the morning shooting the interior.

Early morning is the best time to photograph a cathedral – the visitors are still at their breakfast tables and you have the place to yourself. Start with the general views of the interior, the nave and the main chapels, while the cathedral

Ely Cathedral seen from the east, early in the morning, with a light haze. The light is very flat and the slight three-dimensional effect is created by the line of trees in the foreground.
Nikkormat FT2, 28mm Nikkor H f3.5 lens, FP4, ⅟₆₀ at f8.

The Cathedral as seen from the west, taken in the early morning light. Now, due to backlighting, it stands out in sharp relief, accentuated by the inclusion of the cannon in the immediate foreground.
Pentax 6×7cm, 55mm Takumar f3.5 lens, Ektachrome 200 ASA, ⅟₆₀ at f11.

is still empty, and then, when the first visitors begin to arrive, your camera is already looking up or picking out details. It is advisable to see the verger before you start working, for in all probability there will be an early service in one of the chapels, and he will tell you which to avoid. I find that it takes at least two or three hours to photograph between ten to fifteen parts of a cathedral, especially when using two cameras (one for colour and one for monochrome) and with exposures ranging from about 30 seconds to several minutes.

After the main shots, turn your attention to the ceiling. The interior of Alan de Walsingham's octagon in Ely is magnificent, with its

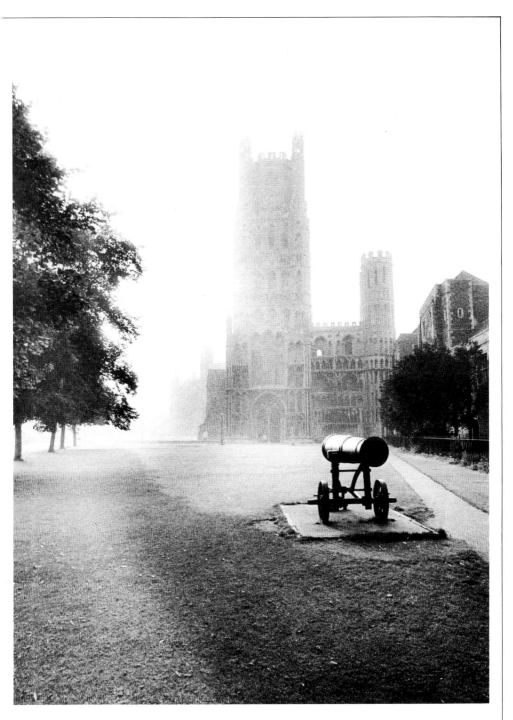

graduated tones and the gigantic wooden lantern in the centre radiating light. When you come to photographing details, the choice is endless. I can never resist the effigies on the tombs with their serene expressions. The choir stalls in Ely, carved by Belgian craftsmen, are of particular interest. The stained-glass windows can be photographed by their transmitted light alone, with the interior entirely dark. If you prefer, however, you can show the detail of the surrounding areas by flashing-in during the exposure. You can even add several flashes since the exposure at a very small stop often lasts several seconds.

Ely Cathedral 2

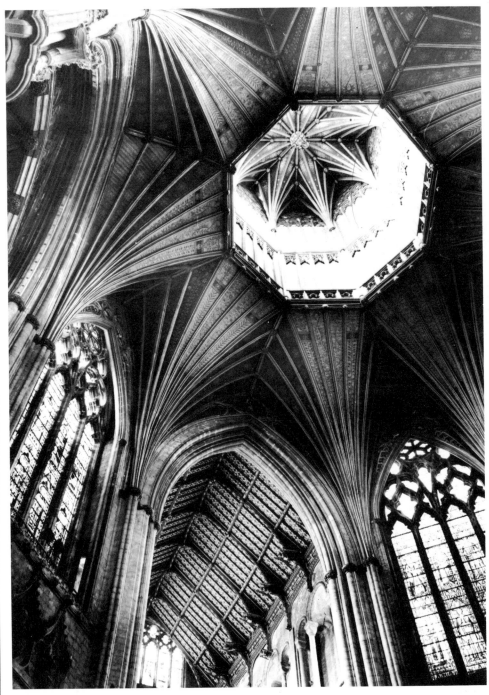

Ely Cathedral octagon with the lantern tower seen from below. Despite the hazy light outside, the illumination is very strong and the contrast fairly high. Note the off-centre placement of the lantern which increases the impact and the impression of height. The lantern was printed-in in the enlarging stage. No attempt was made to straighten the verticals.

Pentax 6×7cm, 55mm Takumar f3.5 lens, Tri X, 30 at f22.

The nave, shot from a very high tripod and with a wide-angle lens. Despite this, it was still necessary to tilt the camera upwards in order to include the whole of the altar and part of the ceiling. The converging verticals in the negative were corrected in the printing stage by tilting the easel of the enlarger.
Nikkormat FT2, 24mm Nikkor f2.8 lens, FP4, 8 at f22.

Above: Detail of a stained-glass window, taken with a long-focus lens (zoom). The reading was taken directly from the light from the window. Nikkormat FT2, 80–200mm Nikkor zoom f4.5 lens, FP4, 4 at f22.

Right: In taking this detail of a funerary monument I used a Micro-Nikkor lens, which allows for a long extension in focusing and is thus ideal for close-up photography. The exposure should be increased by one or two stops – depending on how near you are to the subject – to allow for the longer distance between the lens and the film. Nikkormat FT2, 55mm Micro-Nikkor f3.5 lens, FP4, 30 at f 32.

Kenilworth Castle

In contrast with other subjects which are best photographed in the morning or evening light, some buildings, and especially ruined castles, should be photographed when the sun is higher in the sky. Only then does it penetrate the recesses of the interiors and create strong contrasts of light and shade.

Kenilworth Castle has been called 'the grandest fortress ruin in England'. The dramatic ruins stand on a green slope and can be photographed from many sides. Often, horses graze in the meadows in front of it, providing additional points of interest. In photographing ruined buildings like Kenilworth, light plays a very important part, so if possible choose a sunny day. Strong light accentuates the texture of the crumbling brickwork. Essentially, a ruined building is like a giant, open sculpture and should be photographed as though it were one, with the camera searching for new angles and strong compositions. With the high sun penetrating the interior from above, the patterns of open doorways, of high arches and pillars provide excellent subjects for imaginative framing. A tripod is a great advantage as it is important to stop down as much as possible to retain a sharp focus throughout the whole area of the picture.

Left: The remains of the keep seen in strong, late morning sunlight. The side lighting adds dimension. The low viewpoint lends it strength and also allows the sky to be seen through the windows. Wide-angle lens, 1/60 at f22.

Right: Texture is important in architectural photography. Here the diagonal shadow adds contrast and scale. Taken with an ordinary wide-angle lens, the converging verticals were partially corrected in printing. Medium wide-angle lens, 1/30 at f16.

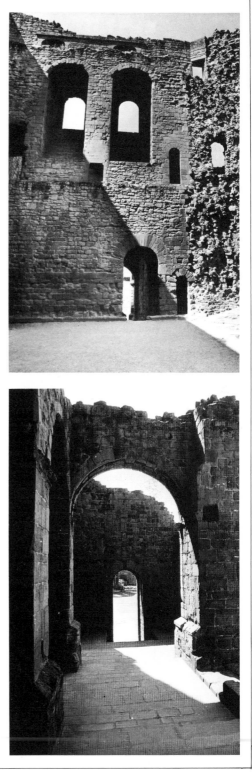

Below right: Entry to the banqueting hall. Taken in the late morning from the steps, looking down slightly in order to avoid excessively converging verticals. The positioning of the main doorway adds to the impact. Wide-angle lens, 1/15 at f22, tripod.

Below: People cannot resist leaving their mark. It seems that this pastime was as popular in the mid-nineteenth century as it is today. A micro-lens was used to facilitate close focusing. FP4, 1/15 at f22, tripod.

PREHISTORIC MONUMENTS

'The ascendancy over man's mind of the ruins of the stupendous past. . . .' The opening sentance of Rose Macaulay's splendid *Pleasure of Ruins* accurately describes the nature of our fascination with what Shelley called 'the pilgrims of eternity'. For, while the ruins of abbeys and castles are often picturesque and romantic, prehistoric monuments are not. Partly because of their connection with religion, and partly because of their little known and mysterious origins, they inspire in us a slight frisson of fear.

As always, you should try to convey in pictures what you experience in reality – in this case, an element of mystery and ambiguity. The great majority of prehistoric monuments consist of large stone slabs, fashioned and decorated, and placed in deliberate arrangements. In photographing them you should avoid excessive realism. Thus flat lighting is not suitable. Work instead in a more dramatic light at a low angle, even leaving parts of the monument in deep shadow. This will emphasize the texture and the abstract qualities of the stones. Low angles and filters, rendering the sky dark (red or orange), also help to achieve a mood of remoteness and power. The play of light, in fact, can be very important; for example, shooting a stone monument with the sun directly behind it creates a luminous halo around its contours. A wide-angle lens, too, would help to create a sense of unreality and strangeness. Naturally, if possible, you should try to avoid any direct reference to the present – such as telegraph poles, signposts or people – as this instantly dispels the mood of mystery.

Opposite: Lanyon Quoit, Near Morvah, Cornwall. Nikkormat FT2, medium wide-angle lens, Plus X, 1/60 at f11.

Stonehenge. An unusual view emphasizes the circular structure.
Panoramic camera, fixed lens, Plus X, 1/30 at f22.

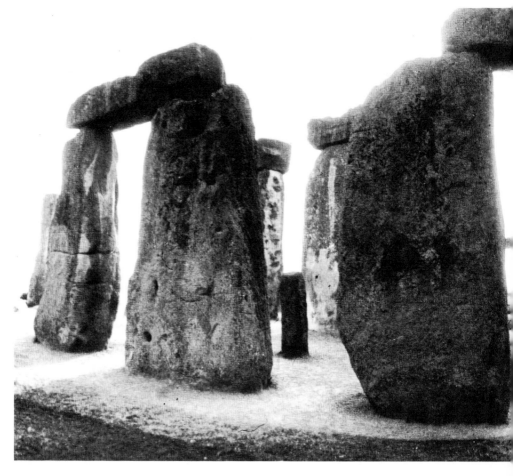

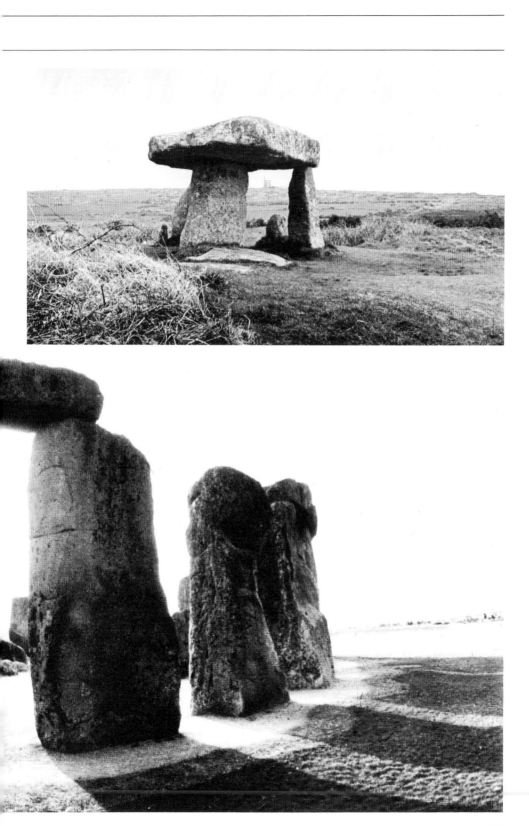

Avebury 1

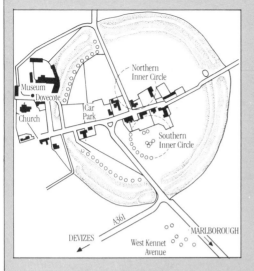

It could be argued that Stonehenge is more impressive at first sight than Avebury. It is certainly more complete; but there is little doubt that, from a photographic point of view, Avebury is far superior. In the first place, you are free to roam about at daybreak or in the evening – there are no wires or guards. Secondly, the slabs at Stonehenge were worked on, while at Avebury the great Sarsen boulders were probably selected for their shapes and left in their natural state. There is thus a greater variety of stones, differently placed and in different settings.

Needless to say, in spite of the fact that Avebury never caught the imagination of the public in quite the same way as Stonehenge, it still gets its share of visitors. Thus early mornings are by far the best time for photography. Park your car in the small car park next to the office. Opposite the car park and immediately to the right, a gate opens into the field containing the stones of the outer circle. The low sunlight should be just beginning to cut across the semicircle of huge stones in front of you. This provides interesting photographic possibilities – the backlit stones can be combined with the line of trees ahead of them, and the white shapes of sheep against the grass Following the stones round, you cross a road and find yourself among the Sarsens of the inner circle. Some of these have extraordinary shapes and are beautifully textured. In the dawn light they seem clearer, more monumental and more sculptural. Do not hurry too much, but select your viewpoints and angles carefully.

Avebury 2

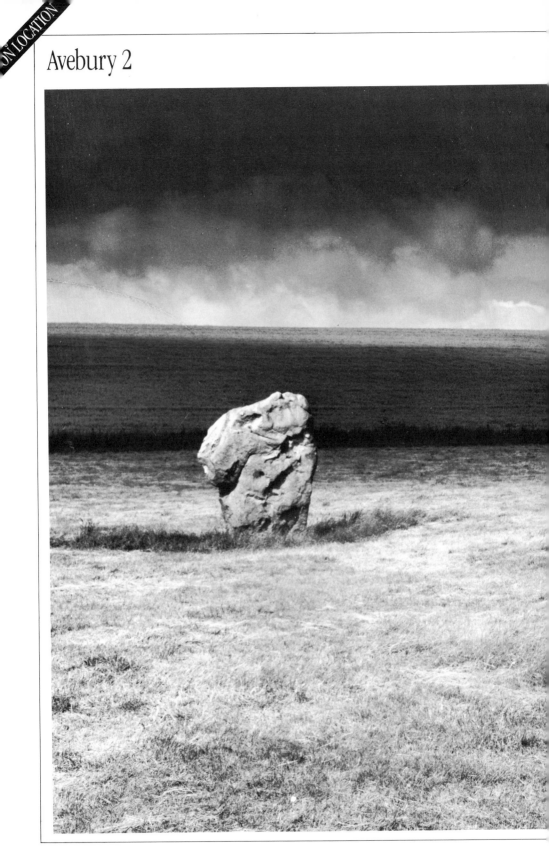

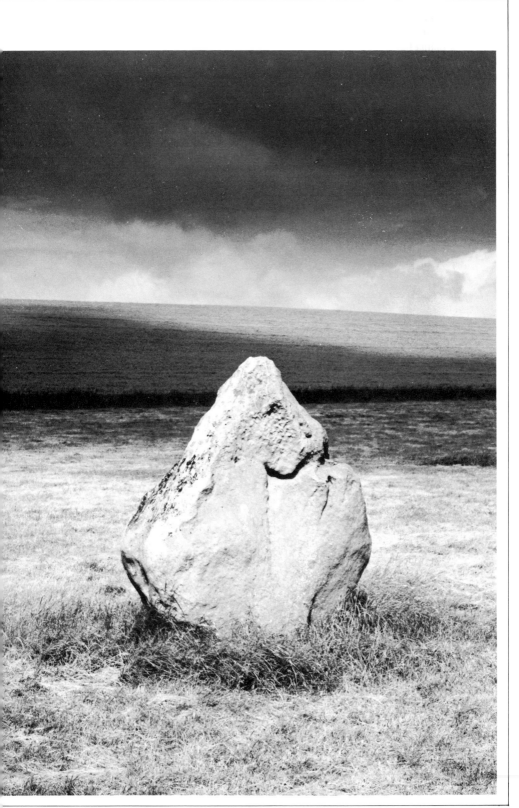

INDUSTRIAL LANDSCAPE

The gradual but inexorable encroachment of industry upon the countryside has changed the face of Britain in many ways and, as we have seen, created some problems for the landscape photographer. Yet, the visual impact of industry is itself not without considerable photographic interest. We are dealing here not with urban landscapes but with industry in the country. A number of photographers find the juxtaposition of modern industrial life with the rural past extremely stimulating. The Industrial Revolution began in Britain, and many a relic of the march of industry has itself become a witness to the past, like the ruins of the once-proud abbeys. Cornish tin mines, abandoned watermills, windmills decaying and forgotten in the fields – the slow erosion and break-up in time of these industrial landmarks is evocative and photogenic. Even the patina of age and the clear signs of erosion on some industrial architecture can be very beautiful.

The effect of graceful bridges, reflected in

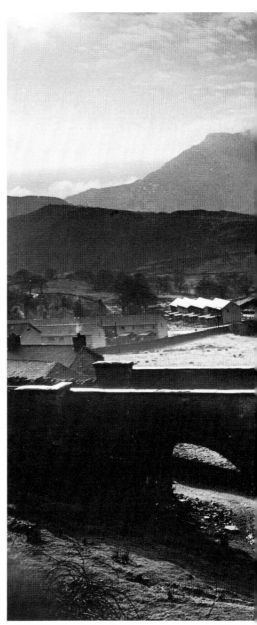

Given a good sky, pylons can become a photographic feature, rather than a nuisance.
Pentax 6×7cm, wide-angle lens, Tri X, ⅟₆₀ at f16, orange filter.

Right: Blaenau Ffestiniog. Shooting almost directly into the sun makes the dark arches of the abandoned viaduct more prominent.
Pentax 6×7cm, wide-angle lens, Tri X, ⅟₆₀ at f16, orange graduated filter.

water or outlined against cloud, or of viaducts cutting across the valleys, or even of a line of pylons merging into the horizon, can sometimes equal the impact of a soaring cathedral spire. Certain tall factory chimneys or cooling towers giving off wisps of smoke or steam are very picturesque. While it still offends the sensibility to see a traditional thatched cottage marred by a jagged television aerial, or the gentle curve of a hill broken by a telegraph pole, some industrial elements have so grown into and merged with the countryside that they no longer offend, but, on the contrary, contribute to the visual harmony.

There is also the element of contrast which can be very photogenic. The interactions of industry with the countryside can be explored visually, not because they are harmonious and

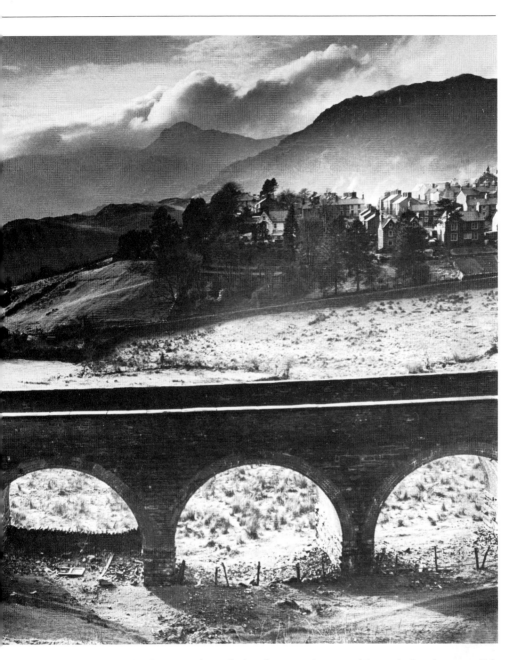

beautiful, but precisely because they clash. There is no reason why photography should be concerned only with the aesthetically pleasing. Ugliness, disfigurement and defacement can be fascinating subjects in themselves. It would be limiting and self-defeating if you confined yourself purely to a romantic treatment of landscape, excluding and studiously avoiding all the more aggressively modern intrusions. One well-known photographic study by the great Edward Weston is based on the arrangement of telegraph poles against a graceful hill; a number of others explore abandoned cars, signposts, and even porcelain lavatories. The discerning photographer should never place any limitations on his subject matter. It is the manner and sensitivity of his seeing, and not necessarily the subject, that is of prime importance.

Left: The old and the new, near Horton. The foreshortening effect of a telephoto lens creates this juxtaposition of windmill and factory chimneys.
Nikon FE, 80–200mm zoom lens, Plus X, 1/125 at f11.

Centre: Viaduct near Halifax, photographed during a snowstorm. In normal circumstances this view would have lacked tonal contrast. Snow creates strong graphic effects.
Nikon FE, wide-angle lens, Tri X (rated at 800ASA), 1/60 at f8.

Below: Barry, Glamorgan. A graveyard for old steam engines makes a fascinating subject. Wild flowers contrast brightly with the patina of old iron.
Pentax, standard lens, FP4, 1/125 at f16.

Opposite above: Maesteg. A working railway linking three collieries. The signal is a reminder of the days when this was a part of the Great Western Railway.
Pentax, standard lens, FP4, 1/125 at f16.

Opposite below: Disused tin mine, near St Just. The camera faced almost directly into the sun, silhouetting the ruined building.
Pentax 6×7cm, wide-angle lens, Plus X, 1/30 at f22, deep yellow filter.

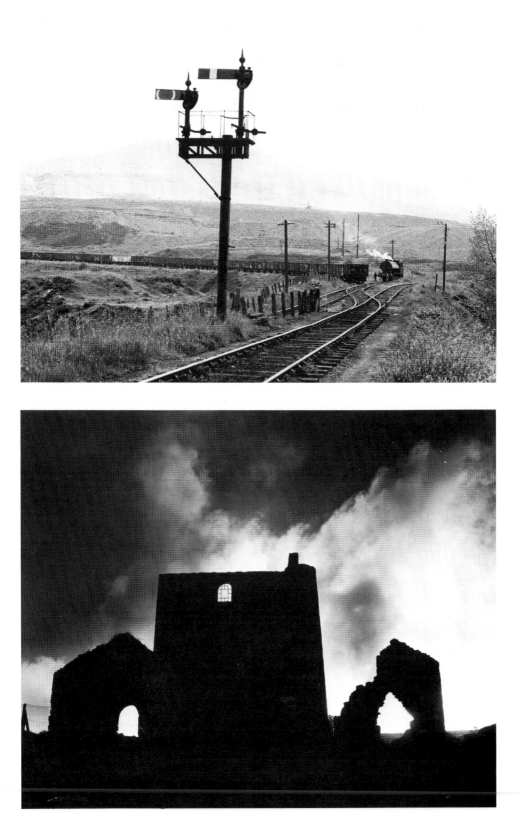

Coalbrookdale and Iron-Bridge

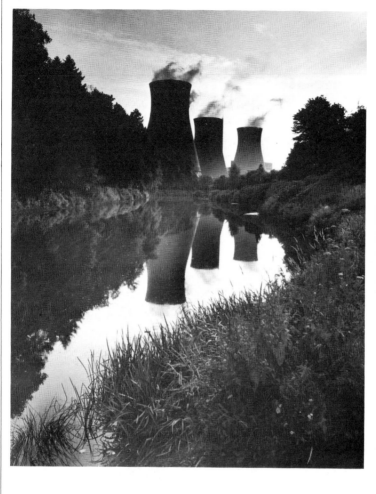

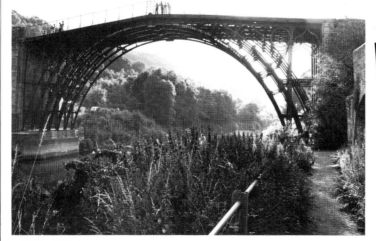

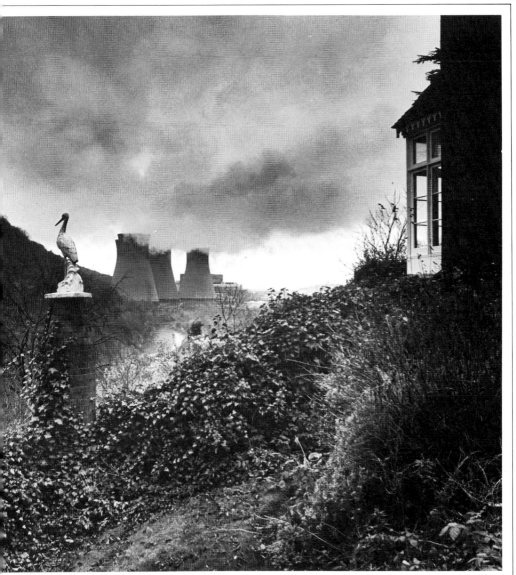

Above: A Victorian oddity at Coalbrookdale, overlooking the gorge and the cooling towers on the other side. The few prominent features have been emphasized by the careful selection of the viewpoint.
Medium wide-angle lens, Tri X, 1/30 at f16, tripod.

Opposite above: Cooling towers in the late afternoon. A distinctly romantic treatment of a very prosaic subject.
Standard lens, Tri X, 1/60 at f16.

Opposite below: Two possible ways of framing the graceful span of the Iron-Bridge. Designed by Abraham Darby II and cast in 1778, the bridge is now only used by pedestrians. The human figures add scale and also act as a lively contrasting element.
Both pictures use a wide-angle lens, Tri X, 1/60 at f16.

Before the Industrial Revolution, this deep gorge with limestone slopes and the River Severn flowing through it, must have been an idyllic spot. Nevertheless, the factories and cooling towers which have grown up since then have not managed to destroy its charm. Some of those industrial eyesores have acquired, in this setting, an almost romantic air. The reflection of pink chimneys in the Severn is almost beautiful and many of the Victorian houses and villas dotting the upper slopes of the valley retain an old-fashioned charm.

The Iron-Bridge spanning the Severn, as if growing out of the tangle of vegetation on the banks, is very much a centrepiece. You can easily spend several hours lining up various frames from beneath it and on top.

FOREST AND WOODLANDS

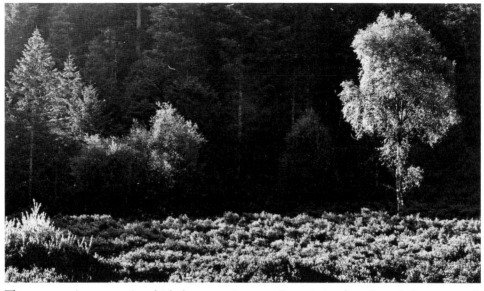

There are various ways in which forests and woods can be photographed. You could look at them from a distance or with a wide-angle lens and see them as an immense mass of vegetation – trees, branches and shrubs combining to give an impression of denseness and impenetrability. On the other hand, you could come close up and examine them in detail, noting the texture of the bark, the structure of single leaves, or the tracery of the ferns. But whichever you decide on, the single most important ingredient is the light. Without a fair amount of bright light, or better still direct sunlight, the forest could look dull and lifeless. While out in the open fields or valleys or on the downs, it is very desirable to have a low morning or evening light, in the forest this is not so. At times it is even better that the light penetrate directly from above, providing greater overall luminosity and brilliance. But in a less dense wood, it is also worth shooting directly into a low light, while taking care to 'hide' the sun behind a thick tree trunk. This gives particularly beautiful colour effects in autumn and spring.

The original woods and forests of Britain are a mixture of several kinds of deciduous trees – oak, beech, birch, ash, sycamore, chestnut – and some evergreens. This gives them a rich and varied colouring. Among the finest are the New Forest in Hampshire (planted over 1000 years ago), the Forest of Dean in Gloucestershire, and what remains of the Ashdown Forest in Sussex and Sherwood Forest in Nottinghamshire. Since the First World War, however, the For-

estry Commission has planted about two million acres. These modern forests consist mainly of conifers (spruce, larch, Douglas Fir, pine and Western Hemlock, among others), planted in regular rows with the trees quite close together. From afar they form swathes of even colour, deep or light green, not differing greatly in winter, summer or autumn. Only recently has the Forestry Commission started to mix conifers with the traditional, broad-leaved, deciduous varieties. These cash-crop forests may be quite interesting to photograph from a distance – the patterns of wide and regular patches of colour imposing a geometrical design upon the landscape – but they are far less rewarding at close quarters. Dull and uniform, often dark and impenetrable, they are not very rich in wildlife and so are silent and impersonal. Natural forests, by contrast, are many different kinds of green in summer, and a blaze of colour in autumn. They also offer a wonderful diversity in close-up – light clearings, patterns of tree trunks, and the contrasting textures of undergrowth.

Forest scenes are composed of basically similar elements. In order to create reasonably distinct images you should try to single out some of these. This can be done partly by differential focusing (focusing sharply on one or two features with the rest of the image falling out of focus) or, better still, by selecting trees or leaves which are spot-lit by the sun, while others remain in the shadow. In autumn, you can spend hours in the woods, picking out interesting arrangements.

Opposite: Trees in Queen Elizabeth Park, the Trossachs. The sidelighting of the late afternoon sun can give some interesting effects. A single tree is caught, while the background woods remain in shadow.
Nikon FE, 80–200mm zoom lens, Plus X, $\frac{1}{125}$ at f11.

Right, above: Near Henley-on-Thames. In bright snow, override the meter, and give a double or even quadruple exposure – or the snow will print a dirty grey.
Pentax 6×7cm, medium wide-angle lens, Tri X, $\frac{1}{250}$ at f16.

Right, below: Remnant of Sherwood Forest, near Edwinstowe. Shot into the sun to create a dramatic mood, and to emphasize the ancient, dying oaks by silhouetting them against the sky.
Pentax 6×7cm, wide-angle lens, Tri X, $\frac{1}{30}$ at f22, orange filter.

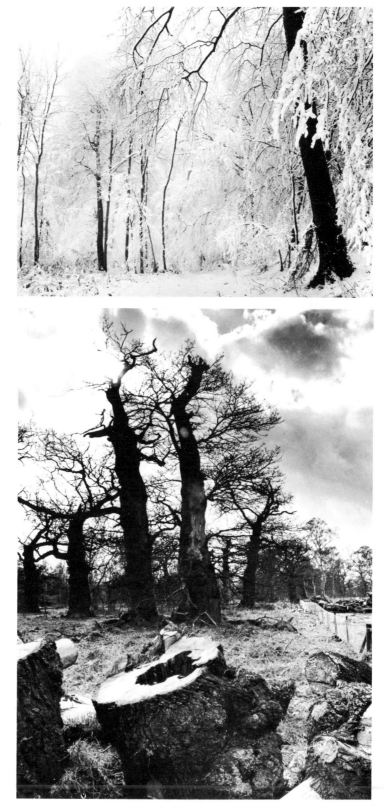

Woodland in Autumn

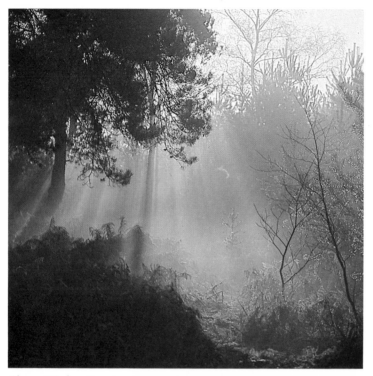

Above: Windsor Forest in early October. For this kind of effect, you need a combination of early autumn colours, a light mist, and bright sunshine. Exposure should be kept at a minimum, in order to achieve a contrast between the dark shapes of the trees and bushes, and the brilliance of the shafts of light.
Medium wide-angle lens, Agfachrome 50S, 1/60 at f11.

Right: Burnham Beeches, November. In close-up shots of this kind, it is important to retain a sharp focus over the whole area of the main subject – in this case the root of the tree – but it may also be useful to show a little less sharpness in the background in order to emphasize the main area.
Ektachrome 200, 1/60 at f16.

A clearing in the woods left ample light for this photograph, which captures the autumn colours at their transient best (usually at the beginning and middle of October).
Pentax 6×7cm, wide-angle lens, Agfachrome 50S, 1/30 at f16.

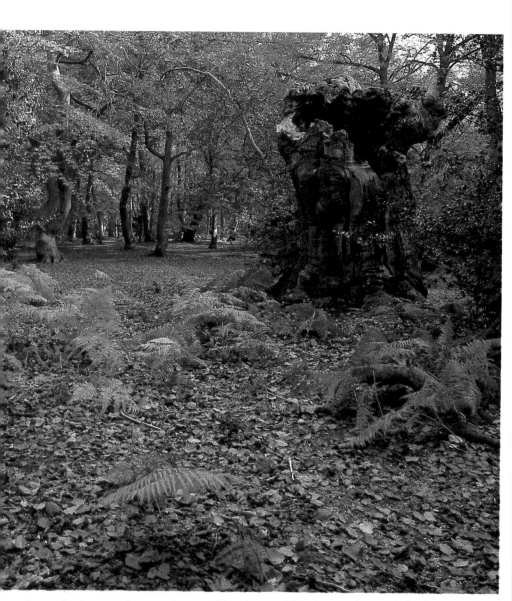

For a landscape photographer working in colour autumn is the best season. Unfortunately, it is also a time of unreliable weather, and autumn colours do need some sun to show them to advantage and to enhance the colour saturation. While fields, especially during the burning of the stubble, can also be quite interesting, in autumn it is mainly the woods and forests which come into their own. It is important to get your timing right, because the period of the most vivid colouring is very short indeed. You begin to notice the colours change in deciduous forests from green to subtle yellow just after the middle of September, with the deepest reds and golden browns at their best around the second and third weeks in October. By the second week of November, the peak is over. By the end of November, it is almost all over; you may still find an occasional yellow leaf on the trees but the variegated mantle of leaves covering the ground is by then already old and dreary.

Most of Britain's woods are beautiful in the autumn and some, like Burnham Beeches, are famous for their vivid colouring. Needless to say, the best effects are achieved against the light, when the leaves are most translucent.

GARDENS, PARKS AND STATELY HOMES

Sissinghurst Castle. Arches provide a useful frame, especially when they enclose another building. Pentax 6×7cm, wide-angle lens, Tri X, ⅟₃₀ at f16.

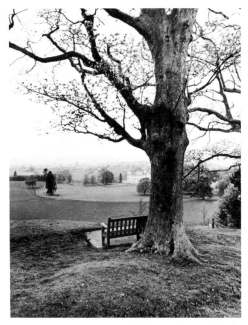

Milton's seat in Hagley Park. A good example of foreground interest in landscape photography. Pentax 6×7cm, wide-angle lens, Tri X, ⅟₃₀ at f22.

Like industrial landscapes, gardens, parks and stately homes have been imposed on the countryside by man. But while the industrialists, prompted only by interest in profit and functionalism, paid little heed to aesthetic values, throwing their mills and factories into valleys and dales in a haphazard manner, gardens and parks were created with an eye for beauty and aesthetic pleasure. Harmony of line, proportion, balance and sensitivity, order and a well-groomed air, are all ingredients of British country houses and estates. I am not concerned here with the architecture of country houses; there is a vast body of literature on the subject, and most houses which are open to the public do not permit photography without prior permission. Their grounds and parks, however, inevitably reflect the architectural fashions of the day. Many of the finest gardens are open to the public, some for a large part of the year, and some for a few months only at specific times in summer.

Garden-making is among the more ephemeral arts. Victorian 'reconstructions' apart, very few examples of the medieval garden survive. These monastery gardens were culinary and medicinal. The first gardens to be laid out

purely for pleasure were the highly compartmentalized Tudor knot gardens, which were viewed from raised walks called 'parterres'. These were the first gardens to feature as an extension of the house. By the beginning of the seventeenth century, gardens and parks started to be planned by architects, influenced in the main by classical Italian models. In the late seventeenth century the austere intellectual classicism of Louis XIV's France had a considerable impact. Formalism was writ large. As at Versailles, grounds were laid out in rigidly intersecting axes, each ending neatly in a terminal feature. Dutch influence gave an impetus to nursery propagation and the introduction of exotic new species from the East. But the geometrical perfection of Continental gardens suited neither the English landscape nor the English temperament. In the early eighteenth century, Alexander Pope was one of the first to ridicule French formalism and to pioneer a

Opposite above: Blenheim palace. Opposite below: Blenheim Park. Try to follow the designer's own conception of the building and its surroundings. Both pictures: Pentax 6×7cm, wide-angle lens, Tri X, ⅟₆₀ at f22.

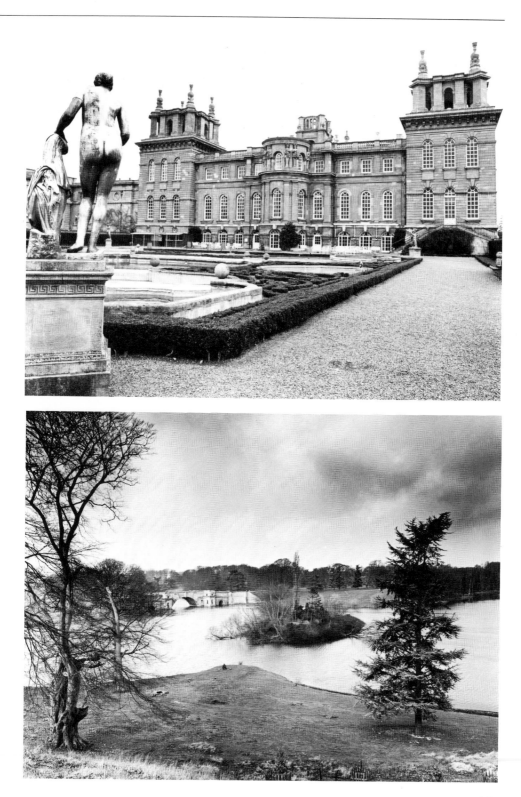

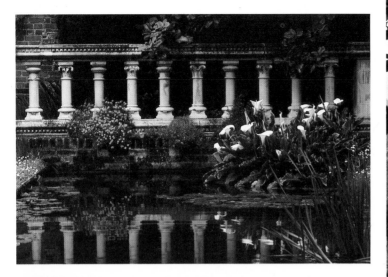

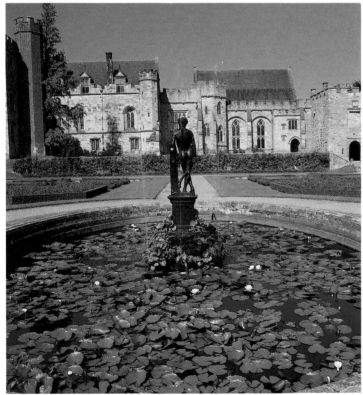

Hampton Court. The massive, clipped yews dominate the photograph. But an exploration of the gardens can produce other, different possibilities, as they are laid out in a variety of styles.
Pentax 6×7cm, wide-angle lens, Ektachrome 200, 1/125 at f22.

Top: On dull days shadows tend to be blue and flat. Colours can be enriched with a warm 81A filter. Nikon, 105mm telephoto lens, Kodachrome 25, 1/30 at f11.
Above: Penshurst Place. A general picture gives a good impression of the imposing sweep of the formal gardens. Pentax 6×7cm, wide-angle lens, Ektachrome 200, 1/125 at f22.

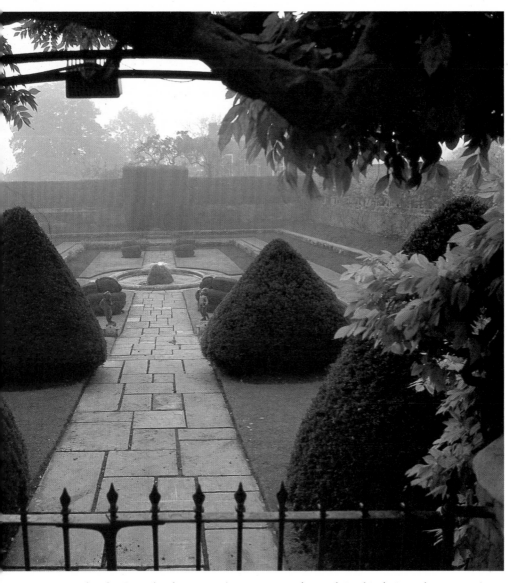

more natural style. Great landscape gardeners, such as William Kent (at Stowe, Rousham and Holkham), Lancelot ('Capability') Brown (Longleat, Petworth, Blenheim) and Humphry Repton (Luscombe), established the new English style by adapting the existing landscape to create free yet 'painterly' gardens. Although meticulously planned and organized, these gardens gave the impression of naturalness and spontaneity. In complete contrast to the rigid symmetry of the formal garden, they were circular in layout. The circuit was enlivened by visual incident, on the way round in the form of temples, obelisks, seats, pavilions and so on. The use of a ha-ha, a concealed dividing wall not seen from a distance, allowed the grounds of the house to merge naturally into the land-scape beyond. In this fusion of nature and art, the English landscape garden achieved its ideal.

Between 1700 and 1800, large parts of the country were forcibly tamed and changed into enormous parkscapes as landowners attempted to turn their properties into works of art. There is thus a curious parallel between the indus-trialization and the neo-classical and romantic beautification of the British countryside; both destroyed large areas of natural country, if for different purposes.

These considerations should be reflected in the manner in which the photographer inter-prets these country showcases. This applies especially to the method of composition. It has been argued elsewhere that photographic com-position should contain a certain amount of

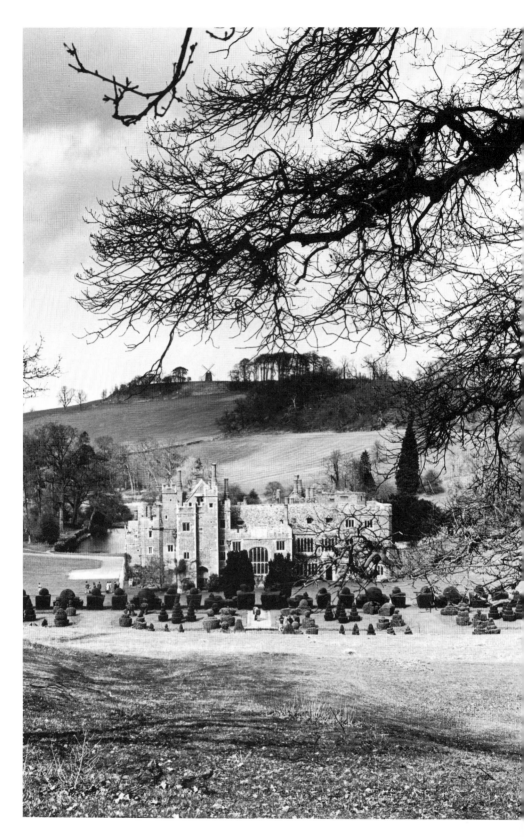

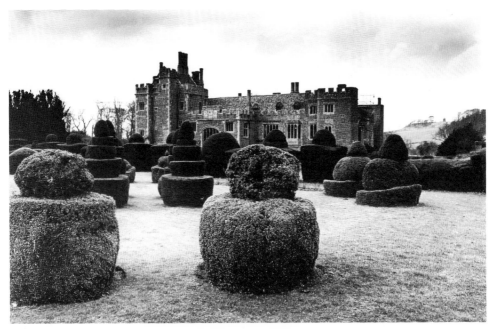

Opposite and above: Compton Wynyates is much photographed, but still offers many possibilities for general or detailed pictures. The setting is perfect – in a hollow, surrounded by gentle hills and with a windmill above. For photographing the house, the yew trees form an ideal frame, and the elaborate topiary of the gardens provides foreground interest for more detailed shots. Pentax 6×7cm, standard lens (opposite), wide-angle lens (above), Tri X, ¹/₁₂₅ at f22.

Above: Sissinghurst is laid out like a series of rooms, each with its own mood. The contrasting designs provide a challenging choice of viewpoints and frames. Here a wide-angle lens accentuates the perspective. Both pictures: Pentax 6×7cm, wide-angle lens, Plus X, ¹/₂₅₀ at f22, deep yellow filter.

dynamism and randomness, in order to preserve the actuality and liveliness of the subject. However, faced with largely artificially elegant vistas, your compositions should emphasize these qualities rather than deny them. Thus you should aim for well-balanced, design-orientated images, based on the classical divisions of thirds and the golden mean. Pictures of gardens, parks and stately homes should portray leisure, repose and good taste, and should avoid harshness and excessive contrast, both in monochrome and, especially, in colour. Colours should be harmonious. Sharp angles and aggressive diagonals should be avoided if possible. Curves, serene horizontals, and proud verticals should dominate the composition.

Stourhead 1

On the bank of the second small lake behind the Pantheon. In the summer, the bank is overgrown with flowers of every colour. Medium wide-angle lens, Kodachrome 64, 1/60 at f16.

Right: A variation on the frontal viewpoint taken with a wide-angle lens focused on large leaves in the foreground, with the Pantheon in the far distance and only a small portion of the lake showing. A light tobacco graduated filter was used for the sky. Agfachrome 50S, 1/30 at f22, tripod.

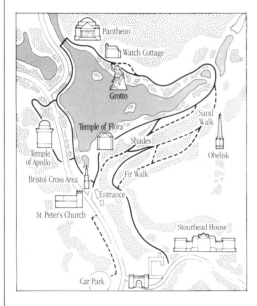

From a photographic point of view, Stourhead – a stately home built in the Palladian style by Colin Campbell in 1722 in the Wiltshire countryside a hundred miles from London – is probably the best choice. It is fairly extensive – the garden circuit is a one and a half mile walk – and it also offers many and varied subjects: garden buildings, trees, flowers, a Palladian bridge and an artificial lake. The greatest attractions are its carefully calculated vistas, meticulously laid out twenty years after the mansion was completed by its eighteenth-century designers. These include not only the famous view of the Pantheon across the lake, with the little stone bridge on the left, but numerous other views planned from different vantage points,

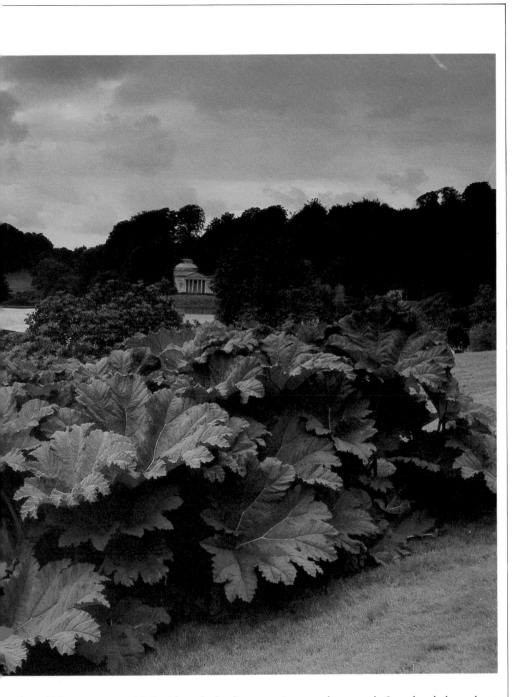

for which you are provided with paths leading towards the wooded hill overlooking the gardens on the right. It is possible to photograph Stourhead at almost any time of the year, but its famous rhododendrons flower in the spring, when their colours are almost overpowering. For quieter effects, late summer and autumn can be very rewarding. It could be an interesting project to photograph Stourhead throughout the year and capture the variations in mood and tone from season to season. Capability Brown's landscapes were based on form, shape and greenery. At Stourhead the accent is on colour and variety. The gardens are open all year round and it is even possible to gain admission early in the morning or late in the evening.

Stourhead 2

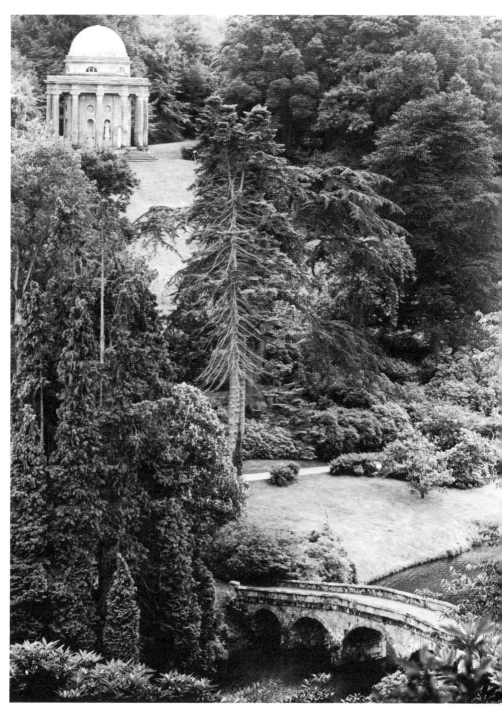

The Temple of the Sun, high among the trees, seen from the opposite hill. One of the many visual incidents which enliven the circuit, this beautiful stone rotunda is only glimpsed from time to time through the openings in the trees at various points along the hill path. Here it is set off by a bridge far below.

Long-focus lens, Tri X, 1/125 at f8.

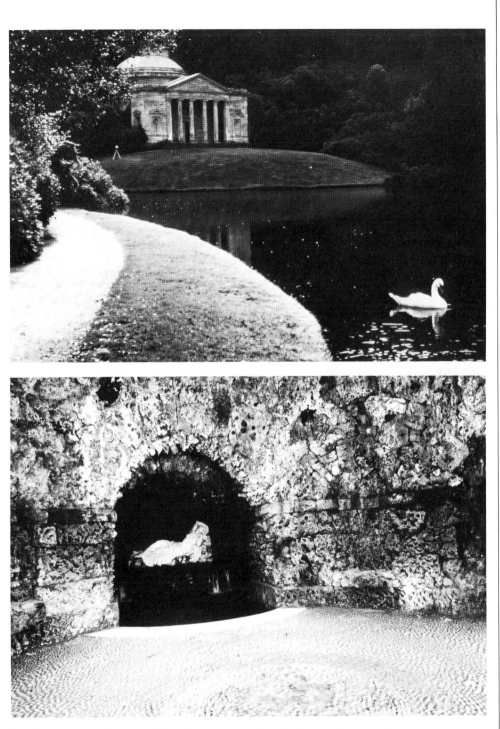

Stourhead's grotto is lit by a small opening in the ceiling. Although weak, the light is well-defined; nevertheless, a long exposure is required. Wide-angle lens, FP4, 2 at f22, tripod.

Top: In the late afternoon, the sun no longer shines on the Pantheon, but a single swan and the paths are briefly caught in the oblique light. Medium wide-angle lens, FP4, ¹⁄₆₀ at f11.

FLORA AND FAUNA

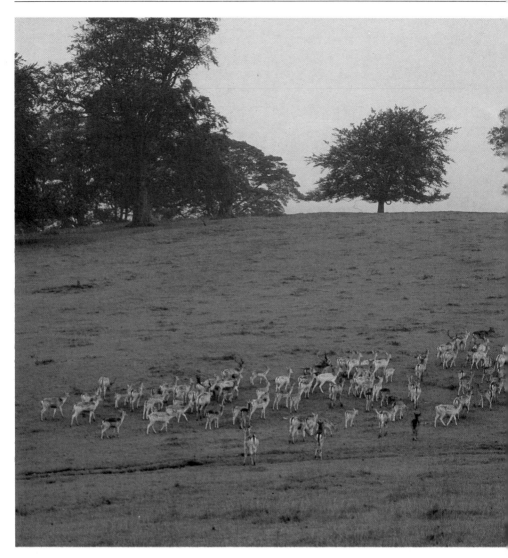

This is a very large photographic subject and one that merits a book of its own. Here it constitutes a kind of postscript, or a reminder, and no more: a reminder that you can take quite respectable pictures of wildlife and plants without spending large sums of money on specialized equipment. Basically, you can manage very well with one long lens (preferably a zoom lens) and, of course, a great deal of patience, where wild animals and birds are concerned; and with no more than a lens capable of being focused at short distances (a simple close-up ring will do) for flowers and plants. Both items are usually part of the modest enthusiast's equipment.

The British Isles provide a rich hunting ground for both flora and fauna, although modern farming techniques have in recent years endangered some of the more vulnerable species. There are, however, various nature reserves and bird sanctuaries where the botanist and naturalist would find rare examples of wildlife. For the photographer wishing to try his hand at wildlife photography, there is plenty of potential subject material virtually on his doorstep. The humble animal and plant life of hedgerows is worth recording photographically. Woodland abounds in ferns and fungi which, because of their patterns and shapes, make interesting subjects. To many birdwatchers, photography provides a rewarding ex-

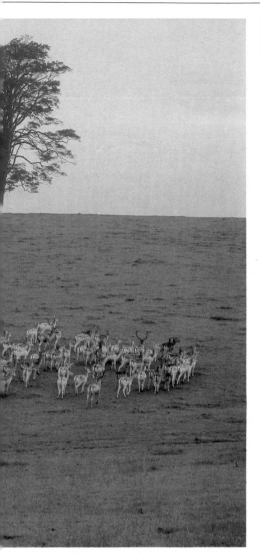

With careful selection, modest subjects can make good pictures. A polarizing filter was used to intensify the colours.
Nikon, 105mm telephoto lens, Kodachrome 25, $\frac{1}{125}$ at f5.6.

Left: Dyrham Park. The composition achieves its effect by the patterning of the herd against the landscape.
Pentax 6×7cm, 200mm long-focus lens, Ektachrome 400, $\frac{1}{60}$ at f8.

Below: Stags in Richmond Park.
Mamyiaflex C3, 80mm standard lens, Tri X, $\frac{1}{125}$ at f5.6.

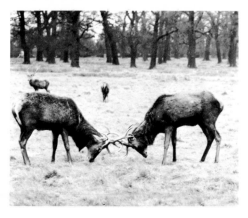

tension of their hobby. The specialized equipment used by the professionals in this field can seem rather daunting, but with patience it is possible to make worthwhile studies of bird life with a comparatively modest camera.

Much of the coastline, too, is easily accessible. The variety of adaptations of plant and animal life to the different coastal environments has great photographic potential. Rocks form a stark and effective background for the delicacy of lichen. In clear water, or offset by patterns of sand and pebbles, the tangles of seaweed, green or brown, can assume an abstract character. In spring and summer, the rugged headlands of Cornwall and Pembrokeshire sometimes re-

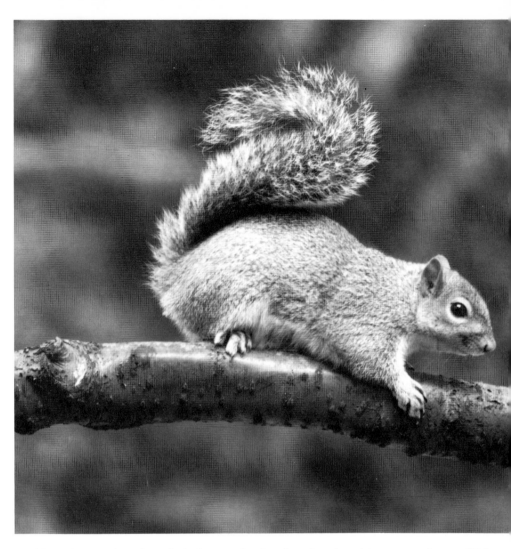

semble sophisticated gardens, decked out with blue viper's bugloss, pink thrift, red valerian, and white sea campion. Sea lavender can stain the salt marshes a delicate shade of blue. The litter of shells on the beaches at low tide is a further source of patterns, colours and shapes. The teeming shore life includes seals, crabs, crayfish, anemones, insects, grubs, and, not least, worms. The coasts, in particular, are the breeding grounds of an enormous variety of seabirds and waders.

The gazetteer gives an extensive but concise list of the various reserves and special sites for wildlife and vegetation. Here, we are concerned with the basic minimum requirements for photographing them.

Wild animals and birds are best photographed with a long lens, but not too long. A telephoto of more than 200mm focal length for a 35mm camera would be rather difficult to handle unless the subject was stationary. Without a certain amount of practice, it is extremely difficult to locate and focus on a quickly moving object with a lens framing only a fraction of the field of vision. Many photographers find a 150mm lens adequate and a 80–200mm zoom is possibly the best choice. Since a tripod is often an encumbrance when following an elusive target, a fast film is a necessity. You cannot hold a fairly long lens reasonably steadily at shutter speeds of more than $1/250$ second and, of course, it is a bonus to be able to stop down to about f8 or f11 in order to be able to keep your quarry in fairly sharp focus.

With flora, the exact opposite is standard procedure. With your subject motionless – even a breeze can be craftily eliminated by shielding the subject with an impromptu screen – a tripod can, and should, be used at all times. Consequently, you can allow yourself the luxury of a

slow, fine-grained film but, on the whole, it is best to keep to a medium-fast film – for instance, Kodachrome 64 for colour, and for black and white, say, FP4 which is 125ASA. This still gives a fine resolution, but it is easier to handle and your exposures will not need to be excessively long. Remember, that with a lens focused very closely, you must give extra exposure and that, in any case, exposure calculation for close-up photography should be more precise than for general landscape photography. It is worth acquiring a hand-held exposure meter since built-in meters are not always the best guide. As for lenses, various close-up rings will allow you to come as close as you need, but there are lenses on the market which do not require close-up attachments. The Nikon 55mm Micro-Nikkor, for example, is specially devised for close-up photography. It provides very good results and is simple to use.

Puffin. Found on isolated coasts and islands in the summer breeding season. With a 300mm lens it is possible to stalk them.
300mm lens, 1/250 at f8.

Opposite: The grey squirrel, a common sight in urban parks. Bait an unshaded tree branch with peanuts or bread. 200mm lens, 1/60 at f8.

Top: The common seal. In wildlife parks, seals will come very close, especially at feeding time. Try for a natural picture.
135mm lens, 1/125 at f8.

Above left: Peacock butterfly. Butterflies are attracted to many flowering plants, particularly buddleia.
100mm lens, 1/125 at f11.

The Kestrel is a wary
bird. It will often use a
regular perch. With this
sort of subject, a hide is
necessary.
300mm lens, ¹/₆₀ at
f11, tripod.

Left, above: Robin.
Photographed from a
clean window with the
cutrains almost drawn.
The lens was held close
to the glass to avoid
reflection.
135mm lens, ¹/₆₀ at f8.

Left, below: Great
Spotted Woodpecker.
Difficult to photograph
as it prefers mature
woodland – except
sometimes in winter.
You can tempt it to
emerge with pieces of
suet.
135mm lens, ¹/₆₀ at f8.

Right: Shot with a long
telephoto lens. The
subject was isolated
from its background by
opening-up the
aperture, and a fast
shutter speed was used
to freeze movement.
When exposing for
close-up shots of
plants, override the
meter by about two
stops.
Nikon, 300mm
telephoto lens, Plus X,
¹/₁₂₅ at f4.5, tripod.

MOUNTAINS

Langdale Pikes, Cumbrian Mountains

The Black Mountains. A range of mountains in Dyfed, Wales, stretching roughly from Hay-on-Wye in the north to Abergavenny in the south. It is a dramatic range of mountains with valleys of oak and spruce, and hills over 2500 feet high where occasionally you can still see farmers riding Welsh ponies to work. (Transport is difficult in this area.) Curiously enough, the Welsh have two Black Mountains. The Black Mountain itself lies to the west, and is probably less interesting than the range of Black Mountains. Possibly the most beautiful route across the Black Mountains starts at Hay-on-Wye and goes south almost immediately by a secondary road, eventually leading to Llanthony Priory. It is a narrow road with stopping places, but the journey is certainly worthwhile. Four or five miles from Hay-on-Wye on the way to Gospel Pass there is a fine view across the Black Mountains. You continue downwards until eventually the road improves as you reach Capel-y-Ffin and its monastery, having passed the castle ruins on your right. Eventually you come to Llanthony Priory, with its superb setting on the Afon Honddu river. From Llanthony there is no need to return by the same narrow road, as you can take the B4423 south towards Abergavenny, but if you would like to see more of this mountain scenery before reaching Abergavenny, you can turn right again after about three or four miles along a minor road towards Crickhowell. Once again, the road goes through a valley, this time to the Grwyne Rawr river and you follow it until you reach Crickhowell. It is a rewarding road,

although it is rather narrow in places.

If, however, you would prefer not to risk the narrow road to the Priory, you can go round the Black Mountains by a fairly good road. Take the B4348 from Hay-on-Wye and turn towards Golden Valley (see Valley section below); go along the Golden Valley with the Black Mountains on your right, turn into the B4347 and continue to Abergavenny on the A465. From Abergavenny take first the A40 and then the A479 towards Talgarth, another very beautiful place. On the route from Abergavenny to Talgarth on the A479, the Black Mountains are on your right again, suddenly close and magnificent. From Talgarth you can return to Hay-on-Wye and from there continue to wherever you fancy – perhaps towards Breconshire.

West of the Black Mountains and the Brecon Beacons is the Fforest Fawr. It is worth making a detour, particularly to the little village of Ystradfellte, deep in the forest on the River Melte – a lovely place, honeycombed with caves, with streams and waterfalls. The whole area around Ystradfellte is extemely interesting. The River Melte vanishes into an enormous cave just north of the village. You will invariably see potholers as this is a well-known caving area. There is also the little ruined castle of Melte, which you drive past when you come out of the Ystradfellte Pass before reaching the main road, the A4059, and turning left towards the Brecon Beacons.

The Brecon Beacons. Now we are in the county of Powys, and although both the Brecon Beacons and

the Black Mountains are part of the National Park, the Brecons are perhaps even more remote and austere than the Black Mountains. From the A4059 you join A470, the main road, passing a great reservoir on your left. You come to a mountain rescue hut and, from there, if you wish you can climb the highest mountain in the range, Pen y Fan. The view is worth the stiff walk. There are many waterfalls in the area.

Another way for the photographer to reach the Brecon Beacons is to go from Merthyr Tydfil. Take the minor road from Merthyr Common travelling due north past the church of Pontsticill, pass several reservoirs (which are extremely photogenic in themselves), and you will reach a number of parking places and forest walks provided by the local authority. Not far from Blaen-y-glyn you will reach a waterfall (in fact, there are two waterfalls there), or you can go a little further north towards Wern. Again, from there across the reservoirs you will see the great expanse of the Brecon Beacons.

The Cumbrian Mountains. The Cumbrian Mountains are synonymous with the Lake District, and relevant information about photographing them will be found under that section. Nevertheless, a few sites should be mentioned here, because they are not obviously connected with the lakes themselves. There is a spectacular road, the B5343, going from Ambleside to Langdale and the Langdale Pikes. It goes up to the head of the valley, where there is a fairly large area to park or camp. From there you can explore and photograph many of the neighbouring peaks, including Stickle Pike. From there, too, you can take a side road (a very steep road, not to be trifled with in winter, and unsuitable for caravans), going first to Little Langdale Tarn and then on through the mountains along the River Duddon to Hard Knott and then on to Beckfoot. Not far from there, you can take another road to the left crossing the River Esk and passing along the Birker Fell as far as Ulpha, another narrow road with several stopping places. Apart from

Glen Coe, Grampian Mountains

that there are two famous mountain passes in the Lakes, Honister Pass, which you take from Borrowdale over the mountains to Buttermere, again with magnificent views, and a second route passing one of the higher peaks in the Lake District, Grisedale Pike, through Whinlater Pass.

The Grampian Mountains. These lie south and east of the Great Glen, running down to the lowlands, the River Dee and the east coast. Within this large chain of mountains there are several smaller chains, of which the highest and perhaps the least explored are the Cairngorm Mountains. There are no roads going through the Cairngorms and to travel round them involves a journey of 140 miles, so the best way to approach them is from the newly-developed skiing resort of Aviemore. From the A9 in Aviemore you can take the A951 to Coylumbridge and then a side road by Glen More and Loch Morlich. This narrow road goes to the Queen's Forest, from where you can see the whole of the Cairngorms and, notably, the view across Loch Morlich. Because of the skiing development, there is a chairlift going almost to the peak of the range, the Cairngorm Mountain. From the last station it is only a 400-foot walk to the top where there is a panoramic view which includes Loch Avon, on the other side of the mountain. The Glen More Forest Park which surrounds the mountains has been developed since 1948 and offers opportunities for walking and for serious climbing. There is, however, a beautiful and safe walk around Loch Morlich of about 10 miles, which does not involve a great deal of climbing, which can be recommended. The encircling mountains and trees offer a variety of photographic possibilities.

Possibly more accessible and more photogenic are the Grampian Mountains in the west, particularly the western glens – Glen Coe and Glen Nevis. When travelling on the A82 towards Glen Coe and Loch Leven, you are among mountains all the time. The Pass of Glen Coe is considered one of the finest of the Scottish glens. It is worth stopping before the entrance to the Pass and taking the old road towards 'The Study', where there is a waterfall. The view is superb, especially the precipices of Bidean nam Bian. If you are historically inclined, you can walk to the site of the 1692 massacre. From Glen Coe you can either turn right and drive round Loch Leven or, alternatively, stay on the A82, cross the bridge and drive along Loch Linnhe towards Fort William, with Ben Nevis – Britain's highest mountain – on your right. If you have some time, it is worth taking a ferry across the loch to Corran and joining the A861 on the other side, where there are wonderful views of Ben Nevis across the water. If time is short, you should take a little side road leading towards Ben Nevis itself. Take the road by Ben Nevis Bridge at Fort William, turn right into a side road, and drive alongside the River Nevis until you come to the stopping point, a car park at the foot of Ben Nevis. The scenery is magnificent all the way, and it is worth staying for a while and walking towards the mountains.

The Peak District. The High Peak is an area of rugged moorland and heather, with many dales and pastures. At its centre is Edale, where the famous Pennine Way begins, stretching 250 miles to the Scottish border. The High Peak is essentially walking country; it is impossible to photograph the best landscapes from the few roads. If you do not wish to walk, you should

start from Glossop and drive on the A57 through Snake Pass, which is extremely rugged, and then descend into Woodlands Valley with its huge reservoirs. This is an area where much has been changed in the last 50 to 100 years by the construction of the reservoirs and dams needed to provide water and electric power to the whole region. These have altered the character of the Peak District enormously. An interesting side road leads to Derwent Dale (described under Dales), but it is necessary to leave the road to get good pictures. Even Edale itself is a little dull until, after a fair amount of walking, you reach the valley's higher slopes which offer fine views. Yet another intriguing route into the Peak District starts from the elegant spa town of Buxton. Take the A6 east through Wye Dale, turning off along the B6049 to Miller's Dale with its little mill, and a little further on to Monsal Dale on the right of a side road. Where minor roads cross the B6465 you find Monsal Head, and a few miles from there is a prehistoric hill fort. Bakewell is a very good base for exploring the Peak District as it is near to many places of interest to the photographer. Further south there is the immortal Dove Dale, or you could take the A619 from Bakewell to Baslow and from there turn north on to the A623 towards side roads to Froggatt, where, by Froggatt Edge, there is a stone circle.

Snowdonia

The Pennines. The longest range of mountains in Britain, they stretch from Hadrian's Wall in the north down to the Peak District of Derbyshire. It is well worth taking the A686 from Penrith to Alston, because the road is so high. You climb up towards Melmerby, along a zig-zag road, and then even higher to Hartside Height for panoramic views across the whole area. Alston itself is probably the highest town in the region. From Alston you can either take a road southeast to the village of Nenthead, reputedly the highest village in Britain, or take the B6277 southward. This road crosses some of the finest northern Pennine country, offering a series of magnificent views. At the head of Teesdale, to the west of the road, you can find two of the most interesting northern waterfalls – Caldron Snout and High Force. A few miles further on you may like to turn right on to the B6276 to Kirkby Stephen. If you are interested in a rough and relatively unexplored but beautiful area, then before Kirkby Stephen take the side road towards Tan Hill. Tan Hill offers extensive views – very bleak, but also extremely stimulating. The little Tan Inn at the top is supposed to be the highest inn in the country. If you continue along this road, you come to what is perhaps the wildest country in this part of Britain, through Arkengarthdale to Reeth. In Reeth, take the B6270, following the River Swale, to Richmond. Immediately below Swaledale are several other Pennine rivers which flow through the Yorkshire Dales, which will be fully described later. Within this range, in an area further south called the Craven District, you will find the remarkable Gordale Scar, near Malham, and Malham Cove, a gigantic limestone cliff about a mile from the village.

Snowdon. Snowdon is probably the best-known and best-loved mountain range in Britain. It lies in North Wales and can be reached by the A5 going through Capel Curig. Three passes are almost a 'must' in Snowdon – the passes of Llanberis, Nantgwynant and Ffrancon – but even before you pass Capel Curig you will see a panorama of Snowdon across the little lake

of Mymbyr on the left of the road. To reach the first of the passes, Llanberis, you follow the A4086 to the little village of Llanberis which has the famous Snowdon railway. The train journey to the summit is rewarding and very slow, allowing plenty of time for photography. There is a narrow mountain path, relatively easy, which roughly follows the route of the railway to the top.

For the second pass, the Pass of Nantgwynant, you again leave Capel Curig on the A4086, but instead of going on to Llanberis turn left on to the A498, and within a mile you will see a striking valley ahead with the Snowdon · range behind, and further on the romantic lake of Llyn Gwynant. About a mile on you will see, this time on your left, Llyn Dinas lake, before Beddgelert. For many people, however, the most impressive of the three passes is that of Nant Ffrancon, through which the A5 runs north from Capel Curig to Bethesda. It is certainly the steepest, and its road offers the most dramatic vistas.

The West Highlands. These lie north and west of the Great Glen with spectacular and lovely scenery including Glen Shiel. From Fort William you strike north on the A82 along the Great Glen joining Loch Lochy, Loch Oich and Loch Ness, but before you reach Loch Ness turn along the A87 on what is probably one of the finest roads in the west of Scotland, leading towards Glen Shiel. You pass several lovely lakes, notably Loch Garry, then Loch Loyne on your left, and Loch Cluanie, before entering the austere and beautiful Glen Shiel with the Five Sisters range on the right and the little River Shiel running through it. Next, you reach Loch Duich with, at the far end, one of the most romantic of the Scottish castles, Eilean Donan, on a modest promontory which enables you to photograph it from both sides. In the morning, it is much more interesting from the far side, and in the evening against the light. From there it is a straight road to the ferry to the Isle of Skye.

HILLS, DALES AND VALLEYS

Annandale. Dumfries and Galloway, Scotland. Mainly interesting because of two spectacular places which can be reached from Moffat. For the first of these, take the A701 north from Moffat to reach The Devil's Beef Tub, a hollow 500 feet deep among four barren hills, which Sir Walter Scott particularly admired. The second of the photographically interesting places within this area – again from Moffat – is along the A708 north towards Selkirk. After about twelve miles you find the remarkable Grey Mare's Tail Gorge, and also Scotland's highest waterfall, which drops about 200 feet into Moffat Water. A little further up is St Mary's Loch, which was a favourite loch of Sir Walter Scott.

Black Down Hill. West Sussex. One mile south-east of Haslemere, this offers lovely views of the whole of the South Downs. It is also the start of a nature trail for those interested in birds and wild life.

Blackmore Vale. North Dorset. The hill-top town of Shaftesbury offers – particularly from Cobbled Gold Hill – a glimpse of the Blackmore Vale stretching beyond. But the true Blackmore Vale lies a little to the west on rivers like the Stour, Lydden and the Caundle Brook. The village of West Stour, a few miles west of Shaftesbury, is beautifully situated, and from there one can explore the Blackmore Vale with its gentle wooded hills.

Borrowdale. The Lake District. Possibly one of the most picturesque and photographed places in the area. It runs along the Derwent River, and is entered from Derwent Water through Borrowdale Gate. Immediately beyond you come to a particularly well-photographed spot, the village of Grange, with its ancient bridge and the Derwent Fells rising behind. Further south along the River Derwent, you come to Rosthwaite and the Bowder Stone which weighs almost 2000 tons and appears to be balanced on its edge. It can be climbed by ladder and there are some splendid walks around it.

Box Hill. Surrey. One of the most popular beauty spots, just outside Dorking. One can easily walk up it, and from it there are some lovely views of the South Downs. Box Hill is famous for its trees and is a popular picnic spot. The ascending road starts east of the A24 north of Dorking and zig-zags to the top of the hill, where there are plenty of parking spaces.

Brendon Hills. Somerset. An eastern part of the Exmoor National Park. The best way to see them is to start from Cleeve Abbey and turn along the B3190. Follow the Brendon Hills along the top of the ridge on the little road going to Heath Poult Cross and you will see on your right, the curious Lype Hill, highest of the Brendon Hills. Next you come to Wheddon Cross, where it is advisable to turn into the A396 going towards Dunster in the north and crossing the Brendon Hills in a very spectacular and pleasing way, with Exmoor stretching on the left towards Dunkery Hill.

Cardingmill Valley. Salop. A short and narrow valley running from Church Stretton in Shropshire on the edge of the Long Mynd. It is best to drive on the side of Burway Hill because from there the Cardingmill Valley stretches splendidly along the bottom.

Cheviot Hills. Scottish Borders. These stretch for about 30 miles and are crossed by very few roads. The main road through is the A68 to Jedburgh, and the Cheviots can be explored from there. Probably the prettiest route follows the River Coquet. Start from the B6341 near Flotterton, follow the side road from Harbottle to Alwinton and on along the River Coquet right into the hills. The highest point in the Cheviot Hills is The Cheviot itself, 2676 feet high, which can be climbed in about an hour and a half from Langleeford, off a small road reached from Wooler on the A697.

Chiltern Hills. South Buckinghamshire. Within easy reach of London (about 25–30 miles), they occupy an area of about 40 square miles. There are many walks, for the ancient Icknield Way runs along the Chilterns, and can be followed on foot. From the Chilterns you can see the upper Thames near Marlow, a landscape celebrated in *The Wind in the Willows* and certainly well worth visiting. Because of the large number of beech trees, it is especially beautiful with splendid colours in the autumn. The famous Burnham Beeches is part of it. Possibly the best views can be obtained by turning off the A4155 from Henley-on-Thames to Marlow into the minor road leading to Hambleden and on to Fingest and Turville Heath. It is also worthwhile going to Coombe Hill near Wendover where again there are some lovely views.

Cleeve Hill. A few miles north-east of Cheltenham on the A46, you reach Cleeve Hill, which is probably the best vantage point in the Cotswold Hills.

Coverdale. One of the Yorkshire Dales, which can be seen along a minor road off the A684 just south of Wensley. It is spectacular in some places especially around Horsehouse and also when the road comes down to the River Wharfe near Kettlewell.

Corve Dale. Salop. A charming valley along the Wenlock Edge. The best spot is the black-and-white village of Munslow, right at the foot of Wenlock Edge and close to Corve Dale and the River Corve.

Box Hill

Cotswold Hills. A range of limestone hills running for 70 miles from Bristol right up to Banbury in Oxfordshire, with many winding valleys and tall beech trees. It is a country of green fields and sheltered honey-coloured villages which are best seen from minor roads. From Cirencester, you can explore all of the Cotswolds. One of the finest parts is near Birdlip Hill and the view from Birdlip Hill itself is also impressive. You can reach it from Cirencester on the A417 to Birdlip; walk from there towards Granham. There are some beautiful views of the Cotswolds from Devil's Chimney Rock near Leckhampton, as well as from Leckhampton Hill. Another splendid view is from Bredon Hill with its aristocratic Gothic folly and the little valleys of the Windrush are interesting to explore. The area around Broadway, and the views from nearby Broadway Hill, are also not to be missed, as is the area immediately south of Broadway around Snowshill.

Dentdale. One of the smallest but most delightful of the Cumbrian Dales. From Sedbergh take a small road towards Dent on the River Dee, a tiny village which, despite its name, has very few houses and possibly no more than 100 inhabitants, but the Dale is worth the photographer's visit.

Derwent Dale. One of the Peak District dales now much altered by dams and reservoirs – it becomes a reservoir for much of its lower course. The first in the series of reservoirs is Ladybower on the A57; turn on to the A6013 to approach the great dam which makes

an attractive photograph. Take the side road to the north and you can follow the Derwent Reservoirs and river for several miles.

Dove Dale. This famous dale is in the southern part of the Peak District. You can reach it from the A515 by turning west into the side road going to Thorpe and Ilam. Before reaching Ilam, there is a little side road going into a parking space in Dove Dale. Dove Dale stretches for two miles, but being the most famous of all the Peak District's valleys, it is always full of tourists, so you are strongly advised to go there in the off season or very early in the morning. There are several viewpoints in Dove Dale – the most prominent being the Ilam Rock, a tall pinnacle on the side of the Dale. There is also an excellent view from Sharplow Point, (also known as Lover's Leap). One of the best-known pictorial view points of Dove Dale are the 20 stepping stones linking the Staffordshire and Derbyshire banks of the river.

Edale. One of the less photogenic of the dales in the Peak District. There are some good walks and magnificent views from the tops of the hills – especially near Upper Booth.

Edge Hill. Warwickshire. Not far from Stratford-upon-Avon, just off the A422 from Banbury to Stratford. It is a hill with extensive views across the countryside – perhaps the most interesting part is the magnificent beech tree drive which leads up to the ridge. But an even finer view of that tree-lined road

The Long Mynd

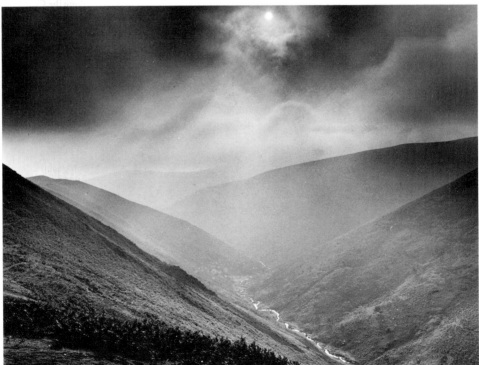

Eildon Hills

village of Kenderchurch. Vowchurch, too, is worth visiting.

Hambledon Hill and its neighbour, Hod Hill. Dorset. Travel from Blandford Forum towards Shaftesbury on the A350 and turn left near Shroton. Although not very high, both hills are dramatic and command fine views of the countryside. They are famous for birds and rare butterflies. On both hills there are forts dating from Roman times; the fortifications on Hod Hill are particularly well-preserved.

Leith Hill. Surrey. A short way south of the A25 from Guildford to Dorking. Easily accessible from Abinger or Friday Street, a charming village at the foot of the hill. On the hilltop there is a tall tower, belonging to the National Trust, open to the public, and providing views of the Surrey countryside. Leith Hill, like Box Hill a few miles away, is particularly beautiful in the autumn, and Friday Street also deserves a visit.

Littondale. A little-known and very small Yorkshire Dale, leading off Wharfedale. A side road leads from the B6160 towards the River Skirfare and the unspoilt villages of Arncliffe and Litton. The far end of the dale is particularly attractive, where the fells close in on both sides.

can be obtained from nearby Farnborough Hall, a National Trust property. On the landscape terraces of Farnborough Hall, you will find two temples and an obelisk as well as a very good viewpoint for this particular district.

Eildon Hills. The Borders, near Melrose. Much admired by Sir Walter Scott. If you do not wish to climb them, a drive around them will probably take no more than half an hour. This will take you from Melrose along the A6091 towards Newton St Boswell turning into the B6398 and then into the B6359 back to Melrose. It is a very scenic route.

Elan Valley. Powys. A very interesting valley photographically. On the landscape terraces of a series of reservoirs. From Rhayader you can take the B4518 which leads you immediately into the valley itself through Elan Village. Turn right and follow the valley along for several miles of water and hills.

Eskdale. A charming Lake District dale which can be reached either from the west from the coastal A595, by turning into the side road to Eskdale itself, or by taking the more difficult route through Hard Knott Pass. The upper reaches of Eskdale near Hard Knott Pass, with the mountains closing in on both sides, present a contrast to the pastoral, gentle slopes further west.

Garsdale. Cumbria. A long winding vale along the River Clough leading to Hawes and then immediately on to Wensleydale – a charming and rather private valley.

Golden Valley. On the Welsh borders, west of Hereford, running along the River Dore between Dorstone and Pontrilas on the B4347 and the B4348. A rich, green valley blossoming with orchards, bordered on the west by the Black Mountains and on the east, by the gentle hills of Herefordshire. It is pretty for most of the way, with interesting spots like Abbey Dore, a partly-ruined Cistercian Abbey, and the charming

Lincolnshire Wolds. A quietly beautiful stretch of gentle hills between Lincoln and the sea. It is a rich, lightly-populated area, with deep valleys, peaceful streams and modest woods. The highest part is near Normanby le Wold. Possibly the best base from which to tour the Wolds is the Georgian market town of Louth. A few miles south is the village where Alfred Tennyson was born, Somersby, and its lovely old church. Or you can take the main A157 road from Louth to Lincoln, turn at Welton le Wold into a side road and drive along to Wold Newton. This is part of the Bluestone Heath Road which runs along the escarpment of the wolds and offers a series of views.

Llangollen Valley. A superb Welsh valley not far from the border on the A5. It lies on the River Dee and the town of Llangollen itself is very photogenic, with an old bridge and Valle Crucis Abbey only a mile away. But the most interesting features of the Llangollen Valley are the Horseshoe Falls just above it, and the Horseshoe Pass going north on the A542 from Llangollen.

The Long Mynd. Salop. A curious ten-mile ridge of austere hills and moors with an ancient track called the Port Way, running along the entire ridge and providing views on both sides. Particularly interesting is the view of the Devil's Mouth from Burway Hill.

Malvern Hills. Just south of Worcester. The best way to photograph the Malvern Hills is from the British Camp (also known as Herefordshire Beacon) which is a few miles from Great Malvern on the Ledbury Road. A car park is provided nearby and there is a short climb on to the bare hills. From there stretch imposing views of all the Malverns and of the surrounding countryside.

Meon Valley. The valley of the River Meon, which flows into the Solent near Gosport. The graceful and quiet countryside, with its small woods (for example, south of Droxford), presents the photographer with fine examples of pastoral landscapes.

171

Mendip Hills. A 25-mile-long ridge of limestone hills in Somerset, interesting photographically. The tops of the Mendip Hills are fairly flat and bleak, with many abandoned mines. More interesting, however, are the two gorges which have been formed in the limestone – Cheddar Gorge and Wookey Hole – both of which run south towards the lowlands. A great number of cars travel through the Cheddar Gorge, particularly in the high season. The best way to photograph the Gorge is early in the morning, or in the off season. It can look extremely striking on a fine winter's day.

Nidderdale. North Yorkshire, east of Wharfedale. The best part of this valley is its upper reaches, which can only be approached on very minor roads, but it is an area which is hardly ever visited by tourists and so is very rewarding to photograph. Go to Pateley Bridge, on the B6265. From there, you take a very minor road to Wath and Gouthwaite Reservoir and on to Lofthouse. Beyond Lofthouse, there is the imposing How Stean Gorge. On the return journey, just north of Pateley Bridge you can visit Foster Beck Mill. About three miles east of Pateley Bridge, you will find Brimham Rocks – sandstone blocks, sculptured by the wind. The surrounding moorland is very picturesque.

Pendle Hill. Lancashire. A curiously shaped hill, above the Ribble Valley about three miles east of Clitheroe, interesting to photograph in itself. From the summit, reached by fairly good paths, there are splendid views of the Forest of Bowland with the far plain and the Irish Sea beyond.

Vale of Pickering. Yorkshire, just north of Malton. Both the Rivers Derwent and Rye flow through the Vale. It is peaceful, secluded and its gentle hills and fields are little-known. It used to be a marshland but has now been drained, and today is mainly pastureland. Nearby is Castle Howard, much visited – and revisited.

Pilsdon Pen. West Dorset, some miles northeast of Lyme Regis. It is fairly easy to climb, and from there, you can see the sea, Marshwood Vale and the countryside beyond.

Purbeck Hills. East Dorset. These run to the sea at Worbarrow Bay, with Corfe Castle to their east. Steeple and Creech Grange are interesting to explore. Just south of the Purbeck Hills, you will find St Alban's or St Aldhelm's Head, with a chapel on the sea promontory, which can be reached on foot.

Quantock Hills. Somerset. The Quantock Hills extend from the Bristol Channel to Taunton. They have gentle slopes, many small villages and cultivated fields. Some of the villages are situated on very steep banks, like the village of Aisholt – the village Wordsworth thought the most beautiful in England. The best way to explore the Quantocks is to cross it by minor roads. The best views are from the crest of the Quantocks on the road from Nether Stowey (which has connections with Coleridge) to Crowcombe. Nether Stowey also makes a good start to the Quantock Forest Trail, a splendid walk which includes Seven Wells Wood with its very tall trees.

Rhondda Valley. Two valleys in fact: Rhondda Fach (small) and Rhondda Fawr (large), running north-west of Cardiff starting from around Pontypridd. Although the Rhondda is one of most extensive coal-mining districts in Britain, it is full of visual interest. The contrast between the industrial landscape and the vivid green surroundings is striking. Strung out along the hillsides, the Welsh villages are full of character. You can reach Rhondda Fawr from Pontypridd via Ystrad. The smaller Rhondda Valley runs from Porth northwards on the B4277, and is perhaps more exciting because it ends in beautiful hills after Maerdy. It is possible to get permission to enter some of the disused pits, or even working ones, and photograph them. The pit machinery against the hills and slag heaps makes a striking picture.

Swaledale. North Yorkshire Dales. Less well-known and less crowded with tourists, Swaledale starts more or less from Richmond. From Richmond Castle, there is one of the best views of Swaledale and Teesdale. On Saturday, market day, there is a colourful view of the market below. For Swaledale itself, proceed to Grinton and Muker on the B6270, and on to Thwaite and Keld, which is perhaps the most attractive of the villages around Swaledale. There, a few hundred yards from the post office, you reach the River Swale among the limestone cliffs, and also Kisdon Force, one of the cataracts cascading down them. This is actually part of the Pennine Way, and four miles north of Keld is the Tan Hill Inn already mentioned above.

Teesdale. Durham. Situated far to the north of the other dales, this can claim to be the most dramatic – especially around High Force, a spectacular moorland waterfall, in upper Teesdale. A little path leads north from the waterfall to the moors beyond. There is another waterfall four miles to the west, Caldron Snout, which is reputed to be the highest in England.

Trough of Bowland. Lancashire. A secluded, lonely stretch of moorland south-east of Lancaster. The best way to see it is to take the minor road from Lancaster to Dunsop Bridge. The road runs across hills, streams and open moorland with only sheep for company. Early on a misty morning particularly, it could reward a visit. Further south of Dunsop Bridge, with its lovely church nearby, the road runs alongside a brook and then along the photogenic River Hodder.

Wenlock Edge. Salop. A straight escarpment, south-east of Church Stretton, Wenlock Edge commands magnificent views, with walks along the top. Some of the surrounding villages in Hope Valley, overlooked by Wenlock Edge, are worth exploring. To the north, near the market town of Much Wenlock, is a steep limestone rock called Major's Leap.

Wensleydale. Yorkshire Dales. It runs almost directly west to east from the end of Garsdale, starting above Hawes. Hawes also may be of interest, because it is still comparatively unspoilt, despite the tourists. The livestock market which is held on Wednesdays is usually a busy affair, particularly in the season. Wensleydale proper runs from Hawes right up to Wensley village. (Unlike most other Yorkshire dales, Wensleydale is not named after the river, which is the Ure, but after the little village of Wensley, which used to be much more important in former times.) As noted in Part II, there are several interesting points along the course of the dale. These include the Aysgarth Falls

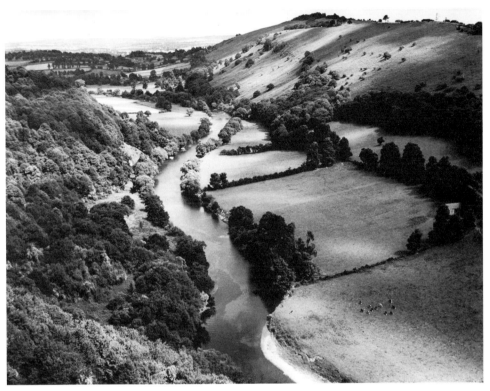

The Wye Valley from Symonds Yat Rock

and, only a mile north of Hawes, lies Hardrow Force. Apart from the main road, which is continuously interesting, you should try a few side roads – the only one past Aysgarth Falls, for instance, running south to West Burton, and following Walden Beck, is very beautiful and extremely photogenic. Another runs along the River Bain, and another along Duerley Beck, starting from Hawes and going on to an extremely picturesque point near Green Side. Several of these roads are dead ends, so you will have to return to the main road.

Wharfedale. Yorkshire Dales. South of Wensleydale running along the River Wharfe. Take the B6160 from West Burton in Wensleydale to Kettlewell. But before that, try making detours towards smaller dales, such as the lovely Langstrothdale in which is the spectacular village of Hubberholme. Later on Wharfedale joins Littondale, described above, and then continues down past Grassington to Bolton Abbey. South of Bolton Abbey, the town of Ilkley is not without interest, with dramatic moors around it, and the famous Cow and Calf Rocks.

Vale of the White Horse. Oxfordshire. On the northern border of the Berkshire Downs. The area is best known for the Uffington White Horse, which can be reached from the B4507, just past Compton Beauchamp. White Horse Hill is easy to climb, but difficult to photograph, as there is hardly a viewpoint – except an aerial one – from which to see the spirited hill carving. On top of the hill is Uffington Castle, the remains of a historic fort, and nearby is the cromlech of Wayland's Smithy. You can drive on to Dragon Hill, reputed to be the hill on which St George killed the dragon.

Wye Valley. Wales, Hereford and Worcester. Rising in mid-Wales, the River Wye flows eastwards into Hereford and Worcester and south near the Forest of Dean, to the mouth of the Severn. The Wye Valley is probably the most photogenic of English valleys. Of the many interesting places on the lower reaches, Goodrich Castle, near Ross-on-Wye, has breathtaking views. Around here, the River Wye performs incredible contortions, turning back on itself like a snake. (It has to avoid the hard ridges of limestone and the coal-bearing rocks of the Forest of Dean plateau in order to reach the sea.) Symonds Yat Rock provides a spectacular view of this loop of the river. Half a mile further on, there are the Biblins, then another U-turn and further on, beyond Monmouth, are several Wye Valley walks. The stretch between Llandogo and Tintern Abbey through the woods offers splendid views. Tintern Abbey itself is superbly set and can be photographed from the little churchyard overlooking it, as well as from the Devil's Pulpit, where the view extends over Tintern Abbey and the valleys below. Parts of Offa's Dyke run parallel to the River Wye, both north and south of Llandogo. South of Tintern Abbey, the valley becomes more built-up and less scenic.

173

DOWNS AND MOORS

Berkshire Downs. An expanse of downland stretching both north and south of Newbury and across the charming Kennet Valley. To the north, the Ridgeway runs across the Berkshire Downs and there are some interesting spots, including the Iron Age hill fort of Segsbury Camp. South of the Kennet River are some outstanding subjects for photography, particularly from Inkpen Hill, Walbury Hill and Combe Hill, where the views are as magnificent as the walks. Combe Hill also contains the famous Combe Gibbet – a curious and lonely gibbet on the downs overlooking a beautiful part of the country. All around are vast expanses of wheatfields, and near Newbury, horses are often exercised on the downs.

Bodmin Moor. A deserted moorland about 12 miles long and 11 miles wide, north of Bodmin in north Cornwall. It is crossed by only one road, the A30 from Launceston to Bodmin, and it is fine walking country. The two highest points of the moor, towering over the horizon immediately north of the A30, are Brown Willy and Rough Tor. These are interesting to see and photograph, but you are recommended to walk to discover the true beauty of the moor.

Dartmoor. Dartmoor Forest is 365 square miles of rugged and desolate country. It is lonely territory, and only a few roads cut across it. (In the northern parts there are several firing-ranges so before going into them you should check whether firing will take place that day. Local papers and post offices carry notices and flags mark the danger areas.) Notwithstanding the hazards, Dartmoor is marvellous to explore from many points. The eastern part is perhaps the easiest because there are several roads through it. One of them, from the village of Bovey Tracey on the edge of the moor, runs past Haytor to the picture postcard village of Widecombe in the Moor. Further west is Postbridge, with its old stone clapper bridge. From there you can go to Two Bridges, and on to glimpse the grim prison at Princetown, or turn right towards Bellever Tor, along a road with some very good views. To the south-east is the famous beauty spot of Dartmeet. But Dartmoor is predominantly walking country – a place for quiet walks, with stops now and again to take photographs, or to climb the great granite tors, from which views are bleak but also highly dramatic. It is country to be enjoyed slowly.

Another interesting part of Dartmoor is further to the south, near the village of Lydford, where there is a very picturesque castle. Lydford Gorge offers spectacular walks alongside the seething waters. Alas, Dartmoor also has one of the worst climates in England, with a very high rainfall, so you should choose your time carefully – although the mists, however treacherous, are also atmospheric.

Exmoor. If Dartmoor is the most rugged and dramatic, Exmoor is the most beautiful moor in Britain. Its beauty lies in its contrasts: contrasts between the smooth, well-cultivated coastal and pastoral land, and the heathlands in the centre of the moor. But there are also the curious shapes of the moorland hills, with their remarkable symmetry of line, which intertwine and recede into the distance.

There are many parts of Exmoor worth exploring. Brendon Common, on the west side, along the B3223 from Simonsbath to Lynmouth, is striking, particularly in the evening light. The celebrated Doone Valley can be reached from Brendon – a rewarding walk of a couple of miles. Dunkery Beacon, further east, is still more ruggedly dramatic, and the views from the top justify the walk. Porlock Bay offers breathtaking views of both sea and land. A major feature of Exmoor is the coast road from Porlock to Lynton (the A39) which is one of the most spectacular in the British Isles, with magnificent views both out to sea and inland – for instance from Yenworthy Common towards the little village of Oare on the edge of the moors. The parallel inland road from Brendon to Oare, and through Oareford and Robber's Bridge to the main road, is also extremely attractive.

Marlborough Downs. A pleasing stretch of downland north of Marlborough and reaching to Swindon. Chalk hills rise to nearly 900 feet and provide a number of promising photographic subjects. The most interesting road through the Marlborough Downs is a side road just past Marlborough off the A345 to Swindon. Turn right after about a mile into the road leading to Hackpen Hill which itself is on the famous Ridgeway. This section of the Ridgeway is a path, about ten miles long, crossing the Marlborough Downs from the south leading past Barbury Castle, the site of the ancient stronghold of which only the ramparts are left. By car, you can reach Barbury Castle from Wroughton by taking the B4005 eastwards and then a minor road to the castle. On the western side of the downs, some miles along the A4 from Marlborough to Calne, you will find the Avebury Circle and some very fine views of the downs themselves.

North Downs. A hilly area south of the Thames valley and roughly following its line. Its western part is in Surrey, and the remaining part in Kent, stretching towards the Dover coast. It is an area to be explored most successfully in spring when the Kent orchards are in full flower. The Kent area of the North Downs also partly coincides with the chronicled Pilgrims' Way to Canterbury, and the North Downs Way can be followed past Colley Hill, through the village of Charing and along Dunn Street. Another picturesque village, Chilham, has timbered black-and-white Tudor houses and a seventeenth-century castle (now a museum). Several rivers cut through the downs: the

Exmoor

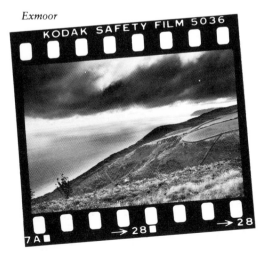

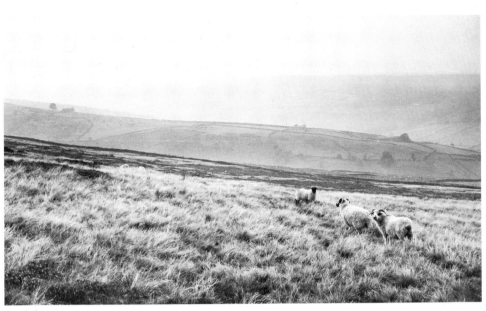

Yorkshire Moors

Wey, Mole, Darent, Medway and Stour among them, and along their banks some charming spots are to be found. The highest section of the North Downs lies between the Medway and the Mole.

North York Moors. This wild district of heather, hills and dales stretches roughly twenty miles from the sea to the Cleveland Hills, from Pickering in the south to Whitby in the north. It is covered by the North Yorkshire National Park. Photographic exploration from a car is possible here because the moors are dissected by many small side roads. Most of the roads off the A170 road from Scarborough to Pickering or along the Rivers Dove and Seven and Hodge Beck are suitable. The A169 road from Pickering to Whitby has majestic views across the moors of ruined farmsteads and the occasional fine tree; there is heather in the autumn. A number of small villages may be used as starting points for exploration: Hackness or Scalby, both close to Scarborough, or Goathland, just off the A169 from Pickering to Whitby, an unspoilt moorland village with several side roads leading off into the moors. Without doubt a sensitive landscape photographer will fully appreciate the North York Moors, but this is an area which should be explored slowly and patiently. Another village, Hutton-le-Hole on the River Dove, is a showpiece, especially in April at daffodil time. Its irregular green is divided by a stream crossed by small white bridges.

Rannoch Moor. A vast wasteland in the northern part of Strathclyde. The only way to reach it is by the A82 which cuts across it. There are stretches of water, with mountains in the background often topped by glorious masses of cloud. The moor can be explored partly on foot, and there are some roads which may be walked, including one from the hotel near Buachaille Etive Moor to Black Corries Lodge. It is possible to negotiate this road with a Land Rover (otherwise it is very difficult), but it leads into an area of wasteland which offers fine opportunities for a photographer. A road to the edge of Rannoch Moor can be taken from Kinlochleven at the eastern end of Loch Leven. This is an untarred road which can only be negotiated in the summer, leading to the Blackwater Reservoir.

South or Sussex Downs. A superb ridge of rolling downland from the Hampshire border through West Sussex ending near the sea at Seven Sisters and Beachy Head. These downs are patterned with rivers, from the River Cuckmere in the east to the Rivers Ouse, Adur and Arun. There are many excellent viewpoints, including Ditchling Beacon, immediately north of Brighton. Four miles to the south-west is Devil's Dyke, a huge cleft in the Downs. To the west, Truleigh Hill, just north of Shoreham-by-Sea, offers some splendid views over the downs. Further to the west, near the village of Washington on the A283, stands Chanctonbury Ring, where there is an Iron Age earthwork and views over 30 miles of countryside. A number of roads along the rivers are strongly recommended to the photographer. A particularly attractive one is the minor road from Horsebridge to Seaford along the Cuckmere River. To the east of this road is the famous Long Man – a figure carved on the hill.

Rannoch Moor

LAKES, RIVERS AND WATERFALLS

Loch Achray. One of the smallest of the lochs in the Trossachs in Scotland's Central Region, and one of the most accessible, as there is a good road around it. The best point to photograph is the western side, where there is a choice of views from the road. On the northern side of Loch Achray is a tiny peninsula jutting into the lake with a little church upon it surrounded by pastures.

River Annan. A Scottish river in Dumfries flowing from north to south and widening out in the valley below Moffat. Its chief interest is the spectacular Devil's Beef Tub, which is a 500-foot hollow among wild hills. The River Annan flows on into Annandale and then into the Solway Firth, passing several castles on its way.

Loch Ard. Another Trossachs lake, south of the main area, which can be reached by the B829 going towards Loch Lomond. It can only be photographed from the road at its northern end. It is particularly attractive near the beginning of the lake where there is a cluster of smaller lakes with fishermen's huts.

Loch Arklet. The most western of the Trossachs lakes, and altered by the great dam which has been built on its western side. It is now much enlarged and in the early morning, when there is hardly any wind, there are some beautiful reflections in it, particularly near the dam. It can be reached either from the Inversnaid Hotel on Loch Lomond (itself only reachable by ferry from the western side of the lake), or alternatively from the Trossachs Lakes, first by the B829 and then left on a minor road.

River Arun. One of the most beautiful of the Sussex rivers crossing rich, peaceful country before it reaches the South Downs, flowing into the sea at Littlehampton. A number of places here could be explored on foot as the Arun flows through a countryside rarely disturbed by roads. The road to Arundel Castle and park follows the river very closely, through some lovely landscape. Between the twin villages of North and South Stoke, the Arun makes a great loop among water meadows.

Rivers Avon. There are three major rivers with the name of Avon: the Hampshire or East Avon, the Warwickshire or Upper Avon and the Bristol or Lower Avon. The East Avon starts near Devizes in Wiltshire and flows through the beautiful Vale of Pewsey and then enters Salisbury Plain, flowing on through Salisbury. Views of the cathedral can be seen from many points on the Avon. From there it becomes more navigable and perhaps less photographically interesting.

The Lower Avon starts in the Cotswolds and flows through Gloucestershire, Wiltshire and the County of Avon. Bradford-on-Avon with its slate-roofed houses climbing the hillside is of interest. Later, the Lower Avon cuts through Bristol and the photogenic Clifton Gorge and suspension bridge.

The Upper Avon is a tributory of the River Severn. It rises in central England and then runs through several counties including Northamptonshire, Leicestershire, Warwickshire and Worcestershire just before ending in Gloucestershire. It flows through many magnificent parts of the country – notably the Vale of Evesham, and also below Warwick and Warwick Castle. The Vale of Evesham is well-known for its scenic beauty, being flanked by the Cotswolds in the south and the wooded Arden districts to the north. The Upper Avon flows through Stratford-upon-Avon. It is navigable for most of its length and is one of the most popular rivers for boats and barges. This river life can be successfully photographed on the Upper Avon.

Loch Awe. Strathclyde. One of the longest lakes in Scotland, with a road running around it. Ben Cruachan, dominating the northern part of the lake offers an impressive view, and on the lake is Kilchurn Castle. The lake roads B840 and a minor road on the other side both run through forests, so the reflections are beautiful, with hills and trees on both sides of the lake.

Aysgarth Falls or Force. A three-tiered waterfall on the River Ure in Wensleydale, just off the main road from Wensley to Hawes. You can get a good view of it from the Elizabethan stone bridge, but still better is the walk from the little gate on the right-hand side of the road through the bluebell wood to the second and third cataracts of the waterfalls.

Lake Bala (Llyn Tegin). The largest natural lake in Wales. A road runs on each side of the lake, the A494 on one side and the B4403 on the other. It is a peaceful place, fed by several small streams, with pastoral landscapes around its wide valley. It may also be worth following the road along the River Tryweryn which flows into the lake. You can follow its course to the north-west along the A4212 and then the B4931 which has mountains on either side.

The Broads. A unique combination of rivers and lakes (mostly man-made) in the north-eastern part of Norfolk. There are about thirty Broads of various sizes, interlinked by the Rivers Bure and Yare. Most of them are quite shallow, and all can be reached by boat, which is perhaps the most interesting way to photograph them. Boats can be hired in many places including Wroxham, Horning and Potter Heigham. It is a little more difficult to photograph the Broads from the road. There are only a few good viewpoints and these can be found between Filby Broad and Rollersby Broad. Rollersby and Ormesby Broads almost touch with only the road (the A149) separating them. There are several parking places, little boats can be hired along both these attractive Broads, and walks can be undertaken from the same spot. Filby Broad is divided by the A1064 and there are several vantage points for photographing. There is also an extensive camping site nearby. Ranworth Broad is an important centre for bird conservation. The village of Ranworth has a little church with access to the tower up some narrow steps. From the flat roof you can photograph the attractive countryside, including Ranworth Broad itself. Hickling Broad, in the northern part of the Broads, is rich in bird life and a respected nature reserve is sited there. The Broads are popular as a sailing centre and, during the season, the rivers, the Broads themselves and their approaches are full of yachts and other boats. The colours in autumn are enhanced by extensive mists which provide interesting photographs.

Caldron Snout. A waterfall on the River Tees dropping some 200 feet down a 450-foot staircase of rocks. It is in a wild setting and some distance from

River Dart

the road. You drive along the B6277 to Langdon Beck where there is a pleasant hotel, and then through some superb countryside. Above Caldron Snout, the path skirts the Cow Green Reservoir. (The dam has been built fairly recently.)

Cautley Spout. A powerful waterfall just north of Sedbergh. You take the A683 from Sedbergh to Cross Keys Inn, from which there is a path going to Cautley Spout, descending 600 feet from Cautley Crag.

Loch Chon. The Trossachs. If you travel by the B829 from Aberfoyle to Loch Lomond you will first encounter another, smaller loch. Early in the morning, the waters of the two lakes are very calm and reflect their surroundings.

River Clyde. Scotland's most important and longest river, discharging its waters into the Firth of Clyde at Port Glasgow. It flows through villages which are largely devoted to the growing of fruit and vegetables. Clydebank and its shipyards provide interesting photographs and to the north, the Kilpatrick Hills offer good viewpoints.

River Conwy or Conway. A Welsh river running north from the Gwynedd Moors past the Conway Falls near Betws-y-coed (just off the A5) and then alongside the Cambrian Mountains through the lovely Vale of Conway towards the sea and the monumental Conway Castle. The A470 follows the river from Betws-y-coed to the sea and on both sides there are appealing side roads, particularly from north of Llanrwst towards Bodnant Garden.

Coquet River. This runs from the Cheviot Hills on the English side of the Borders through a countryside which is particularly fine around Alwinton and Har-

bottle, where there are a number of castles. The river then flows through the Coquet Valley from Rothbury and Rothbury Castle, and Cragside House and Gardens, to end in the sea near Amble, close to Coquet Island and its lighthouse. Coquet Dale is particularly noteworthy near Brinkburn Priory, which can be reached on the B6344.

Cuckmere River. A river running through East Sussex and the South Downs. The lower reaches of the river near Alfriston, Wilmington and the Cuckmere Haven estuary just by the Seven Sisters are the most photogenic, the best sites being on minor roads with a continuous view of the downland. For the Cuckmere River, take the A259 from Seaford to Eastbourne. Immediately past the bridge over the River Cuckmere, take a road on the left going by Charleston Manor and Litlington and then either make a detour to see the Long Man hill figure, or follow the river at Alfriston.

River Dart. Dartmoor. The Dart begins as two rivers – the East Dart which runs through Postbridge, and the West Dart which goes to Two Bridges. The two little rivers join at the spectacular Dartmeet. From there, the Dart runs past Buckfast Abbey which is worth visiting and Buckfast itself, flowing on to the well-known Dartmouth estuary. The picturesque part of Dartmouth is near the ruined stronghold of Bayard's Cove. A good way to explore the Dart valley and to photograph its lower part is to take a river boat through this wooded valley from Dartmouth to Totnes, a distance of about eleven miles. The journey takes approximately 75 minutes and it is not difficult to take photographs from the slowly moving boat. The private steam railway which runs seven miles along the Dart, from Buckfastleigh to Totnes and

back takes about an hour for the round trip – you can board the train only at Buckfastleigh.

River Dee. Wales and England. The Welsh river starts near Llyn Tegid, or Lake Bala, and runs to Corwen and eastwards, meandering through the Llangollen Valley. The best view of the Dee Valley is from Castell Dinas Bran just above Llangollen, or from the Horseshoe Pass on the A542, where the river is overlooked by bleak mountains to the south.

River Dee. Scotland. This rises in the Cairngorms and flows through a magnificent Highland valley, rich in castles: including Braemer, Balmoral and Crathes. It is estimated that there are something like 150 castles along the valley of the Dee and its companion valley of the Don, both of which reach the sea at Aberdeen.

River Derwent. Peak District, Derbyshire. This has been largely altered this century since three reservoirs have been built along its course: Howden Reservoir in 1912, Derwent in 1916 and Ladybower, completed in 1943. The area is now known as a Peak 'Lake District', not only because of the three reservoirs but also because of the often awe-inspiring scenery around them. Further down, the Derwent runs into the grounds of Chatsworth House and then becomes part of Darley Dale between Rowsley and Matlock, with High Tor nearby. There are several places from which it can be well seen including Riber Castle near Matlock and the Heights of Abraham, which are about 750 feet above the town and give a panorama of the Derwent.

Derwent River. North Yorkshire. The river rises on Fylingdale Moor, about six miles from the North Sea, and yet it flows down through the Vale of Pickering, past Malton and Kirkham Priory, through most of South Yorkshire to join the Ouse between Selby and Goole.

River Derwent

Devil's Bridge. On the A4120 about ten miles east of Aberystwyth in Wales. In fact, there are three bridges – the oldest was built in the twelfth century – and now the three bridges, the newest next to the oldest, stand together at the meeting point of the Rivers Mynach and Rheidol above the most spectacular waterfalls.

Lake (Llyn) Dinas. A fine lake south of Snowdon on the A498 from Capel Curig, just past the famed Nantgwynant Pass. As you drive, you are suddenly confronted with the beautiful lake on the left.

Loch Earn. This, and the river of the same name, are in Tayside, Scotland. It is a long lake with a road on both sides. The south side also carries a castle giving views towards Ben Vorlich. At both eastern and western ends, there are interesting villages, the best one being Lochearnhead to the east, especially in the spring when red nasturtiums grow wild on the hills, giving lake and village a glow of colour.

Eas Coul Aulin. In the wild and rugged Highland country far to the north of Scotland is the highest of waterfalls, Eas Coul Aulin. It comes from Glas Bheinn mountain and has a sheer drop of 658 feet – approximately four times the height of the Niagara Falls! It can be reached most easily by a boat from Loch Glencoul. The countryside around is utterly unspoilt as very few tourists travel so far north. While in this district, you may wish to visit the village of Inchnadamph which is honeycombed with caves and set in magnificent scenery. It is a few miles south of the waterfall, on the A837 to Ullapool.

Eden River and Valley. Near Carlisle in Cumbria. Not in the Lake District, but still an attractive and sparsely-populated valley, just off the main A6. You take a side road to Armathwaite and work your way up to the castle ruins at Kirkoswald. Nunnery Woods are also worth a visit.

River Exe. Devon. An energetic river which starts on Exmoor and then winds its way through the Exe Valley. It is particularly beautiful above Tiverton, and then descends towards Exeter and Exmouth.

Loch Garry. Highland. An attractive and not very well-known lake on the way to Loch Ness, off the A82 past Loch Lochy. Turn off on to the A87 and the loch is very close. After a couple of miles the main road leaves Loch Garry; here take the left fork on to the small side road leading into Glen Garry and the little-known Loch Quoich. This is a beautiful area, and almost deserted.

Gordale Scar Waterfall. North Yorkshire. One of the most striking and dramatic sights a photographer may see. (See Pennines section above.) It is particularly impressive after the rains, when Gordale Beck is fuller.

Grey Mare's Tail Waterfall. One of Scotland's highest waterfalls in the spectacular Moffat Gorge, north of Moffat. You take the A708 northeast from Moffat towards Selkirk, and within a few miles, you reach Grey Mare's Tail just off the road.

Llyn Gwynant. At the foot of Snowdon on the A498 from Capel Curig to Beddgelert. The best view is from

the beginning of the Nantgwynant Pass, where the whole valley and the lake can be seen.

Hardrow Force. North Yorkshire. One of the highest waterfalls in England in a magnificent setting just off the A684. Take a side road to the north from Hawes village to Simon Stone, and Hardrow Force is very close. It is a narrow cascade plunging over a lip of limestone and falling some 96 feet into a dark pool surrounded on three sides by tall cliffs.

High Force Waterfall. In Upper Teesdale, reputedly the most spectacular of the moorland waterfalls, dropping about 70 feet over a steep cliff called Great Wind Sill. You take the B6277 north from Barnard Castle and follow Teesdale until you come to the High Force Hotel past the village of Newbiggin. The signposted footpath leads through woodlands of pines and beeches to this famous waterfall.

Loch Katrine. The Trossachs, Central Scotland. It became celebrated through Walter Scott's *The Lady of the Lake* and from then on, visitors have flocked to see it. It is not easy to explore, as the main road goes only to Loch Katrine pier on its eastern side – but there is a steamer which starts from the pier several times a day and it is a marvellous trip across the lake and back, particularly in the evening. At this end of the lake is the famous Ellen's Isle of Scott's novel. There is a road which goes around the lake on its northern side but it is not open to tourists, as it belongs to the Water Board. It is also possible to reach Loch Katrine from the western side, by following the B829 towards Loch Lomond and turning right into the side road immediately opposite Loch Arklet. The road is open for a few hundred yards and the view from there early in the morning can be very exciting.

Lakes of the Lake District

Buttermere. Considered by many to be the most picturesque of the sixteen major lakes. It can be approached from three roads: possibly the easiest and most attractive is from Cockermouth on the B5289 by Crummock Water, the neighbouring lake; the other road, which is much tougher, is from Borrowdale through Honister Pass; and the third is from Keswick across the fells to Buttermere Village. There is a most pleasing walk all around the lake. Yet another walk which could be photographically rewarding is from the B5289 on the eastern side of the lake to Warnscale Bottom, between two high mountains, Haystacks and Fleetwith Pike. From Buttermere village, you can take a path just past the church to the vividly-named Sour Milk Gill Waterfalls. Those who like stiffer walks can take a path which leads right to the top of Red Pike, 2479 feet high. At least five lakes can be seen from the top.

Coniston Water. One of the two most southerly lakes, running almost parallel to Lake Windermere. The road follows the long, thin lake for 5½ miles. It is a side road off the A5084 with lovely picnic spots with wooden benches on the side of the lake. Perhaps the prettiest point is near Machell Coppice. On this lake is Brantwood, the home of John Ruskin.

Crummock Water. A lake about twice the size of Buttermere, to which it is linked on its north side by the B5289. The most attractive area is a ten-minute walk away from the road: the little valley of Rannerdale, running along Rannerdale Beck. From the top of Lanthwaite Hill, 670 feet high, on the north side of the lake there are superb views towards Buttermere and Great Gable beyond.

Derwent Water. One of the largest and most accessible of the lakes on the B5289, Derwent Water becomes very crowded during the tourist season, as Keswick is at its northern end. Worth visiting are the Castle Head immediately south of Keswick, Friar's Crag on the lakeside a few hundred yards away, and the three little islands in the lake. The country immediately to the north is beautiful. It is almost flat, but the mountains beyond could provide some good photographs, particularly early in the morning.

Ennerdale Water. The most westerly lake and the only one not accessible by road. The road stops about half a mile away, and so the lake is only visited by serious walkers. They are rewarded by exhilarating walks along Ennerdale Water, which has several large mountains, including Red Pike, and the beautiful Ennerdale Forest. You can approach Ennerdale Lake from the A595 along the coast, turning by Egremont into the A5086 and then taking a side road to Kirkland, Ennerdale Bridge and Ennerdale Water.

Esthwaite Water. West of Windermere, reached by ferry across that lake and then on through Near Sawrey on the B5285 – there is a convenient road around the lake. This lovely lake is little visited, as it is slightly off the beaten track. Hawkshead, at its northern end, is well-known for its connection with Wordsworth; it has a graceful church on the hill with fine views.

Grasmere. Many people maintain that the best lakes in the Lake District are small ones and Grasmere is one of these, together with neighbouring Rydal Water. Grasmere is immediately north of Windermere and the drive around it gives fine views, but perhaps the finest is on its western side. You drive from Grasmere towards Loughrigg Terrace on a narrow road with not much space for parking but there are superb views both of Grasmere and of Rydal Water on the left.

Rydal Water. One of the prettiest of the small lakes on the A591, about two miles from Ambleside. Rydal Mount was the home of Wordsworth at the end of his life. It would be a pity to miss the walk around Rydal Water, which takes about an hour, or the walk from Rydal itself up to Loughrigg Terrace.

The Tarns. This is a small mountain lake which is quite easy to reach. Take the B5285 from Hawkshead and turn right into a well-signposted side road leading to the Tarns over Hill Fell. There is ample parking space and it is only a short walk to the Tarns, but more adventurous and interesting is the walk round it, which should take about an hour. The Tarns is dotted with little clumps of trees, some growing out almost into the lake and there are several wooded islands. Late evening is possibly the best time to photograph here.

Ullswater. Second largest lake in the Lake District. If you want to go all the way round, you will have to walk, but the A592 from the south goes through Patterdale village and along the northern side of the

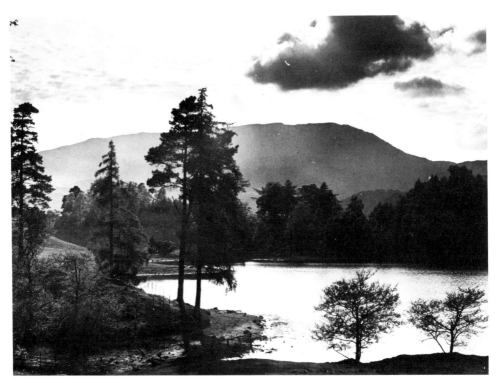

The Tarns

lake to the end at Pooley Bridge. It is worth taking the little road from Pooley Bridge along the south-eastern side of the lake, even though it is a dead end. Swarthbank and Howtown offer beautiful views of the lake, but a more remarkable view can be obtained by climbing Hallin Fell Beacon.

Wast Water. Possibly the lake the least frequented by tourists – except for serious mountaineers, as it is the centre for climbing the challenging Scafell Pikes. The area is rugged, and awe-inspiring rather than pretty, particularly since the mountains come very close to its southern side. Travel north on the A595 past Bootle, and take a side turning to Santon Bridge and Wast Water. The road goes only as far as the climbing centre at Wasdale Head.

Windermere. The largest of the lakes. There are very few glimpses of mountains from its sides as the banks of the lake are heavily-wooded. Opposite Windermere railway station, there is a path going north to Orrest Head, from which you can see the lake and the countryside around. To the south-east of Windermere is the village of Bowness-on-Windermere which offers fine views of the lake. There are fourteen islands in Windermere, and during the season, boats constantly travel up and down the lake. The best, but possibly most difficult, view to capture is from the mountain of Gummer's How. This can be reached from Fell Foot on the A592 which runs along the eastern side of the lake. Take the steeply-rising side road and in about two miles, there is a path marking out the half-mile climb to the top of Gummer's How.

Loch Leven. Highland. The lake is immediately north of Glen Coe. It can be driven round, and there are a number of parking spaces provided. You follow the A82 from Glen Coe Pass, turn on to a side road and go round the lake, and rejoin the A82 and drive on to Fort William and Glen Nevis.

Loch Lomond. The largest and perhaps most beautiful of the Scottish lochs and therefore a great tourist attraction. There are many good sites from which to photograph Loch Lomond along the main A82 on the western side of the loch. A different angle can be obtained by leaving Dumbarton on the A82 and then taking the A811 to Gartocharn. From there, it is a short walk to Duncryne Hill. Although it is only 450 feet high, it gives a splendid view of the loch at its widest point as well as its many islands. You could follow the A811 east to the B837, a little-used road which comes to an abrupt end a few miles beyond Balmaha. Balmaha Bay is immediately opposite the island of Inchcailloan, which is one of the more important nature reserves on Loch Lomond. Probably the best way to photograph Loch Lomond is to take a steamer. Day tours in the summer last about three to four hours on 'Maid of the Loch'. Worth visiting are the remains of the castle on Inveruglas Isle, and the village of Luss accessible on the A82.

Llyn Llydaw. A spectacular lake reservoir at the foot of Snowdon, with no access by road. It can be seen from the Snowdon Mountain Railway, and from the top of Snowdon, or reached by a scenic walk from the eastern end of the Llanberis Pass. Llyn Llydaw is only

a short walk from the road. Well worth the effort.

Lake of Menteith. The most southerly of the Trossachs lakes and the only one to be called Lake rather than Loch. It can be reached from the A873 from Stirling which is about ten miles away, and can be seen from only two sides, the north and the east. There are no roads, or even walks, on the other side of the lake. It is a lake with no large mountains above it. The most interesting part is the little island of Inchmahome which has a ruined Augustinian Priory. The ferry sails from the Port of Menteith several times a day to Inchmahome which can be photographed from all sides.

Meon River. A pretty river in Hampshire, flowing south to the Solent through the Meon valley, passing the attractive villages of East and West Meon.

Loch Morlich. One of the most beautiful Scottish lakes, at the foot of the Cairngorms. Take the A9 and turn east near Aviemore on to the B951, and then into a little road running to the loch along the River Luineag. It is worth walking around the lake. The eastern part is particularly beautiful and on the western side, there is the extensive Rothiemurchus Forest, with a side road running through to Rothiemurchus Lodge on the other side of the forest.

Loch Ness. In the northern part of Scotland in the Highland Region, running from Inverness to Fort Augustus. One can drive around Loch Ness. The best place to photograph the loch is from Drumnadrochit beside Urquhart Castle. It is elevated here, so that a large portion of Loch Ness can be seen. It is the deepest, as well as the darkest, loch in Great Britain.

River Ouse. Sussex. It runs through Lewes, then cuts through the chalk ridges of the South Downs to join the Channel at Newhaven. One of the famous beauty spots on the Sussex Ouse is Barcombe Mills. This is a favourite spot for anglers, and can be reached by a minor road from Hamsey, just north of Lewes.

River Rother. An East Sussex river flowing through hopfields and orchards, and past a number of castles, including moated Bodiam Castle, which is on the riverbank. The river flows by Romney Marsh to enter the sea at Rye. By the estuary of the Rother is another interesting castle, Camber.

Scale Force. An impressive 100-foot waterfall, the highest in the Lake District. It can be reached on foot from the western side of Crummock Water.

River Severn. The longest river in Britain, it rises in the Plynlimon Hills in Wales, then flows through Llanidloes. Beyond Welshpool, it turns its course towards England and the old industrial district of Iron-Bridge, made beautiful by the Severn Gorge. It then follows the course of the Vale of Gloucester through Gloucester, finally making a last loop through Westbury Court Gardens before entering the Severn Estuary.

Sour Milk Gill Waterfalls. There are two waterfalls with the same name: one in Borrowdale and the other beside the village of Buttermere, north of the lake, reached by a lane to the south of the village. The abundance of white spray created as they fall, have given them their name.

River Spey. A great Scottish river flowing north-east towards Spey Bay. After Grantown-on-Spey, it flows along the magnificent valley of Strathspey, cutting terraces through the glacial deposits. You can follow this part of its course on the A95. Many distillers of Scotch whisky have used its waters for their finest blends.

River Stour. There are two river Stours. The first is in East Anglia, flowing eastward through part of Essex and Suffolk passing farmland villages and the little towns of Clare and Sudbury. In its latter course, when it reaches Dedham Vale (painted by Constable), it becomes wider, flowing through very beautiful countryside, bounded by willows and poplars. This is where Flatford Mill and Constable's birthplace at East Bergholt are situated. The second, Kentish, Stour, flows from west to east through the North Downs and the cathedral city of Canterbury, ending at the north end of the Straits of Dover. It flows by the attractive villages of Chartham and Chilham, the whole valley being photogenic.

Tamar River. Bordering Cornwall and Devon. Particularly attractive in the deep valley it has cut through wooded country between Tavistock in Devon, and Callington in Cornwall. Its estuary both above and below Saltash is worth visiting.

Loch Tay. A long and beautiful loch in Tayside. It is possible to drive on both sides of the lake. The main road is the A827 from Killin to Kenmore on the north shore. Because of the narrowness of the lake, you can always see the reflections of the opposite bank.

River Tees. A splendid Durham river which flows from the Pennines through rugged country with two waterfalls, Caldron Snout and High Force. It then enters the valley of Barnard Castle, and in its lower course, on the way to the North Sea, flows through the largely industrialized areas around Darlington and Teeside.

River Teme. Predominantly in Shropshire and Hereford and Worcester, the river starts in the Welsh hills and then flows through Knighton across Offa's Dyke. From there, the Teme flows through Ludlow near Ludlow Castle, through Tenbury Wells and on to join the River Severn near Worcester. Take either the B4355 from Knighton or the parallel smaller road to Llanfair Waterdine. It is also worth following the side road across Offa's Dyke to Clun and its castle.

River Test. An outstandingly beautiful Hampshire river famous for trout fishing. The river rises near the little village of Ashe, collecting many tributarie, becoming wider and quite shallow. Because it starts from chalk hills, it is exceptionally clear. It does not often run as one stream, but as two or even three parallel streams which sometimes join together. There are many lovely places along the river as it flows through water meadows and reeds dotted with fishermen's huts. One such is Longstock, just off the A3057 near Stockbridge. As well as being one of the most beautiful, it is also possibly the most expensive of fishing spots.

River Teviot. Borders, southern Scotland. The A698 between Hawick and Kelso follows the river and the valley of the Teviot. In Kelso, it flows in a wide stream

181

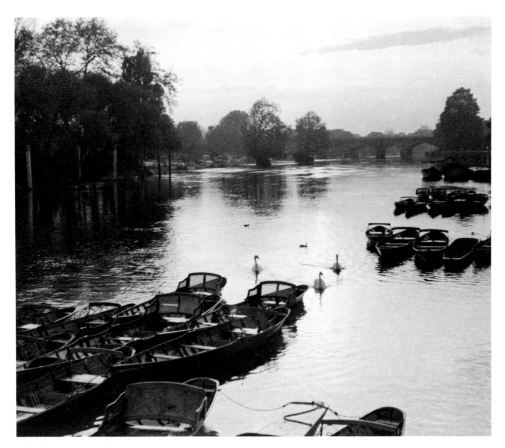

The Thames near Richmond

beside the castle where anglers fish for trout, and joins the River Tweed.

River Thames. England's greatest river rises in the Cotswolds and winds 210 miles eastwards through London to the North Sea. There are a number of books about the river and the places which are worth visiting along its long and lovely course. Most of the Thames is navigable, and it is extremely popular with yachtsmen and boatmen in general, and a river trip could produce some striking photographs. A number of inviting pubs line its course, and there are many good places to hold picnics. The most popular parts of the Thames are its reaches from Oxford to London when it meanders through Berkshire and Oxfordshire. From Abingdon to Goring, the river flows through many locks. You can reach Abingdon from Oxford on the A34 and then follow the course of the river on the A415 towards Dorchester. Cross the river to Wittenham Clumps, from which there is an excellent view of its curving course. There are picturesque stretches at Wallingford and Goring, where it is worth taking the B4526 and then a side road leading to Mapledurham, a secluded village with a lock. Nearer Henley-on-Thames and Marlow, the river is continuously attractive, and any of the roads along

the banks are worth following towards Cookham. Approaching London, the river is particularly beautiful at Richmond, and it can be photographed from the woody terraced gardens on Richmond Hill. Greenwich is magnificent with its fine architecture, and Greenwich Park and the Old Royal Observatory provide panoramic views of the Thames. Beyond London, the Thames flows through an industrial and commercial landscape which is not without its photographic possibilities. In their differing ways, the Surrey and Millwall Docks, the Isle of Dogs, and the dock at Rotherhithe are sites worth photographing.

Loch Torridon. A sea loch on the western coast of northern Scotland in Highland, amongst the wildest scenery in this part of Scotland. It can be reached from Glen Shiel by the A87, taking the A890 for part of the way, and then the A896 along Loch Carron.

River Trent. Midlands. Interesting photographically where it flows through the Fens, particularly near the Isle of Axholme where it can be followed, north of Gainsborough, by little roads on both sides. The villages of Stockwith and Wildsworth are both visually exciting. In its lower course, the Trent goes through many fine places including Gainsborough itself, an

attractive Lincolnshire town, but is perhaps at its most interesting when it flows through Staffordshire past the famous potteries at Stoke-on-Trent, a perfect subject for industrial photography.

The Trossachs. In central Scotland. These lakes have been discussed separately.

River Tweed. In the southern Scottish borders. A river evocatively described by Sir Walter Scott. It flows through Melrose with its Abbey and down past the ancient abbey of Dryburgh, to join the River Teviot in Kelso. Closer to the North Sea, it skirts many magnificent Scottish castles, notably Neidpath and Norham, which stands ruggedly, high above the Tweed, providing a very good viewpoint.

Usk River. Powys and Gwent. A clear river, photographable from its source on the Black Mountain. It flows through a valley with views of the mountains, and green banks on either side of it. The stretch of the A40 from Sennybridge to Brecon is especially worth following.

Loch Venachar. Central. Possibly the least attractive of the three main Trossachs lakes, but the lake you first encounter when driving from Callander first by the A84 and then on the A821. This road runs along the northern bank, but there is a far more attractive road on the other side which is a dead end.

Virginia Water. Surrey. The nearest lake to London, being less than thirty miles south-west of it. It embraces a considerable part of Windsor Great Park and is a popular area for picnics. It is advisable to avoid the high season and weekends.

Loch Voil and Loch Doine. Loch Voil is the larger of the two lakes. Loch Doine is almost connected to it and somewhat smaller. Both of these lochs lie north of the Trossachs. You can reach them by following the A84 northwards and turning left at Kingshouse along a dead end road, which follows the northern side of the lakes. Both are spectacular, and being just off the tourist circuit they never become overcrowded. Both lakes are set in beautiful countryside particularly to the north. It is difficult to reach the southern parts. There is a small road with camping spaces which runs along Loch Voil to Muirlaggan, which you are advised to take for the view across Loch Voil to the mountains beyond.

Lake Vyrnwy. Central Wales. Can be reached from Welshpool by taking the A490 to Llanfyllin and then the B4393. It is a long lake beautifully set in wooded hills.

River Wye. One of the loveliest rivers in Britain. Its lower reaches have been described under the Wye Valley, but its upper reaches are at least as lovely and not so often photographed. The Wye rises in the moorland of central Wales from a tiny spring in the Plynlimon Hills. It is already very beautiful on its way from Llangurig to Rhayader, along the A470 which accompanies it, but the further down you go, the more attractive, narrow and photogenic it becomes. After Newbridge-on-Wye, you are advised to take the side road which follows the loop of the river as far as Builth Wells. From Builth Wells down towards Glasbury, the valley is guarded by castles including Llangoed and Boughrood. Then the river curves gracefully round towards Hay-on-Wye. Clyro village lies nearby on the A438 and the village of Bredwardine, a little way downstream on the B4352, is also extremely attractive. From there it flows on to Hereford and becomes the already described Wye Valley.

River Wye

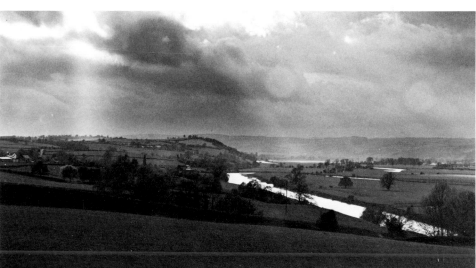

THE COAST

Beachy Head. East Sussex. The highest cliffs on the south coast, a few miles from Eastbourne, and popular with tourists. The cliffs tower 500 feet above the sea, with a lighthouse at their base. The view, on a clear day, is very stimulating, but it often tends to be windy.

Bedruthan Steps. Cornwall. Fantastically shaped cliffs, one of them, the famous Queen Bess's Head. The rocks are magnificent especially when the surf is crashing against them. There are many coves and tiny beaches. One of the finest pieces of coast scenery in the area. Take the B3276 north from Newquay and it is just past St Mawgan.

Budleigh Salterton. Devon. A few miles to the east of Exmouth. This is a quiet seaside resort, not of any particular photographic merit, but the walk along the red cliffs provides a fine view over the pebble beach and the whole of Lyme Bay.

Covehithe. Suffolk. Not far from the hamlet of Covehithe, the coast offers crumbling coves, their beaches dotted with huge boulders. Take the A12 south from Lowestoft, and a side road to the sea. Covehithe is about five miles down.

Durdle Door. Dorset. One of the finest views on the southern coast. East of Weymouth and next to Lulworth Cove. There are two bays immediately below sheer cliffs, divided by a limestone arch which juts into the sea. Early in the morning against the sun it makes a good picture. The entrance is through a caravan park.

East Neuk. Scotland. A fine coastline along the Fife promontory, on which is the village of Crail with its attractive harbour. Further south, at St Monans, is an interesting old kirk by the sea.

Flamborough Head. Humberside. A picturesque promontory just north of Bridlington, reached on a side road from the A165 from Bridlington to Scarborough. The headland is surrounded by coves and rockpools which can be explored at low tide. It is not good for swimming but is for photography.

Formby Sands. Lancashire. South of Southport. Many miles of beautifully-shaped sand dunes along the sea, particularly photogenic at sunset.

Gower Peninsula. Wales. The little peninsula running down from Swansea is of great interest, and the coast from Mumbles right round to Llanelli is superb.

Budleigh Salterton

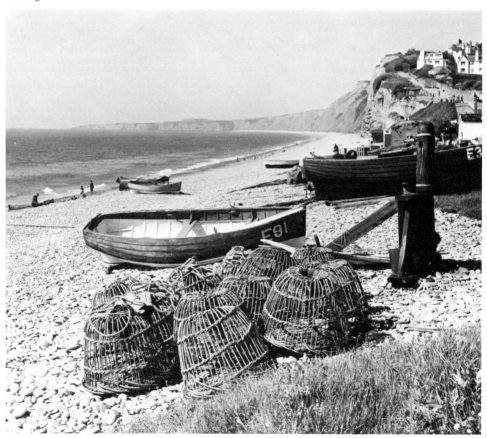

Notable points are Oxwich Bay, the village of Rhossili, with its bay, and Worms Head. An interesting photographic subject can be found in the northern part of the Gower Peninsula by Penclawdd on the B4295. Here, cockle-gatherers ride on ponies and donkeys across the sands to the cockle beds of the Loughor Estuary.

Hartland Point. The north-western tip of Devon. Drive from Bideford on the A39 past Clovelly, take the B3248 and then a side road to Hartland Point. There is a large car park next to a lighthouse and a splendid cliff walk of about two miles, among fields high above the sea. A mile or so south is Hartland Quay, under an impressively rugged cliff.

Hunstanton. North Norfolk. A holiday resort on the Wash. There are some beautiful brown and white cliffs not far from the resort, and the whole coast is photogenic, with flat sands textured in patterns at low tide. About half a mile north is Old Hunstanton, and among the dunes of the beach, a straggle of holiday shacks.

John O'Groats. Highland. Not quite the most northerly point in Great Britain (that's Dunnet Head), with views across the eastern tip of the country and the sea beyond.

Kennedy's Pass. Girvan, Strathclyde. The most dramatic piece of coastal scenery along the road from Girvan to Ardstinchar Castle. The 1100 foot high rock of Ailsa Craig, ten miles off the shore of Girvan, is a nesting ground for many birds. A number of castles are worth visiting. Drive from Girvan on the A77 past Woodland Bay to Bennane Head and Ballantrae to Downan Point. A marvellous coast.

Land's End. Cornwall. A mass of dramatic cliff scenery at the south-western tip of Britain. You drive from Penzance on the A30 down past Sennen Cove towards Land's End. There is a large parking area and you can explore the cliffs.

Laugharne and Laugharne Bay. Dyfed. A very fine sandy bay, especially at low tide and early in the morning. This is the place where Dylan Thomas wrote *Under Milk Wood*. There are also the ruins of a castle on the crags across the bay. Take the A40 from Carmarthen and at St Clears, the A4066 to Laugharne.

Lindisfarne. Holy Island, off the east coast, south of Berwick-upon-Tweed. You take the A1 from Berwick and turn towards the sea on the minor road to Beal. From there is a three-mile causeway, which can only be taken at low tide. (It is easy to be cut off on the island for some hours at a time.) Do not miss the brooding castle or the ruins of the eleventh-century Benedictine Priory. Masses of birds and sometimes even seals can be seen off shore.

Lizard Point. Cornwall. The most southerly point in Britain with majestic rocks and coves – particularly Kynance Cove with red, green and purple cliffs, composed of the stone called Serpentine. Next to it, the Devil's Bellows rocks are worth visiting; in a rough sea, the waves hurl themselves furiously against them. Not far from there is Mullion Cove, a popular natural harbour. Drive to Lizard Point on the A3083 from Helston and you will pass by Goonhilly Downs,

Formby

which in May and June are aglow with wonderful colours.

Lleyn Peninsula. Gwynedd. A dramatic peninsula which it is possible to drive around. The coastline is different from the rest of Wales, more mountainous and rugged, with the mountains sometimes dropping sheer to the sea. Very few trees, lonely vistas with small settlements tucked in to the mountains and fishing villages. The most southerly part near Uwchmynydd (opposite Bardsey Island) offers a ruined abbey and splendid cliff scenery.

Lulworth Cove. Dorset. One of the more famous beauty spots in the South of England and visited annually by many tourists. It is a beautiful bay, surrounded by a tight circle of caves. (Nearby is Durdle Door, already described.) From Wareham, you take the A352 and then turn into the B3070.

Morecambe Sands. Lancashire. An unpretentious seaside resort. It is photographically worth visiting because of its unusual beach which grows huge at low tide. A walk along the great expanse of sand at this time can be interesting, with glorious clouds and the tiny figures of people against an immense horizon of sand.

Mull of Galloway. Dumfries and Galloway. In the most southerly part of Scotland, at the tip of a narrow peninsula called the Rhins. This beautiful peninsula is rarely visited by tourists. It has the extraordinary Logan Gardens, with tropical plants that grow in the warmth of the Gulf Stream which washes the coast. Wonderful scenery, rocky promontory and ancient earthworks at the point.

The Needles. Isle of Wight. The western tip of the island with huge and dramatic chalk stacks. The many-coloured sands of Alum Bay are sold to tourists in little bottles. There is a chairlift which takes you to the top of cliffs from which there is a lovely view of the bay below. Possibly even more rewarding is a walk or drive to Tennyson Down and further on to Freshwater Bay, which also has a number of powerful and dramatic rock formations.

Pembroke Coast. South-western Wales. The whole area of the Pembrokeshire coast (now Dyfed), including St Brides Bay, has been declared a National Park because of its outstanding beauty. Everywhere there are splendid views of the sea and the rugged rocks. In the south, you should try to visit St Ann's Head. Go from Haverfordwest to Dale on the B4327 and from there, take the small road leading right to St Ann's Head and the lighthouse. Further north is St David's Head and one of the smallest cathedrals in Britain. The whole of St David's peninsula is extremely interesting with Ramsay Island a short trip across the bay. Whitesand Bay near St David's Head is one of the finest in this part of Wales. A good viewpoint for St Brides Bay is on the A487 north from Haverfordwest where the road dips towards the sea at Newgale. In the southern part of St Brides Bay is Wooltack Point on the tip opposite Skomer Island. You can reach it by taking the B4327 and then a side road to Marloes and Wooltack Point. Further north, Strumble Head and, especially, Dinas Head are magnificent sights.

Porlock Bay. Somerset. A beautiful bay surrounded by cultivated fields with a road descending at the gradient of 1:4, offering new vistas every few hundred yards. A place to visit is Porlock Weir, a tiny bay surrounded by a group of attractive, whitewashed cottages. The secluded village of Culbone can only be reached from Porlock Weir by a walk of two miles.

Portland Bill. A strange, treeless peninsula south of Weymouth in Dorset. The Portland stone, with which St Paul's was built, is still quarried here. It has an incredible sweep of semi-circular sands which could make attractive photographs, particularly when picking out sections of the houses and bay with a long-focus lens. The castle is also well worth visiting.

Prawle Point. Devon. A fearsome seascape which can be reached only by walking some distance. Take the A379 east from Kingsbridge and then a side road crossing the creek at Frogmore to the little village of East Prawle. The open sweep of bracken-covered cliffs contrasts with the deep secluded valleys behind.

St Abb's. Borders. An unspoilt fishing village surrounded by crags, some of them rising to 300 feet. St Abb's Head itself dominates the village, with its lighthouse. The whole area, but particularly the rocks north towards the Wheat Stack, is very photogenic. You can get there by taking the A1 from Berwick-upon-Tweed, and then turning along the B6438 to St Abb's.

St Govan's Head. Dyfed. You can reach it from Pembroke in South Wales, taking the B4319 south, and then taking a side road to Bosherton and St Govan's Head. This is a rugged piece of countryside with splendid rocky landscapes, but most remarkable is the little chapel, built into a cleft of the rock, on St Govan's Head. You reach the chapel by 52 stone steps down from the cliff top – and it makes a fascinating photograph.

Seven Sisters. East Sussex. There is a remarkable 1½ mile walk along the Seven Sisters cliffs. You can reach it from Seaford on the A259 and then by walking towards Cuckmere Haven and Seven Sisters. It is a popular spot during the holiday season, with many walkers about, but at other times it can be remote and very beautiful. There can be high winds and the cliffs are dangerously steep. It is probably better to photograph the Seven Sisters from South Hill on the other side of the Cuckmere River as this gives a splendid view of these curving white rocks and the pebble beach below.

Spurn Head. Holderness, Humberside. A hook-shaped piece of land off the Holderness Peninsula. You can reach it from Kingston Upon Hull by the A1033 to Patrington, then the B1445 to Easington and a side road to the headland. It is a very narrow peninsula, sometimes no more than 150 feet wide, with masses of birds. It is a nature reserve, and parking is limited, so you should check before going there. The sea here, particularly when rough, offers interesting photographs.

Start Point. Devon. A rugged headland with its lighthouse jutting into the Channel and overlooking the sweep of Start Bay. It can be reached from the A379 from Kingsbridge to Dartmouth by taking a side road from Salcombe. The countryside behind is all steep valleys, honeycombed with high banks and deeply set roads.

Sutherland Coast. Highland. On the northern part of the A838 and the A836. A sparsely-inhabited area seldom visited by most photographers. The road runs mainly about a mile inland with a sprinkling of lonely villages and sandy beaches along a rocky coast line. The two lochs, Kyle of Tongue and Loch Eriboll, are worth stopping for. There are no towns for about 80 miles, just a few hotels and refreshment places. Essentially a wild and isolated part.

Tintagel Head. A promontory on the rugged coast of north Cornwall. You can reach it by taking the A39 south-west from Bude, and then turning along the B3263 going to Tintagel and Boscastle. The ruined castle is associated with Arthurian legend. The neighbouring rocks overlook the castle and fields, with fine views. The sunsets can be beautiful.

Trevose Head. Cornwall. A dramatic coastline, jutting out into the sea. From the tip of Trevose Head, you can see the coast both south and north, particularly south towards Dinas Head, with Constantine Bay nestling below it. The lighthouse is also worth visiting. You can reach Trevose Head from Padstow by taking the B3276 to St Merryn and then a side road towards the sea.

Walney Island. Off Barrow-in-Furness, Cumbria. A residential island, with a good road running to it via a bridge. Neighbouring Piel Island can be reached by boat from Roa Island, which is connected to the mainland by a causeway. The only other building on the island, apart from the superb ruins of Piel Castle, is a pub. It is an attractive island with a very good bird sanctuary.

Welcombe Gap. Devon. A cliff with rock jutting out in parallel ridges towards the sea for several miles. It can be found from tiny Welcombe village, a few miles south of Hartland Point. You take the A39 from Stratton northwards, a side road to Welcombe and then walk.

White Cliffs of Dover. A moving sight when crossing the Channel to Dover Harbour. On the left are the famous white cliffs, and on the right the castle. The port itself is not especially photogenic, but the walk along the cliffs is still a romantic one.

MARSHES AND FENS

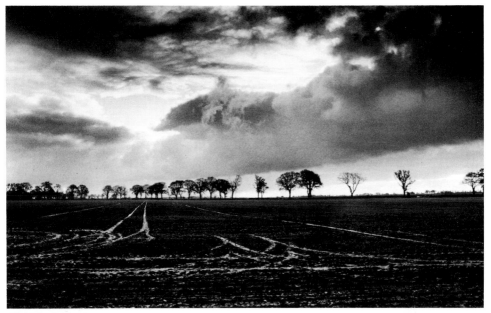

The Wash Marshes

Blakeney Marshes. On the north Norfolk coast, east of Hunstanton, the Blakeney Marshes lie between the villages of Blakeney and Cley-next-the-Sea. There are rare marsh flowers and a bird sanctuary.

Borth Bog. Borth Bog, with its many rare plants, lies between Aberystwyth and the Dovey Estuary. To reach it take the A487 from Aberystwyth, and then the B4353 to Borth and on to Foel-ynys. The minor coastal road from the village of Foel-ynys provides splendid views of the saltings and marshes of the Dovey Estuary.

The Fens. This low-lying marshland used to stretch over an enormous area, roughly from Newmarket in Cambridgeshire to Lincoln beyond the Wash. Effective drainage began in the seventeenth century, and most of the land is now under cultivation. In the early nineteenth century there were hundreds of pumping windmills draining the fens. These were gradually replaced by steam pumps, which in turn gave way to electric and diesel engines. Only a few scattered windmills remain.

At certain times of the year the fens are a sea of colour. In April, the fields around Spalding become a mighty patchwork of flowering tulips. The lavender crop near Heacham flowers in July and early August, while the flower- and fruit-growing area around Wisbech is best visited in blossom time.

Many of the early drainage channels survive, overgrown but still in straight lines, creating pleasing geometric patterns. High viewpoints are difficult to find, though. The original fens have been preserved in small nature reserves, the most important of which is Wicken Fen. An undrained stretch of fenland along the little New River, it is rich in marsh plants and wildfowl. Wicken Mill is worth a visit.

You can reach Wicken Fen by driving from Newmarket on the A142 towards Ely, and taking the A1123 past Fordham on the left. Shippea Hill, on the A1101 off the A10 going north from Ely, provides a good vantage point (even though it is still below sea level). The flatness of the landscape emphasizes the skyline. The light is subtle and changeable, and the sunsets are magnificent. March, on the A141 northwest of Ely, is also fairly high and offers fine views of the Fens.

Romney Marsh. A flat, lonely marshland near the Kent coast. Reclaimed from the sea over the years, the area is crossed by a maze of water channels. Until the early nineteenth century it was a haven for smugglers. The land is used for sheep grazing and, more recently, tulip-growing. It is often misty in the evenings, even in mid-summer. Two interesting villages, Brookland and Appledore, overlook the marsh. To the south lies Rye, once a fortified seaport, an unspoilt and picturesque town. The Romney, Hythe and Dymchurch Railway runs along the coast.

The Wash Marshes. This is the area around the coast which stretches from Boston and Skegness in Lincolnshire to King's Lynn and Hunstanton in north Norfolk, a distance of about fifty miles. Walls and dykes prevent the sea from encroaching upon the fertile, reclaimed land. There are few roads. Although completely flat and windy, the region is photographically rewarding. There are often stunning cloudscapes. Dawn on the marshes can be very beautiful. Well worth a visit is the village of Freiston Shore near Boston, which lies on the Wash, and has walls protecting it from the sea. The desolate area west of King's Lynn towards the Wash is also interesting, especially around Gedney Drove End and Nene Outfall. You can reach Gedney Drove End by taking the A17 from King's Lynn and turning right immediately after the River Nene canal, and then threading through the by-ways.

187

VILLAGES

Abbotsbury

Abbots Bromley. Staffordshire. A charming village of warm stone, partly encircled by hills, containing ancient buildings, particularly the church. It is famous for its annual Horn Dance on 4 September, which is fascinating to photograph. Abbots Bromley can be reached from Burton-upon-Trent by taking the B5234.

Abbotsbury. Dorset. One mile from the sea and surrounded by green hills. A particularly exciting vantage point is St Catherine's Chapel at the top of a 250-foot hill. Follow the lane past the church to the fifteenth-century tithe barn built by Benedictine monks. The field behind this imposing ruin provides another view of the village and the church. The swannery, created by the monks, still flourishes. The Admiral Hardy Memorial can be seen clearly from the nearby car park. In the spring, there is an exotic display of camellias and magnolias in the village gardens. The village is easily reached from Bridport or Weymouth on the B3157.

Aberedw. Powys. Situated beneath a high ridge overlooking the River Wye. It is small, secluded and very photogenic. A footpath runs from the churchyard down to the river. The ivy-covered post office is one of the most picturesque in Wales. You can reach the village from Builth Wells by the A481 and then the B4567.

Abinger. Surrey. Near to London, the village still has its old whipping post and stocks. Nearby Abinger Hammer proudly displays a hammer clock on the main road which would make an interesting subject to photograph. Take the A25 from Dorking and turn left after Wotton on a side road to Abinger.

Aisholt. Somerset. In the Quantock Hills. Situated on a hill, Aisholt has a fine small church. From the church-yard, there is a magnificent view of the Quantocks. Wordsworth thought Aisholt one of the best villages in England.

Aldbourne. Wiltshire. Set on hills high up on the Marlborough Downs and commanding a superb view. Noteworthy are the old village green, the duck-pond, and some pretty thatched and colourwashed cottages. The twelfth-century church is also worth visiting. From Hungerford on the A4 take the A419 north-west to Aldbourne.

Aldworth. Berkshire. Charmingly placed red-tiled village on the hill above Goring-on-Thames, with beautiful views around. Sunsets at Aldworth are well worth waiting for, and don't miss the church because inside are some of the strangest effigies – tombs for what seems to be a family of giants. From Newbury on the A4, take the B4009 to Aldworth.

Alfriston. East Sussex. The capital of the Cuckmere Valley. On the edge of the green is the Clergy House, the first building ever bought by the National Trust. The winding High Street is rich in old buildings (especially inns). To the west of it are The Twittens, narrow footpaths with tall flint walls. A market cross and fourteenth-century church complete the scene. West of Polegate on the A27, take a side road left to Alfriston.

Allendale Town. Northumberland. Situated some 1400 feet above sea level and beside the gorge of the River East Allen. Scattered throughout the dale are the ruined chimneys and furnaces of the old lead workings. The lanes to nearby Hexhamshire Common are worth photographing. At New Year, the villagers stage a curiously pagan ceremony, carrying barrels of blazing tar on their heads to a bonfire in the market place. From Hexham on the A695, take the B6305 and then the B6295 towards Allendale Town.

Amberley. West Sussex. On the crossing of the South Downs Way, and a favourite spot for walkers. There are several delightful pubs. Marsh and river views can be seen from the south face of Amberley Castle which stands massively behind the church. The village is at its best in late spring and summer when the cottage gardens are full of flowers. It can be reached from Arundel on the A284 going north, and turning right on to the B2139 to Amberley.

Applecross. Highland. Neat and tree-lined village on the edge of the sea, surrounded by enormous mountains. To reach it, you need to drive along steep mountain roads. While the mountains dominate the view to the east, westwards there are islands, sea and beaches with white and yellow sand. You can reach Applecross from the A896, taking a side road immediately after Loch Kishorn through the mountains to Applecross.

Arisaig. South Morar, Highland. Just south of Skye. Surrounded by crags and mountains with a little harbour and fantastic views of the sea and the islands close by. Totally isolated, since the A830 leads to Mallaig and no further. From Mallaig there are ferries to the Isle of Skye.

Ashmore. Dorset. Situated 700 feet up on Cranborne Chase, Ashmore is the highest village in Dorset. From practically every point in the village, there is a beautiful view of surrounding countryside. The village itself is exceptionally attractive with thatched cottages and a duckpond. You can reach it travelling south-east from Shaftesbury on the B3081.

Askham. Cumbria. Off the tourist track, just east of Ullswater. You can reach it from Penrith by taking first the A6 southwards and then taking a side road to the right at Hackthorpe. The village has two greens. Rocky Pennine views all around. The romantic ruin of Lowther Castle towers above the village and the

prospect from the village of castle and mountains is superb.

Ashford-in-the-Water. Derbyshire. The clear waters of the River Wye wander through this limestone village with its three old bridges. Behind the church are traces of a moat. Water is the visual theme of this village; a well-dressing ceremony is held on Trinity Sunday. Off the A6, north of Bakewell.

Balquhidder. Central. Stone cottages, a ruined kirk and a Victorian church at the eastern end of Loch Voil. Off the beaten track. You take a side turning from the A84 to the loch itself and the village. Surrounded by the steeply-wooded Braes of Balquhidder.

Baslow. Derbyshire. Well-placed on the River Derwent with a charming church and an ancient and sturdy packhorse bridge with toll-house. A few miles from Chatsworth House, also on the Derwent. On the A619 west of Chesterfield.

Beddgelert. Gwynedd. Just south of Snowdon. Commands magnificent views. The Nantgwynant Pass leads to the village and two crystal clear streams meet at its centre. You reach Beddgelert on the A4085 from Caernarvon.

Benington. Hertfordshire. A typical English village, with the classic ingredients of church, stately home, pond and pub. Certainly worth visiting. Take the A602 north from Hertford and the side road to the right immediately after Watton-at-Stone.

Bibury. Gloucestershire. On the River Coln, which meanders through the village centre, passing some pretty weavers' cottages and an impressive Saxon church in a dignified square. Leave Burford on the A40, take the A433 south-west to Bibury and neighbouring Arlington.

Birchover. Derbyshire. With steep rocks overlooking the river on several sides, one of them Row Tor. South of the village, a short walk away, is the famous pinnacle with a 20-yard gap, which Robin Hood was supposed to have jumped. Leave Matlock on the A6, take the B5057 to Darley Bridge and then a side road on the right.

Blair Atholl. Tayside. The meeting point of several glens, surrounded by the most photogenic mountain scenery. Blair Castle itself looms very near and the River Garry flows through the village. On the main A9 north from Pitlochry.

Blanchland. Northumberland. A trim village of grey and yellow lead-miners' cottages, on the site of Blanchland Abbey. The church and gatehouse are what remain of the ruined abbey. From Hexham on the A695, take the B6306 south through Blanchland Moor.

Bosherston. Dyfed. Just north of spectacular St Govan's Head. A beautiful, whitewashed village, famous for its large pools which in summer are covered with white lilies. (Take the path from the thirteenth-century church.) Take the B4319 from Pembroke and then side roads to Bosherston.

Abinger

Bramshaw. Hampshire. Hidden deep in the New Forest. Some of the houses are thatched and look on to open moorland. From Southampton, take the A336 to Bartley and then the B3079.

Bredwardine. Hereford and Worcester. Serene hill-side village on the peaceful River Wye. The oddly-shaped church with its tree-filled churchyard and the local inn are worth visiting. From Hay-on-Wye, take the B4348 and then the B4352.

Brightling. East Sussex. The village is set among the hills with views across the River Rother. An added attraction is Brightling Park, where the eccentric nineteenth-century MP, Mad Jack Fuller, built strange follies – a rotunda and a classical temple. From Battle, you take the A269, then the B2096, and finally a turning right at Darwell Hole, to Brightling.

Broadway. Hereford and Worcester. The perfect Cotswold village, with its honey-coloured cottages and houses. The road runs up the hill, giving a magnificent view towards Tewkesbury Abbey. Several buildings are notable, including the Lygon Arms and the twelfth-century church, and at the top of the hill, the curious Fish Inn with a sun-dial on its roof. Broadway lies on the A44 between Evesham and Moreton-in-Marsh.

Burley. Leicestershire. A village with views across the Vale of Catmose. The Manor House on the hilltop is also worth visiting because of its superb parkland and position. From Oakham on the A606, take the B668 to Burley.

Burwash. East Sussex. Once an important iron-making centre. The brick-faced cottages are spread along a ridge between two rivers, with hills running down towards the beautiful countryside on both sides. Bateman's, a stone house with tall chimneys, and a watermill beyond, the home of Rudyard Kipling, can be visited nearby. Burwash lies on the A265 west of Hurst Green.

Cape Cornwall. Cornwall. Photographically, an absolute 'must' when in Cornwall. A secluded village, hardly ever visited by tourists. The road wanders among the stone walls down towards the sea, cliffs and this unspoilt village. From St Just on the A3071, head towards the sea at Cape Cornwall and a little chapel on the hill.

Castle Combe. Wiltshire. Steep hills covered by beechwoods surround the village. Very unspoilt despite its film career, it has a fifteenth-century church and market cross, and some beautifully coloured houses with grey slate roofs. From Chipping Sodbury on the A432, take the B4040 to Acton Turville and the B4039 to Castle Combe.

Cerne Abbas. Dorset. Situated in a hollow, the village can be seen from the hills around. The Abbey church-yard is strikingly photogenic with views of the countryside, including the famous hill figure of the Cerne Abbas giant. Take the A352 south from Sherborne to Cerne Abbas.

Chelsworth. Suffolk. A quiet village on the River Brett. Although not far from Lavenham, it is rarely visited by tourists. There are many old houses, a medieval church and a seventeenth-century grange.

From Sudbury, take the B1115 to Monks Eleigh, join the A1141 for about a mile and then turn into the B1115 again to Chelsworth.

Chiddingstone. Kent. This is a completely preserved village, now under the auspices of the National Trust, which owns some of the sixteenth- and seventeenth-century timber-framed houses in the main street. There is a sandstone church and a huge churchyard, dotted with yews. Take the A21 north from Tonbridge, then the B2027 and side roads after Penshurst Station.

Chilham. Kent. On the famous Pilgrims' Way from London to Canterbury. There is a square of half-timbered houses; narrow lanes run downhill to cottages below. Chilham Castle has a Norman keep and a Jacobean house. From the village there are views of the River Stour and the rolling countryside beyond. From Canterbury, take the A28 and turn right into the A252.

Christmas Common. Oxfordshire. The village lies on top of the Chiltern Ridge above Watlington. Watlington Hill, which belongs to the National Trust, offers wide views of the Thames Valley and Henley. In the autumn, the Chiltern Forest is at its best. Take the A423 from Henley to Wallingford, then the B480, and at the crossing with the B481, a side road goes to Christmas Common.

Cilgerran. Dyfed. Overlooked by a castle, this grey-stone village is a couple of miles south of Cardigan. A number of artists have painted Cilgerran Castle, including Turner. From Cardigan, take the A478 south and turn left to Cilgerran.

Cil-y-cwm. Dyfed. It lies in the ravine of a river surrounded by forest and hills, a rugged and forbidding terrain, but the countryside around the village itself is exceptionally photogenic. A short walk north of the village is a new reservoir, Llyn Brianne, which is worth photographing. From Llandovery on the A40, take a side road north towards Cil-y-cwm.

Clovelly. North Devon. One of the best-known fishing villages, now overrun with tourists in the season. The main street is cobble steps, and brightly coloured shops and houses line the steep descent to the narrow quay below. During the summer season, there is a landrover bus to take you back up the hill. From the A39 west of Bideford, take the B3237 (you have to park on top of the hill).

Clyro. Powys. A peaceful village nestling among the hills on the Herefordshire border, it has a charming church and yew-lined churchyard, made famous through the diaries of the Rev. Francis Kilvert. From Hay-on-Wye, take the B4351 north-west.

Combe. Berkshire. This secluded village is situated in a hollow between three downs and is little visited by tourists. The three downs are Walbury Hill, Combe Hill and Sheepless Hill. From any of these three, there are beautiful views across the Kennet Valley. Take the A4 from Newbury, then a side road near Hungerford south towards Inkpen and down towards Combe.

Crackington Haven. Cornwall. This is possibly one of the most dramatic villages on the Cornish coast. An enormous rock rises from the sea to about 400 feet

and the promontory of Cambeak is a little further south. You can reach Crackington Haven from Bude going south on the A39 turning towards the sea at Wainhouse Corner.

Diabaig. Highland. A dramatic and lonely place, Diabaig, in the northern Highlands of Scotland, is situated off Loch Torridon on Loch Diabaig. The switchback road to Diabaig along Upper Loch Torridon and through wild hill country is dramatic, especially at sunset. The road is narrow and unsafe in bad weather.

Dinas-Mawddwy. Gwynedd. An outstandingly beautiful village rarely visited by tourists. It lies on two rivers, the Cerist and Dyfi, with the steep Cambrian Mountains towering above. Dinas has many old slate workings. Take any of the footpaths leading from the village to some of the magnificent waterfalls. The village is also a centre for climbing in the Cambrian Mountains. From Dolgellau, take the A470 to Dinas-Mawddwy.

Dolwyddelan. Gwynedd. Dolwyddelan, with its worked out quarries, stands amongst woods and peaks, waterfalls and rivers: very much a place to stay in and explore. The castle ruins stand on a crag, a mile away from the village, and there is a quaint old church. Take the A5 and then the A470 from Betws-y-Coed towards Blaenau Ffestiniog (famous for its slate quarry).

Downham. Lancashire. At the foot of sinister Pendle Hill. A lonely and uniformly grey village in rugged Lancashire countryside. From Clitheroe, take the A59 north and a side road to Downham, just past Chatburn.

Dunster. Somerset. It is more than a village – almost a town – and exceptionally attractive. The curiously-shaped Yarn Market and the castle perched on the hill are possibly the best features of the town, but others include the garden next to the splendid St George's Church. Off the main A39 road, just east of Minehead.

Egton Bridge. North Yorkshire. The road from Egton High Moor plunges down to the water meadows and trees of the Esk Valley. Several interesting points like the old railway station and bridge are worth photographing. From the main A169 road from Pickering to Whitby, take a side road to Grosmont and Egton Bridge.

Elterwater. Cumbria. Even in the tourist-ridden Lake District, Elterwater is a little off the beaten track. Situated in magnificent country with Langdale Pikes above it, Elterwater lies very low on the river beside a lake of the same name. The best viewpoint is from the expanse of turf above the village. From Ambleside, take the A593 and the B5343 towards Langdale Pikes.

Kersey

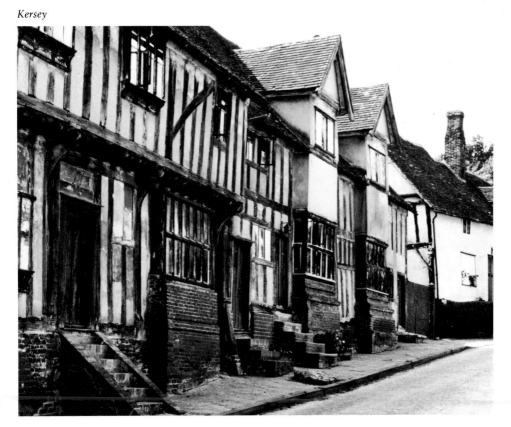

Finchingfield. Essex. All the ingredients of an ideal village are there – the church on the hill, the duckpond and even a windmill. From Braintree you take the B1053 to Finchingfield.

Friday Street. Surrey. A charming village not far from London, south-west of Dorking. A little lake overlooks it and reflects the fine hills. Not far from there is Abinger. Above Friday Street is Leith Hill, a favourite picnic spot for Londoners. From Dorking, take the A25 west and turn left for Friday Street.

Foyers. Highland. On the eastern side of Loch Ness. There are two parts to the village, one overlooking the Loch and the other in the valley. Footpaths ramble in several directions, one of them leading to the spectacular 90-foot Falls of Foyers. Take the B862 from Fort Augustus on the southern tip of Loch Ness, and then the B852 which branches off towards the Loch and runs right alongside the water.

Glaisdale. North Yorkshire. High on a ridge in the North Yorkshire Moors – on all sides of the village there are splendid prospects of the River Esk and the valley below. A noted beauty spot is Beggar's Bridge, an old pack-horse bridge built in the seventeenth century. Glaisdale lies about a mile from Egton Bridge. It can also be reached by the A171 from Whitby, turning to Egton and then to Glaisdale.

Hambleden. Buckinghamshire. Yet another village almost straight from the Middle Ages. Very well-preserved, with village pump, one of the few remaining Victorian smithies and best of all, a water mill, a rare sight on the Thames. The surrounding Chiltern Hills add to Hambleden's natural beauty. From Henley-on-Thames, take the A4155 and at Mill End, turn left to Hambleden.

Hemingford Grey. Cambridgeshire. A charming old village on the Great Ouse. There is a Norman manor house. A bend in the river holds the twelfth-century church and its stump of a spire. There are some marvellous walks in both directions along the Ouse. From Huntingdon, take the A1123 and then turn right into the A1096 and right again into a side road.

Horning. Norfolk. On one of the many waterways which make up the Broads, Horning is an ancient village, famous for the ferry which has ceased to run after more than 1000 years. (You can still hire boats here.) Horning's church is at Ranworth, two miles south. Climb the tower for fine views. From Norwich, take the A1151 and the A1062 at Hoverton.

Hurstbourne Tarrant. Hampshire. Pretty village in the North Downs at the foot of a steep and narrow hill, from which it should be viewed. A stream runs through it and is often dry in the summer. From Andover, take the A343 north to the village.

Keld. North Yorkshire. Tiny granite village hidden in western Swaledale. Fine views eastwards from the grounds of the chapel. Scenic walks on the Pennine Way can be taken from the village, and dramatic Tan Hill lies to the north. On the B6270 which can be joined from the A6108 near Richmond.

Kersey. Suffolk. An outstanding village, set between church and Augustinian priory. Weavers' cottages and other timbered houses descend to a small stream and a ford flows across the street. From Ipswich, take the A1071 past Hadleigh and turn right to Kersey.

Lacock. Wiltshire. A show village not far from Bristol visited by practically every tourist in England and the

Lacock

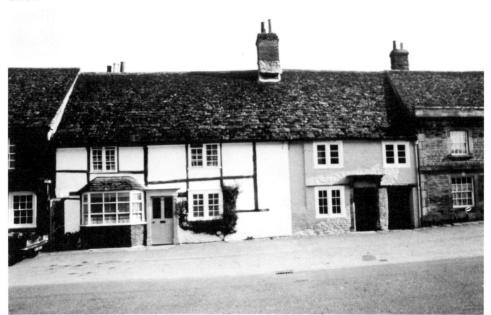

goal of photographers from all over the world, for its link with William Henry Fox Talbot. One of the few villages where television aerials are forbidden. Being so popular it should be avoided in high season. Try taking pictures from the top of the church tower. From Chippenham, take the A350 south and a side road towards Lacock.

Linton-in-Craven. North Yorkshire. The little beck is crossed by foot, road and pack-horse bridges. There are neat stone cottages, a village green and tall rook-filled trees. From Skipton, go north on the B6265 for about six miles.

Llanstephan. Dyfed. Delightful little village opposite Laugharne. Llanstephan lies on the estuary of the River Tywi and it is an immaculate and brightly painted village running down towards the water – exceptionally interesting to photograph. The small square is overlooked by the church, and high above the estuary are the ruins of the twelfth-century Norman castle. From Carmarthen, take the A40 to the west and almost immediately turn into the B4312.

Lustleigh. Devon. A small village on the edge of Dartmoor. The River Bovey flows nearby and enormous granite boulders surround the village. The hills above and the countryside around are rugged and dramatic. Lustleigh is famous for its May Day festival. From Newton Abbot, take the A382 and a side turning to the left after Bovey Tracey.

Lydford. Devon. A Dartmoor village with a magnificent gorge carved out by the River Lyd, a bend away from the village itself. A ruined castle, once a prison for Dartmoor tin miners, sits at the centre of the village. Many interesting wood and river walks can be taken. Driving west from Oakhampton on the A30, take the A386 south from Meldon.

Minster Lovell. Oxfordshire. Historic Cotswold village on the clear waters of the River Windrush. Minster Lovell old town, off the road, is exceptionally attractive. Some of the houses – and the inn – have been rebuilt and restored, but the village is still very photogenic, especially the ruins of the Hall. From Witney on the A40, take the side road leading straight to Minster Lovell.

Mousehole. Cornwall. A picture-book fishing village in south-western Cornwall, looking into Mount's Bay, overrun by tourists in the summer. The church on top of the hill, St Paul's, is worth visiting as there is a beautiful panorama from there, when not obscured by parked cars. From Penzance, take the Newlyn road, then drive along the coast to Mousehole.

Nunney. Somerset. In a wooded valley of the Mendip Hills. The houses gather around a 'fairy-tale' moated castle, which is particularly striking if approached from Frome, when it suddenly comes into view above the village. There is a side road from Frome direct to Nunney.

Nunnington. North Yorkshire. Situated on the border of the North Yorkshire Moors on the River Rye, Nunnington has superb views and walks. From the village itself, and from the church which is set on a hill, there is a fine view of the Vale of Pickering. From Helmsley, take the A170 to Sproxton and then the B1257 and a side road to Nunnington.

Old Bolingbroke. Lincolnshire. An interesting village, steeped in the history of the Civil War. The surrounding wolds are very photogenic. From Horncastle, take the A158, turn into the A1115 and at Mavis Enderby, there is a side road to Old Bolingbroke.

Plockton. Highland. Here, palm trees and wildlife flourish on the shores of Loch Carron. In contrast, the route from Loch Alsh to Plockton (once you have passed Kyle of Lochalsh), reveals wild highland scenery at its best. The A87 from Glen Shiel goes to the tip of Kyle of Lochalsh. From there, take the side road to Plockton.

Port Isaac. Cornwall. This is a picturesque, working fishing village with houses decorated by shells, souvenirs from exotic voyages. Cars, fortunately, have to be left on the cliff above, making photography easier. Beautiful Cornish cliff scenery all around. Go north from Wadebridge on the B3314, and then turn left to Port Isaac.

Portmeirion. Gwynedd. Portmeirion is an anomaly, designed by the Welsh architect Clough Williams-Ellis. Originally inspired by the Italian village of Portofino, it has a campanile, shuttered houses and a cobbled square. All that is lacking is the Mediterranean sun, and it is a photographic curiosity worth visiting. From Porthmadog on the A487, you go to Minffordd and take the short side road to Portmeirion.

Rhossili. West Glamorgan. The village is near Worms Head, a spectacular crag, jutting into the sea. It is set high on the cliffs, some 200 feet above the sea, so the views from the village itself are spectacular. The church, and the churchyard, with its moss- and lichen-encrusted graves, should not be missed. It is a short walk along the rocks to Worms Head, and there is also a little island opposite which can be reached on foot at low tide. From Swansea, take the A4118 and then the B4247 at the end of the peninsula.

The Rodings. Essex. An interesting group of eight villages all ending in Roding – for example, Abbess Roding, White Roding, Aythorpe Roding. They are in rich farming country, slightly hilly, which in summer offers vistas of endless fields of corn. Most of the villages have old churches, moated halls and sweeping expanses of farmland, grass- and woodland. From Chelmsford, take the A414 and then the A1060 north-west to Margaret Roding.

Sawrey. Cumbria. Two Lake District villages, set in wooded and hilly country between Windermere and Esthwaite Water, made famous through the books of Beatrix Potter, whose house can still be seen in Near Sawrey. Far Sawrey is in a narrow lane, giving sudden glimpses of Windermere. From Windermere, you can take a ferry across the lake and then the B5285 to Sawrey.

Selborne. Hampshire. A village immortalized by the naturalist Gilbert White, but photogenic in its own right. Climb the Zig Zag Path, described by White, to Selborne Hanger for sweeping views down towards the village. From Petersfield, take the A325 north and then the B3006 to Selborne.

Snowshill. Gloucestershire. Pretty Cotswold village just south of Broadway. Built in the mellow stone of the Cotswolds, with a parish church and views of the

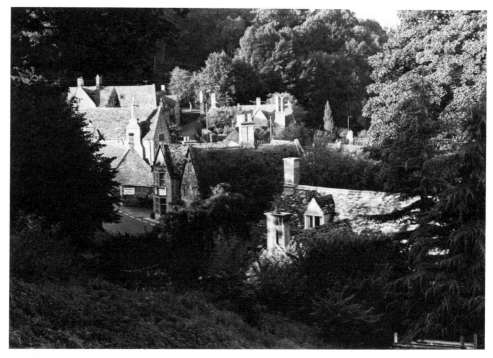

Snowshill

village from the hills around. From Broadway on the A44 take a side road south to Snowshill.

Slaughter. Cotswolds, Gloucester. There are two Slaughters, Upper and Lower, with mellow stone houses and the River Eye running through them. Upper Slaughter, on a gentle hill, is particularly attractive, with views across the countryside. From Stow-on-the-Wold, take the A436 west and at Lower Swell, take a side turning to Upper Slaughter.

Staithes. North Yorkshire. Rugged fishing village north of Whitby. Very steep streets with a jumble of houses running down towards a precipitous coast and a number of hidden coves and cliffs. Much photographed by Sutcliffe. Two miles to the west is one of the highest cliffs in England, Boulby Cliff. From Whitby north on the A174.

Sydling St Nicholas. Dorset. Two miles south-west of Cerne Abbas, set in a little valley. The village can be seen very well when approached from the north. It has a stream, a smithy, a church with gargoyles, and a tithe barn. From Dorchester, take the A37 to Grimstone and take a side road north to Sydling St Nicholas.

Teffont. Wiltshire. There are two Teffonts, Evias and Magna, situated half a mile apart in the Nadder valley. A brook, the Teff, flows through both the villages and many houses have their own miniature bridges crossing the brook to their doorsteps. The parish church stands almost in the woods which adjoin the villages. From Wilton, take the A30 and then B3089 to both Teffonts.

Wherwell. Hampshire. This village of thatched cottages on the River Test is popular with fishermen. The village is famous for its wooden bridges and its skilled thatchers. South from Andover on the A3057 and then the B3420.

Winsford. Somerset. At the foot of the Brendon Hills on Exmoor. Winsford Hill to the west can easily be climbed, to gain a good view of the village. The River Exe flows through it, alongside some notable buildings, including the Norman church of Mary Magdalene. From Dunster take the A396 and after Wheddon Cross, turn right to Winsford.

Woolpit. Suffolk. This ancient village has many fine old houses, some of them recorded in the Domesday Book. The village is architecturally interesting because of its age. St Mary's Church is reputed to be one of the most beautiful churches in Suffolk. From Stowmarket, take the A45 and in about four or five miles, there is a side road to Woolpit on the left.

Yoxford. Suffolk. Yoxford is sometimes called The Garden of Suffolk. Lanes and cottage gardens offer a profusion of flowers and colours. On the A12 from Ipswich heading north at the A1120 junction.

Zennor. Cornwall. A village on the Cornish coast, some miles south-west of St Ives. The twelfth-century church lies slightly away from the village and its silhouette can be photographed against the sunset. The walk from Zennor to the cliffs is exhilarating, with some superb views. Zennor Head is a cliff rising sheer from the sea. East of the village is Zennor Quoit, a megalithic burial chamber. From St Ives, take the B3306 running south.

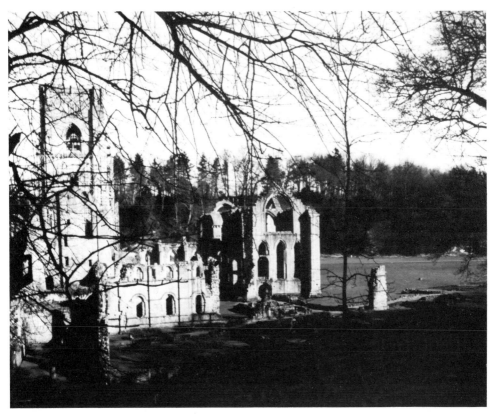

Fountains Abbey

Abbeys

Note: You are advised to check times of opening, where appropriate, before making your visit.

Battle Abbey. East Sussex. An abbey built by William the Conqueror after the Battle of Hastings on the site where King Harold was killed. Part of it is now used as a girls' school, but the rest of it, though only a ruin, is certainly worth a visit – particularly the decorated Gate House, which is one of the finest in England. On a small hill overlooking the town of Battle, on the A2100 from Hastings.

Beaulieu Abbey. Hampshire. Beautifully situated in the New Forest on the River Beaulieu. It has been much altered: part of it is now the house of the present Baron Montagu of Beaulieu. Another part, the Refectory, has become the parish church, but part of the ruined abbey still remains. More people visit Beaulieu for its motor museum than for its delightful ruins.

Bolton Abbey. North Yorkshire. In its setting, one of the finest Augustinian priories in England. It lies in a hollow by the River Wharfe, which loops gracefully around it. It can be photographed from a hill above, with the famous stepping-stones crossing the Wharfe. Part of the priory remained in use as a church after the Dissolution, but the rest is exceptionally beautiful and photogenic. From Skipton take the A59 towards Harrogate and then the B6160 north.

Buildwas Abbey. Salop. A ruined abbey, though surprisingly well preserved, 800 years old. It is situated on a meadow beside the River Severn and can be contrasted in photographs with a modern six-chimneyed power station nearby. You can find it on the road from Much Wenlock – take the B4378 northwards and it is on your left on the river.

Byland Abbey. North Yorkshire. An impressive, though little visited, ruin on the curve of a road. From a nearby hill you can photograph the grazing sheep and the ruins of the Byland Abbey in the hollow. Its best feature is the West Front, with partly preserved rose windows. You can include this abbey after a visit to Rievaulx Abbey to the north. Take the A170 west from Helmsley and turn left on a side road to Wass and Coxwold. The Abbey is between these villages.

Castle Acre Priory. Norfolk. The ruins of a Cluniac priory founded in the eleventh century, and superbly positioned by the river. Very little is left of the castle itself. You can get to Castle Acre from Swaffham on the A1065 and take a short side road to Castle Acre.

Cleeve Abbey. Quantocks, Somerset. Possibly the finest monastic ruins in the western counties. A Cistercian abbey of which much has disappeared, but the fifteenth-century Refectory Hall, with its lofty timbered roof, is outstandingly interesting. Note also the steps leading to it. You can find Cleeve Abbey on the

A39 from Bridgwater, going west through Williton, on the left, at Washford.

Dryburgh Abbey. Borders. Beautifully set in a horseshoe bend of the River Tweed, among leafy woods. Some of the statuary is exceptional. It was one of Sir Walter Scott's favourite places, and he is buried in the grounds. You can find Dryburgh Abbey if you take the A699 from Kelso to St Boswells and then the B6404.

Evesham Abbey. Evesham, Hereford and Worcester. Here, the ruins tumble right down to the River Avon. Only the gateway and the Bell Tower remain, but the river setting is charming.

Fountains Abbey. North Yorkshire. A Cistercian abbey in the wooded valley of the River Skell. The little river flows through the grounds alongside the ruins, which extend over a large area. There are two ways to get to Fountains Abbey: through Fountains Hall or through lovely Studley Park, four miles south-west of Ripon. From Ripon take the B6265 to the west and then a side road on the left to Fountains Abbey. The Abbey is popular, so it is advisable to visit it at less congested times. (It is impossible to get in early in the morning; it opens about 8 a.m. in the summer months.)

Furness Abbey. Lancashire. The splendid ruins of the Cistercian abbey nestle in the narrow, thickly wooded valley. It is easy to photograph from elevated ground. The red sandstone ruins are open all year round. A mile or two north of Barrow-in-Furness on the A590 to Ulverston. (Go early in the morning, or in the evening when the light is at its best).

Glastonbury Abbey. Somerset. Fragments of a very splendid abbey, surrounded by lawns. The Abbot's Kitchen is exceptionally well preserved. The Lady Chapel still stands, with sculptured doorways. On the A39 from Wells through Glastonbury, a mile on the far side of town.

Jedburgh Abbey. Borders. The splendid remains of one of the finest abbeys in Scotland. Although burnt down several times by the English in their battles with the Scots, much has survived. The three-tiered walls are magnificent and the medieval tracery of the rose windows, particularly in the west, is very delicate. Good light is needed. On the A68.

Jervaulx Abbey. North Yorkshire. In parkland by the side of the River Ure. The remains of this ancient Cistercian abbey are well preserved and interesting. Shaggily overgrown with shrubs, the old stones have a certain air of romance. From Ripon take the A6108 to Jervaulx Abbey via Masham. Telephone for permission to visit.

Kelso Abbey. Borders. In the twelfth century, this was a powerful abbey. It was razed in the sixteenth century and little is now left, but it is worth visiting for its mellow stone walls, overgrown with trees. You can reach Kelso on the A698 from Berwick-upon-Tweed.

Kirkstall Abbey. Yorkshire. The ruins are extensive, and nearly as well preserved as those of Fountains, but they are surprisingly deserted and little known. The banks of the River Aire are overgrown with sycamores and other trees. Take the A65 in Leeds and turn into the B6157.

Lindisfarne Priory. Holy Island. Ruins of a Benedictine priory with the little castle nearby (see under Castles) well worth visiting. The priory is built of dark red stone, close to the sea. Take the A1 south from Berwick-upon-Tweed and a side road to Beal and Holy Island. (The three-mile track to Holy Island can be used only when the tide is out, so check your times.) You can visit the grounds fairly freely.

Malvern Priory. Great Malvern, Hereford and Worcester. Unlike most of the other religious foundations of the eleventh century or earlier, Malvern Priory has been carefully rebuilt and is now in full use. It is a remarkable priory on a hill above an elegant town. Some of the interiors are very fine. The tiles of the tower were hand-made in the fifteenth century. Many of the forty reconstructions of the vast stained glass windows are exquisite. The churchyard is well worth visiting. From Worcester take the A449 and then the A4532 to Malvern.

Melrose Abbey. Borders. Much was destroyed by English raids (three in the sixteenth century), but enough still remains to show how beautiful the abbey once was. Set among tall trees and smooth lawns, most of the old plan can be seen, including some splendid arches and cloisters, and the kitchens. From Selkirk take the A7 and then the A6091 to Melrose.

Newstead Priory. Nottinghamshire. An Augustinian priory which, after the Dissolution, became the home of the Byron family (see under Stately Homes). Some parts are in ruins, others are restored. There are nine acres of gardens, lakes and walks. From Nottingham take the A60 north. Newstead Priory is well signposted.

Rievaulx Abbey. North Yorkshire. A most outstanding Cistercian ruin. It is beautiful from most angles, but the best vantage-point is the landscaped Rievaulx Terrace and Temples, east of the ruins. There are walks among classical fragments, and some magnificently planned views. The River Rye flows nearby. From Helmsley on the A170 take the B1257 northward.

Tintern Abbey. Gwent. The remains of a Cistercian abbey founded in twelfth century. Its unique situation on the River Wye, among tree-covered hills, gives it particular appeal and pictorial power. Try photographing it from several spots – the elevated churchyard overlooking the abbey, or the wooded hills beyond. But from any position the abbey is magnificent. From Chepstow on the A48 take the A466 to the north.

Valle Crucis Abbey. Clwyd. Another romantic Cistercian abbey, though without Tintern's superb position. It lies in a sheltered and secluded spot with hills above, so the hills and their lonely trees can be framed through the empty windows of the abbey. Close to Llangollen and in the same scenic valley. From Llangollen on the A5 take the A542 north to Valle Crucis Abbey.

Tintern Abbey

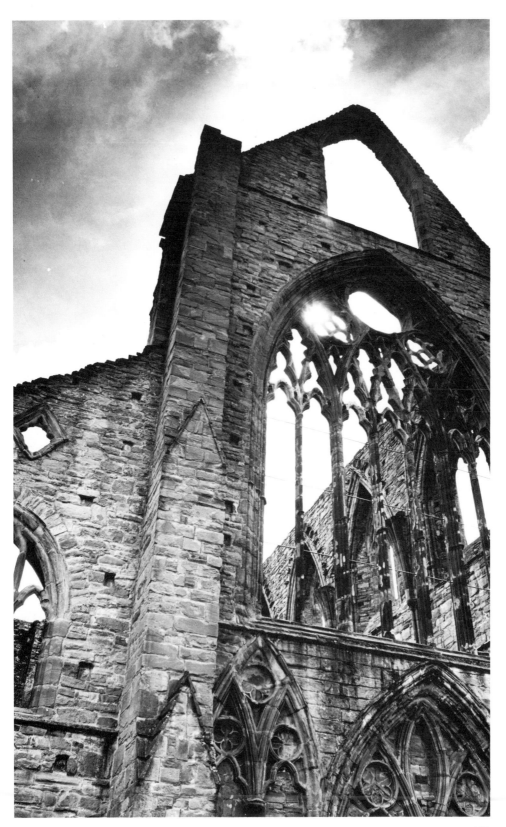

Lincoln Cathedral

Cathedrals

Bangor Cathedral. Gwynedd. A nineteenth-century cathedral on an ancient site. It contains several interesting items, including the carvings on the stalls and the fine lantern tower. The famous Bible Gardens contain examples of plants described in the Bible. Bangor lies in the north-west of Wales opposite Anglesey.

Brecon Cathedral. Powys. Interesting as a part-thirteenth-century fortified cathedral. Notice particularly the font and the cresset – an ancient stone lamp with 30 hollows for oil. Brecon itself is well placed as a centre for other aspects of photography.

Canterbury Cathedral. Kent. One of the most beautiful cathedrals in England. From the outside, the Bell Harry Tower, the fifteenth-century central tower, should be seen against the setting sun. The cathedral itself contains a number of items for the architectural photographer. The stained glass is celebrated, and it has one of the finest Perpendicular naves in the country. The crypt is probably the largest in the country; look out for strange and unusual carvings on its capitals. The worn treads of the pilgrims' steps are visually interesting – and these are only a few features of this outstanding cathedral.

Chester Cathedral. Cheshire. Of red sandstone and previously a Benedictine abbey, it is mainly fourteenth century. The exterior is handsome, although unassuming. Inside, see the choirstalls with their 48 carved misericords – one of the main features of the interior. The several other fine photographic subjects include the Early English Lady Chapel.

Chichester Cathedral. West Sussex. A twelfth-century cathedral, with a fine tapering spire which was reconstructed in the nineteenth century and can be photographed from a number of angles, both in the city and outside. When visiting the interior, look for the magnificent window in the south transept.

Christ Church. Oxford. In the middle of Christ Church College, the cathedral is a Norman church in the grounds of the old priory of St Frideswide, incorporating many architectural styles. A unique feature of the cathedral is the beautiful lierne vaulting, built over the choir in the fifteenth century. It has outstanding stone lanterns hanging from concealed arches in a star pattern with contrasting areas of light and dark. The Tom Tower was built by Wren.

Coventry Cathedral. West Midlands. A modern cathedral, photographically exceptional. The old cathedral was destroyed by bombing in 1940 and some of the charred remains form a foreground to the new cathedral designed by Sir Basil Spence. Generally there is much to see, both outside the cathedral and within. The bronze statue of St Michael and Lucifer by Epstein is certainly worth photographing, particularly from below. The view from the south-west reveals the interesting arrangement of the windows. Inside there are numerous items of interest, including stained glass by John Piper and the tapestry by Graham Sutherland.

Durham Cathedral. County Durham. Photographically speaking, there is little doubt that Durham holds the most outstanding position of any cathedral in Britain. It is built on a high hill, encircled by the River Wear. It can be seen reflected in the water on a peaceful day or viewed from across the river. A large part of the cathedral is of Norman origin. The interior is impressive, with a splendid nave, fine screen and a number of interesting tombs. The twelfth-century brass knocker is an outstanding example of Romanesque metalwork.

Ely Cathedral. Cambridgeshire. This used to be called the Cathedral of the Fens, and at the time when the fens were not reclaimed it was possible to see Ely Cathedral soaring magnificently above the flat countryside from all points of the compass. Now that the town has grown around it, the cathedral is more difficult to photograph from afar, yet can still be seen from many points. The tower, seen early in the morning from across the large green with its cannon, is splendid. The vast, magnificent nave is exceptionally attractive to photograph, and the Octagon and Lantern even more so – a masterpiece of engineering both in conception and in workmanship. With a camera low to the ground you can capture the arrangement of the Octagon, with its vaultings and stained glass windows. The Lady Chapel is one of the largest and finest in England. The sculptured Norman doorway, with its pair of corbel heads suporting the lintel, and the Prior's Door are photographically interesting also.

Exeter Cathedral. Devon. A splendid medieval cathedral. It has two famous Norman Towers and wonderfully carved figures on the West Front. The interior has the longest roof in the country; the magnificent arches sweep from one end of the cathedral to the other and are superb to photograph. Don't miss the Minstrels' Gallery on the north side of

the nave, or the curious astronomical clock. There are some charming buildings around the cathedral. It is worth wandering around to select a view of the cathedral through an arch or window or alley.

Glasgow Cathedral. The only Scottish medieval cathedral, built on the site of a sixth-century church. It is a pity that some of the tiles on the central tower are missing, but the interior is striking, particularly the extensive crypt of the lower church (which can be photographed only with artificial illumination). Externally the most interesting spot from which to photograph the cathedral is the Necropolis, a cemetery full of weird monuments.

Gloucester Cathedral. Gloucestershire. One of the finest Perpendicular cathedrals in the country. It is difficult to get a good view – it almost becomes a challenge. The tower is beautiful and from below gives a wonderful effect of height. Note the Glazed Cloisters with some very early fan-vaulting and complete with monks' lavatoriums and carrels.

Hereford Cathedral. Hereford and Worcester. Severely damaged in the sixteenth century and then rebuilt, it is a combination of two styles, Norman and Gothic, and in places not entirely convincing. But there is a fourteenth-century tower. The interior contains the well-known *Mappa Mundi* – a map of the world made c. 1300. The medieval library contains about 1500 books, each of which is chained to its shelf: an unusual photographic subject.

Iona Cathedral. Strathclyde. Perhaps the most beautifully situated cathedral in the British Isles. Take a boat from Oban; when you round the island of Mull, you will see the cathedral in the distance, gleaming in the sun, with rocks and hills above. The best way to photograph the cathedral is to climb up behind it so that you can see it below in the hollow by the shore, with the sea and the island of Mull beyond. With good cloud formations, it is an inspiring sight. The cathedral itself dates from about 1500, although the site is much older – St Columba had his abbey there in 563. In the interior are some good nave capitals and carved doorways in the sacristy.

Lichfield Cathedral. Staffordshire. A splendid cathedral in a now mainly industrialized town. 'The Ladies of the Vale', the three spires of the cathedral, are a spectacular sight, especially in the spring when seen among the trees. There is some interesting sandstone statuary on the West Front, and above the central pillar is a bas-relief of Christ in Majesty, which was saved from the original cathedral. (The cathedral was badly damaged by Cromwell's soldiers and much had to be restored.) Don't miss the sixteenth-century stained-glass windows in the Lady Chapel and the illuminated manuscripts in the library.

Lincoln Cathedral. Lincolnshire. The cathedral stands on a 200-foot plateau overlooking the River Witham and is surrounded by medieval buildings and narrow streets. Its towers rise to some 365 ft. Find an elevated spot from which to photograph the beautiful West Front towering over the old houses. Visit the Observatory Tower at the south-east corner of the Norman castle for another superb view of the West Front. In the spring, daffodils add to the cathedral's beauty.

Salisbury Cathedral

Liverpool Cathedral. Merseyside. Liverpool has two modern cathedrals. Both are on high ground overlooking the city, can be photographed effectively from afar and are interesting subjects. The Roman Catholic cathedral is visually more striking. The most interesting feature is the stained-glass windows which, on a sunny day, release their colours to glimmer on the walls and floor. The central lantern is entirely of stained-glass, and is exceptional. Most of the windows were designed by John Piper. The Anglican cathedral is built of red sandstone in a Gothic style.

Norwich Cathedral. Norfolk. A splendid Norman nave and tower, with a spire added in the fifteenth century. The best view of the city with the cathedral at its heart is from Mousehole Heath – a heather-covered slope on which Norwich citizens like to walk. There are views of the cathedral from the Georgian square of Tombland and, closer, from the cloisters, which were rebuilt in about 1300. Many interesting carvings are to be found on the cathedral doorways, particularly on Ethelbert Gate, but the most glorious interior shot is of the apse, which has a fine vaulted ceiling and exceptionally beautiful windows.

Peterborough Cathedral. Cambridgeshire. A lovely old cathedral in a modern industrial town. In spite of the factories and modern blocks which crowd around it, it is still rewarding to photograph the triple-arched West Front. In the fine Norman interior there is much to interest the photographer.

St Albans Cathedral. Hertfordshire. Set regally on a hill, this is an old abbey much enlarged, and is, after Winchester, the second longest cathedral in Britain. It dominates the town and so can be seen from several points. The view from the tower is good. Inside, there are fine medieval wall paintings.

St Asaph's Cathedral. Clwyd. One of the smallest cathedrals in Britain, of Norman origin, and built of sandstone. It is the only Welsh cathedral set on a hill, and can be seen from a number of places in the town. It has a fine west window of six lights, and notable carving on the stalls.

St David's Cathedral. Dyfed. A cathedral built of local sandstone and sited in a hollow. Since the town is on a sea promontory it can be seen from hills above. The best view is from the south-east. There are lawns around the cathedral, some tombstones, a brook nearby, and the ruins of the Bishop's Palace.

St Giles' Cathedral. Edinburgh. St Giles' church, (known as St Giles' Cathedral) is well worth a photographic visit. Set in a cobbled square in Edinburgh's Old Town, it can be seen from many of the surrounding hills. The interior is bright with the colours of the Scottish regiments.

Salisbury Cathedral. Wiltshire. Perhaps the most perfect of British cathedrals, because it was built as a single conception; few additions were made after it was built in the thirteenth century. The 400-foot spire dominates the countryside and views of the cathedral may be found from many places. The Purbeck stone columns within the cathedral are well spaced and there are many impressive monuments and carved tombs. The cloisters, the largest in England, display beautiful tracery in the arcades. Two cedar trees add to the attraction.

Southwell Minster. Nottinghamshire. This twin-towered minster is a beautiful sight, particularly when seen through the gates in front of the minster or from the side of the churchyard. The outstanding interior feature is the famous 'Leaves of Southwell': stone carvings of all kinds of flowers and leaves, beautifully executed, realistic and yet at the same time curiously abstract. There is a profusion of shape and line, and the undercutting and simulated shadows are a triumph of the stonemason's art which should be photographed in detail.

Southwell Minster

Wells Cathedral

can be obtained from the nearby modern hotel. Inside, Worcester Cathedral has a wonderful forest of pillars supporting the vaulted roof. The Norman crypt is perhaps the most interesting in Britain.

York Minster. North Yorkshire. The largest cathedral in Britain, beautifully executed, with a fine front and towers. Yet, because it is surrounded closely by small houses, it is perhaps difficult to appreciate properly its size or beauty. The finest part of York Minster is its interior, and particularly the stained-glass windows. In good light they flood the cathedral with glorious, brilliant colour.

Castles

Alnwick. Northumberland. A splendid castle on a hill, especially fine when viewed across the River Aln or from any of a number of roads into Alnwick. Figures of men-at-arms stand out on the walls and within the castle are extensive treasures, including 1600 books and paintings by Titian, Vandyke and Canaletto. In spite of changes and extensive refurbishings the castle still looks very much as it did in the fourteenth century, with the Lion Bridge and the famous Percy Lion guarding its door. Just off the A1, in north Northumberland.

Arundel Castle. West Sussex. A castle immortalized by painters, including Turner and Constable. It is situated over the valley of the River Arun and the surrounding town, and is amazingly complete, with embattled barbican towers and wooden drawbridge. It becomes overrun with tourists in the summer, so select your time carefully. A27 to the east of Chichester.

Bamburgh. Northumberland. A massive, dark-brown castle placed ominously on a high cliff, called Wind Sill, and extending over about eight acres. Part of it has been converted into flats, but it remains impressive and is rewarding to photograph, both from the sea and from the village. Go south from Berwick-upon-Tweed on the A1, pass the side turning to Holy Island and then take the B1342 to Bamburgh.

Barnard Castle. Durham. This skeleton of a castle stands on high ground above the Tees. Silhouetted against the sun, it is a magnificent sight. The circular keep and the tower are as they were in the time of Sir Walter Scott. From Darlington take the A67 west.

Beeston Castle. Cheshire. Situated on steep and isolated rocks, about 700 feet high and overlooking wonderful countryside. Nearby is a modern, mock-medieval castle in the Peckforton Hills, and the two can be photographed together. From Chester take the A51 east and turn into the A49 across the canal. The castle is signposted on the right.

Belvoir Castle. Leicestershire. The castle, on its high, wooded hill was ruined in the sixteenth century, and has been stylishly rebuilt with elegant interiors. The position of the castle is particularly satisfying photographically, because it can be appreciated from all sides across the fields. Sometimes, in the autumn, when fires are burning, it looks mysterious and intri-

Truro Cathedral. Cornwall. An interesting example of Victorian Gothic – the cathedral was finished in 1910. It blends very well with the surrounding Georgian houses and so is fascinating architecturally and photographically. Inside, note the subdued colours of the embroidery and stone. The stained glass is also very fine.

Wells Cathedral. Somerset. One of the finest of British cathedrals, set on a spacious green amongst trees. The best view is perhaps from the south-east, showing its marvellously proportioned pinnacles. Its most famous part is its West Front. Originally there were nearly 400 carved figures – many were destroyed in the seventeenth century, but other fine examples still remain. In the interior, look out for the comic carved capitals in the South Transept – such as the man swollen with toothache, and the life-like lizard. By the Chain Gate opposite the north porch is the Vicars' Close – a street of lovely old houses, and yet another view of the cathedral.

Winchester Cathedral. Hampshire. A very fine cathedral, and the second longest in Europe. Travelling west from Alresford, you will suddenly catch sight of this long, low-lying cathedral. Its main interest lies in its size and strength, and in the greatness of its conception. The nave is impressive and there are seven beautiful chapels. Don't miss the carved black marble font from Tournai, or the many tombs and wall-paintings. The cathedral is spaciously set amongst lawns and trees, and St Giles' Hill, just above Winchester, gives a good view towards cathedral and town.

Worcester Cathedral. Hereford and Worcester. A splendid cathedral, on the banks of the River Severn and next to the cricket ground. Another good view

Berkeley Castle

guing in a drift of smoke. From Grantham on the A1 take the A607 south-west. A side road at Croxton Kerrial will lead you to Belvoir.

Berkeley Castle. Avon. Not to be missed. An ancient castle and grounds overlooking the Severn, and visible for miles. Occupied by the Dukes of Berkeley, it is the oldest inhabited castle. It offers an unusual selection of viewpoints for a photographer, and also much of purely general interest. Don't miss the dungeons, or the historic bowling alley, both with great photographic possibilities. Take the A38 north from Bristol and turn left on to the B4509 at Stone.

Blair Castle. Tayside. Amid highland scenery, a meeting point of several glens, with the River Garry running through, this gleaming white castle can be photographed from many positions. On the A9 north from Pitlochry.

Bodiam Castle. East Sussex. On the River Rother, a magnificent sight from many angles and from the charming village below. Perhaps photographically the most interesting feature is the moat in summer, full of lilies. You can also visit, by arrangement, the Guinness Estates hop farms, which are close to the castle. Daily, April to September. From Hastings take the A21 and then the A229 and a side road to Bodiam.

Bolton Castle. North Yorkshire. (Sometimes called Castle Bolton.) Overlooking Wensleydale, a romantic ruined castle, partially restored. From Wensley on the A684 take a side road to Castle Bolton.

Braemar Castle. Grampians. Now largely ruined, with beautiful views all around. Braemar is famous fot its highland games, usually held in September. Six miles to the east lies the famous Balmoral Castle, whose grounds can be visited as well. Just off the A93 where it turns to the east and Aberdeen.

Brough Castle. Cumbria. A majestic ruin on a hill in beautiful Pennine country close to the Lake District. Good views from below, and far-reaching country-

side around. It was known as the Castle of the Butcher, because of the behaviour of the thirteenth Baron Clifford in the Wars of the Roses. Just off the A66 some miles south-east of Appleby, on the right.

Brougham Castle. Cumbria. Another fine castle in splendid countryside, on the River Eamont. This is an old fort, once partly restored but now a romantic ruin. It is only a few miles from Lowther Castle (see below). Just off the A66 a short way east of Penrith.

Caernarvon Castle. Gwynedd. A vast castle, of special photographic interest for its reflections both in the River Seiont and in the Menai Strait. It is often floodlit at night, and the reflections become doubly fascinating, especially for the photographer. You can also see the castle from the Anglesey side: pick it out at night with a long-focus lens. It is on the A487 south-west of Bangor.

Carisbrooke Castle. Isle of Wight. A steep climb brings you to Carisbrooke, high on a hill with splendid views all around. The castle itself is Norman, and well-preserved. You can photograph the donkeys which plod inside, drawing water from the well beneath the castle. A mile and a half south-west of Newport on the B3401.

Carreg-Cennen Castle. Dyfed. Precipitously situated on a very high crag and overlooking a lovely river valley, this old fortress has an aspect both rugged and romantic. Green hills with grazing sheep surround it and, from the top, among the ruins, you can see the distant Black Mountains. From Llandeilo on the A40, take a side road to Trapp.

Castle Ashby. Northamptonshire. More like a stately home than a castle, but fascinating nevertheless. Drive up through avenues of trees past the eighteenth-century iron gates. The castle is beautiful both inside and out. The park was landscaped by Capability Brown – yet another photogenic item. From Northampton you take the A428 south-east and a side road left after Denton.

Castle Drogo. Devon. The turreted granite walls of Castle Drogo stand high on a rocky outcrop, 900 feet above the River Teign. Its appearance is deceptive: it looks medieval, but was built by Lutyens between 1910 and 1930. Inside, too, is an exhilarating (and impractical) mix of styles. There is a formal garden and a huge circular lawn, hedged by yews. Off the A382 at Drewsteignton.

Castle Hedingham. Essex. One of the mightiest and most impressive of East Anglian castles. Exceptionally well preserved, the twelfth-century castle has towers 100 feet high, a moat and bridge; and a beautifully decorated interior. From Braintree take the A1017 and then branch off at Sible Hedingham to the castle on the B1058. Visits by appointment only.

Castle Tioram. Highland. A most romantically sited castle, far away from the tourist track. It is set on the fringe of Loch Moidart on a high, projecting cliff, overlooking the countryside and many other lochs. Take the A861 from Salen and then a side road to Shielfoot and Dorlin. The castle is situated on a little island, which can be reached on foot at low tide.

Chepstow Castle. Gwent. On the River Wye, at a point where the river goes into one of its many beautiful curves. It is an elongated castle, with several courtyards along the river. There are splendid views of the Wye and surrounding countryside. One of the best views is from the Castle Dell, a path leading up from the car park. From the M4 heading across Severn Bridge take Exit 22 to Chepstow.

Cilgerran Castle. Dyfed. A much-painted Welsh castle overhanging the River Teifi. From Cardigan on the A487 take the A484 towards Newcastle Emlyn for about three miles and then a side road to the right.

Conwy Castle. Gwynedd. A massive castle on the promontory of a precipitous rock over the River Conwy. This is an impressive, and therefore popular, tourist spot. Off the A55 in Conwy.

Corfe Castle. Dorset. This castle is set among the rolling Purbeck Hills on its own high hill overlooking the countryside. The ruins are grandly impressive. In a good light, with some clouds, it can be outstandingly picturesque. From Wareham on the A351 towards Swanage just off the road.

Craigievar Castle. Grampian. An outlandish castle, very photogenic, in lush, hilly countryside. It has a set of elaborate turrets, built in the seventeenth century in the Scottish Baronial style, and a very fine interior. Just off the A980 from Banchory just after Kintocher.

Dartmouth Castle. Devon. One of a pair of castles built at the entrance to the River Dart in the fifteenth century. It is in good condition, and overlooks the lively and photogenic town of Dartmouth. From Plymouth, take the A379 right to Dartmouth.

Deal Castle. Kent. A squat castle with very thick walls, built almost on the beach. It is, oddly, rose-shaped, with a set of six battlements. It is a little difficult to get a good viewpoint for photography, but it can be done from the upper windows of some houses on the left. The castle is also very interesting inside. From Dover on the A258 north to Deal.

Dover Castle. Kent. When visiting Deal, have a look at Dover Castle too. It is very impressive, overlooking harbour and sea, but because of the modernization of the harbour, the views are not perhaps as spectacular as they used to be. The castle itself is certainly worth visiting: the photographer can stand high above the sea and look down on the White Cliffs. At the end of the A2 from Canterbury.

Duart Castle. Strathclyde. At the end of the Mull promontory overlooking Duart Bay. From the castle much of the Strathclyde coast can be seen, as well as Lismore and the far shores of Loch Linnhe. The castle itself is splendid. You can present it as dour and forbidding, or as romantic and enchanting, depending on the weather, which is extremely changeable in these part. Duart Castle is just off the A849 in Mull which can be reached by the ferry from Oban.

Dunnottar Castle. Grampian. One of the most spectacular Scottish castles, on a semi-island jutting out to the sea. There is a path leading up to the castle, and from there the views are breathtaking. The battlements and other remains of the castle are well worth photographing. About two miles south of Stonehaven on the A92 by the sea.

Dunstanburgh Castle. Northumberland. The magnificent ruins of a castle on a high cliff, overlooking the sea, amid rocky Northumberland scenery. It is not easy to reach – from Alnwick on the A1 you take the B1340, and then a side turning to Dunstan and Craster. From Craster (itself a charming village), it is a mile and a half's walk along lofty cliffs to the castle – a very exhilarating approach.

Dunure Castle. Strathclyde. Another spectacular ruin overlooking the sea and a rocky coast. The small village and harbour below provide a further wealth of scenes to photograph. From Ayr take the A719 along the coast and within a few miles is the village of Dunure with the castle close by.

Edinburgh Castle. Not to be missed, like Edinburgh itself. This beautiful castle dominates the entire city. There are many viewpoints; from almost any main street in Edinburgh you can see this wonderfully commanding building. The light is perhaps best in the early morning.

Eilean Donan. Highland. A splendid castle built on a tiny promontory in Loch Duich. It can be seen from both sides as the road loops round it. It is particularly attractive in the summer amid a mass of wild flowers. On the A87 after Glen Shiel, just before the village of Dornie.

Glamis Castle. Tayside. Haunted by not one, but nine ghosts, although it's unlikely that you will find one of them on the frame of your film. The castle is interesting in itself, being built like a French *château*. The grounds are superb and give stunning views of the whole of the Strathmore valley, which can be photographed from the castle battlements. In the garden is the famous sundial with 84 dials. From Dundee take the A929 and turn left on the A928 to Glamis.

Goodrich Castle. Hereford and Worcester. A twelfth-century castle standing high above the River Wye, ruined by time and Oliver Cromwell. The cannon which breached it is called Roaring Meg, and can be photographed. Mount the steep and narrow staircase to the Norman keep, as from there the most spectacular views can be seen. The whole castle is highly picturesque. Take the A40 north from Monmouth: the castle is just to the side of it.

Hardknott Castle. Cumbria. Certainly one of the finest remains of a Roman fort (Mediobogdum) to be found in Britain. It is sited on the Hardknott Pass in the Lake District, on the edge of a precipice, with mountains all around. Much of the Roman fort survives, and the whole area is exceptionally photogenic. From Ambleside take the little side road off the A593 to Hardknott Pass, or start from the other end of the same road by the bridge over the Esk on the A595. The Roman fort lies just above the road.

Harlech Castle. Gwynedd. A very large and formidable castle. Even though the water which surrounded it has receded, there is still a wonderful view of the countryside, and the castle itself is very photogenic. On the A496 south-west of Blaenau Ffestiniog near the sea.

203

Hever Castle. Kent. A well-preserved castle, if somewhat altered, but still very charming. The particularly magnificent gardens and the 35-acre lake offer some very promising shots. The castle is set on the River Eden, and its fascination lies perhaps in its smallness – it is almost a miniature. The Astors, who bought the house early this century, added a number of features, including a little piazza with Roman statues overlooking the lake. From Tunbridge Wells take the A264 west and then the B2026 north and a side road to the castle.

Inveraray Castle. Strathclyde. An eighteenth-century castle, in a fine situation. There are some good viewpoints towards it from the little brook which flows through the grounds, and also from the lake. From Glasgow take the A82 northwards and then at Tarbet the A83 to Inveraray.

Old Inverlochy Castle. Highland. In a romantic spot near Fort William below Ben Nevis, these castle ruins amid waving sycamores look down towards the mouth of the River Lochy. On the A82 just beyond Fort William.

Kenilworth Castle. Warwickshire. Thought by many to be the most impressive fortress ruin in England. It stands on a little hill and is ideal to photograph. (It has already been described in Part II.) From Coventry take the A46 south and turn in to Kenilworth on the A452.

Kilchurn Castle. Strathclyde. On an island in Loch Awe, this castle ruin can only be photographed from the side of the loch. It is a spectacular sight, especially from the south, with the impressive Ben Cruachan in the background, and is at its best early in the morning or in the late afternoon. In autumn, the colours around are warmly brown and yellow, and the castle is even more dreamlike, mirrored in Loch Awe. From Inveraray on the A819 north. (It is not possible to visit at the moment as it is undergoing restoration.)

Lancaster Castle. Lancashire. A very impressive castle situated on a hill above the town, and with superb views towards the Lake District and Morecambe Bay with its endless sands (described elsewhere). Photography from the castle, particularly with a long-focus lens on a clear day, could be outstanding. Take Exit 34 of the M6 and then the A683 to Lancaster.

Lindisfarne Castle. Holy Island, Northumberland. A tiny sixteenth-century fortress built to defend the harbour and now converted into a private house. It is very picturesque on its hilltop overlooking the sea and shingle beach. Take the A1 south from Berwick-upon-Tweed and a side road to Beal and Holy Island (passable only at low tide).

Lowther Castle. Cumbria. A stately ruin of a castle, very well preserved. There is surrounding parkland which abounds in unusual wildlife. From the M6 take Exit 40 and the A6 south to Lowther Castle.

Maiden Castle. Dorset. A gigantic Iron Age hill fort with an intricate system of ramparts and ditches still clearly visible. It is advisable to go late in the afternoon, because then the low sun outlines the ridges and the battlements are sharply dramatic. From the castle are sweeping views of the Dorset countryside

and the sea. From Dorchester take the A354 south for a mile. The castle is on a well-signposted side road.

Newark Castle. Nottinghamshire. The impressive red shell of a great castle overlooking the River Trent. This is its main pictorial interest, as it is beautifully and moodily reflected in the waters of the river. The views from the empty windows are good. From Nottingham take the A612 north and then the A617 to Newark-on-Trent and the castle is nearby. Visiting by appointment only.

Norham Castle. Berwickshire. The remains of a Norman castle perched on rocks above the River Tweed and overlooking some beautiful countryside beside the winding river. The castle was immortalized in Sir Walter Scott's *Marmion*. From Berwick-upon-Tweed take the A698 in the direction of Kelso and a side road to Norham.

Pembroke Castle. Dyfed. A Welsh castle surrounded on three sides by river and marsh. Its size and construction are impressive and there are views on the same scale, especially from its 75-foot rounded keep. In Pembroke, off the B4320.

Pevensey Castle. East Sussex. Overlooking Pevensey Bay. The castle is interesting from a historical point of view as it contains both Roman and Norman ruins, notably the Roman walls. From Eastbourne take the A259 along the sea to Pevensey.

Portland Castle. Isle of Portland, Dorset. An impressive and well-preserved castle opening out on to Portland Harbour and Weymouth Bay with fascinating sea views. From Weymouth take the A354 south.

Powis Castle. Powys. This medieval castle has been much remodelled over the centuries, and is perhaps a little ornate, but the formal seventeenth-century gardens are magnificent and well worth photographing, with their four terraces curving down towards the River Severn. The views around are superb. Powis Castle is near Welshpool on the A458 to the west of Shrewsbury.

Raglan Castle. Gwent. Much survives, and may be seen, including the banqueting hall and the grand staircase. There is a moat, and some beautiful surrounding countryside. From Monmouth south-west on the A40.

Restormel Castle. Cornwall. An aloof, dramatic ruin of a castle behind a wide moat and on a hill which has been artificially heightened. Its trees and lawns overlook some interesting countryside, including the valley of the Fowey River. From St Austell take the A390 to Lostwithiel and then a side road to the castle.

Richmond Castle. North Yorkshire. A huge ruined castle, almost square, and with battlements still intact. The castle overlooks the town and Swaledale, one of the most attractive of the Yorkshire dales. The Barbican and Robin Hood Tower are particularly worth visiting. From the A1 take the B6271 to Richmond and the castle.

St Michael's Mount. Cornwall. A 'must' for photographers when in Cornwall. It is a fairy-tale castle on a little island off the coast. The views from it towards

Warwick Castle

Land's End and the Lizard are spectacular, and there are some tropical gardens to be visited. From Penzance take the A394 to Marazion and then on foot or by ferry, according to the tide. The opening hours are complicated!

Stirling Castle. Central Scotland. A remarkable Renaissance castle overlooking the town from the sheer precipice of a 250-foot crag, with correspondingly dramatic views. It is also worth photographing the castle from the little church and churchyard immediately opposite. From the M9 take Exit 9 and the A80 straight to Stirling.

Tantallon Castle. Lothian. An amazing feat of engineering, the castle has three sides on high cliffs. It looks impregnable, but submitted to Cromwell's artillery in the seventeenth century. Now it is only an impressive ruin, with stupendous views across the countryside, including the Firth of Forth. There is a bird sanctuary on the Bass Rock immediately opposite. From North Berwick take the A198 due east: the castle is about three miles away.

Tintagel Castle. Cornwall. The ruin of a twelfth-century castle, itself built on the site of a monastery, dramatically situated on a headland overlooking the bay and a rocky coastline. Try going to the far side of

the bay, and photographing the castle at sunset when it is at its most dramatic. From Wadebridge take the A39, then the B3266 and the B3263 to Tintagel.

Urquhart Castle. Loch Ness, Highland. An impressive ruin of a castle overlooking Loch Ness from a high hill. The views to and from the castle are superlative. Along the western side of Loch Ness on the A82 near the village of Drumnadrochit.

Warkworth Castle. Northumberland. This castle guards the spot where the River Coquet joins the sea; hence it commands a beautiful view all around. It is especially worth going up to the top of the lookout tower, 32 feet above the roof. From there the vista stretches over the river and open sea, and to the Cheviot Hills. From Alnwick take the A1068 south towards the sea. The castle is just before Amble.

Warwick Castle. Warwickshire. The castle is perched perilously on a crag above the Avon. Its most impressive features are Caesar's Tower, the Gatehouse and Guy's Tower. It had been continuously inhabited since the seventeenth century when it was remodelled. The grounds were laid out by Capability Brown. In 1978 it was bought by Madame Tussaud's. There are fine views from the castle along the Avon. South of Coventry on the A46.

PREHISTORIC MONUMENTS

Avebury Circle. Wiltshire. The largest and most important of the prehistoric stone circles erected in the Bronze Age around 1800 B.C. Stonehenge is a more famous henge circle, but photographically, Avebury is to be preferred. It is larger, consisting of the imposing West Kennet Stone Avenue, the Internal Circle, and the great circle of stones which surround the village. Not surprisingly, some of the stones are missing, but those which remain are impressive, as they are wholly natural shapes, standing upright. Each has a different shape and a different texture as well. Avebury is visited by many tourists, and thus it is better to go early in the morning. Unlike Stonehenge, it is unfenced and so can be visited at any time. Ten miles west of Marlborough on the A4, take the A361 and Avebury is about a mile north.

Badbury Rings. Dorset. It covers 18 acres and has three circles of chalk banks and ditches with a tangle of trees and a desolate countryside around. It is a popular place, particularly at weekends, when people come for picnics and walks, so it is best to photograph it at a quieter time. You can find Badbury Rings by driving from Blandford Forum on the B3082 towards Wimborne Minster, along a superb avenue of beech trees which are about 100 years old and which stretch for two miles.

Barbury Castle. Wiltshire. A beautiful Iron Age hill fort. Only the mighty ramparts and deep ditches are left, circling an area of about 12 acres. You can get there by going past Avebury on the A361 until you reach Wroughton, and taking a side road from there, but it is better to take the B4005 for about a mile, and then the road to Barbury Castle past the Military Hospital. There is a convenient car park and from there a short walk to the fort. The Ridgeway runs right by the side of the castle, on its way through the Marlborough Downs.

Cairn Holy Chambered Cairns. Dumfries and Galloway. A neolithic or Bronze Age monument on Wigtown Bay. There are two burial chambers, of which the first and more interesting, is called the Cairn Holy One. They are wonderfully-formed standing stones, surrounding the burial ground and overlooking the Bay. From Newton Stewart, take the A75 past Creetown along Wigtown Bay and Cairn Holy will be signposted to the left.

Callanish Standing Stones. Lewis, the Western Isles. An impressive monument of many standing stones, possibly as impressive as Stonehenge, but not so well known, due to its remote situation. From Stornaway, take the A858 and as soon as you reach the western side of the island, you will find Callanish Standing Stones very well signposted. A little further along the same road, you will find another fascinating prehistoric monument, Dun Carloway Broch. The Broch is a prehistoric round tower made of stone with just one door, and very thick walls. It is entirely open to the sky and exceptionally well preserved, one piece still looming some 22 feet high.

Castlerigg Stone Circle. Cumbria. Exceptionally interesting from a photographic point of view, as this is an almost complete prehistoric circle of 38 stones in one of the loveliest parts of Britain. The surrounding countryside is superb, with mountain views all around. The stones are individually interesting as each one is different, like an independent sculpture. You can get there by taking the A66 east from Keswick. Just after the crossing with the A591, there is a road climbing towards the stone circle which is very well signposted.

Cerne Giant. Dorset. The giant is thought to date from Roman times and is enormous – 180 feet tall – cut into the chalk hill. His white outline is clearly visible from the A352 north of Cerne Abbas. The giant brandishes a club above his head and unblushingly displays a huge phallus. It is assumed, therefore, that the hill-carving involved fertility rites.

Hambledon and Hod Hills. Dorset. Two hill forts of Roman date, with many ditches and fortifications still intact. Both hills are superbly sited, so by walking on the tops of them, you can take some good photographs of the countryside around. From Blandford Forum, take the A350 north past Stourpaine. Hod Hill is immediately on the left and Hambledon Hill slightly to the north and a little further from the road on the same side.

Harold's Stones. Monmouth, Gwent. Three finely-shaped and strangely-placed stones, each at a different angle. There are many standing stones in Wales but these are perhaps visually the most interesting. There are other interesting monuments in the little Welsh village of Trelleck where Harold's Stones are found. There is the Virtuous Well, also called St Anne's Well, just outside the village, and an oddly-shaped mound called Tump Terret. From Monmouth, take the B4293 towards Chepstow and you will find the Stones just beyond Trelleck, and well signposted.

Herefordshire Beacon. (Also called British Camp.) Hereford and Worcester. Very near Great Malvern

Badbury Rings

206

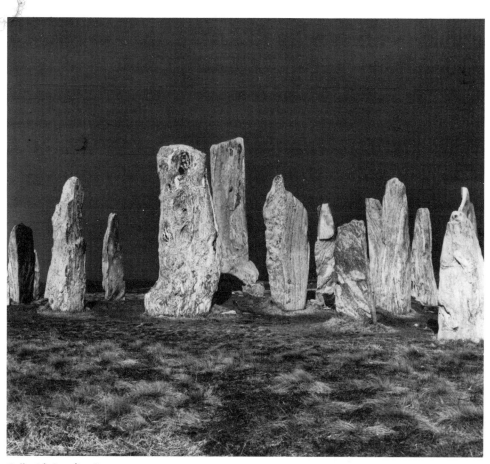

Callanish Standing Stones

and on the top of the Malvern Hills. An exceptional hill fort of Roman date, with many of the ramparts, paths and bridges still extant, giving magnificent views. The hill fort itself is very rewarding to photograph, especially in late afternoon when the sun is low, bringing the hills and ridges of the battlements into sharp relief. Take the A449 from Malvern. The car park is just at the turn of the road, and from there it is a short climb.

Lanyon Quoit. Cornwall. One of many similar quoits, but in an exceptional hilltop setting. The quoit is an enormous granite capstone, balanced on the top of three upright stones. There are others in the same area, such as Mulfra and Chun quoits, on hills overlooking the sea, the bay and the Cornish countryside around. From St Just, take the B3306 north-and at Morvah, take a side road to the right, signposted to Lanyon Quoit. Mulfra Quoit, Chun Castle and Chun Quoit are just before it, on the right.

Loch Stemster Standing Stones. Scottish Highlands. A mysterious prehistoric site with 36 standing stones of unknown origin arranged in a U-shape. In typical Highland countryside not far from two interesting lakes, Loch Stemster and Loch Rangag. Off the A895

just before Achavanich – the stones are to the south of Loch Stemster.

Long Man of Wilmington. East Sussex. A figure of a man 231 feet tall, cut in the Downs just above Wilmington. Take the little road off the A27 between Wilmington and Polegate. The Long Man is on the left in splendid surroundings. (The neighbouring road runs by the beautiful Cuckmere River.)

Maiden Castle. Dorset. The largest, and possibly the most important fortification in Europe, built around 2000 B.C. Fortified in the Iron Age, it was later captured by the Romans. It is some two miles in perimeter and situated in lovely Dorset countryside. The whole structure is highly complex and very interesting. It is obviously best seen from the air, but can also be photographed from the ground. From Dorchester, take A354 south and then Maiden Castle Way, which leads off to the right.

Nine Stones. Derbyshire. Despite the name, there are only four stones, standing on top of Harthill Moor. From Bakewell, take the side road to Alport and then continue south. Nine Stones is signposted just off the road.

Penrhos-Feilw Standing Stones. Anglesey, Gwynned. The island of Anglesey has a multitude of prehistoric stones and chambers, many of them not very far from Holyhead itself, some better situated than others. The two 10-foot high Penrhos-Feilw standing stones are to be found in a beautiful moorland setting. There are others not so far away, notably the Trefignath Burial Chamber, which, although interesting, is not so well-situated as Penrhos-Feilw. From Holyhead, take a side road south-west and just before this side road joins another, not far from the sea, you will find the standing stones.

Pentre Ifan Cromlech. Pembroke, Dyfed. There is a number of these burial chambers in Wales. A cromlech has three to five standing stones, usually very sharp along the top edge, on which is a carefully balanced capstone (not unlike the Cornish quoits). Pentre Ifan Cromlech is the finest and most intriguing of the Welsh examples. It is like an enormously graceful piece of sculpture. From Cardigan, take the A487 and then B4329 to Crosswell, where there is a side road signposted to Pentre Ifan.

Rollright Stones. Oxfordshire. Three sites of prehistoric importance. The biggest is the King's Men, with about 70 stones, none of them very high. The Whispering Knights' site is very photogenic, particularly in a delicate light, because it consists of five stones, leaning like tired old men. The third site is the King Stone. Take the A34 from Chipping Norton towards Long Compton, and a side road to Little Compton. The three groups are signposted.

St Lythans Cromlech. South Glamorgan. An impressive cromlech, with three tall standing stones supporting a massive capstone. The structure is a striking feature in a rather desolate stretch of countryside. From Barry, take the A4226 north and a side road to St Lythans. St Lythans Standing Stones are just past Dyffryn. Close by is the Tinkinswood Burial Chamber, which is also worth visiting. Take the side road towards St Nicholas from Dyffryn, and the Burial Chamber is on the left.

Silbury Hill. Wiltshire. An enormous regularly-shaped mound, possibly the largest man-made prehistoric hill. You can see it from Avebury, and so you can photograph Silbury Hill with Avebury Stones in front. Silbury Hill is just south of Avebury by Beckhampton on the A4.

Spinster Rock. Devon. A cromlech with two large standing stones and a third flat capstone which gives an interesting sculptured effect amidst pleasing countryside. Drive from Exeter towards Okehampton on the A30 and just past Whiddon Down, take the A382 south. Spinster Rock is on the left, on a side road to Drewsteignton.

Stonehenge. Wiltshire. This is the most famous and impressive of the prehistoric monuments in Britain. It is a familiar but striking sight, seen from the A303, standing on Salisbury Plain. As it is visited by thousands of tourists every year, it is now surrounded by a fence. It is no longer possible to go among the stones themselves; all you can do is circle them (and pay for that privilege). It is more difficult to produce unusual pictures than at Avebury. Nevertheless, Stonehenge is enormously impressive, particularly

Uffington White Horse

seen against the setting sun, with the rays slanting through the stones. From Andover on the A303, turn into the A344. Stonehenge is at the fork of the two roads. The car park is on the A344 and the entrance is from that side.

Uffington White Horse. Oxfordshire (And also Uffington Castle.) The strangest, and by far the oldest, of all the white horse figures. It is cut into the turf of the hill, a white figure outlined in chalk. From the ground, it is impossible to see or photograph it well and without any distortion. It is only from the air that we can see it clearly. Although in Oxfordshire, it seems more a part of the Wiltshire Lambourn Downs. The countryside around is very photogenic. From Swindon take the B4507. A side road to the left goes to Uffington and to the right is the car park. (You pass the White Horse on the way.) Uffington Castle is just above White Horse Hill. 250 yards long and 200 yards wide, it is an Iron Age Camp with ramparts, from which, it is said, on a clear day at least five counties can be seen.

Wayland's Smithy. Oxfordshire. Near the White Horse at Uffington. It can be reached by a gentle walk, following the Ridgeway through groves of beeches. Wayland's Smithy is not easy to photograph, as it is a long bowed chamber, but it is certainly a challenge and is set in splendid countryside. From the B4507, take the side road opposite Compton Beauchamp. This will lead to the Ridgeway and a short walk to Wayland's Smithy.

Westbury White Horse. Bratton Down, Wiltshire. Close to Stonehenge. While the Uffington White Horse is the oldest, the Westbury White Horse is perhaps the best known. It is the largest, most clearly cut and the most photographed of all the horses. From Warminster, take the A350 towards Westbury Lea and then the B3098 towards Bratton. You will see the horse clearly on your right.

FORESTS

Ashdown Forest. East Sussex. The remains of the great forest which the Romans called Anderida. What is left can mainly be found south of East Grinstead. A number of minor roads run south through the forest. The best point to start an exploration is the village of Wych Cross on the A22. (Or try Forest Row nearer East Grinstead.)

Forest of Bere. Hampshire. A remnant of forest immediately north of Portsmouth and Havant. From the A3, take the B2150 which crosses the Forest of Bere and turn left into the maze of side roads, where little villages still hide in parts of the forest. In the north, the Forest of Bere merges with the Meon Valley and some of the valley borders are also covered with patches of forest, for example, south of Droxford.

Border Forest Park. Northumberland. This is the largest man-made forest in Europe. It covers an enormous area from Hadrian's Wall right to the Scottish border. Many drives can be taken through the wood and the information centre is the little village of Kielder in Kielder Forest. From Hexham take the A6079 to Low Brunton and then the B6320 north. From Bellingham, take a side road going to Hesleyside and to Kielder.

Forest of Bowland. Lancashire. (Also called the Trough of Bowland.) You can cross it by taking the B6478 from Clitheroe to the River Hodder. From Newton on the river, take a side road into the forest. There are not many trees, but there are hills, moorland, and some lonely, wooded land to explore. From Dunsop Bridge near Newton, there is a little road going into the middle of Bowland.

Burnham Beeches. Buckinghamshire. 600 acres of massive beech trees. A very popular area in the autumn when it is aglow with brilliant colours. Take Exit 6 of the M4, and then the A355 north to Farnham Royal and Farnham Common. Burnham Beeches stretch along the left side of the road, crisscrossed by little roads.

Cannock Chase. Staffordshire. An area of wooded country, partly natural and partly planted by the Forestry Commission. It extends from Rugeley in the east to the A34 in the west, and the best place to start from is Brindley Heath on the side road from the A460. You can cross Cannock Chase from Brindley Heath to Etchinghill and the valley of River Trent. There are some specially good viewing points including Coppice Hill, 600 feet high. An ancient area, rich in oaks, is in the northern part of Cannock Chase near Brocton Coppice.

Charnwood Forest. Leicestershire. The forest no longer exists but the area remaining, although hardly a 'forest', is still beautiful to explore, with patches of wood and moors. It stretches on either side of Exits 22 and 23 of the M1. The area is best crossed by little roads. Try taking the B5350 south from Loughborough to Nanpantan and a side road across the forest. Some places from which to explore Charnwood Forest are Bardon Hill and Beacon Hill. (Beacon Hill is near Woodhouse Eaves and Bardon Hill is near Bardon village.) From both of these elevated viewpoints, you can see moorland and woods stretching on all sides.

Clun Forest. Salop. The forest stretches south of Bishop's Castle westwards from the A488 and it is worth crossing by minor roads. The best way is to go to Clun itself, on the A488 south of Bishop's Castle, and then take the B4368 westwards to Newcastle. From Newcastle, you can branch off into the small roads crossing the forest.

Coed-y-Brenin. Gwynedd. You can take A470 from Dolgellau northwards along the River Mawddach, and the little forest stretches on both sides of the valley.

Forest of Dean. Gloucestershire. For many, the most beautiful of all the forests in Britain. It is very large, covering around 27,000 acres with perhaps 20 million trees – including oak, beech, birch, ash and a variety of conifers. Essentially the finest of the British natural forests and abounding in splendid views. One of the most famous is from Symonds Yat Rock in the midst of the forest which overlooks the River Wye. Start exploring in Newnham on the A48, go on to the

New Forest

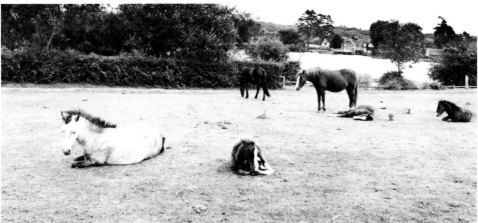

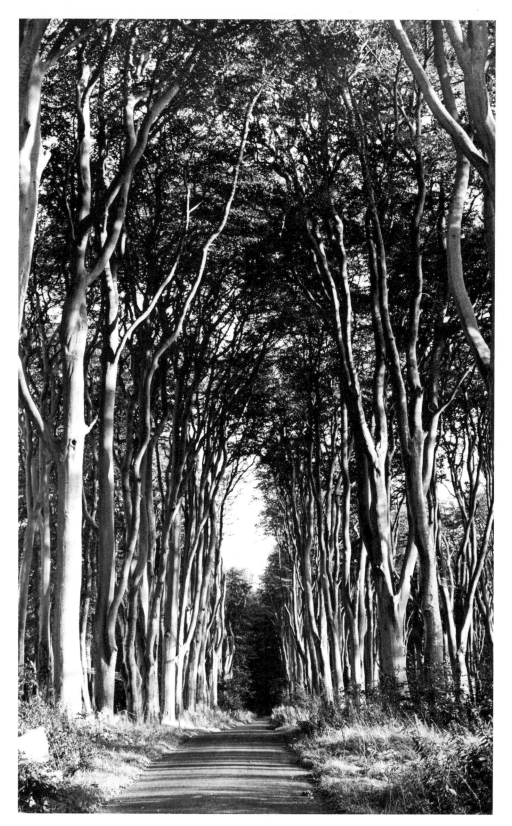

village of Littledean by a side road and from there, work your way south to the beautiful villages of Upper and Lower Soudley with magnificent views of the Soudley valley and forests. South-west towards the Wye valley and Tintern Abbey, is Hewelsfield, a pretty village with lovely views around. Possibly the best road running through the forest is the B4234 north from Lydney.

Delamere Forest. Cheshire. An area of forest now mainly planted by the Forestry Commission, but once a hunting forest belonging to the Earls of Chester. It extends north of the A556 at Delamere. The best way to cross the forest is on the B5152 from Delamere.

Epping Forest. Essex. On the northern fringes of Greater London, a forest which was purchased by the Corporation of London in the late nineteenth century and is a good place for walks and picnics. The M11 to Cambridge crosses Epping Forest, and the best way to explore it is to take side roads from the M11 towards High Beach and the other small settlements about.

Fforest Fawr. Powys. A wild forest stretching between the Black Mountain and Brecon Beacons. From the A465 from Swansea, take a side road at Pont Nedd Fechan along the River Melte to Ystradfellte, the little village within the forest. From there, continue north through the Fforest Fawr. The scenic A4067 also runs from Swansea to Forest Fawr, and you can take side roads from it.

Glentrool Forest. Dumfries and Galloway. A superb area of forest, now largely planted, but nevertheless of exceptional beauty. The best route is from Newton Stewart, taking the A714 to Bargrennan and then a side road to Glentrool village, from which there are two roads: one dead end, leading only to the lovely Loch Trool and Glen of Trool, and the other going north to the Water of Minnoch, with the tall peak of Merrick to the right.

Grizedale Forest. Cumbria. Between Coniston Water and Windermere in the Lake District. It is a beautiful area of recently planted forest mixed in with the old. Its heart is Satterthwaite, and the best way to get there is to take a ferry from Windermere across the lake, and then the B5285 from Sawrey to Hawkshead where there is an information centre. Take a side road south to Grizedale and Satterthwaite, and from there you can walk around.

Gwydr Forest. Gwynedd. One of the forests created in the 1920s by the Forestry Commission and occupying a large area from Betws-y-Coed to Capel Curig, covering many of the Snowdonia foothills, and stretching north from Betws-y-Coed into the Conwy valley. It is worth going from Betws-y-Coed along the A470 to Llanrwst and then taking a side road to the left.

Lune Forest. Durham. A wild area of forest, fells and heath, west of Middleton in Teesdale. The best way to get there is to take the B6278 from Barnard Castle to Middleton in Teesdale, and then the B6276 west through Lunedale, which gives its name to the forest. There are no roads crossing the Lune Forest, but there

Savernake Forest

are some walks in this rough and uninhabited country.

New Forest. Hampshire. One of the finest forests in Britain, and the most varied, with a mixture of trees and wildlife, wood clearings and roads. It lies in the southern part of Hampshire between Southampton Water in the east, Lymington in the south, and Ringwood in the west. Lyndhurst is the established capital of the New Forest, and many walks and drives are taken from there. There are many lovely villages within the forest itself, including Cadnam and Minstead.

Radnor Forest. Powys. An area not of deep forest, but of ravines, and hills, dales and heaths stretching from New Radnor in the south and bounded by the A488 in the north. The best way to explore the forest is to leave Builth Wells on the A481 and then take the A44 to New Radnor. There are no roads through Radnor Forest. The road from Kinnerton goes along the side of the forest rather than through it. In the south of Radnor Forest, not far from New Radnor, is a waterfall called Water Breaks Its Neck.

St Leonard's Forest. West Sussex. The remains of a once great oak forest, but St Leonard's still boasts the largest number of oaks surviving in southern England and is spectacular to cross. The best way to see it is to go to the end of the M23 and then take the side road to Colgate through St Leonard's Forest. From there, you can take another little road southwards to Mannings Heath on the far side of the forest.

Savernake Forest. Wiltshire. A splendid piece of ancient forest retaining its old beeches and oaks, some of which are in grand avenues. The forest is on the Wiltshire Downs east and south of Marlborough, and the Forestry Commission has provided many drives, walks and parking spaces in the forest. Because of the strict protection of its trees, Savernake Forest is becoming more beautiful as time passes. The grand avenue, which runs from north-west to south-east, goes straight through the heart of the forest. Cars must be left on the roads, as there are riding and walking paths only. It is best to enter the forest off the A4 just before Marlborough, and to drive across to the little village of Durley on the other side.

Sherwood Forest. Nottinghamshire. The famous forest where Robin Hood roamed, used to be composed mainly of oaks. These days it is largely depleted, but some parts still retain their oaks, which may be up to 800 years old. You can find some splendid oak trees, including the Major Oak, at Bilhagh, north of Edwinstowe, and also in Clumber Park off the B6005 from Worksop. The best part of Sherwood Forest stretches from Worksop in the north towards Mansfield in the south and can be explored via the side roads and little villages.

Thetford Chase. Norfolk/Suffolk. The largest forest in England, stretching for 53,000 acres and containing the headquarters of the Forestry Commission. There are two-mile trails through avenues of beautiful trees. Many of the trees border on fields of corn and barley. Some of the groups of already-felled trees are very photogenic. The best place to start is the capital of Thetford Forest, Santon Downham, from where there is a forest trail. You can reach Santon Downham by taking the A134 from Thetford and turning off after about six miles.

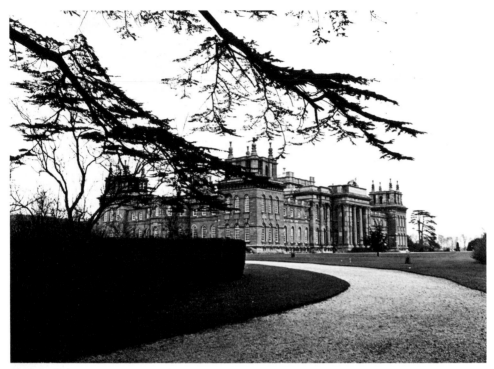

Blenheim Palace

Abbotsbury. Dorset. The village has sub-tropical gardens with exotic trees and plants and an ancient swannery which used to house some thousands of swans (there are still about 300 there). From Bridport or Weymouth on the B3157.

Alton Towers. Alton, Staffordshire. A fantastic garden, begun by the Earl of Shrewsbury early in the nineteenth century. There are eccentricities, such as an imitation Stonehenge and an unusual Chinese pagoda with a fountain. There are also woodland parks and walks, pony and donkey rides, etc. From Uttoxeter on the B5030, the B5031 and the B5032.

Anglesey Abbey. Cambridgeshire. A superb park and garden with geometric alleyways, classical statues, clipped hedges, leafy trees and avenues. See the Emperor's Walk. The present house is no longer an abbey, and has been much altered, but has interesting tapestries, paintings and sculptures. You can get there from Cambridge on the A45 and then the B1102.

Aros Park. Isle of Mull. A splendid park, with waterfalls, woodlands and a little loch. It is best to visit it in early summer when there are displays of rhododendrons and azaleas. You can get there on the A849 which circles the north-eastern side of the island.

Bible Gardens. Bangor, Gwynedd (within Bishop's Gardens). An interesting little garden, laid out next to the cathedral, with examples of every flower, shrub and tree mentioned in the Bible. Bangor is in North Wales on the A55 from Conwy.

Bicton Gardens. Devon. There are several different types of garden here, including Italian, with lawns and classical sweeps, and American. The ornamental lake and summerhouse are pretty and picturesque. From Budleigh Salterton north on the A376.

Blenheim Palace. Oxfordshire. Built by Sir John Vanbrugh for the first Duke of Marlborough, the house itself is spectacular both inside and out. The park, designed by Capability Brown, includes a lake which is considered by many to be his masterpiece. There are also beautifully laid out gardens and the whole park is worth exploring. At Woodstock, near Oxford on the A34.

Bodnant Garden. Gwynedd. Thought by many to be one of the most beautiful gardens in Britain, partly because of its superb situation on the slopes of the River Conwy with the Snowdonia range on the horizon. It is laid out in Italianate terraces, with the unusual Pin Mill at one end along a narrow pool. South of Colwyn Bay on the A470.

Brockhole. On Windermere, Cumbria. Some 30 acres of parkland and gardens sweeping down towards the shore of Windermere. There are wonderful walks and views of the mountains and across the lake to Langdale Pikes (views which could be taken with flowers in the foreground). On the A591, a mile or so north of Windermere village.

Burford House Garden. Salop. Masses of unusual shrubs and plants, well laid out. An added attraction is the River Teme, which winds its way through the

grounds, feeding the fountains and providing the finishing touches to this charming little garden. From Tenbury Wells one mile west on the A456.

Burghley House. Cambridgeshire. One of the most splendid of Elizabethan houses, of especial interest for its architectural perfection and interior decoration. There is also a park and a rose garden. By Stamford on the A1 take the B1443 for about a mile.

Castle Howard. North Yorkshire. One of the finest of England's houses, designed by Sir John Vanbrugh, built at the beginning of the eighteenth century and set in magnificent parkland. The grounds are superb both for photography and for exploration. The expanse of lake with the noble silhouette of the castle beyond is very picturesque, especially in the late afternoon. Six miles from Malton off the A64.

Chatsworth House. Derbyshire. This house is superbly set, overlooking the Derwent Valley, in a park remodelled by Joseph Paxton, creator of the Crystal Palace. There are terraced water gardens and lakes. The interior of the house is equally interesting, with magnificent state rooms and many great paintings. From Bakewell take the A619 and then the B6012 to the right.

Cliveden House. Buckinghamshire. A beautifully laid out park running down to the River Thames, with lovely views. From Marlow take the A4155, A4094 and the B476.

Clumber Park. Nottinghamshire. A 3800-acre landscaped park sold to the National Trust by the Duke of Newcastle. It is very picturesque, with a two-mile long avenue of limes and some 3000 trees. There are lakes and bridges, woodland paths and many wild plants, and also a huge Victorian church. From Worksop take the B6005 south to Clumber Park.

Compton Acres. Dorset. There are seven different styles of garden here – Italian, Japanese, and so on, with unusual plants and many other attractions. You can find it between Bournemouth and Poole on the B3369, by the sea.

Chatsworth House

Compton Wynyates. Warwickshire. An exceptional Tudor house, built in brick in a landscaped setting, with a little windmill on top of the hill behind it and some sculptured yews in front. There is a very good view of it from the main road. From Shipston on Stour on the A34 take the B4035 to Upper Brailes and a side road to Winderton and on to Compton Wynyates.

Crarae Forest Garden. Inveraray, Strathclyde. A remarkable garden, running down to Loch Fyne, with many varieties of shrubs and plants (especially rhododendrons), and the added attraction of a mountain stream. You can climb up to Crarae Lodge, which overlooks the whole of the loch. The best time to go is May or June, when many of the shrubs are in full flower. From Inveraray on the A83 south towards Loch Fyne – Crarae Garden is on its northern bank.

Culzean Castle. Strathclyde. A splendid mock-Gothic 'castle' built by Robert Adam; one of his finest houses. It overlooks the Firth of Clyde and has views of the sea and rocky headlands. The grounds include gardens and a country park; the walled garden is particularly fine, with an aviary and camellia house. There is also access to the beach, so photography can be from above or below. From Ayr take the A719 along the coast. Culzean Castle is signposted.

Cymerau Gardens. Dyfed. Not large, but an exceptionally beautifully set landscaped garden with a large collection of shrubs and superb views towards the Dovey Estuary. From Machynlleth on the A487 take the road south to Glandyfi and Cymerau Gardens.

Dawyck House Gardens. Borders. An enchanting little garden laid out on the banks of the River Tweed and with fine river views. There are avenues of limes, and wooded glens. From Peebles take the A72 west and then the B712 to Dawyck House Gardens.

Dyrham Park. Avon. A splendid stately home with beautiful interiors, including particularly fine tapestries. The park is extremely picturesque; it is kept in a fairly natural state, with two lakes and a medieval church. The large herd of fallow deer could be photographed on the hill overlooking the house and would make a dramatic photographic study. From the M4 take Exit 18 and the A46 towards Bath, turning almost immediately into the side road on the right leading to Hinton and Dyrham.

East Lambrook Manor. Somerset. If you like intimate and well-kept cottage gardens, this is certainly the place for you. It was created by the late Margery Fish, author of many gardening books, and features an extensive variety of shrubs and flowers, plus a silver garden and willows. The house is noted for a fine Minstrels' Gallery. On the A303 past Ilchester, take the B3165 north past Martock and side roads to East Lambrook Manor. Enquire before visiting.

Edwalton Rose Gardens. Nottinghamshire. Edwalton, on both sides of River Trent, is well known for its roses. The nursery fields glow with colour throughout the summer and autumn. Visitors are welcome, and the scope for photography is wide. From Nottingham take the A606. Edwalton is on a side road just beyond West Bridgford.

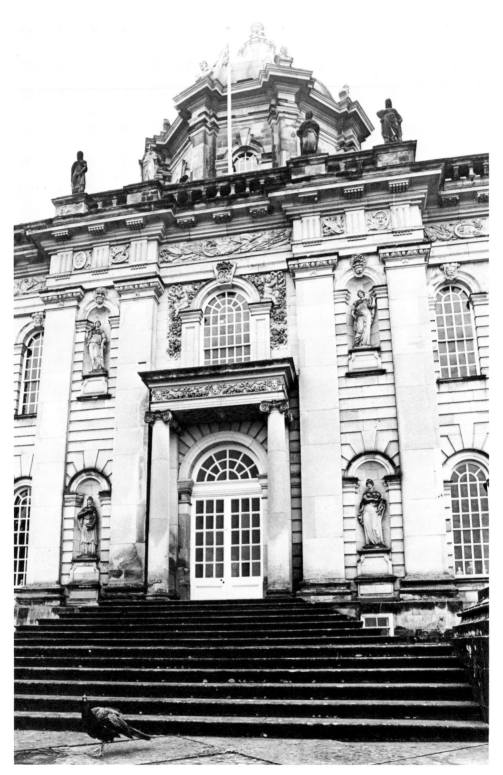

Edzell Castle. Tayside, Scotland. This splendid six-teenth-century ruin has unusual and fascinating wal-led gardens. The remarkable tracery of the gardens, where the clipped green plants spell out all manner of sayings is enhanced by the splendours of the castle itself. From Brechin take the B966 north to Edzell. The castle is nearby.

Exbury Gardens. Hampshire. On the fringes of the New Forest, in the grounds of Exbury House, home of the Rothschilds. This 250-acre rhododendron and azalea garden is famous for its size and beauty. You can get there from Lyndhurst by taking the B3056 to Beaulieu, then the B3054 east and a side road to Exbury.

Furzey Gardens. Minstead, Hampshire. A charming garden, particularly so in early summer, with azaleas and rhododendrons, and also in the autumn. It is set in a New Forest village with a notable thirteenth-century church. From Lyndhurst take the A337 north and then secondary roads to Minstead on the left.

Glendurgan Gardens. Cornwall. These gardens have a wealth of plants both English and exotic, including many Mexican and South American evergreens. The gardens are on the side of a valley sloping down towards the Helford River Estuary, and are certainly worth visiting both for the plants and the views. Four miles south-west of Falmouth on a minor road beyond Mawnan Smith.

Graythwaite Hall Gardens. Windermere. On the wooded slopes of the lake, with many views of the water. The gardens are particularly exciting in late spring and early summer. You can get there from Windermere by taking the ferry and the B5285 to-wards Near Sawrey. Turn left before the village on the beautiful road along the banks of Windermere, and you will come to Graythwaite Hall on the right.

Gwyllt Gardens. Portmeirion, Gwynedd. There are 20 miles of attractive walks amid rhododendrons and azaleas, with Cardigan Bay and Snowdon as a back-ground. There could hardly be a more beautiful set-ting – mountains and water, and a foreground of bright flowers. From Blaenau Ffestiniog, take the A496 and then the A487 towards Porthmadog. Port-meirion is about three miles before Porthmadog, down a side road to the left. Enquire before visiting the gardens: although they are generally open, they are private.

Hampton Court Palace. Middlesex. Built by Cardinal Wolsey and presented to Henry VIII, enlarged by Sir Christopher Wren and sumptuously decorated by many great masters. The exterior is exceptional, with its avenue of trees and the elegant river canal. The walled gardens are considered the finest in the world – and see also the orangery, the great Vine and the Maze. All these are extremely pictorial, but be wary of the crowds. The palace is extremely popular, being so close to London. Early mornings are advised, or off-season, during the winter, when it is also very beautiful. From Richmond upon Thames take the A307 to Kingston and Hampton Court.

Castle Howard

Hatfield House. Hertfordshire. A splendid Jacobean house, possibly the finest in Britain. Apart from the beauty of the house itself and the interior, the grounds are magnificent. There are 1500 acres of park, wood-land and avenue walks. From London take the A1000 to Potters Bar and continue on the road past Welham-green. Hatfield House is before Hatfield on the right.

Heveningham Hall. Suffolk. An impressive Palladian building with some rich interiors, and grounds laid out by Capability Brown. The orangery is especially fine. From Halesworth on the A144 take the B1117 to Walpole and Heveningham Hall.

Hidcote Manor Gardens. Gloucestershire. The lover of flowers and gardens should certainly not miss this garden, which is ideally situated with views over the Vale of Evesham. Small, hedged gardens are each devoted to a different species. They are best visited in spring and summer. From Chipping Campden take the B4081 towards Mickleton. The garden is on the side road to the right towards Hidcote Boyce.

Hodnet Hall Gardens. Shropshire. Laid out in 60 acres of woodland in a valley which was drained and made into these superb gardens by the previous owner. A cascading stream links several lakes, there are graceful clusters of trees, and a shrubbery with flowers. Best in summer and spring. From Market Drayton take the A53 south to Hodnet. The gardens are half a mile from the village.

Holker Hall. Grange-over-Sands, Cumbria. Well situated north of Morecambe Bay, a splendid house with attractive grounds. It is best in spring and early summer when the rhododendrons, azaleas and other shrubs are in flower and the deer can be seen wander-ing about. From Grange-over-Sands take the B5277 and then the B5278. Holker Hall is about five miles further along the bay.

Holkham Hall. Norfolk. A magnificent classical man-sion. The interior is sumptuously decorated, and has some fine paintings. The grounds laid out by Capabil-ity Brown include a picturesque lake and some excel-lent walks among trees and flowers. The Hall is popu-

Holkham Hall

lar with tourists, so pick your time carefully. From Hunstanton on the Wash take the A149 as far as Wells-next-the-sea. Holkham Hall is just before it on the right.

Inverewe Garden. Highland. Unusually situated gardens on a headland into Loch Ewe. Begun in the middle of the nineteenth century, the gardens have slowly been brought to a glorious state with many uncommon plants, informally laid out. The displays last throughout the year and include lilies and hydrangeas. It is not an easy drive: take the A832 from Kerrysdale to Gairloch and beyond Poolewe to Inverewe.

Kirby Hall. Northamptonshire. Photographically, not to be missed. This is a stately mansion which has been allowed to fall into ruin, with gaping, empty windows. In front of it the once famous gardens have been replanted with thousands of roses, making it an attractive place to visit in summer. From Stamford take the A43 south, and just past Bulwick take a side road to the right to Deene and Deene Park. Kirby Hall is a little further on.

Knole House. Kent. A great stately home. The interior is elaborately decorated with fine paintings and tapestries, and there is a fine staircase, which (with permission) is well worth photographing. There are interesting grounds with deer. From Sevenoaks take the A25 east and then at Seal a side road to Knole.

Lacock Abbey. Wiltshire. The travelling photographer should not miss Lacock Abbey, the home for many years of William Henry Fox Talbot. Many souvenirs of Fox Talbot remain; there is a fine museum and the barn from which he used to photograph. The abbey is laid out among groups of trees in splendid countryside and is next to the lovely village. Don't miss the cloisters. From Chippenham take the A350 towards Melksham. Lacock Abbey is just off the road to the left.

Levens Hall. Cumbria. One of the most attractive gardens in the north of England, laid out by a Frenchman at the end of the seventeenth century and almost entirely unchanged. The formal gardens contain fantastic shapes cut out in yew and a collection of steam engines as a bonus The Elizabethan house is also magnificent. From Kendal take the A6 south and turn into the A590. Levens Hall is on the left.

Lingholm Garden. Cumbria. On Derwentwater, a splendid garden with remarkable trees, particularly fine in the spring and early summer with rhododendrons and azaleas. From Keswick take the A66 and turn into a side road towards Grange.

Lochinch and Castle Kennedy Gardens. Dumfries and Galloway. These gardens have been laid out in an interesting location between two lochs, Black and White. The many outstanding features include a curious avenue of monkey-puzzle trees. The grounds, inspired by Versailles, cover 70 landscaped acres. From Stranraer take the A75; the gardens are just past Aird on the left.

Logan Botanic Gardens. Dumfries and Galloway. A sub-tropical paradise, because of the warm Gulf Stream which flows past the Mull of Galloway. There are no frosts, so there is a profusion of exotic flowers and plants and some beautiful rhododendrons for which Logan is especially famous. Spring and early summer are the best times to visit. From Stranraer take the A77 and the A716; Logan Gardens are just after Ardwell on the right.

Longleat. Wiltshire. Here you can go on safari in your car and photograph Bengal tigers, lions and monkeys in this 200-acre park. You can also take a trip on a safari boat! From Warminster take the A362 towards Frome and Longleat is on the side road to the left.

Luton Hoo. Bedfordshire. An amazing extravaganza of a stately home, the house was built originally by Robert Adam in 1768, but remodelled after the fire of 1843. The finest feature is the park, designed by Capability Brown, with its beautiful lake. Try to photograph the grounds from the house itself – it is a splendid view. Close to Exit 10A of the M1.

Lyme Hall and Lyme Park. Cheshire. Free-roaming red deer, and 1300 acres of park and moorland. The formal gardens, bright with flowers, should be seen in spring or summer. From Stockport take the A6 south and a side road from Disley to Lyme Park.

Montacute House. Somerset. Thought by many to be the most beautiful Elizabethan house in England, with a magnificent interior. The original Elizabethan gardens have little walls and summer houses. Don't miss the village of Montacute, which is exceptionally picturesque. From Yeovil on the A30 take the A3088 to Montacute.

Ness Gardens. Cheshire. Now mainly run by Liverpool University. The many botanic gardens here include a Far Eastern one, with Chinese lilies of the valley, and one with plants from the Himalayas. Because of the mild climate in this particular part of the Dee Estuary there is a mass of colour the whole year round. From Chester take the A540 towards Heswall and turn left into a side road towards Ness after about six miles.

Newstead Priory. Nottinghamshire. A stately home with the remains of an old priory (see under Abbeys). The grounds run down towards two lakes and there are nine acres of well planned open grounds with flowers and trees. This was the ancestral home of the Byron family until 1817 when the poet Lord Byron sold it to pay his debts. There are a number of mementoes of his life. From Nottingham take the A60 northward for about nine miles; Newstead Priory is on a side road to the left.

Nymans Garden. West Sussex. A fascinating garden, laid out at the end of the nineteenth century, with fine topiary and a rose garden. It is celebrated for rhododendrons, magnolias and camellias, so spring and early summer are the best times to see it. From Crawley, take the A23 to Handcross and the B2114 for one mile.

Packwood House. Warwickshire. A Jacobean house with excellent panelling and some period furniture, but most famous for its garden and particularly its skilfully clipped yew trees. The topiary garden represents the sermon on the mount, with Christ, his Apostles and the Evangelists. Look for the beehives set in niches around the walls, and the sundials. The yews are always clipped in August, providing another in-

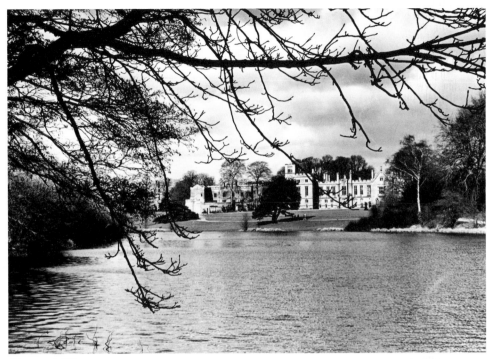

Newstead Abbey

teresting photographic subject. From Henley-in-Arden take the A34 north and then a side road towards Packwood House when you reach Lapworth.

Penshurst Place. Kent. Originally medieval, this manor house was enlarged in Elizabethan times and contains many interesting interior features. Its situation in magnificent parkland around two rivers, Medway and Eden, is delightful. The formal gardens are elaborately laid out and lovingly cared for. From Royal Tunbridge Wells take the A26 north and then turn west into the B2176 to Penshurst.

Petworth House. Sussex. A beautiful mansion in fine grounds. The house contains paintings by Titian, Gainsborough, Turner and others. Turner stayed there for some time, and painted in the grounds. The 2000-acre park was laid out by Capability Brown, and the house is reflected in the ornamental lakes. From Chichester take the A285 for about 14 miles to Petworth.

Plas Newydd. Gwynedd. A five-minute walk from Llangollen will bring you to this house, in formal gardens, which was the home of the 'Ladies of Llangollen'. The gardens are ideally situated in a valley overlooked by mountains and are well worth a visit. Just off the A5, east of Llangollen.

Polesden Lacey. Surrey. Opulent house and gardens in charming countryside. There are lovely views of the wooded Ranmore Common: perhaps this is the English landscape at its best. The house belonged to the playwright Sheridan, and is now the property of the National Trust. From Guildford take the A246

and then a side road to Polesden Lacey on the right. (Not far from Abinger Hammer, also worth visiting.)

Pusey House Gardens. Oxfordshire. Not large, but there are several elegant features, such as the terraces full of flowers, and the bridge over the lake. From the house may be had some sweeping views of White Horse Hill and the Berkshire Downs. From Faringdon take the A420 and turn into the B4508 to Pusey.

Ragley Hall. Warwickshire. A superb Palladian house with fine interiors and an astonishing collection of ceramics, carvings and gold. The gardens were laid out by Capability Brown, with lakes and glorious views of the surrounding Cotswold countryside. From Evesham take the A435 north to Dunnington and the A441 for Ragley Hall.

Rousham House. Oxfordshire. William Kent's masterpiece. Anyone who admires classical forms, pagodas, Doric temples and artificial ruins amid lakes and other enchanting vistas, should go to Rousham. The scope for photography is superb. From Chipping Norton take the A34 towards Oxford and turn into the B4030. Rousham is on the right.

Rydal Mount. Cumbria. The home for 37 years of William Wordsworth, who himself laid out the charming gardens on two levels. Look at the view from Rydal Mount, the surrounding countryside and lovely Rydal Water. About a mile and a half northwest of Ambleside, is Dora's Field, which the poet filled with daffodils for his daughter. From Windermere take the A591. Rydal is just past Ambleside on the right.

Savill Gardens. Surrey. Splendid gardens in Windsor Great Park. Here are 20 acres of woodland, gardens and heather, all in harmony with the surrounding natural valley. The azaleas and Japanese maples are particularly fine. Take the A30 from London past Egham and a side road to Englefield Green.

Sissinghurst Castle. Kent. A Tudor and Elizabethan mansion restored in the 1930s by Harold Nicolson and his wife Vita Sackville-West, who created the delightful gardens, perhaps the most beautiful in England. The series of lovingly planned small gardens, bordered by a moat, each have a theme; perhaps the best known is the White Garden. Climb the tower to have a fine view of the Kentish countryside. From Hawkhurst, take the A229 north past Cranbrook and then the A262 east to Sissinghurst.

Springfield Gardens. Near Spalding, Lincolnshire. These gardens are on the outskirts of the town. There are sunken gardens, lawns, lakes – even an aviary – and, of course, tulips in season, for this is the main tulip-growing area of England. A mile out on the A151 from Spalding.

Stowe Park. Buckinghamshire. For some, England's finest park; now a public school. Visit its temples; also look at the house, beautifully reflected in the lake with water lilies around. The 200 acres of parkland were laid out by Capability Brown and William Kent. From Buckingham take the A413 north and turn left into a side road to Stowe.

Tatton Park. Cheshire. A superb piece of whimsy by Humphry Repton, who created a variety of features. There is an authentic Japanese garden, a Shinto temple on a tiny island and a 1000-acre deer park. The mere is a haunt of wildfowl. It is well worth a visit, but try to avoid the crowds. From the M6 take Exit 19 and then A556 north. Tatton Park is on a side road to the right.

Stowe Park

Threave Garden. Dumfries and Galloway. National Trust gardens, planted in such a way that, whenever you go, there are displays of flowers. Specialities include daffodils, roses and heather. The neighbouring small Threave Castle lies on a low island in a fork of the River Dee, and is exceptionally picturesque. From Dumfries take the A75 past Castle Douglas and then a side road to the right.

Trelissick Gardens. Cornwall. These charming gardens overlooking the Fal Estuary and Falmouth harbour are especially beautiful in spring, when shrubs and bulbs bloom early in the mild Cornish climate. From Truro take the A39 south and then the B3289.

Uppark. West Sussex. On the crest of the South Downs with grounds looking down to the valley. The gardens were landscaped by Humphry Repton at the start of the nineteenth century. On a clear day the Isle of Wight is visible. The house contains several interesting features, particularly the white and gold saloon. From Petersfield take the B2146. Uppark is just beyond South Harting.

Waddesdon Manor. Buckinghamshire: A huge country mansion, in the style of a French *château*, on a hilltop amid extensive grounds. The house includes many interesting features, and there are tropical birds in the charming aviary in the garden. Look for the Italian fountain and sculptures in the grounds as well. From Aylesbury take the A41 to Waddesdon.

Westonbirt Arboretum. Gloucestershire. Famous Forestry Commission grounds. Almost every known species of tree is here, planted over about 116 acres, together with the nearby silk wood. Try to be there in the autumn, when the colours are quite breathtaking. The arboretum is off the A433, about three miles south-west of Tetbury.

Winkworth Arboretum. Surrey. Conveniently placed for the London tree lover, this is a magnificent 95-acre hillside site, with a lake at the bottom. Trees of various kinds have been collected here and, in the autumn, are ablaze with colour. From Guildford take the A3100 to Godalming and then turn into B2130 for the Arboretum.

Wisley Gardens. Surrey. This is the place for anyone interested in gardening, in particular, or plants in general. It is the Royal Horticultural Society's garden, where you can see every kind of experiment and practically every kind of plant. There are rock gardens and wonderful azaleas, camellias, roses and rhododendrons. It is very near to London. Take the A3 through Cobham, and after about three miles, a well-signposted side road to Wisley Garden.

Woburn Abbey. Bedfordshire. Largely rebuilt in the eighteenth century, the house contains magnificent collections of pictures, furniture, silver and porcelain. Try to see it in the morning when the crowds have not yet arrived at this much-commercialized stately home with its animal park. The grounds and the park, landscaped by Humphry Repton, are beautiful; special features include the Chinese Dairy, the Ice House, the Sculpture Gallery and a maze. From Exit 13 of the M1, take a side road and then the A418 to Woburn village.

NATURE TRAILS AND RESERVES

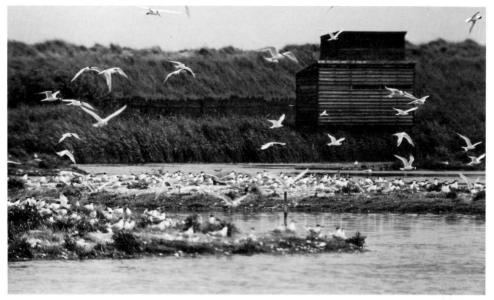

Minsmere Nature Reserve

Beinn Eighe Nature Reserve. Highland, Scotland. A fine Scottish reserve, rich in plants, woodlands and also some animals. In order to know more about it, enquire at the Nature Conservancy Board in Edinburgh. The nature reserve starts by the A832 at Kinlochewe.

Bempton Cliffs. Near Flamborough Head, Humberside. A superb place for watching masses of birds, as it is reputed to be the largest area for breeding sea birds in England. There are guillemots, razorbills, puffins and fulmars. Although it is a reserve, the public can walk along the cliffs. From Bridlington, take a minor road to Bempton and walk from there.

Bentley Wild Fowl Gardens. East Sussex. Alive with varieties of birds: swans, geese, ducks and also foreign birds, in a garden of more than 20 acres. From Eastbourne, take the A22 to East Hoathly.

Blakeney Point Nature Reserve. Norfolk. From the small fishing village of Blakeney, you take a boat to Blakeney Point Nature Reserve, a wonderful wild fowl breeding-ground. Seals can sometimes be seen about four miles further on. Blakeney is on the A149 from Cromer.

Breydon Water. Norfolk. A large lake just inland of Great Yarmouth. A recommended tour is to follow the southern shore to Burgh Castle. You will see flocks of geese and ducks and also a number of more unusual birds, often in great quantities in autumn and winter.

Bridgwater Bay Nature Reserve. Somerset. Especially good for large flocks of white-fronted geese, shelduck flocks in the summer and autumn, and for all kinds of waders and white wildfowl. The best approach is by the A39 from Cannington, when you can take a side road to Steart and Steart Flats.

Brownsea Island Nature Reserve. Dorset. A very interesting reserve indeed with heath, woodlands, marsh and lake providing habitats for a wide range of birds including herons, terns and nightjars. Also red squirrels. You can get there from Sandbanks or Poole Quay by boat. Open Easter to September daily.

Chew Valley. Avon. A large and attractive valley, famous for its birds, particularly in the spring and autumn when there are many migratory birds there. It is in itself a beautiful place, because the road passes along the valley and lakeside, with wonderful landscapes all around, but above all, this is the place for birdwatchers. From Bristol, take the A37 south and the B3130 to Chew Magna. The B3114 will take you to the edge of the lake.

Cley-next-the-Sea, and Salthouse. Two small fishing villages on the far north coast of Norfolk, both renowned for the number of birds which nest and breed in the region. The area itself is also extremely attractive for coastal photography. A great variety of different birds can be seen there. You can even observe them from the main A149 between Cley and Salthouse.

The Dinas Nature Trail. Dyfed. One of the finest of the Welsh nature trails. Start from Rhandirmwyn which is also the information centre. It is a photographically superb part of the country and one can also see many varieties of birds – buzzards, sparrow-hawks, and ravens – which are quite common there. The track along the River Towey is exciting. From Llandovery on the A40, take a side road first to Cil-y-cwm and then to Rhandirmwyn.

Dovey Estuary. Dyfed. Another area which is well worth visiting to photograph wild life and also plants. It is part of the National Nature Reserve and is particularly good for winter wildfowl. From Dolgellau,

take the A487 to Machynlleth and then the A493 along the Dovey Valley right to the estuary.

Ebbor Gorge. Near Wells, Somerset. Interesting for woodland birds. The setting is very beautiful and the walks from the car park of Ebbor Gorge National Nature Reserve are very interesting. Near Wells on the A371.

Eyebrook Reservoir. Leicestershire. A newly-constructed reservoir, also called Empingham Reservoir, and now an excellent spot for photographing wild birds: winter duck, widgeon, and pintails. There are also good places for seeing kingfishers. From Stamford on the A1, take the A606 to Empingham and a side road to the left.

Farlington Marsh. Hampshire. A strange area of marsh and mudflats, mainly between Portsmouth and Hayling Island, and best approached from Langstone Harbour. It is a splendid area for waders and winter wildfowl. You can see it almost from the main road and no permit is required. From Portsmouth, take the A2030 along the edge of the harbour and then the A27.

Farne Island. Northumberland. There is perhaps no better place in Britain for observing and photographing wild birds than this island. It is, in any case, a fascinating place to visit. You can take a boat to the lonely Farne Island from Seahouses on the B1340 below Bamburgh.

Gibraltar Point. Lincolnshire. A nature reserve on a little promontory on the coast. It is well known and well-attended, and so there are three car parks and many well-trodden tracks along the coast. In spite of that, it is still extremely interesting. In the spring, there are thousands of larks singing overhead – and also kestrels preying on them. From Skegness south on a minor road.

Hawksmoor Nature Reserve. Staffordshire. A reserve containing mainly the more common species of bird, with some scenic nature trails as well. There are 250 acres of moors, marshes and woodlands where you can observe and photograph birdlife. From Cheadle on the A521, take the B5417 for two miles.

Hickling Broad National Nature Reserve. Norfolk. One of the outstanding bird reserves in the country. Hickling is the largest broad in Norfolk and provides great photographic possibilities, particularly from the boats which can be easily hired. Take the A149 from Great Yarmouth, and side roads to Hickling Heath. The approach to the lake is from that side (although it can be approached from the north).

Holme-next-the-Sea Nature Reserve. Norfolk. A few miles from Hunstanton on the A149. Good for various kinds of birds, particularly waders and migrants, so it is essentially an autumn and spring reserve. There is also a bird observatory, but you have to apply for permission to visit it. The entire reserve is closed in winter.

Inchcailloan Island Nature Reserve. Central. An outstanding island on Loch Lomond, which is a nature reserve with proper trails. Go by boat from Balmaha

to Inchcailloan. As many as 140 different species of birds have been observed round Loch Lomond. From Glasgow, take the A809 to Drymen, and the B837 to Balmaha and a boat from there.

Loch Garten. Highland. On this beautiful loch, the Royal Society for the Protection of Birds has established an observatory where visitors are permitted. Here, one of the rarest of the birds of prey, the osprey, can be seen, particularly at nesting times in the spring, late April to May. (Though the ospreys are there throughout the summer.) There are many other different kinds of birds there too. From Boat of Garten which is on the A95 two miles south of Carrbridge.

Lundy Nature Reserve. Devon. An island off the rocky Devonshire coast. Boats can be taken from Ilfracombe. It is an important reserve for the breeding of sea birds. There are also ravens, buzzards and a bird observatory. Lundy is an attractive island, and completely unspoilt.

Lye Rock. Cornwall. A rock with a splendid cliff view and one of the largest puffin colonies in Cornwall. There are other birds as well, including buzzards. Lye Rock is near Bossiney, just north of Tintagel.

Marloes Sands Nature Trail. Dyfed. An exciting stretch of Pembrokeshire scenery. Wonderful cliffs, and a good place to observe and photograph grey seals, and also many types of birds, particularly ravens. From Haverfordwest on the A40, take the B4327 almost to its end and then a side road to Marloes.

Marsden Rocks. Tyne and Wear. Cliffs where interesting birds abound, particularly fulmars and cormorants in the summer. You can get to Marsden from South Shields by taking the A183 right along by the sea.

Minsmere Nature Reserve. Suffolk. On the coast south of Dunwich, a very good observation and photographic point for a great number of birds including terns, bitterns and other migrants. Public hides are open on the beach, and can be used at any time, but one has to apply for a permit to get into the reserve. The best way to get there is from Saxmundham on the A12, taking the B1119 and side roads. Minsmere is fairly well signposted.

New Grounds Nature Reserve. Near Slimbridge, Gloucestershire. One of the largest collections of waterfowl and the headquarters of the Wild Fowl Trust. You will find Bewick swans, ducks, pintails, white-fronted geese and many other migrants. For Slimbridge, take the A38 north from Bristol and turn left south of Cambridge. Well signposted to New Grounds.

Ouse Washes Nature Reserve. Norfolk. An extensive area for a great variety of birds. Admission is limited. You can get there from Chatteris on the A141, by taking B1098 along Sixteen Foot Drain Road and turning right along the B1093 to Manea. From there, it is signposted to Purls Bridge.

Portland Bill. Dorset. An excellent bird-watching and photographing area, particularly rich in sea birds.

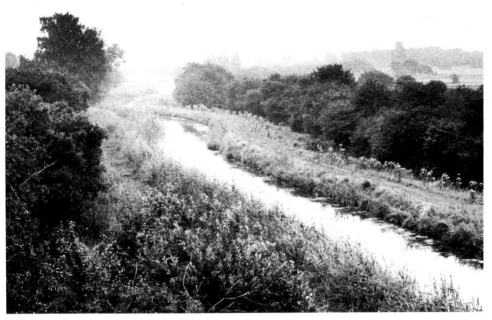

Wicken Fen

There are also some special Portland Bill bird observatories, and a field centre where information can be obtained. From Weymouth, take the A354 right to Portland.

Quantocks Forest Trail. Somerset. A rare and beautiful forest track, with a number of birds, particularly buzzards, and also some red deer to be seen and photographed. A good starting point is Nether Stowey on the A39, from where you can take a side road south.

Romney Marsh. Kent. A dramatic district of desolate marshland, famous for its dawns and sunsets, and a very good area for watching birds of various kinds. As Romney Marsh is fairly large, it is perhaps best to start exploring from Ivy Church on the B2070.

St Bees Head. Cumbria. Excellent seabird colonies are to be found here, particularly razorbills, fulmars, and puffins. There is also an exciting footpath along the cliffs. From Whitehaven on the A595, take the B5345 to St Bees and walk from there.

Slapton Ley Nature Reserve. Devon. Freshwater lake by the sea with many migrant waders and terns, a bird observatory and field study centre to help you make use of it. From Dartmouth, take the A379 south to Slapton Sands.

Spurn Peninsula Nature Reserve. Humberside. (Already described under The Coast.) It is a narrow spit of land on the River Humber, containing a highly important nature reserve with a large number of birds

all the year round. Ask for details first from the Yorkshire Naturalist Trust; it is a marvellous place to visit. From Kingston Upon Hull, take the A1033 to Patrington and then the B1445 to Easington, and a side road to Spurn Head.

Tarn Hows Nature Trail. Cumbria. A trail through magnificent scenery of botanical and ornithological interest, but mainly worthwhile for the quite outstanding views. From Windermere, take a ferry across the lake. Go through Near Sawrey on the B5285 past Hawkshead and you will see signposts to Tarn Hows which lies north-east of Coniston.

Virginia Water. Surrey. Perhaps not as rich in wildfowl as some remote spots, but conveniently close to London. It has a large lake with many splendid birds, and is particularly rich in mandarin duck. Take the A30 from London to Egham and then the A329 to Virginia Water.

Walney Nature Reserve. Cumbria. An island off the Cumbrian coast, reachable from Barrow-in-Furness on the A590. The nature reserve is interesting – there are various birds to be observed and photographed, and the place itself is photogenic.

Wicken Fen. Cambridgeshire. The last remnant of the ancient Lincolnshire and Cambridgeshire fenland, still preserved in its natural wet state. It provides a sanctuary for a number of unusual plants, butterflies and even spiders. The bird life is particularly lively in spring and autumn. From Cambridge, take the A10 to Stretham and the A1123 east to Wicken. From there, it is signposted.

MAP 1 MOUNTAINS/HILLS, DALES AND VALLEYS/DOWNS AND MOORS

Mountains

Hills

Downs and Moors

Dales and Valleys

Mountains

1 The Black Mountains
2 The Brecon Beacons
3 The Grampian
 Mountains
4 Snowdon
5 The Pennines
6 The Peak District
7 The Cumbrian
 Mountains

Hills

1 Blackdown Hill
2 Box Hill
3 Brendon Hills
4 Cheviot Hills
5 Chiltern Hills
6 Cleeve Hill
7 The Cotswolds

8 Edge Hill
9 Eildon Hills
10 Hambledon Hill
11 Leith Hill
12 Lincolnshire Wolds
13 The Long Mynd
14 Malvern Hills
15 Mendip Hills
16 Pendle Hill
17 Purbeck Hills
18 Quantock Hills
19 Wenlock Edge

Dales and Valleys

1 Annandale
2 Blackmore Vale
3 Borrowdale
4 Cardingmill Valley
5 Coverdale
6 Corve Dale
7 Dentdale
8 Derwent Dale
9 Dove Dale
10 Edale
11 Elan Valley
12 Eskdale
13 Garsdale

14 Golden Valley
15 Littondale
16 Llangollen Valley
17 Meon Valley
18 Nidderdale
19 Vale of Pickering
20 Pilsdon Pen
21 Rhondda Valley
22 Swaledale
23 Teesdale
24 Trough of Bowland
25 Wensleydale
26 Wharfedale
27 Vale of the White
 Horse
28 Wye Valley

Downs and Moors

1 Berkshire Downs
2 Bodmin Moor
3 Dartmoor
4 Exmoor
5 Marlborough Downs
6 North Downs
7 North York Moors
8 Rannoch Moor
9 South Downs

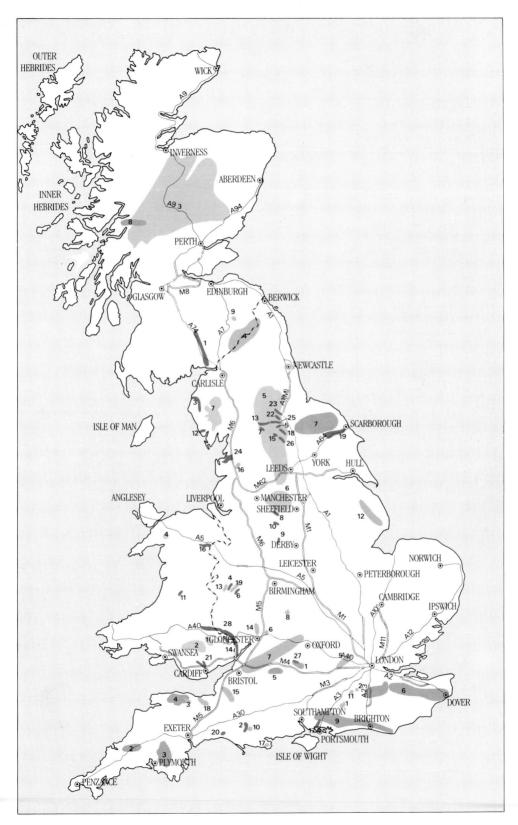

OUTER
HEBRIDES

WICK

INVERNESS

ABERDEEN

INNER
HEBRIDES

A9 3

A94

8

PERTH

GLASGOW M8 EDINBURGH BERWICK

9

A74 A7

1

A1

NEWCASTLE

CARLISLE

3

7

5

A1(M)

ISLE OF MAN

M6

23

22

25

13

5

7

18

15

26

7

SCARBOROUGH

A6

19

12

24

16

LEEDS YORK HULL

M62

ANGLESEY LIVERPOOL MANCHESTER 6

SHEFFIELD

8

A1

10

12

4 A5 9 DERBY

16 M6

LEICESTER

NORWICH

4 19 A5 PETERBOROUGH

13 6

11 BIRMINGHAM CAMBRIDGE

M5 IPSWICH

8 M1 A10

A40 28 14 6 A12

1 GLOUCESTER OXFORD M11

SWANSEA 2 14 27 5 A40 LONDON

21 7 M4 1 A2

CARDIFF 5 A23 DOVER

BRISTOL M3 6

15

4 3 A3 11

18 A10

M5 SOUTHAMPTON 9 BRIGHTON

EXETER A30 2 10 1

20 PORTSMOUTH

2 17 ISLE OF WIGHT

3 PLYMOUTH

PENZANCE

MAP 2 LAKES, RIVERS AND WATERFALLS/MARSHES AND FENS/THE COAST

▪ Lakeland Areas
▫ Marshes and Fens

Lakes, Rivers and Waterfalls

1 Loch Achray
2 River Annan
3 Loch Ard
4 Loch Arklet
5 River Arun
6 River Avon
7 Loch Awe
8 Aysgarth Falls or Force
9 Lake Bala (Llyn Tegin)
10 Norfolk Broads
11 Caldron Snout
12 Cautley Spout
13 Loch Chon
14 River Clyde
15 River Conwy (Conway)
16 Coquet River
17 Cuckmere River
18 River Dart
19 River Dee
20 River Dee
21 River Derwent
22 Derwent River
23 Devil's Bridge
24 Lake (Llyn) Dinas
25 Loch Earn
26 Eas Coul Aulin
27 Eden River
28 River Exe
29 Loch Garry
30 Gordale Scar
31 Grey Mare's Tail Waterfall
32 Llyn Gwynant
33 Hardrow Force
34 High Force Waterfall
35 Loch Katrine
36 Lakes of the Lake District

a Buttermere
b Coniston Water
c Crummock Water
d Derwent Water
e Ennerdale Water
f Esthwaite Water
g Grasmere
h Rydal Water
i The Tarns
j Ullswater
k Wast Water
l Windermere
37 Loch Leven
38 Loch Lomond
39 Llyn Llydaw
40 Lake of Menteith
41 Meon River
42 Loch Morlich
43 Loch Ness
44 River Ouse
45 River Rother
46 Scale Force
47 River Severn
48 Sour Milk Gill Waterfalls
49 River Spey
50 River Stour
51 River Stour
52 Tamar River
53 Loch Tay
54 River Tees
55 River Teme
56 River Test
57 River Teviot
58 River Thames
59 Loch Torridon
60 River Trent
61 The Trossachs
62 River Tweed
63 Usk River
64 Loch Venachar
65 Virginia Water
66 Loch Voil – Loch Doine
67 Lake Vyrnwy
68 River Wye

Marshes and Fens

1 Blakeney Marshes
2 Borth Bog
3 The Fens
4 Romney Marsh
5 The Wash Marshes

The Coast

1 Beachy Head
2 Bedruthan Steps
3 Budleigh Salterton
4 Covehithe
5 Durdle Door
6 East Neuk
7 Flamborough Head
8 Formby Sands
9 Gower Peninsula
10 Hartland Point
11 Hunstanton Cliffs
12 John O'Groats
13 Kennedy's Pass
14 Land's End
15 Laugharne – Laugharne Bay
16 Lindisfarne
17 Lizard Point
18 Lleyn Peninsula
19 Lulworth Cove
20 Morecambe Sands
21 Mull of Galloway
22 The Needles
23 Pembroke Coast
24 Porlock Bay
25 Portland Bill
26 St Abb's Head
27 St Govan's Head
28 Seven Sisters
29 Spurn Head
30 Start Point
31 Sutherland Coast
32 Tintagel Head
33 Trevose Head
34 Walney Island
35 Welcombe Gap
36 White Cliffs of Dover

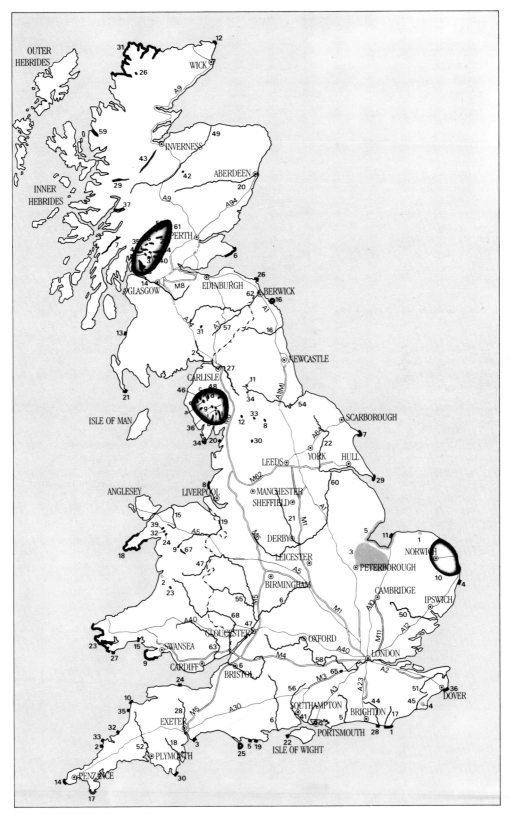

OUTER
HEBRIDES

WICK
31
12
26

A9

59
INVERNESS
49
43

INNER
HEBRIDES

42
ABERDEEN
29
20
37
A9
A94

61
PERTH
35
6
4
40
A9
6

14
GLASGOW
M8
EDINBURGH
BERWICK
26
62
6
16

13
31
A7
57
16
2
NEWCASTLE
CARLISLE
27
46
48
c
11
g
34
54
36
12
33
SCARBOROUGH
34
20
8
22
7
30
LEEDS
YORK
HULL
29
M62
60
ANGLESEY
LIVERPOOL
8
MANCHESTER
SHEFFIELD
15
19
21
A1
39
32
M6
DERBY
5
11
1
24
9
67
LEICESTER
3
NORWICH
18
47
PETERBOROUGH
10
4
A5
BIRMINGHAM
CAMBRIDGE
2
23
55
M5
M1
IPSWICH
68
47
50
A12
23
A40
GLOUCESTER
63
OXFORD
A10
M11
15
SWANSEA
A40
LONDON
27
9
M4
58
A2
CARDIFF
6
BRISTOL
M3
65
51
24
56
A3
A23
36
DOVER
10
M5
SOUTHAMPTON
44
45
4
35
28
A30
41
5
BRIGHTON
17
EXETER
6
PORTSMOUTH
28
1
32
18
22
33
3
5
19
ISLE OF WIGHT
2
52
25
PLYMOUTH
14
PENZANCE
30
17

ISLE OF MAN

225

MAP 3 VILLAGES

1	Abbots Bromley	30	Burwash	59	Keld
2	Abbotsbury	31	Cape Cornwall	60	Kersey
3	Aberedw	32	Castle Combe	61	Lacock
4	Abinger	33	Cerne Abbas	62	Linton-in-Craven
5	Aisholt	34	Chelsworth	63	Llanstephan
6	Aldbourne	35	Chiddingstone	64	Lustleigh
7	Aldworth	36	Chilham	65	Lydford
8	Alfriston	37	Christmas Common	66	Minster Lovell
9	Allendale Town	38	Cilgerran	67	Mousehole
10	Amberley	39	Cil-y-cwm	68	Nunney
11	Applecross	40	Clovelly	69	Nunnington
12	Arisaig	41	Clyro	70	Old Bolingbroke
13	Ashmore	42	Combe	71	Plockton
14	Askham	43	Crackington Haven	72	Port Isaac
15	Ashford-in-the-Water	44	Diabaig	73	Portmeirion
16	Balquhidder	45	Dinas-Mawddwy	74	Rhossili
17	Baslow	46	Dolwyddelan	75	The Rodings
18	Beddgelert	47	Downham	76	Sawrey
19	Benington	48	Dunster	77	Selborne
20	Bibury	49	Egton Bridge	78	The Slaughters
21	Birchover	50	Elterwater	79	Staithes
22	Blair Atholl	51	Finchingfield	80	Sydling St Nicholas
23	Blanchland	52	Friday Street	81	Teffont
24	Bosherston	53	Foyers	82	Wherwell
25	Bramshaw	54	Glaisdale	83	Winsford
26	Bredwardine	55	Hambledon	84	Woolpit
27	Brightling	56	Hemingford Grey	85	Yoxford
28	Broadway	57	Horning	86	Zennor
29	Burley	58	Hurstbourne Tarrant		

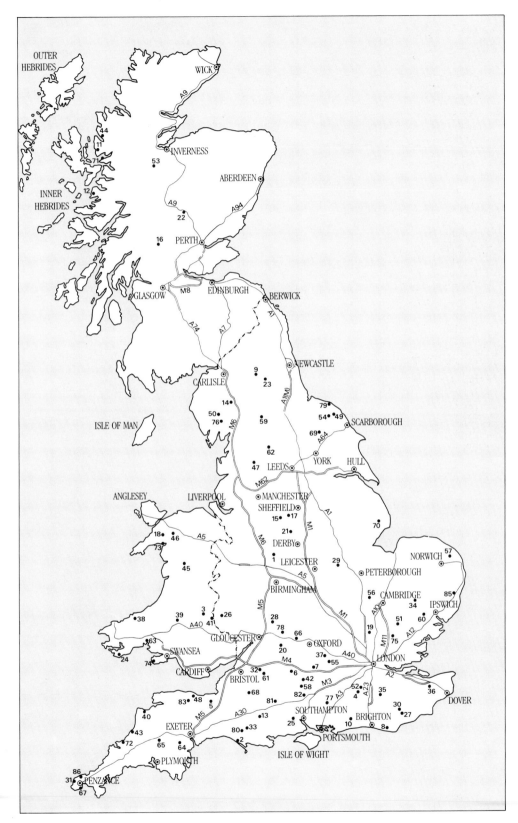

OUTER
HEBRIDES

WICK

A9

44
11
7
INVERNES

53

ABERDEEN

INNER
HEBRIDES

12

A9
22

A94

16
PERTH

GLASGOW M8 EDINBURGH BERWICK

A74 A7 A1

9
23 NEWCASTLE

CARLISLE A1(M)

14
50 59
76 M6

ISLE OF MAN

79
54 49 SCARBOROUGH
69 A64

62
47 LEEDS YORK HULL

M62

ANGLESEY LIVERPOOL MANCHESTER
SHEFFIELD
15 17
18 21 70
46 A5 DERBY
73 M6
45 1 LEICESTER
29
A5 PETERBOROUGH
BIRMINGHAM
56 CAMBRIDGE 85
34 IPSWICH
38 39 3 26 51 60
A40 41 28 M1 A12
63 M5 78 19 75
SWANSEA 20 66 OXFORD M11
24 74 M4 37 55 A40 LONDON
CARDIFF 32 6 7 A2
BRISTOL 61 42 M3
83 48 68 58 52 35 36
5 81 82 77 A3 4 A23 30
40 13 SOUTHAMPTON 10 27 DOVER
43 80 33 25 BRIGHTON 8
72 EXETER A30 PORTSMOUTH
65 64 2 ISLE OF WIGHT
PLYMOUTH
86
31 PENZANCE
67

NORWICH 57

A1 M1 M6 A5 A64 A94 A9 A7 A74 A1(M) M62 M5 M4 M3 M11 A12 A23 A3 A2 A40 A30

MAP 4 HISTORIC BUILDINGS/PREHISTORIC MONUMENTS

▲ Cathedrals

● Abbeys

■ Castles

ı Prehistoric
Monuments

Cathedrals

1 Bangor Cathedral
2 Brecon Cathedral
3 Canterbury Cathedral
4 Chester Cathedral
5 Chichester Cathedral
6 Christ Church
7 Coventry Cathedral
8 Durham Cathedral
9 Ely Cathedral
10 Exeter Cathedral
11 Glasgow Cathedral
12 Gloucester Cathedral
13 Hereford Cathedral
14 Iona Cathedral
15 Lichfield Cathedral
16 Lincoln Cathedral
17 Liverpool Cathedral
18 Norwich Cathedral
19 Peterborough Cathedral
20 St Albans Cathedral
21 St Asaph's Cathedral
22 St David's Cathedral
23 St Giles' Cathedral
24 Salisbury Cathedral
25 Southwell Minster
26 Truro Cathedral
27 Wells Cathedral
28 Winchester Cathedral
29 Worcester Cathedral
30 York Minster

Abbeys

1 Battle Abbey
2 Beaulieu Abbey
3 Bolton Abbey
4 Buildwas Abbey
5 Byland Abbey
6 Castle Acre Priory
7 Cleeve Abbey
8 Dryburgh Abbey
9 Evesham Abbey
 Fountains Abbey

11 Furness Abbey
12 Glastonbury Abbey
13 Jedburgh Abbey
14 Jervaulx Abbey
15 Kelso Abbey
16 Kirkstall Abbey
17 Lindisfarne Priory
18 Malvern Priory
19 Melrose Abbey
20 Newstead Abbey
21 Rievaulx Abbey
22 Tintern Abbey
23 Valle Crucis Abbey

Castles

1 Alnwick
2 Arundel Castle
3 Bamburgh
4 Barnard Castle
5 Beeston Castle
6 Belvoir Castle
7 Berkeley Castle
8 Blair Castle
9 Bodiam Castle
10 Bolton Castle
11 Braemar Castle
12 Brough Castle
13 Brougham Castle
14 Caernarvon Castle
15 Carisbrooke Castle
16 Carreg-Cennen Castle
17 Castle Ashby
18 Castle Drogo
19 Castle Hedingham
20 Castle Tioram
21 Chepstow Castle
22 Cilgerran Castle
23 Conwy Castle
24 Corfe Castle
25 Craigievar Castle
26 Dartmouth Castle
27 Deal Castle
28 Dover Castle
29 Duart Castle
30 Dunnottar Castle
31 Dunstanburgh Castle
32 Dunure Castle
33 Edinburgh Castle
34 Eilean Donan
35 Glamis Castle
36 Goodrich Castle
37 Hardknott Castle
38 Harlech Castle
39 Hever Castle

40 Inveraray Castle
41 Old Inverlochy Castle
42 Kenilworth Castle
43 Kilchurn Castle
44 Lancaster Castle
45 Lindisfarne Castle
46 Lowther Castle
47 Maiden Castle
48 Newark Castle
49 Norham Castle
50 Pembroke Castle
51 Pevensey Castle
52 Portland Castle
53 Powis Castle
54 Raglan Castle
55 Restormel Castle
56 Richmond Castle
57 St Michael's Mount
58 Stirling Castle
59 Tantallon Castle
60 Tintagel Castle
61 Urquhart Castle
62 Warkworth Castle
63 Warwick Castle

Prehistoric Monuments

1 Avebury Circle
2 Badbury Rings
3 Barbury Castle
4 Cairn Holy Chambered
 Cairns
5 Callanish Standing
 Stones
6 Castlerigg Stone Circle
7 Cerne Giant
8 Harold's Stones
9 Lanyon Quoit
10 Loch Stemster Standing
 Stones
11 Long Man of
 Wilmington
12 Maiden Castle
13 Nine Stones
14 Penrhos-Feilw Standing
 Stones
15 Pentre Ifan Cromlech
16 Rollright Stones
17 St Lythans Cromlech
18 Silbury Hill
19 Spinster Rock
20 Stonehenge
21 Uffington White Horse
22 Wayland's Smithy
23 Westbury White Horse

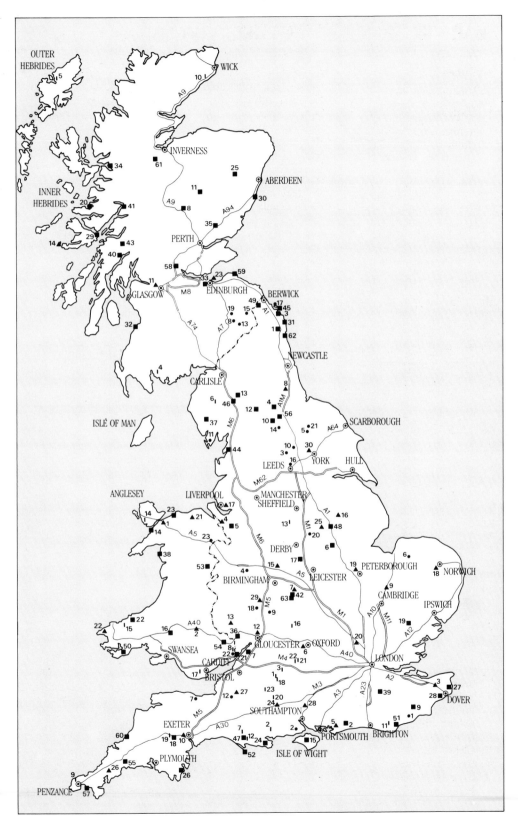

OUTER
HEBRIDES
5

WICK
10 1

INVERNESS

34
61

INNER
HEBRIDES
20

41
25

ABERDEEN

11
8
30

A9
A9
A94
35

14
29
40

43
PERTH

32
58

11
GLASGOW
M8
33 23 59
EDINBURGH
BERWICK
17
45
3
31
62

A74
A7
19
8
15
13
49
1

NEWCASTLE

4
CARLISLE

6
46
13
8
12
A1M
56
37
10
14
5 21
SCARBOROUGH
A64

ISLE OF MAN
M6
11
44
10
3
30
16
LEEDS
YORK
HULL

M62

ANGLESEY
LIVERPOOL
17
MANCHESTER
SHEFFIELD
A1
16
25
48
13
20
DERBY
6
17
19
6
PETERBOROUGH
18
NORWICH

14 23
21
4
5
M6
M1

14
1
A5
23
53
BIRMINGHAM
15
A5
LEICESTER
9
CAMBRIDGE
IPSWICH

38
4
29
M5
63 42
19
22
15
16
7
20
A10
M11
19
A12

22
16
A40
13
36
12
18
9
M1

50
SWANSEA
54
8
12
22
2
GLOUCESTER
OXFORD
20
LONDON
A40
A2
17
CARDIFF
7
6
M4 22
21
A23
3
27
BRISTOL
1
18
23
M3
A3
28
39
DOVER
12
27
24
120
A3
5
9
EXETER
28
51
1
SOUTHAMPTON
A30
7
2
2
5 2
11
BRIGHTON
60
19
18
10
47
12 24
15
PORTSMOUTH
26 55
PLYMOUTH
52
ISLE OF WIGHT
9
26
PENZANCE
57

229

MAP 5 GARDENS, PARKS AND STATELY HOMES

1 Abbotsbury	27 Furzey Gardens	50 Ness Gardens
2 Alton Towers	28 Glendurgan Gardens	51 Newstead Abbey
3 Anglesey Abbey	29 Graythwaite Hall	52 Nymans Garden
4 Aros Park	Gardens	53 Packwood House
5 Bible Gardens	30 Gwyllt Gardens	54 Penshurst Place
6 Bicton Gardens	31 Hampton Court	55 Petworth House
7 Blenheim Palace	32 Hatfield House	56 Plas Newydd
8 Bodnant Garden	33 Heveningham Hall	57 Polesden Lacey
9 Brockhole	34 Hidcote Manor	58 Pusey House Gardens
10 Burford House Garden	Gardens	59 Ragley Hall
11 Burghley House	35 Hodnet Hall Gardens	60 Rousham House
12 Castle Howard	36 Holker Hall	61 Rydal Mount
13 Chatsworth House	37 Holkham Hall	62 Savill Gardens
14 Cliveden House	38 Inverewe Garden	63 Sissinghurst Castle
15 Clumber Park	39 Kirby Hall	64 Springfield Gardens
16 Compton Acres	40 Knole House	65 Stowe Park
17 Compton Wynyates	41 Lacock Abbey	66 Tatton Park
18 Crarae Forest Garden	42 Levens Hall	67 Threave Garden
19 Culzean Castle	43 Lingholm Garden	68 Trelissick Gardens
20 Cymerau Gardens	44 Lochinch and Castle	69 Uppark
21 Dawyck House	Kennedy Gardens	70 Waddesdon Manor
Gardens	45 Logan Botanic Gardens	71 West Wycombe Park
22 Dyrham Park	46 Longleat	72 Westonbirt Arboretum
23 East Lambrook Manor	47 Luton Hoo	73 Winkworth Arboretum
24 Edwalton Rose Gardens	48 Lyme Hall and Lyme	74 Wisley Gardens
25 Edzell Castle	Park	75 Woburn Abbey
26 Exbury Gardens	49 Montacute House	

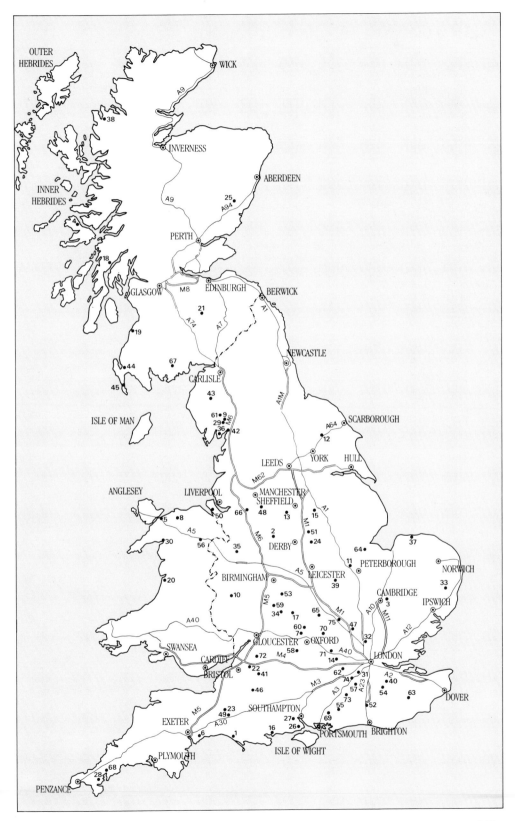

OUTER
HEBRIDES

WICK

38

INVERNESS

A9

INNER
HEBRIDES

ABERDEEN

25
A94

4

PERTH

18

GLASGOW M8 EDINBURGH BERWICK

21

A74 A7 A1

19

67 NEWCASTLE

44 CARLISLE

45 43

A1M

ISLE OF MAN

61 9 SCARBOROUGH
29 M6 A64
36 42 12

LEEDS YORK HULL

M62

ANGLESEY LIVERPOOL MANCHESTER
SHEFFIELD A1

5 8 50 66 48 13 15

A5 M1

30 2 51

56 35 DERBY 24

M6 64 37

20 11 PETERBOROUGH NORWICH

A5 LEICESTER 33

BIRMINGHAM 39 CAMBRIDGE IPSWICH

10 53 3

M5 59 65 A10 M11

34 17 75 A12

A40 60 70 47

7 32

SWANSEA GLOUCESTER OXFORD LONDON

58 71 A40

CARDIFF 72 M4 14 DOVER

BRISTOL 22 62 31 A2

41 74 40

46 M3 57 54 63

A3 73 52

SOUTHAMPTON 55 69 BRIGHTON

23 27 PORTSMOUTH

EXETER 49 26

A30 16 ISLE OF WIGHT

6 1

PLYMOUTH

28 68

PENZANCE

231

MAP 6 FORESTS/NATURE TRAILS AND RESERVES

- Forests

■ Nature Trails and
 Reserves

Forests

1 Ashdown Forest
2 Forest of Bere
3 Border Forest Park
4 Forest of Bowland
5 Burnham Beeches
6 Cannock Chase
7 Charnwood Forest
8 Clun Forest
9 Coed-y-Brenin
10 Forest of Dean
11 Delamere Forest
12 Epping Forest
13 Forest Fawr
14 Glen Trool Forest
15 Grizedale Forest
16 Gwydr Forest
17 Lune Forest
18 New Forest
19 Radnor Forest
20 St Leonard's Forest
21 Savernake Forest
22 Sherwood Forest
23 Thetford Chase

Nature Trails and Reserves

1 Beinn Eighe Nature
 Reserve
2 Bempton Cliffs
3 Bentley Wild Fowl
 Gardens
4 Blakeney Point Nature
 Reserve
5 Breydon Water
6 Bridgwater Bay Nature
 Reserve
7 Brownsea Island Nature
 Reserve
8 Chew Valley
9 Cley-next-the-Sea –
 Salthouse
10 The Dinas Nature Trail
11 Dovey Estuary
12 Ebbor Gorge
13 Eyebrook Reservoir
14 Falington Marsh
15 Farne Island
16 Gibraltar Point
17 Hawksmoor Nature
 Reserve
18 Hickling Broad
 National Nature
 Reserve

19 Holme-next-the-Sea
 Nature Reserve
20 Inchcailloan Island
 Nature Reserve
21 Loch Garten
22 Lundy Nature Reserve
23 Lye Rock
24 Marloes Sands Nature
 Trail
25 Marsden Rocks
26 Minsmere Nature
 Reserve
27 New Grounds Nature
 Reserve
28 Ouse Washes Nature
 Reserve
29 Portland Bill
30 Quantocks Forest Trail
31 Romney Marsh
32 St Bees Head
33 Slapton Ley Nature
 Reserve
34 Spurn Peninsula Nature
 Reserve
35 Tarn Hows Nature
 Trail
36 Virginia Water
37 Walney Nature Reserve
38 Wicken Fen

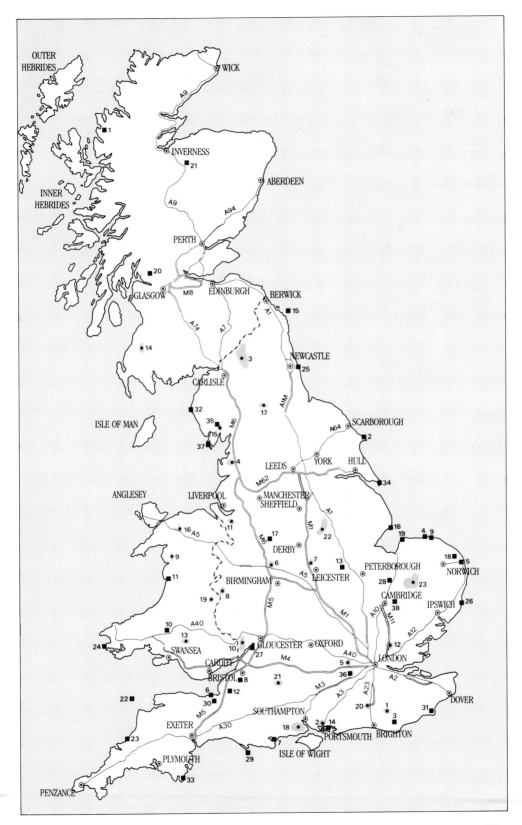

INDEX

Page numbers in *italics* refer to the illustrations and their captions.

ACKNOWLEDGEMENTS

I would like to thank John Raddon of Pentax Ltd and Harry Collins of Nikon for their kind help and assistance. Also Suzy Falkner for her incredibly fast typing of the gazetteer, Judith Stinton for her equally speedy editing of the same, and Geoffrey Chesler for his great patience and painstaking attention to detail, as well as for overlooking my grammar and spelling. Above all, I would like to thank my wife for putting up with my prolonged absence.

The publishers and the author wish to thank the following for permission to reproduce photographs and illustrations:

Ace Photo Library, photos by Pamla Toler, pages 25 *above right*, 106 *above* from 'National Trust Book of the Farm' pub. Weidenfeld and Nicholson
Sam Alexander, 108, 112 *below left and right*, 188, 200, 202

Barnabys Picture Library, 173, 182, 210
J. Allan Cash, 178
Peter Cavalier, 140 *below*, 141 *above*
Jeremy Enness, 50/51, 164/165
Fay Godwin, 207
Eric Hosking, 219
Illustra Design, 16/17, 26, 40/41, 45, 46/47
Norwich Central Library, 102 *above*
Dave Paterson, 52/53, 54
Press-Tige Pictures, 160, 161, 162
Sutcliffe Gallery, Whitby, 102 *below*
Patrick Thurston, 111 *above*, 112 *above*, 191
Vision International, photos by Angelo Hornak, 120, 121
Roy Westlake, 184
George Wright, 30 *left*, 36, 92, 104, 113, 115, 150 *above*, 159 *above*, 163
Jon Wyand, 33 *right*, 105, 114 *below left and right*